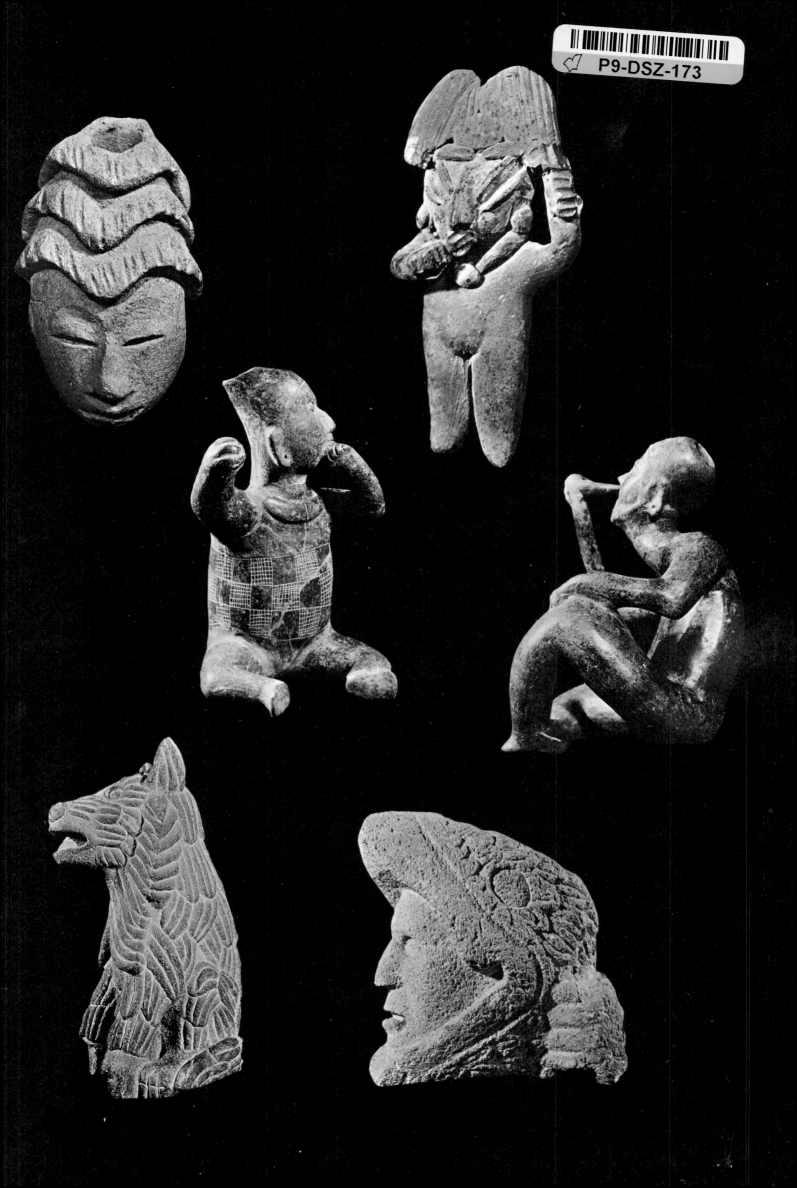

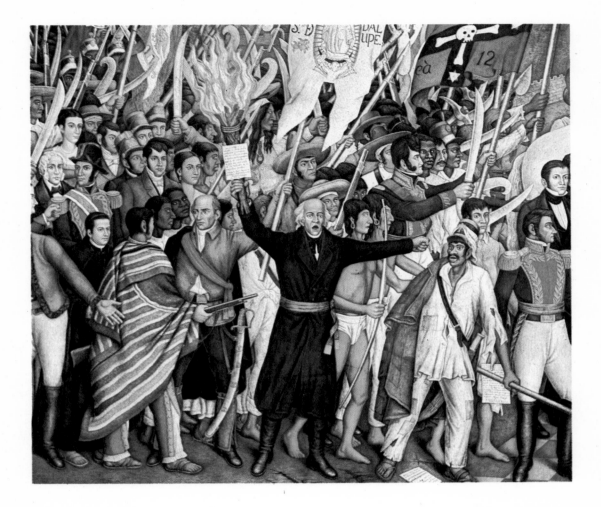

MEXICO
A HISTORY
IN ART

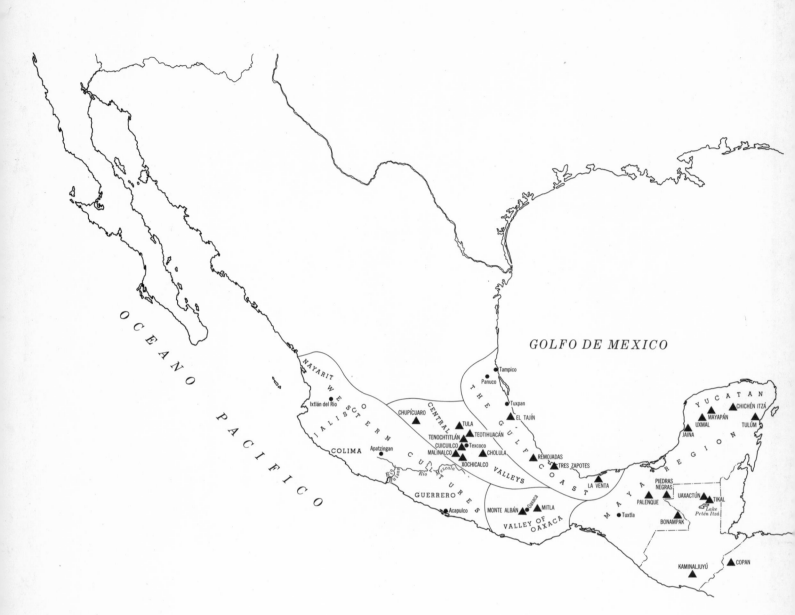

GOLFO DE MEXICO

OCEANO PACIFICO

NAYARIT

Ixtlán del Rio

JALISCO

COLIMA

Apatzingan

WESTERN CULTURES

GUERRERO

Acapulco

CHUPÍCUARO

CENTRAL VALLEYS

TULA

TENOCHTITLÁN
CUICUILCO Texcoco
MALINALCO
XOCHICALCO

TEOTIHUACÁN

CHOLULA

VALLEY OF OAXACA

MONTE ALBÁN Oaxaca MITLA

Rio Balsas
Rio Mexcala

Tampico
Panuco

Tuxpan

EL TAJÍN

THE GULF COAST

REMOJADAS

TRES ZAPOTES

LA VENTA

Tuxtla

YUCATAN

CHICHÉN ITZÁ

MAYAPÁN

UXMAL TULÚM

JAINA

MAYA REGION

PIEDRAS NEGRAS
UAXACTÚN
PALENQUE TIKAL
Lake Petén Itzá
BONAMPAK

KAMINALJUYÚ COPAN

ancient mexico

2

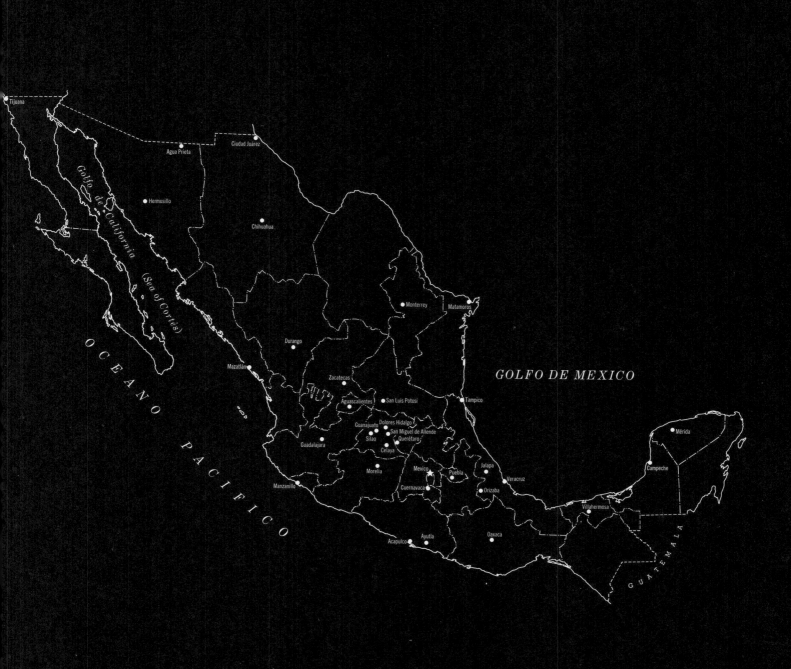

Tijuana

Agua Prieta Ciudad Juárez

Hermosillo

Golfo de California (Sea of Cortés)

Chihuahua

Monterrey Matamoros

Durango

OCEANO Mazatlán

Zacatecas *GOLFO DE MEXICO*

Aguascalientes San Luis Potosí Tampico

Guanajuato Dolores Hidalgo

Silao San Miguel de Allende Mérida

Guadalajara Celaya Querétaro

PACIFICO Morelia Mexico Puebla Jalapa Campeche

Manzanillo Cuernavaca Veracruz

Orizaba Villahermosa

Acapulco Ayutla Oaxaca *GUATEMALA*

modern mexico

mexico

A HISTORY IN ART

BY BRADLEY SMITH / *A Gemini-Smith, Inc. Book published by Doubleday & Company, Inc. Garden City, New York*

Consultants DR. ROMÁN PIÑA CHÁN,
Archaeologist,
Museo Nacional de Antropología e Historia

LIC. JORGE GURRIA LACROIX,
Director of Publications,
Instituto Nacional Antropología e Historia

DAVID H. STECH, *Graphics Director*
EARL T. GLAUERT, *Technical Editor*
NANCY G. HENDERSON, *Production Supervisor*
HENDRIK HERTZBERG, *Editorial Assistant*
VICTORIA CABRERA ECHEVERRIA, *Research*
HELEN REED GOLDSTEIN, *Research*
Printed in Japan by TOPPAN

ISBN: 0-385-03239-0

World rights reserved by Gemini Smith Inc. Library of Congress Catalog Card No. 68-28219. First printing 1968. All photographs of paintings or sculpture belonging to Mexican museums were taken with the cooperation of the Instituto Nacional de Antropología e Historia of Mexico City.

Published in the Spanish language by EDITORA CULTURAL Y EDUCATIVA, S.A. de C.V., Mexico D.F.

Cover: *Completion of the Agrarian Revolution*
by Diego Rivera

Mayan Dancer
collection of Kurt Stavenhagen

Title page: *The Mexican and his World*
(pgs. 4–5) by Rufino Tamayo

Page 1 *The War of Independence*
by Juan O'Gorman

End pages: *Ceramics* from the collections of
Kurt Stavenhagen and the Museo Nacional
de Antropología e Historia, Mexico City

PREFACE

In ancient Mexico the wise man was called *tlama-tini,* or "he who knows"; he was the repository of the collected knowledge, oral and graphic, of a rich culture. The visual records in his keeping took the form of sequential picture-symbol drawings illustrating, among other themes prosaic and profound, the creation of man, the histories of dynasties, and the laws and customs of the time. The men who made these book-scrolls, drawing in brilliant color on cured animal skins, became the first historians of the Americas. I have tried to emulate the early sages by retelling the history of Mexico through the creations of her artists.

Another early concept central to the Mexican tradition has guided me in the preparation of this book: the idea of duality, which appears again and again in the Mexican art of all periods. Light and darkness as different sides of the same stone, ending as beginning, decay becoming growth, death as a part of life—from dualities such as these the book takes its form. It, too, is a dual work, for it traces the ancient culture and the modern one as they flow together to create the unique Mexico of today. The first half, devoted to ancient Mexico, illuminates the second half, devoted to modern Mexico, and forms a base on which it stands. This is a book of images; its text is separate but integrated.

No single book, not even a hundred books, could encompass all of the art and history of Mexico. This book, like the mosaic work of the Toltecs, is made up of selected gems of art wrought together to form a representation of the whole. It is presented as a sketchbook of history, with its details painstakingly chosen to evoke the spirit of Mexican life and art. It is not a political, economic, or social history, but it contains enough elements of all three to give the reader a general understanding of the evolution of Mexico from prehistoric times to 1940, when the Mexicans at last repossessed their natural resources from the foreign interests which had so long exploited them.

It will make it easier for the reader to pronounce the exotically spelled Nahuatl names of places and people if it is understood that they are pronounced phonetically with, however, the final "l" unemphasized and the "x" pronounced as "sh."

The works of art reproduced here, all photographed especially for this book, are with only three exceptions still to be found in Mexico. There are of course great examples of ancient and modern Mexican art in other countries, but the preponderance of the best, and the widest and most representative selection, remains in the country where it was created. There is another reason for concentrating on Mexican art located in Mexico: it makes it possible for the visitor to see the originals on a journey there.

Government and private museums and private collectors allowed me to photograph whatever I wished. Priceless original and facsimile codices, as the book-scrolls of the ancients are now called, were put at my disposal. The chronicles of Bernardino de Sahagún and his disciples, of Diego Durán, and of Toribio de Motolinia—three of the many dedicated friars who preserved countless visual and oral records from destruction or oblivion—became my guide to ancient Mexico.

The use of visual images as a means of communicating information belongs to every era in Mexican art and history. But this is art that did, and does, transcend mere information. The murals of Teotihuacán, the ceramics of Tlatilco, Colima, and Jalisco, the frescoes of Monte Albán, the Mayan bas-reliefs of Palenque, and the sculpture of Jaina speak not only of what man accomplished but also to what he aspired. From this rich traditional base came the European-influenced folk art and the Spanish-Indian baroque forms of the Colonial period. The final flowering came with the burst of color, form, and searing emotional content of the revolutionary painters of the modern Mexican renaissance.

In the work of Orozco, Rivera, Dr. Atl, Fernando Leal, Lozano, Siqueiros, Tamayo, and their contemporaries may be seen the most vivid and moving account of a country's revolutionary history ever created. But it is more than a record of a revolution. These artists have created a passionate testament to the ability of mankind to rise above slavery and degradation to build a life of dignity and of drama.

—BRADLEY SMITH

ACKNOWLEDGMENTS

The author wishes to gratefully acknowledge the co-operation of the Consejo Nacional de Turismo de Mexico, headed by the distinguished former president of Mexico, Sr. Miguel Alemán. Sr. Alemán was most gracious with his time, as were his assistants, Sr. Miguel Guajardo, Coordinator General; Sr. Guillermo Moreno B., Sub-Coordinator General; Ing. Xavier Frías; and Mr. Peter J. Celliers, the Director of the Mexican National Tourist Council in New York.

I am equally grateful to the members of the staff of the Instituto Nacional de Antropología e Historia. The late Dr. Eusebio Davalos Hurtado directed me to those people throughout Mexico who could be most helpful. His successor, Dr. Ignacio Bernal, gave generously of his time and advice. I made many field trips throughout Mexico with Lic. Jorge Gurria Lacroix, who was most helpful in preparing the chronologies for the last four periods in Mexican history. I also wish to extend my thanks to Lic. Eugenio Noriega Robles and Joaquín Cortina Goríbar.

I was introduced to the staff of the Museo Nacional de Antropología e Historia by its gracious publicity director, Sra. Margarita A. de Laris. They assisted me in the selection of many of the works of art shown. I am especially grateful to Dr. Román Piña Chán, who supplied the information for the chronologies of the first four chapters. Sra. Margarita A. de Laris gave freely of her time. Sra. Zita Canesi was my guide to the codices in the Museum's Library, which is directed by Sr. Antonio Pompa y Pompa. Sra. Susana Hendricks Vda. de Pérez made it possible for me to photograph priceless objects under ideal conditions. Anthropologists attached to the museum, who gave freely of their time, include Sra. Doris Heyden, Sra. María Antonieta Cervantes, Sra. Silvia Garza Tarazona, Sra. Amalia Cardós de Méndez, Sr. Carlos Navarrete, and Sr. Otto Shondube.

Also I owe much to the Instituto Nacional de Bellas Artes, in Mexico City, and to its Director, Sr. José Luis Martínez, and his Deputy, Sr. Jorge Hernández Campos, Chief of the Department of Plastic Arts. I am grateful to Sra. Carmen Barreda, Director of the Museo Nacional de Arte Moderno; Sr. Jesús Talavera, Director of the Galerías de Bellas Artes; Sra. Carmen Andrade of the Pinacoteca Virreinal de San Diego; Sr. Lic. Antonio Arriaga Ochoa of the Museo Nacional de Historia at Chapultepec; Sr. Lic. Ernesto de la Torre of the Biblioteca Nacional de Mexico; Dr. Gustavo A Pérez Trejo of the Hemeroteca Nacional de Mexico; Sr. José Ignacio Rubio Mañe of the Archivos General de la Nación at the Palacio Nacional; Sr. Agustín Yañez, Minister of Education at the Secretaría de Educación Pública; Sr. Roberto a la Torre Padilla of the Preparatoria Nacional de Mexico.

Outside Mexico City, I had the pleasure of meeting and working with the distinguished anthropologist Dr. John Paddock of Stanford University and the Museo Frissell de Arte Zapoteca at Mitla in Oaxaca, where I also consulted with Mr. Howard Leigh. I appreciate the courteous assistance given me by Sr. Miguel Celorio, Director of the Museo Nacional del Virreinato at Tepotzotlan; Arch. Alfonso Medellin Zenil, Director of the Museo de Antropología de la Universidad Veracruzana, Jalapa, Veracruz; Sr. Lorenzo Gamio, Director of the Museo Regional de Antropología e Historia of Oaxaca; Dr. Carlos Pellicer at the Parque La Venta, Villahermosa in Tabasco; and Sr. José Guadalupe Zuno, Director of the Museo Regional de Guadalajara, Jalisco. I received much help from Sr. Carlos Sebastian Hernández, Deputy to Dr. Carlos Pellicer at the Museo Regional de Antropología e Historia, Villahermosa, Tabasco.

In the Palenque area, I was accompanied by Sr. Mario León Tovilla of the Palenque Chiapas Archaeological Zone, who made it possible for me to research and photograph that fascinating region. Sra. Concepción García Sancho, Director of the Hospicio de Cabañas, Guadalajara, Jalisco, was most helpful in relating her memories of the painter Orozco.

Extensive interviews with Sra. Lola Olmedo, Dr. Edmundo O'Gorman, Rufino Tamayo, and Juan O'Gorman were most useful and informative.

In the United States, my thanks are due to Dr. Gordon Ekholm, Curator of Mexican Archaeology at the Ameri-

CONTENTS

can Museum of Natural History in New York; Mr. Elwood Logan of their Photographic Department, who made their studio available to me; and Miss Elisabeth Little of the Museum of Primitive Art in New York.

I am also grateful to many private collectors who allowed me to photograph their works of art in Mexico and especially for the courtesy and cooperation of Dr. Kurt Stavenhagen of Mexico City. I appreciate the advice and arrangements made by Barry Lee Bishop of the Chicago Tribune, during my stay in Mexico; Mr. Joe Nash of the News; and to Frank and Nancy Lowenstein of Posada Piramides at San Juan Teotihuacán.

Special thanks are due to my personal staff, both in Mexico and the United States. I am indebted to Sra. Victoria Cabrera Echeverria, who assisted with my research in Mexico and was most efficient in making arrangements and appointments. Sr. Celedonio Mercado worked long hours as my driver, photographic assistant, and guide.

My special thanks to my long-time secretary, Mrs. Florence Kronfeld, and to Mrs. Dorothy R. Stolp, both of San Diego, California; Mr. Steven Bradley Smith, of Los Angeles, California; Mr. Paul Perez, of Oaxaca, Mexico; and Mr. C. Peter Davis, of New York.

Finally, my thanks to my wife, Ruth Heinz Smith, whose deep understanding and constant encouragement have made my work, in Mexico, California, and New York, pleasant and rewarding.

Acknowledgment of the assistance I have received from all of the above individuals does not imply any responsibility for the viewpoints expressed or for any inadequacies in the text.

Furthering his great work of bringing to light the history and art of various countries, Bradley Smith now presents his volume devoted to Mexico. This study is of marked interest, including, as it does, an exposition of Mexico's ancient culture and the highlights of our colonial and modern art.

Mr. Smith's work gives readers a picture of the evolution of our nation from its beginnings and reflects the fruits of the Revolution carried through to the present day. The book is illustrated with magnificent color photographs that, conveying a clear appreciation of our creations, are an important contribution to any understanding of the development of our artistic life.

Mr. Smith's text draws upon the leading sources and documents of our history and makes clear the efforts that Mexicans had to make to rise above their environment and create the institutions of nationhood—as much in the era prior to the Conquest, when diverse levels of civilization flourished in our land, as during the Colonial period, when religious fervor in the building of churches

INTRODUCTION TO THE ART OF MEXICO

Mexican art has flourished for twenty centuries. The body of work covered by the term "Mexican art" includes three great historical periods: the Indian, the Colonial, and the Modern.

The long Indian period, which ends with the arrival of the Spaniards, embraces all the original cultures of the country, including the Archaic, Olmec, Teotihuacán, Toltec, Mayan, Mixtec, Zapotec, and Aztec. Because of the originality and the character of its forms, the art of the Indian period is today compared to that of the great classical cultures.

However, early Mexican art has not always been held in such esteem. It became known to western culture during the Renaissance. In this restricted Christian world, the daring and different art of the New World was seen only as the work of the devil. During the nineteenth century, early Mexican art came to be the object of archaeological and ethnographical interest.

Only in our time has it come to be regarded as art. Present-day opinion is the result of greater historical awareness and the break with the traditional concepts of classical beauty and realism. Each of the major perspectives of contemporary scholarship—aesthetic, religious, historical, archaeological—helps us transcend the limits of our western classical tradition. Today it is no longer possible to deny that these works are art—and great art.

From western Mexico, there are myriad ceramic sculptures, sometimes polychromed, whose beauty is immediately apparent. They belong to the Tarascan culture, whose sculpture tells a complete story. Although their function was funereal, the images are expressions of the life of the people. Men, women, animals, vases, and family or ritual scenes are depicted with great freedom of form and style. The artists imparted, through simplified forms, a naturalness and beauty of attitude and movement to these works.

Around the Gulf of Mexico, to the east, the Olmec

nd convents gave rise to a form of baroque art of singu-
ar importance as well as to the teaching of the humani-
ies and the arts in religious centers and colleges.

This period of evolving national identity, during which
he conquered blended with the conquerors to produce
he mestizo element, played a most important role in our
evolution. In this period, too, the loveliest cities of our
epublic were founded, and major mineral exploitation
egan.

But the Mexican nation gained its most important
orm, and independent life, as the result of various strug-
les and of the Revolution that brought about the fall
nd banishment of General Porfirio Díaz.

Today, in modern times, the Mexican people stand as
masters of their own destiny and are creating legal insti-
utions and a social organization favoring the broad
majority, under a constitution that aspires to the rule of
ustice, to true democracy, and to general enjoyment of
the national wealth. To this end, we have fought against
privileged ownership of the land, establishing human
bases for relations between the worker and the capitalist,
nd have ensured the reach of education to every level
of the population rather than allowing this to be the
heritage of the few.

On the other hand, against the backdrop of history, we
note the conditioning of Mexico's art by the nation's
social life: the plastic marvels of the earliest civilizations,
the superb religious art of the Colonial period, the con-
temporary achievements of the great muralists, depicting
the people's struggle to affirm their own future in an
atmosphere of peace and work but with liberty and
without unjust exploitation.

Destined to spread greater knowledge of our past and
of our culture, this book will be of real value to the
stranger as well as to the old friend on our shores, for
its contents provide a clear synthesis of the progress of
Mexico and particularly of the forward movement of the
arts in those great sculptural and historical works that
grip us by their aesthetic values in a world become
fiercely materialistic. Its pages depict the cultural itin-
erary of a nation loving justice, whose ancient stones
and folklore provide enchanted moments for the visitor.
But the book also generates notable thoughts on what
a people can do to determine their liberty and, even more
desirable, it generates a spiritual understanding in the
world community.

—MIGUEL ALEMÁN
President of Mexico 1948–1952

culture left sculptures, in the form of altars and
great monolithic heads, whose formal simplicity and
proportions give them a colossal character. The
famous smiling heads from this area are exceptional
in all early Indian art. The Huaxtec and Totonacs
created stone sculptures of formidable proportions.
The pyramid El Tajín has no rival for its original
form and geometric precision.

Classic Mayan art, with its monumental architec-
ture and exquisite reliefs, such as those of Palenque,
is unique. In these reliefs the human figure has an
elegance of attitude even though the well-propor-
tioned bodies are left free and nude. The fresco
paintings of the buildings of Bonampak are also
magnificent examples of refinement.

Classic Mayan art is quite different from all the
others. A building like the Governor's Palace in
Uxmal, because of its architectural beauty, rivals
similar buildings of the East and the West. No other
sites equal the Mayan designs with their majestic
proportions and rich ornamentation, as exemplified
by the 2,500-year-old ceremonial and religious cen-
ter of Chichén Itzá.

The plans of sacred cities are most notable for their
order, but none exceeds the perfection of Teotihua-

cán, near Mexico City. This ancient city is famous
for its long Avenue of the Dead, its high pyramids
of the Sun and the Moon, and its ornate palaces. If
any site can offer the serene calm and majestic beauty
of classical art, it is Teotihuacán. However, the Tula
of the Toltecs, with its severe architectural forms and
its columns of stone serpents with erect bodies, is
equally impressive.

In Oaxaca, located in the Valley of Mexico, Monte
Albán towers from the summit of a mountain. There
the sweep of a great rectangle, limited only by pyra-
mids and altars, produces an impressive effect. The
tombs discovered there and the gold Mixtec objects
found in one of them add interest to the site. A pic-
torial gold piece with an image of Mictlantecuhtli,
lord of the region of the dead, is a piece of excep-
tional beauty. The palaces of Mitla have walls cov-
ered with geometric designs reminiscent of Greek
forms. With their serenity and abstract ornamenta-
tion, these impressive palaces have a mystical quality.

The Spanish Conquest razed Tenochtitlán, the
capital of the Aztec empire, but its stone sculptures
still exist. These huge Aztec (or Mexica) sculptures
are among the most important in the history of art.
The Aztecs had a sense of the monumental and an

expressive synthesis in carvings of incomparable strength and beauty. The originality of the "Calendar Stone" or the "Goddess Coatlicue" impresses one with the artistic and aesthetic ability of the people that created such majestic works.

The Spanish Conquest introduced western culture to the country. The symbols began to change as monks erected crosses throughout the country. The conquerors became colonists and Mexico became a new and great nation. The Colonial period of Mexico—or New Spain, as it was termed—existed from the beginning of the sixteenth to the beginning of the nineteenth centuries, and gave us a new world of artistic complexity. At first Gothic forms were combined with Renaissance and Mozarabic. Later, baroque and ultrabaroque forms predominated until the advent of classicism, which coincided with the end of New Spain. Side by side with these styles was the art of the people, of which marvelous examples remain, such as the interior of the Church of Santa María Tonantzintla, near Puebla.

For some, the art of New Spain is no more than a reflection of European styles, and indeed the relationship is a strong one. However, Mexican Colonial art is not exactly like that of Europe. The simple transfer of people and concepts to different atmospheres and circumstances guarantees that European and Mexican art cannot be the same. Of course, if elements are taken out of the context that gives them meaning, it is possible to draw conclusions that are separated from life and its expressions.

In the sixteenth century, Franciscan, Augustinian, and Dominican monks, often with the help of the Indians, built churches and monasteries throughout the country. In the beginning there were no professional architects, so the monks themselves became designers. This resulted in a series of original religious constructions in which Romanesque, Gothic, and Renaissance elements are mixed, producing surprising innovations and effects. Sometimes, as in Acolman, the portal is of a magnificent plateresque style. Fresco paintings covered the walls of churches and cloisters; the models used were engravings from illustrated books. Interpreted by monks or skilled Indians, the paintings have a simple charm. The various sizes of the churches and monasteries, with their individual frescoes, give each religious building a singular, delightful appearance.

At first it was not possible to erect complete churches, so open chapels were constructed. The altars were covered, but the faithful remained in the open air. These open churches are of varied types, from very modest ones to those of great proportions, such as Teposcolulu. Many of them served as apses once the churches were constructed, especially in Yucatán.

When the clergy became organized in the country, it constructed great cathedrals and numerous chapels and parishes. Along with paintings and sculpture of the sixteenth century, some golden altarpieces, such as those from Huejotzingo and Xochimilco, still exist.

The flourishing of baroque art in New Spain can hardly be rivaled in any other country for its richness and number of examples. It reached its peak in the eighteenth century with the ultrabaroque, a term that embraces the churrigueresque, the rococo, the popular, and various other styles. Two magnificent examples of ultrabaroque art are the façade and, above all, the interior of the Church of Tepotzotlán, now belonging to the Museo de Renovado, and the Church of Santa Prisca in Taxco. The history of baroque art is not complete without considering that of Mexico.

Painting in New Spain thrived in the seventeenth century. Great painters of the time include Baltasar de Echave and his son and grandson, López de Herrera, Arteaga, Luis and José Juárez, Villalpando, Correa and his successors, and Rodríguez Juárez, whose works, in part, are of the following century. In the eighteenth century painting deteriorated, but remarkable decorative creations were produced, such as the works of Miguel Cabrera. Portrait painting flowered. Baroque sculpture formed an integral part of the architecture and of the golden altarpieces.

But neoclassical art of an international character marked an end of the ultrabaroque period, especially when the Royal Academy of San Carlos was founded at the end of the eighteenth century. New ideas developed and the forms of Greek and Roman antiquity were revived. El Palacio de Minería in Mexico City is a prime example of the new concepts, as is the magnificent equestrian statue of Charles IV. Both are works of Manuel Tolsá. With those and other neoclassical monuments by Francisco Eduardo Tresquerras, the Colonial or New Spain period came to an end.

The Modern period began after the War of Independence, which lasted from 1810 to 1821. Then Mexico emerged as an independent country eager

o become a modern, progressive nation. The Academy of San Carlos, center of education and art, was reorganized and played a dominant role in the art of the second half of the nineteenth century, which corresponds with the romantic period. But the predominant concept of art was still classical and idealist, since it was preferred by the faculty and was thought to be the expression of modernity. In their paintings of biblical scenes, idealists showed the influence of the sentimental art of the German romantics of the Nazarene group. In their portraits, Mexicans were influenced by the objective classicism of Ingres. Delacroix was unknown. The Spaniard Pelegrín Clave was the prime influence. He was an excellent portrait painter who introduced the painting of history and encouraged some of his disciples to produce subjects, idealized in the academic manner, that dealt with the Indian past. The rival of Clave was the Mexican painter Juan Cordero, who, besides producing historical works and portraits, revived monumental painting, both lay and religious.

Eugenio Landesio was instrumental in the trend toward landscape painting in relation to history. The most important result was the imposing work of his disciple José María Velasco, who not only surpassed his teacher but also, with great individuality, created an original vision of the Valley of Mexico. In other parts of the country, portrait painting of great freedom thrived in addition to academic painting. Painters like José María Estrada and Hermenegildo Bustos left a vision of the provincial society of that time, as did Augustín Arrieta in his paintings of everyday life.

In the last quarter of the nineteenth century an excellent statue of Cuauhtemoc by Miguel Norena was erected. Paintings continued to portray historical Indian themes, such as the *Suplicio de Cuauhtémoc* by Leandro Izaguirre. But romanticism became more intense at the end of the century, and new trends appeared that departed from classical art and traditional themes. Impressionism and synthesism were represented by Joaquín Clausell and Dr. Atl (Gerardo Murillo) in landscape painting. Romantic *fin de siècle* anguish had an exponent in the great draftsman Julio Ruelas. In architecture the advent of *art nouveau* left an important monument, the Palace of Fine Arts in Mexico City, which is the work of Adamo Boari. Two artists introduced Mexican daily life into their revealing creations: the brilliant engraver José Guadalupe Posada and the painter

Saturnino Herrán. Posada's free expressionistic work anticipates the later art of the twentieth century. Herrán, an open and refined spirit, left on his canvases excellent visions of native scenes, Indian and creole, in a style similar to that of Gauguin.

The second period of Modern Mexican art is the one that corresponds to our time. After the Revolution of 1910, the movement of primary importance was in mural painting with an acute and critical historical sense. Three great artists of very different personalities and techniques are the most distinguished exponents of mural painting: José Clemente Orozco, Diego Rivera, and David Alfaro Siqueiros. In Orozco, historical criticism, thought, and imagination are raised to the highest possible point. He is the major expressionist of the century and a deep tragic poet. His monumental fresco paintings in Guadalajara testify to his originality.

Rivera, with his classical sense of form as well as his sensual colors, creates a pictorial history in which Mexico occupies first place. In his masterpiece, the murals of the Salón de Actos of the National School of Agriculture in Chapingo, the most important female nudes of the time may be found.

For his part, Siqueiros brought to mural painting a critical social sense and created monumental works of impressive dramatic character with new materials and effects, such as those in the National Museum of History in Chapultepec.

The dominant figure of the following generation is Rufino Tamayo, who has departed from the current trend. His murals and other works display a great capacity for colorful geometric design and semiabstract expression.

It is natural that artists of the new generation should follow their own impulses and interests, different from the immediate past and in tune with the latest currents. Their art has great quality and, in the best artists, compelling originality—as, for example, in the works of the great colorist Pedro Coronel and of José Luis Cuevas.

The uninterrupted creative activity of Mexican artists presents the art historian with a vast pageant marvelously full of the surprises that await understanding spirits. The art of Mexico, through its universality, high spiritual sense, and beautiful forms, has found its place among the great creations of humanity.

—JUSTINO FERNÁNDEZ
Universidad Nacional Autónoma de México

INTRODUCTION TO THE HISTORY OF MEXICO

The extraordinary characteristic of Mexico is the complexity both of the land and of its inhabitants. Within its 760,000-odd square miles Mexico has everything from hostile deserts to thick jungles. Beneath mountains more than 16,000 feet high, crowned with eternal snows, lie vast, black, humid plains where rice and sugar cane are cultivated under a blazing sun. In some places mountain ranges and precipices give a savage beauty to the landscape. Lakes and pastures and the temperate climate of the highlands temper this severity and give to it the mildness of an idyll.

Richard S. MacNeish, a Canadian anthropologist interested in locating the origins of the first agriculture in Mexico, found evidence in Teotihuacán of small bands of four to eighteen persons that before the year 6800 B.C. set up temporary seasonal encampments. He found that between this early date and the year 5000 B.C. these people had already cultivated squash and chili. These small bands increased their population fourfold and initiated the first cultivation of maize and beans.

Southeast of this setting, 3,500 years ago, in the humid jungles of Tabasco and Veracruz, the Olmecs made their first appearance. The jaguar, lord of the jungles, was their obsession. Consequently, their works frequently display representations of human beings with jaguar traits or even "humanized" jaguars. These and many other themes became part of the cultural development in Mesoamerica, of which the Olmec has been called the mother culture.

In the great zones of the Mayan regions, as in other centers of the classical cultural period, the Olmecs left vivid evidence of their influence. The Teotihuacanos might well have learned the method of peaceful conquest from the Olmecs, since, curiously, no evidence has been found that either were warriors.

However, as with other great classical cultures of the country, just when this civilization appeared to be in its apogee, it disappeared.

Many theories have been presented to account for the sudden extinction of a people that had attained such splendor. In the case of Teotihuacán, the cause is be-lieved to lie in an internal disintegration of the societ Priests and nobility ostentatiously displayed their wealt before the poor masses, whom they exploited. We do n believe, however, that the same cause was responsib for the extinction of such cultures as the Monte Albá or the Mayan, since other factors exist to explain th abandonment and destruction of their great cities.

The Mayas attained incredible advances in art an science. The agricultural cycle prompted them to delv deeply into astronomical and mathematical knowledg and they made important discoveries (among which w; the zero, which they were using many centuries before would be discovered in the East and then used by Eur peans).

In this epoch, in which the so-called postclassic perio began, the peoples of Mesoamerica had not only eno mously increased their technical and agricultural know edge and elaborated their religion but also had initiate a militarist society of conquest and tribute. The so-calle Toltec empire, with Tula its capital, was perhaps th prototype of the first politico-military state. Its founde were hunters and gatherers.

Perhaps an overthrow of the priestly class by militaris and warriors caused the fall of the magnificent Tolte culture in Tula. Later, other peoples arrived in the Valle of Mexico; they were an impoverished, miserable lot, b they had a stoicism and a vigor seldom seen. This peop constituted the beginnings of an empire that woul extend throughout a great part of the territory in whic the great Mesoamerican cultures developed.

At the beginning of the fourteenth century the Mexic later to be called the Aztecs, came from the legendar Aztlán to the north and founded Tenochtitlán, the capit of Mexico. Later, through coalitions with neighborin chiefs, they consolidated their domination over most c the people.

The Aztec knowledge of plants, especially medicin plants, was perhaps the most advanced in the worl They used a pictographic writing to record their trad tions and legends, their astronomical knowledge, an their administrative records. Dance, music, song, an even poetry occupied the time of the nobility. They love flowers, and some of their kings created botanical an zoological gardens. Unfortunately, their warlike spir and their religion, which required them to sacrifice cor stantly to their gods the blood and hearts of their victim made them odious to the people they conquered. Whe Hernán Cortés and his followers arrived, they foun valuable allies in those who had been long exploited b the Aztecs.

How can one account for the overthrow of an empir as powerful as that of Moctezuma by an apparentl insignificant group of foreigners? The Indian governo knew that in a year that corresponded to the arrival o the ships of Cortés, the white, bearded god, Quetzalcoat who was overthrown by Tezcatlipoca, would be return ing by sea. When Moctezuma was informed by his spie that the expected one had arrived from the east, he ha

no recourse but to prepare to turn over his throne and instruct his emissary to relay this fact to Cortés. The Spaniards' callous behavior convinced the people that they were not gods and could be killed like other men, but the military technology of the Indians was unequal to that of the conquistadores. However, the most important of the fatal circumstances against the Aztecs was the hate aroused by them in the enslaved tributary peoples. The handful of Spaniards acquired hundreds of thousands of collaborators who fed them, guided them, and gave them knowledge of the land. On both sides there burned a superhuman fanaticism. The conquerors showed no mercy for the conquered. All that reflected the glorious past of the Aztec people was eradicated. When destruction was impossible, as with ancient customs and traditions, a Spanish superstructure was imposed on the existing Indian thought and sentiment.

Besides the new material culture, new forms of thought were forged; Christianity, with variations, was adopted by the inhabitants. The monks wisely used many of the old beliefs in orienting them to the new religion.

Not only a mixing of ideas and customs began, but a biological mixing as well. This created the future characteristic people of the nation—the mestizos, a fusion of two Indian and European races marked by a vigorous and contradictory personality.

Perhaps the combination of ethnic antecedents has made the Mexican proud of being mestizo, since he feels in his body and his spirit the combination of these complex races. However, if this feeling prevails in the modern mind, in the Colonial period it was the motive for the inquietude and the instability that made the mestizo the prototype of the social outcast.

The exploitation of the Indians and the Negroes (who had been imported as slaves), the creation of the caste system, and the restriction of employment to whites all encouraged discontent. A moment arrived in which the situation became intolerable. The Revolution exploded when the Catholic priest Hidalgo in 1810 started an armed movement, though military organization was completely lacking. However, since the majority of the people were in favor of terminating an intolerable situation, they followed their chiefs at whatever cost and whatever sacrifice. But lack of military organization and rivalry among chiefs caused considerable losses, redefinition of the objectives of the emancipation movement, and a search for new means to bring about the destruction of Spanish power. The hope of triumph was not lost, but the insurgents had to struggle to maintain contact between the dispersed armies in different zones of the country.

The situation in Spain, which had adopted a democratic regime, stimulated the Mexican liberals' hope for eventual triumph. Iturbide, a creole who supported the governing forces, managed to obtain command of the army of the south. Here he gained the support of the principal authorities, both religious and civil. With the same cleverness, when he was unable to defeat the leader of the south, Don Vicente Guerrero, he entered into peace talks with him. They both proclaimed a plan that had as its fundamental objective the independence of the country. As a result, Iturbide was regarded by the people as a hero and the savior of the country.

A major decision of the independence leaders was which type of government to adopt. The Constituent Congress was unable to agree on a constitution. Impatient with the delays, Iturbide purged it of its liberal members, had himself elected emperor, and adopted an imperial-type government reminiscent of Napoleon's.

Iturbide's experiment proved to be short-lived, however, and he was forced to leave Mexico. The liberals, now in power, drafted a republican constitution. The tricolored flag with the seal of an eagle and a serpent was raised over a vast territory, from northern California to Yucatán. The first election brought Guadalupe Hidalgo to the presidency in 1824, but powerful conservative interests refused to recognize the new government, and when Iturbide attempted to re-establish a monarchy, he was captured and executed.

Unfortunately for Mexico, violent overthrow of government became the order of the day. This was due not so much to political inexperience as to the great gap that existed between the nascent middle class and the upper class. Another factor contributing to difficulties was the recurrent intervention of foreign governments in Mexico's internal affairs. Spain refused to recognize the new government and worked to subvert the country's independence; England sought to control Mexico through diplomatic and economic means; the French made excessive demands on Mexico and used armed intervention. The United States, ambitious to become a great power and to checkmate European influence, took advantage of Mexico's difficulties, engaged her in war, and pressured her to relinquish one-half of her national territory.

As a result of these forces, Mexico's early national history was one of alternating anarchy and dictatorship. Military leaders, including the mercurial General Santa Anna, rose to high office. Posing as defenders of either the liberal or conservative cause or of the territorial integrity of the nation, they were able to acquire power, wealth, and prestige.

With the outbreak of the Revolution of Ayutla in 1854, however, the era of irresponsible military adventure drew to a close, and a new period, commonly referred to as "the Reform," began. Unlike previous revolutions, this one brought fundamental changes in the economic, social, and political structure throughout the country.

It was in the midst of this civil strife and foreign intervention that Mexico became a modern nation, and it is owing to the heroic efforts of Benito Juárez that it was accomplished at this time. He more than anyone else kept alive the war against the French. To a large extent he was responsible for the legislation that secularized the Mexican state and established the basis for a public-school system. From 1857 until his death in 1872, his policies

laid the basis for the future development of the country.

But Juárez' reforms were not entirely successful. He failed to leave behind a functioning liberal constitutional form of government, and shortly after his death the Mexican government began to assume the characteristics of an oligarchy. Thus, once again, an attempt to establish a constitutional democratic government had met with defeat, and the reforms that were to free land and capital for the benefit of all worked in practice to the advantage of a limited percentage of the population.

From the last quarter of the nineteenth century to 1910, this wealthy liberal elite, instead of encouraging the growth of a democracy, supported a dictatorship. With their support General Porfirio Díaz was able to perpetuate himself in power for over thirty years. On the one hand, the country made great economic progress. But on the other hand, the policy of the government adversely affected the rural areas and the small towns. The large landed properties grew at the expense of the small property holder, foreign interests profited at the expense of domestic interests, and industrial and commercial interests benefited at the expense of the agricultural community.

This imbalance in economic development caused by the policies of the Díaz government helps explain the social and political upheaval that followed. From the outset, the Revolution of 1910 had an agrarian and nationalist character. Demands for land reform and nationalization of natural resources became a central theme. This Revolution, which was to take thirty years to run its course, gathered the force of a hurricane and defied the efforts of the leaders to bring it under control.

The first leader to be swept into power was Francisco Madero. Though inexperienced, he gained support for his courageous challenge to the political system. But Madero never understood the expectation of the people who joined the Revolution. Disappointed by his reluctance to adopt social and economic reforms, his followers turned to leaders such as Emiliano Zapata.

Madero was overthrown in a counterrevolution headed by Victoriano Huerta, who took drastic steps to end the revolt. But Huerta, too, underestimated the vitality of revolutionary forces.

At first the resistance to Huerta and his "scorched earth" policy was in the form of guerrilla-type operations, but in time a constitutionalist army, organized under the leadership of Venustiano Carranza, governor of Coahuila, forced Huerta to withdraw.

Carranza now arose to the position of *jefe máximo* of the Revolution. He was at first more successful than his predecessors. Yet he could not comprehend the clamor for land reform and social legislation. This almost cost him control, for Zapata and Villa broke with him, and Carranza was forced to flee Mexico City. Faced with impending defeat, Carranza took steps toward land reform and social welfare and was able to establish control over most of Mexico.

As a man of constitutional principles, Carranza declared that the Revolution was over and called on Congress to lay the basis for a civilian government. The Congress represented a wide spectrum of revolutionary interest, and, to the dismay of Carranza, the Constitution of 1917 included provisions for further land reform, nationalization of resources, and labor legislation.

At the time, the constitution was viewed as a radical document. Carranza's administration showed a notable lack of enthusiasm for its implementation, and his support began to vanish. In 1920, his most trusted ally, Álvaro Obregón, broke with him. Obregón's call to arms in the Plan of Agua Prieta gained widespread support and Carranza was quickly overthrown. Organizing a new administration, Obregón brought in leaders of the revolutionary groups and broadened the base of his government.

Obregón's successor, Plutarco Calles, continued most of his policies but tended to take a more direct line of action. This made his government more efficient, but it also provoked more reactions, the most profound occurring in his struggle with the Church, which brought on the *cristero* revolt.

While Calles was President, Obregón stayed out of politics, but when the election of 1928 approached he announced his intention to run. Although Obregón won easily, he was assassinated before he could assume office. This event almost provoked a civil war, but Calles adopted a statesmanlike position and announced that the era of dictatorship was over.

For the next six years Calles honored his pledge. While he continued to exert influence, he permitted free debate within the party, and a left-wing group began to gain influence in the formulation of policy. Within the party, voices called for a more rapid implementation of the constitution, and new leaders appeared. It was in this climate in 1934, as new forces were pressuring for further reform, that Lázaro Cárdenas was elected.

When Cárdenas took office he was faced with the same kinds of economic problems that Roosevelt faced in the United States, and both leaders adopted emergency programs. Land reform was speeded up. Railroads, oil fields, and mines were nationalized. Thus, the Cárdenas administration brought about a further implementation of the provisions of the constitution. Responding to the ideals of the Revolution, he broadened the economic base, strengthened the political structure, and promoted social justice in Mexico.

Contemporary Mexico is one of the most vital and healthy countries of the Americas. By 1940, the date Mr. Smith has chosen to end this history, the Revolution had been fulfilled and the basis laid for the prosperity and stability characteristic of the Mexico of today—and the Mexico of the future.

—EUSEBIO DAVALOS HURTADO
*Instituto Nacional
de Antropología e Historia*

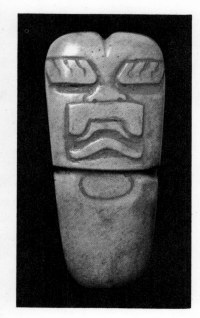

1700-100 B.C.
PREHISTORY

How did man come to Mexico? Ancient legends support modern research. The cultivation of maize marks the change from nomadic to village life. Ancient Olmec culture spreads through central and southeast Mexico. Northern and western people follow other cultural directions.

HISTORICAL CHRONOLOGY		ART CHRONOLOGY	
B.C.		**B.C.**	
10,000–6000	Hunters traverse Mexico. Tepexpán man pursues mammoth.	6000–3000	Baskets and mats.
6000–3000	Maize, squash, and chili peppers become staples.	3000–2300	Grinding stones (metates).
3000–2300	Semiunderground living quarters. Dog domesticated.	2300–1700	Ceramics with cord, textile, and rocker-stamp impressions.
2300–1700	Ceramics introduced. Burial rites initiated.	1700–1300	Zacatenco style. Tlatilco figurines.
1700–1500	Villages. El Arbolillo, Zacatenco, and Tlatilco.	1300	Olmec style penetrates central Mexico. Figurines with "Oriental eyes" and "jaguar mouths."
1500–1000	Olmec culture spreads, appearing in Puebla, in Morelos, and in the Valley of Mexico.	1000	Realistic ceramics. "Pretty women" types at Tlatilco.
800	Architectural beginnings at Cuicuilco and Cerro de Tlapacoya.	900	Ticomán-style figurines. Clay earplugs.
700	Mayan ceremonial center at Uaxactún. Traces of Olmec influence.	700	Mayan temple at Uaxactún.
600	Climax of Olmec civilization at La Venta. Priesthood. Sacred city of Monte Albán. Calendar, numerals, and hieroglyphics developed.	600	Zenith of Olmec style. Colossal heads of basalt, stone mosaic pavements, monolithic altars, figurines in jade and jadeite. Danzantes, bas-relief figures on stone slabs at Monte Albán.
500	Chupícuaro culture plays major role in western Mexico.	500	Chupícuaro "slanting eye" style in figurines. Earplugs with geometrical designs.
300	Civic-religious center expands at Monte Albán. Pyramids and astronomical observatory.	300	Monte Albán style. Ceramic statues of aristocratic personages. Great funeral urns. Arrow-shaped building. Olmec influence evident.
200	Izapá, Chiapas ceremonial center, reflects contact with Olmecs.	200	Izapá sculpture with Olmec influence in Chiapas.
A.D.		**A.D.**	
100–300	Preclassic village cultures in Nayarit, Jalisco, and Colima.	100–300	Nayarit statuettes. "Elongated head" figures of Jalisco. Colima clay figurines.

In the Beginning

The country now known as Mexico once supported the most important civilizations of North America. Within that funnel-shaped land, offering every type of climatic condition and variety of terrain, classic cultures arose that, considering the late arrival of man in Mexico, are comparable in their art, architecture, and city planning with the earlier cultures of Egypt, Sumer, and Greece. The extraordinary accomplishments of these early American civilizations have gone largely unrecognized. Yet the early civilizations of Mexico achieved an efficient irrigation system, an accurate calendar, and a precise method of mathematics before these progressive ideas were perfected by Europeans.

The two earliest-recorded dates in the Western Hemisphere, which may themselves be superseded by new discoveries by the time this is read, were found in Mexico—in the land of the Olmec people. One is a stone slab known as Stela C and has a date that has been deciphered as 31 B.C. Another date is inscribed on a small jade figure in Olmec style. Called the Tuxtla statuette, it was discovered in the Olmec heartland southeast of the present city of Veracruz, and carries what is known as the Long Count date of 8.6.2.4.17, or the year A.D. 162. The

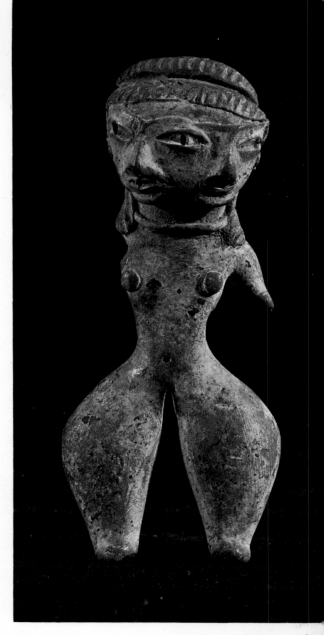

Two faces share a common eye in an early sculptural expression of the ancient concept of duality

A thousand years before Christ, a Tlatilco artist created this maternity figure. Note Asiatic slant of the eye

Long Count was a system of computing time that began with a starting date for the beginning of the world. For some reason not yet understood, this date was set at 3113 B.C. From this date the prehistoric Mexican was able to project his calendar far into the future, as well as the past, much as modern man uses the birth of Christ to separate periods. The Long Count, therefore, numbered the days from a specific beginning. Numerals were expressed by the use of bars and dots. Each bar had the value of five, each dot one. That is, one bar and four dots equaled nine

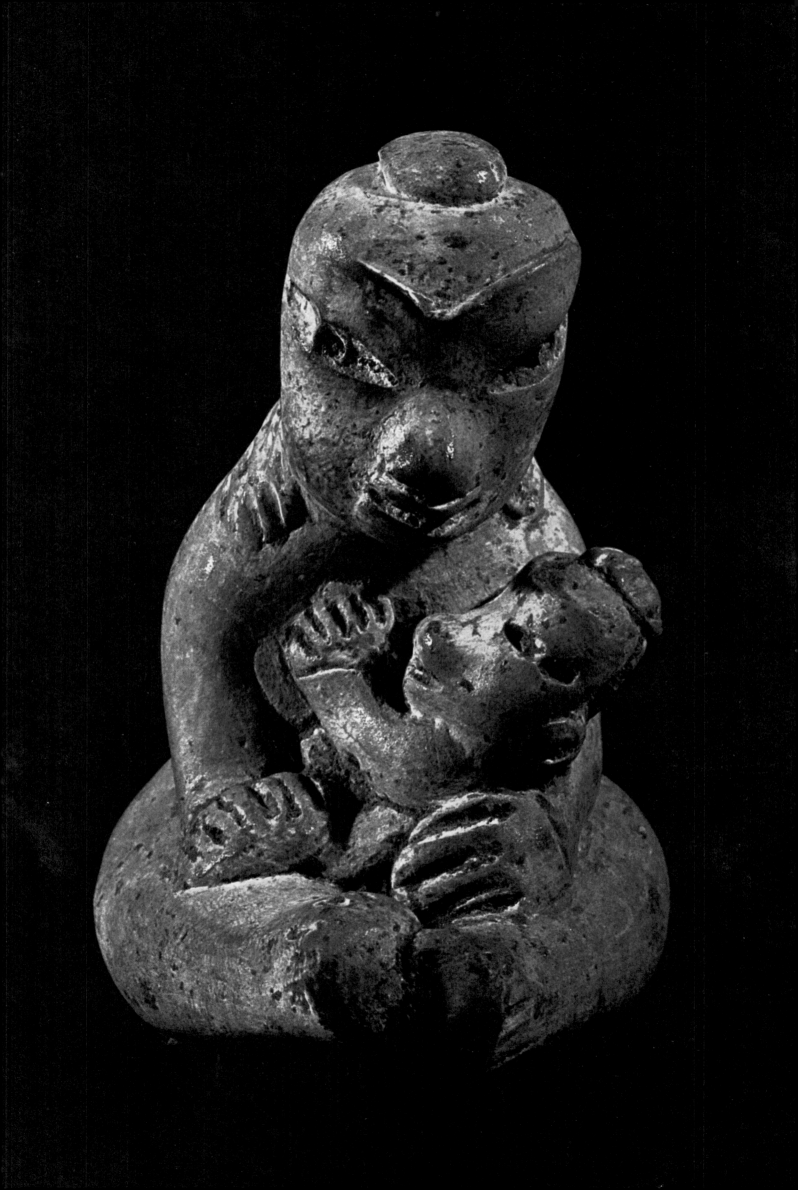

But a date like 31 B.C. is very late for the existence of man in Mexico. He goes back to the migrant hunters who traveled there more than 10,000 years ago. Two revealing pieces of evidence denote his presence. One, found near Tepexpán, was the remains of a man of medium height and between fifty and sixty years of age at death. His head was of the mesocephalic type, meaning of average size—neither predominantly round nor broad—much like the present-day Mexican. Other objects have been unearthed in the same region near Santa Isabel Ixtapan. In the rib of an elephant, a spearhead of flint was embedded. Around the remains, buried near the edge of a dry lake, obsidian objects were found, including a knife and a sharp blade for cutting up the huge animal. Stone scrapers used for skinning lay nearby. Other finds in North and

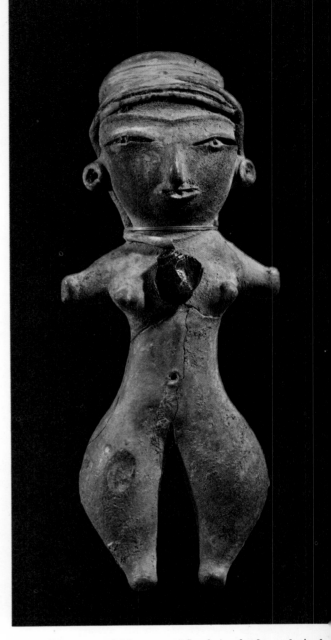

This young girl has rouged her hair, cheeks, and nipples. She wears a pyrite pendant around her neck as a mirror

South America have disclosed remains of the now extinct animals that they hunted.

But how and when did man get to Mexico? The geological and anthropological evidence seems clear that he migrated more than 8,000 but less than 50,000 years ago from northeast Asia, moving across the Bering Strait over the great plain then at least 1,000 miles wide. This broad land bridge had been exposed when advancing glaciers locked in so much water that the sea level was greatly reduced between Siberia and Alaska. Because the ice finally receded some 8,000 years ago and flooded the land bridge, we know man crossed earlier, probably following the

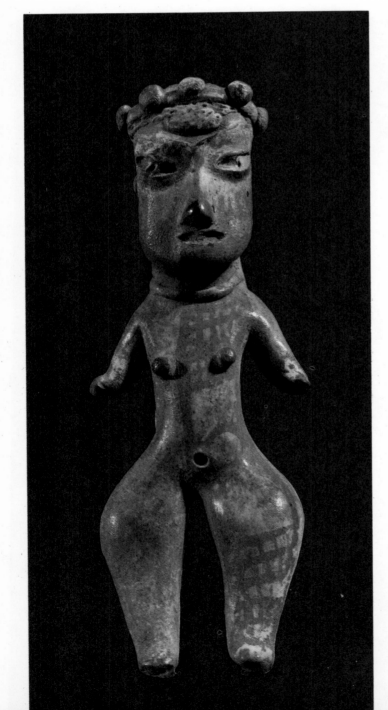

Rich, red crosshatching on this primitive clay figure shows the ancients' interest in bodily adornment.

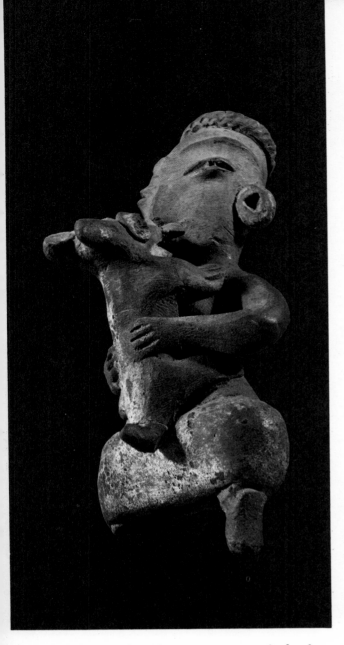

In this delightful figure, a woman nuzzles her dog. Her long skirt is an unusual mode of dress for the period.

people who, in historic times, have traveled to and from the Asiatic mainland even though the Strait is now covered with water and ice.

Like the Eskimos of today, they hunted sea mammals as well as land-based animals. Some tribes, pushing south, settled in the coastal area of Mexico and, for generations, continued to find their living on the foreshore as well as in the forest.

But why did villages and great cities—with a high level of cultural achievement—develop in Mexico and not in the region now occupied by the United States? The answer may lie in the abundance of game in the northern regions and the difficult climatic conditions that reduced the amount of wild life in the Mexican regions. In the fecund country of bison, antelope, prehistoric horse, birds, and waterfowl of many types, there was no pressing need for

migrating game—bison, camel, horse, antelope, elephant, and reindeer.

The trek over the strait and down the west coast of North America surely lasted thousands of years. Traveling in small groups, men, women, and children moved southward from Alaska, through what is now California, and into Mexico. Others fanned out across North, Central, and South America to become the ancestors of the so-called Indians.

Skeletal remains found from Alaska to Peru prove the Asiatic origin of the first Americans. The archaeological evidence is well supported by the living testimony of the Eskimos, a distinctly Asiatic

A woman wears a turbanlike headdress and carries a child in a figure doubtless related to the cult of fertility.

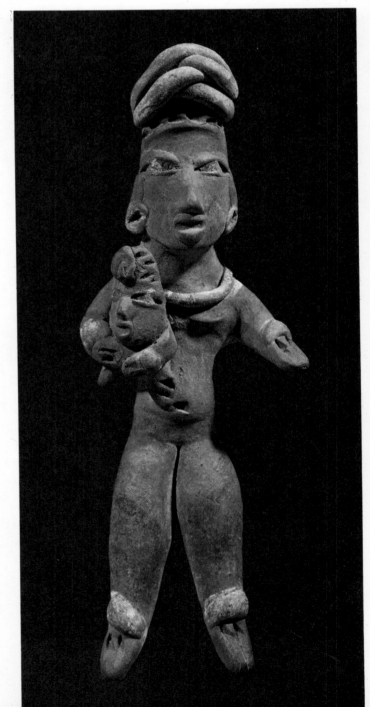

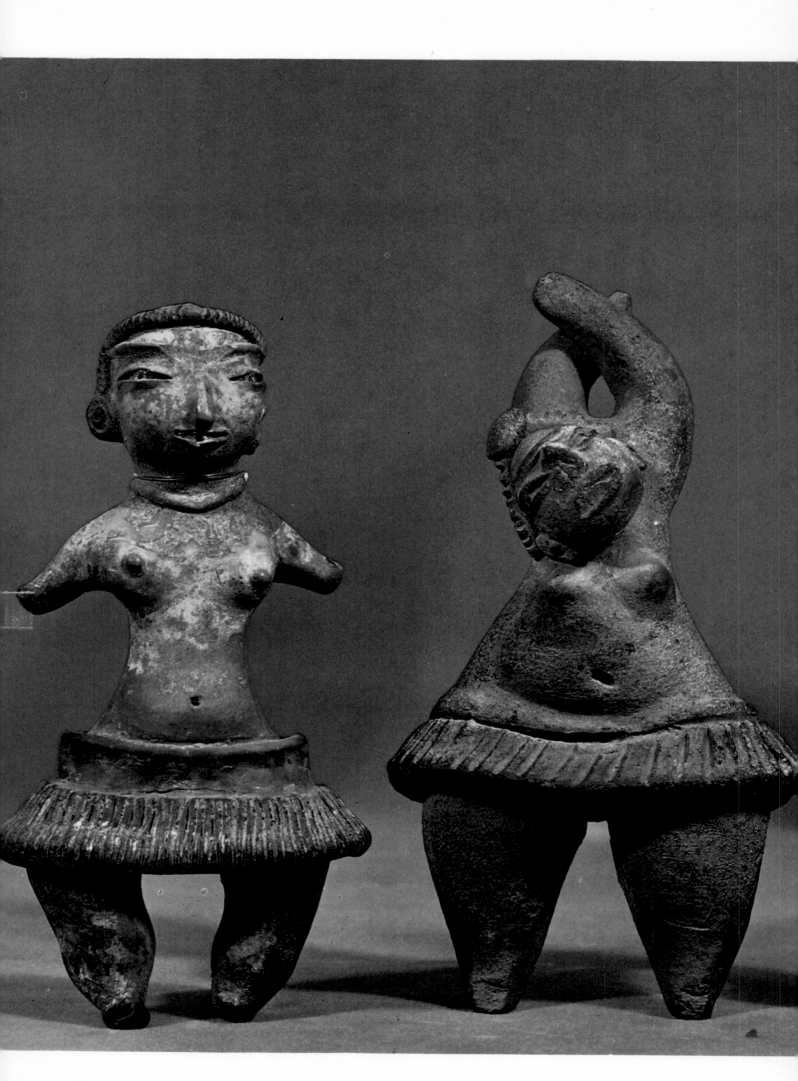

22

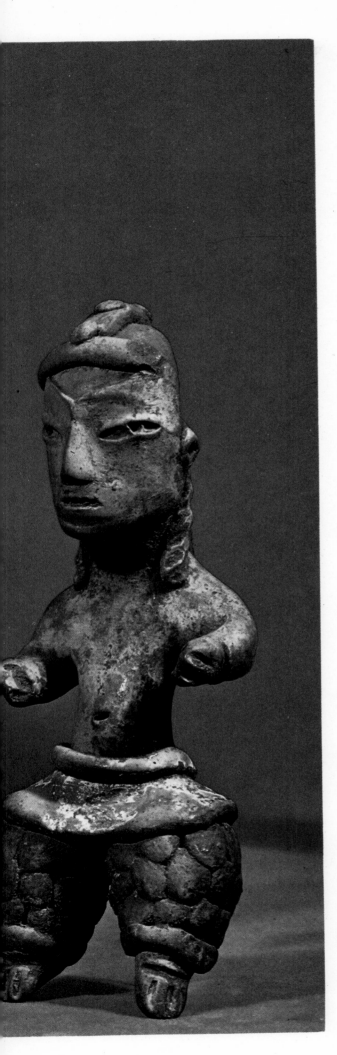

the development of agriculture. Early man in the areas north of Mexico could move from one hunting ground to another as the supply of food decreased. But this was not so in Mexico. Lakes dried up and the air became warmer, lands were parched and animals grew scarce. If the population was to survive, the people had to find some other way to feed themselves.

As the big game slowly disappeared, smaller animals were hunted. Plant gathering also became important. Then came the domestication of various varieties of squash. Finally, maize was cultivated. This proved to be the key to survival. Its controlled growth had a profound effect on emerging man in the New World. In Mexico, the growth of population up to the time of the Conquest seems to have been in direct relation to the amount of corn grown.

We know from archaeological evidence that a type of corn was domesticated as early as 3000 to 4000 B.C. Knowledge of this date is possible because of a recently perfected scientific method called carbon dating. By measuring the residue from a radioactive isotope of carbon, called carbon 14, which is present in most living organisms (and is measurable because it disintegrates at a constant rate after being separated from its host or after the death of the living matter), it is possible to date with reasonable accuracy the age of the substance tested. For instance, the age of a tree limb is determined from the time it was cut; the approximate date of a man's death is determined from his teeth. In the first case, the dating starts when the part was separated from the living matter; in the second, when the living matter died.

How the discovery that led to the cultivation of maize came about makes interesting conjecture. The best explanation seems to be that the early people of central Mexico, faced with the ever-decreasing number of wild game, were forced to find another source for their food supply—or starve. Among other plants, they gathered wild maize (*teocentli*). Some

Dancers like these—two women and a man—performed in preclassical Mexico more than 3,000 years ago.

of the more observant food gatherers selected the largest plants, which must have included a mutation, or sport. The bigger ears of maize were caused by a reduction in the amount of chaff (in which the small nutritive kernels are enclosed). The energy going into these kernels caused the stalk to be shorter and stronger. After most of the edible portions were taken from this plant, the remainder, which contained seeds that would reproduce it, was thrown on the refuse heaps that were part of each village site. From these mutant seeds sprouted the first domesticated corn. The early Americans, probably by a happy accident, saved themselves from extinction.

Of course, it is possible that maize was not initially cultivated in what is now Mexico. It could have started in one of the Central American regions, or South America, and been carried north to Mexico. Yet the evidence from many anthropologists points to Mexico as the source. There is little proof that maize was carried from the north, for its cultivation by the people of the north seems to have been a considerably later development. Some anthropologists believe that the idea of planting and cultivating maize traveled north from Mexico up through Texas or even by canoe along the coast of the Gulf of Mexico as far as Texas, Louisiana, and Florida.

What manner of man cultivated and spread corn throughout the Americas? So far we have been dealing with a faceless, bodiless, nomadic "hunter." Yet he was not a strange or primitive creature. If one of the first migrants was wearing conventional clothing, he would not be out of place on the streets of the modern cities of the world. He was broad-shouldered, of medium height, with straight, very dark brown to black hair, and, like all Mongolian types, he had broad cheekbones, a long head, and in many cases a distinct "fold" at the outer corners of his brown eyes. His natural skin color, which sometimes had a reddish or yellowish tone when not burned by the sun, was as light as that of the people of the Mediterranean, Japan, or China. This light color is still reflected in the warm brunette complexions and rosy cheeks of the indigenous children of Mexico. It is also interesting that many babies born to the relatively pure native group have the blue-purple spot on their buttocks which is typical of Asiatic infants.

For the sake of clarity, we will refer to the indigenous peoples of Mexico, those founders of the important early cultures, as Indians even though this name was a grave error on the part of Christopher Columbus. He thought he had reached the Indies, and so named the native peoples of North and South America Indians. Yet, unwittingly, the Admiral of the Ocean Sea may have been right. It is entirely possible that the remote ancestors of the migrant

The eyes of this magnificent head have an oriental cast, while the generous mouth shows a strong Olmec influence.

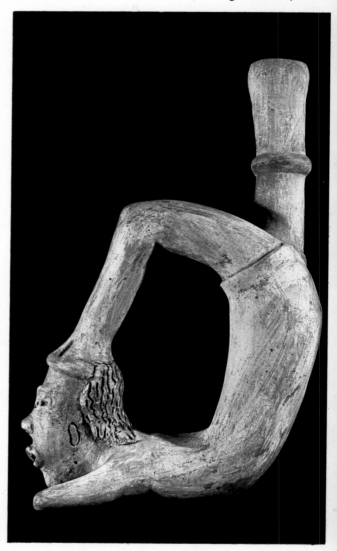

Dancers, acrobats, and skilled contortionists like this one entertained the people of the Tlatilco culture.

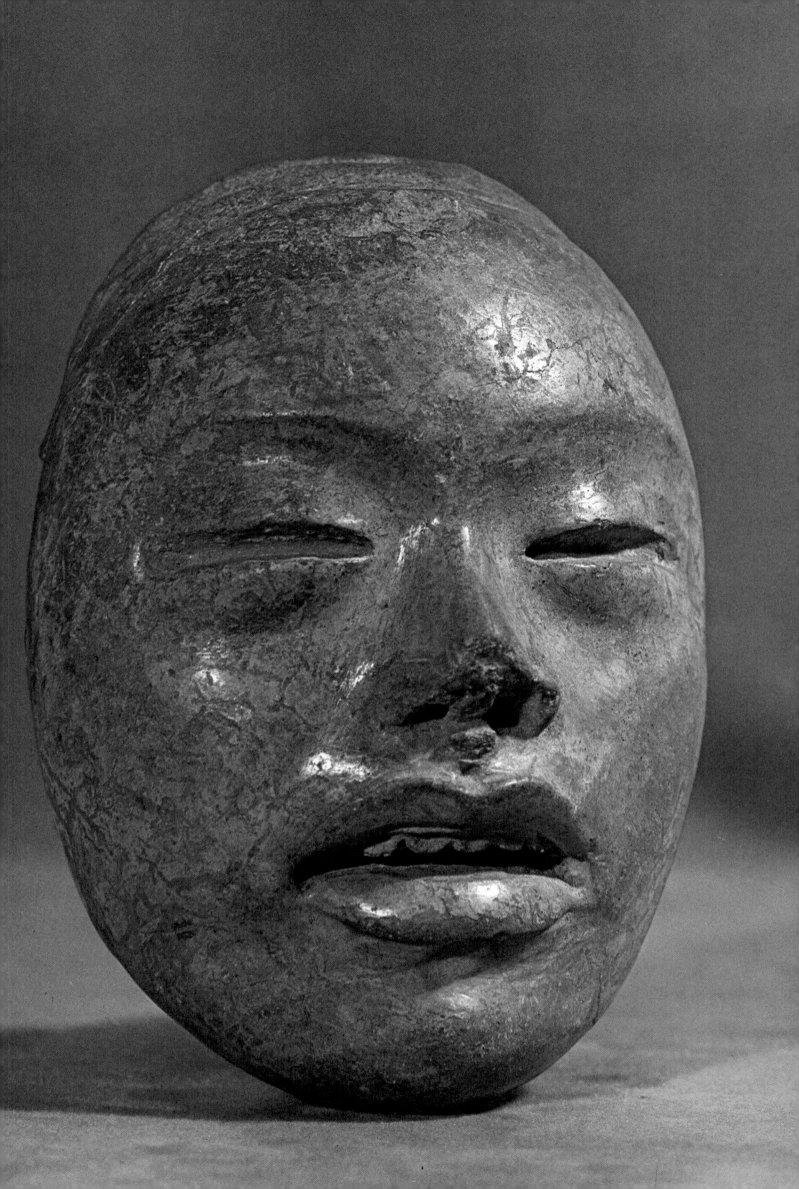

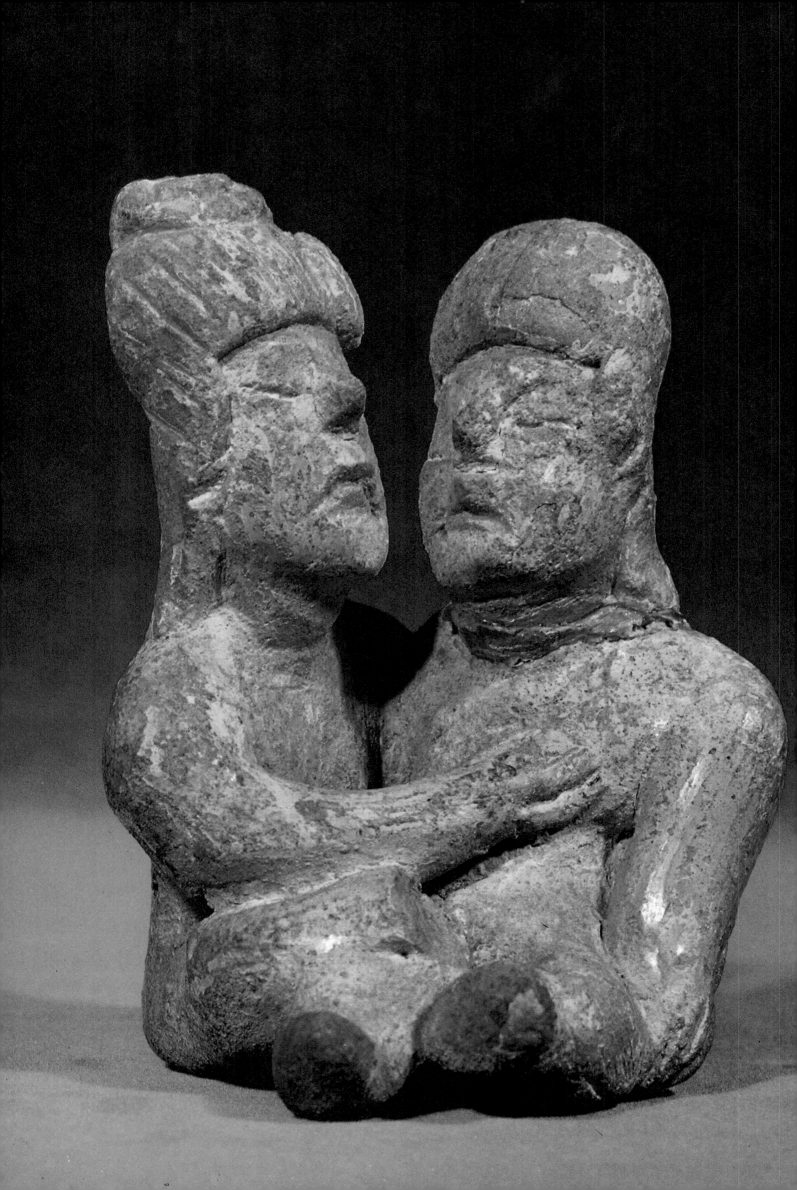

hunters who found their way from Siberia to North America and down the coast to Mexico may have originally come from the region that we now know as northern India and Tibet.

Though the area of Mexico continued as the homeland of nomadic hunting tribes for thousands of years, before the year 1700 B.C. distinct villages appeared in the coastal areas and in the valleys. Three important sites that existed on the threshold of civilization have been explored. All were located in the central valley of Mexico. El Arbolillo (from the Spanish: little tree) was on the shore of a great lake. Zacatenco, also a lakeside village, showed similarities to El Arbolillo. Both preceded the most important village of Mexico thus far discovered: the large village of Tlatilco ("where things are hidden"), which was settled some 1,700 years before Christ.

Based on the thousands of objects that have been recovered, we can reconstruct the village life of Tlatilco fairly well. The climate was mild and sunny most of the year; even in the rainy season there was sun almost every day. The people wore little or no clothing except on ceremonial occasions. Women occupied an important place in Tlatilco society and must have spent considerable time adorning themselves. This is indicated by the thousands of nude figurines showing small-waisted, high-breasted, wide-hipped women wearing only a variety of elaborate hair styles, earrings, and necklaces. They dyed their hair, sometimes bleaching it and sometimes using a red dye. Some of them painted their bodies, often using patterns on one side of the body only.

Their dancers wore short skirts, made of grass or woven fiber. Their broad-hipped women have much in common with the earliest representations of Asiatic figurines such as in the Jomon and Haniwa cultures of Japan; the famous Venus of Willendorf, Austria; or the Venus of Lespugue, France, except

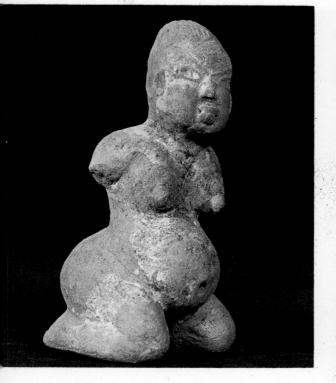

In this clay figurine, a pregnant woman kneels in the position adopted by most Indian women for giving birth.

A woman nurses the xoloitzcuintli, or common hairless dog. These dogs were used for foot warmers and were also eaten.

In a sensitive and intimate sculpture of two lovers, the artist has accentuated their Olmec mouths and headdresses.

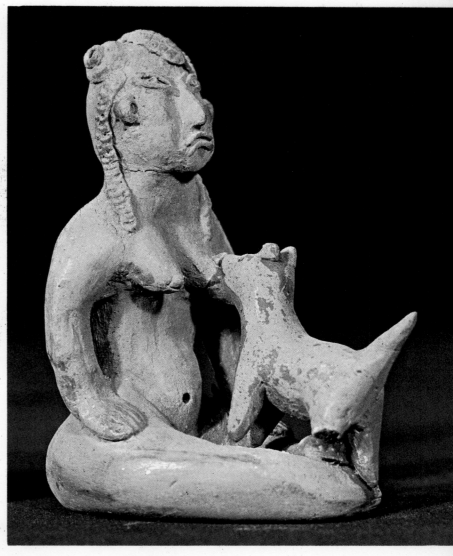

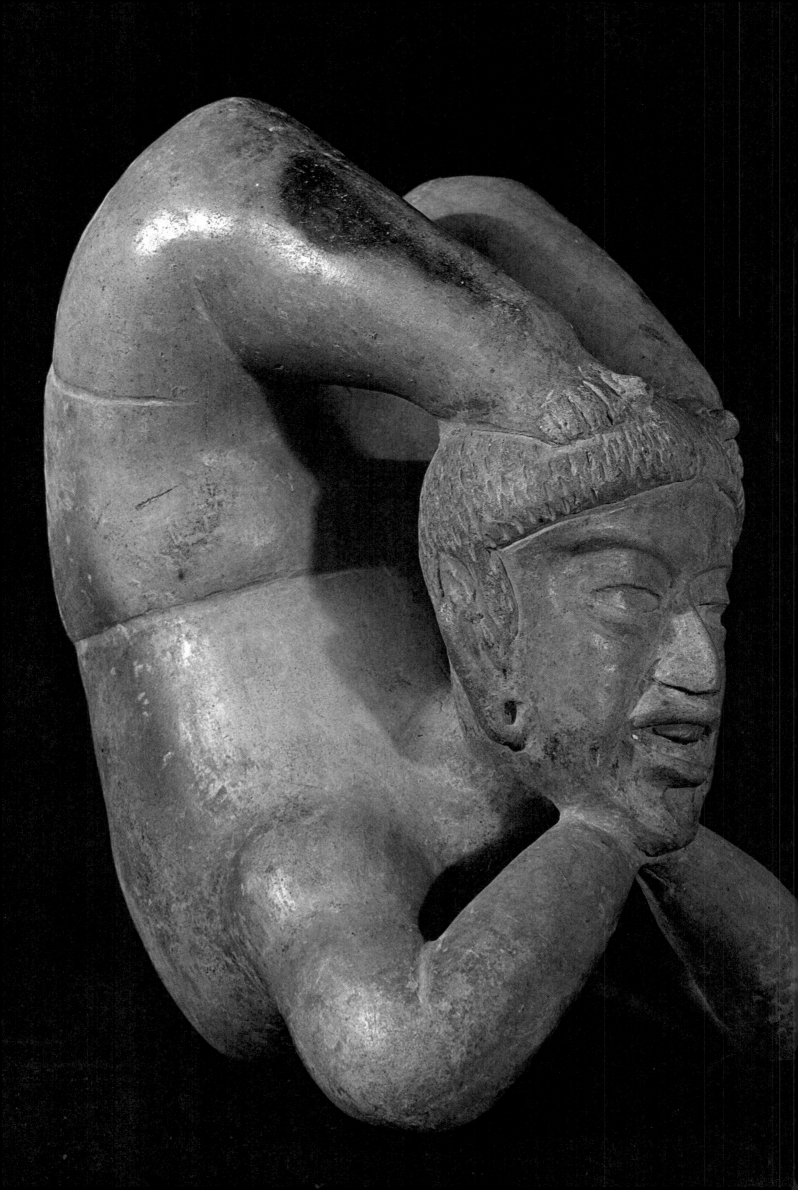

that their breasts are not emphasized. But the figurines of Tlatilco are far more numerous and more attractive than their older sisters. Men are sometimes seen in full-legged bloomers, giving them almost the same appearance as the Haniwa figurines of ancient Japanese warriors.

Woman figurines outnumber the men by one hundred or more to one and may have been household goddesses of fertility, but it is more likely that they were created to be buried in the tombs as substitutes for living persons to accompany the dead on their journey. This kind of small figurine has been found in the tombs of the Shang period of China, which corresponds to the Tlatilco dates. It is credible that the early cultures of El Arbolillo, Zacatenco, and Tlatilco worshiped gods representing wind, water, sun, and moon, but that in the faraway past they felt no need, or perhaps they did not dare, to give human form to the elements.

The villages were made up of hunters, fishermen, agricultural workers, and artists. They ate meat of deer, rabbits, and a plump domesticated dog with the almost unpronounceable name of *tepexcuintle*. From the deer also came hides that were cleaned of fat with sharp scrapers flaked from obsidian. From the bones, awls and needles were fashioned. Fish from the lakes was supplemented with ducks, which may also have been domesticated.

Clay walls of houses were reinforced with branches. Thatched roofs dotted the countryside. Within were three-legged stools, raised beds, grass mats, and a wide variety of pottery. Much of their early pottery was patterned after the gourd, or calabash. Bowls were also made of stone, but these early villagers were primarily ceramists and their decorations and pottery were beautifully and delicately made from the clay that abounds in that region.

Animals were well represented in clay by talented artisans; turkeys, bears, frogs, rabbits, turtles, possums, and armadillos came to life in miniature.

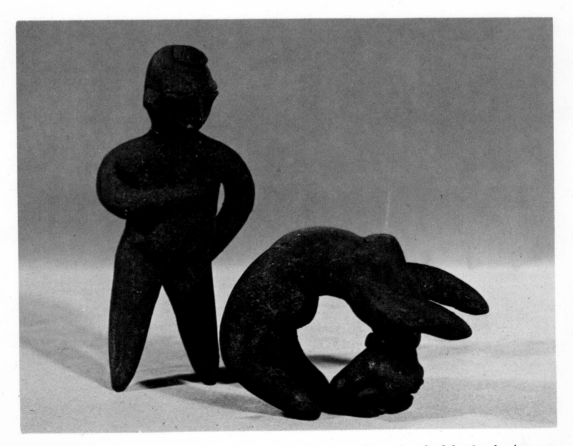

A nude woman does a deep back bend as her instructor looks on. These detailed figures are only two inches high.

This vase in the shape of an acrobat was found at a burial site. The sharpened teeth were the custom of the time.

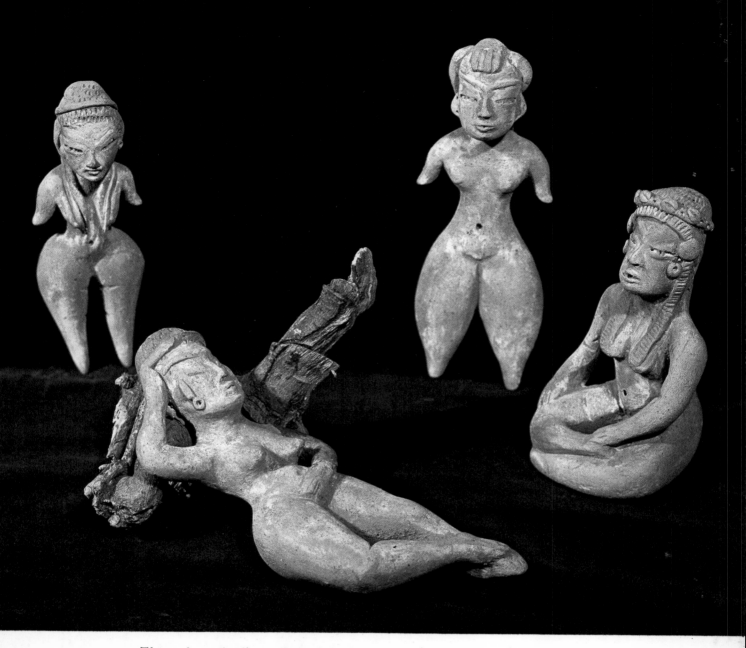

*The gently curving lines and rounded volumes of
these four nudes convey an impression of relaxed femininity.*

Class distinctions were either nonexistent or were
not emphasized in the culture of Tlatilco, for there
are no figures depicting rulers or slaves. The figu-
rines show a great variety of happy people. Women
are seen nursing their babies and occasionally
nursing small dogs. Numerous figurines show
women in the squatting, childbearing attitude.
Other figurines represent glamorous girls reclining
in provocative positions as though in a harem. Men
play on flutelike musical instruments while acrobats
and contortionists perform handstands, chest stands,
and backbends. Affectionate couples are seen in
lovemaking positions, sometimes seated on a simple
four-legged couch. Even diseased and deformed
people are shown in Tlatilco art. The ancient Mexi-
can Indian concept of duality is seen in figurines of
two-headed women. Some of these give the impres-

sion of Picasso paintings, for they are seen in full
face and in profile simultaneously.

The most important dual images are the life-death
statuettes. Split down the middle, ranging in height
from six to twelve inches, these dramatically show a
fully fleshed living person on one side with a skele-
ton figure representing death on the other. Such
figurines depict babies, children, and adults in the
duality of life and death.

This theme is repeated, with varying degrees of
emphasis, throughout each period in Mexican cul-
ture. Death seems to hold no terror for these or later
Mexicans. Death is taken seriously or lightly, but he
is always with the people—in their art, their legends,
and their religion. Death was not a mysterious and
fearful presence but a realistic recognizable char-
acter, as much a part of life as life itself.

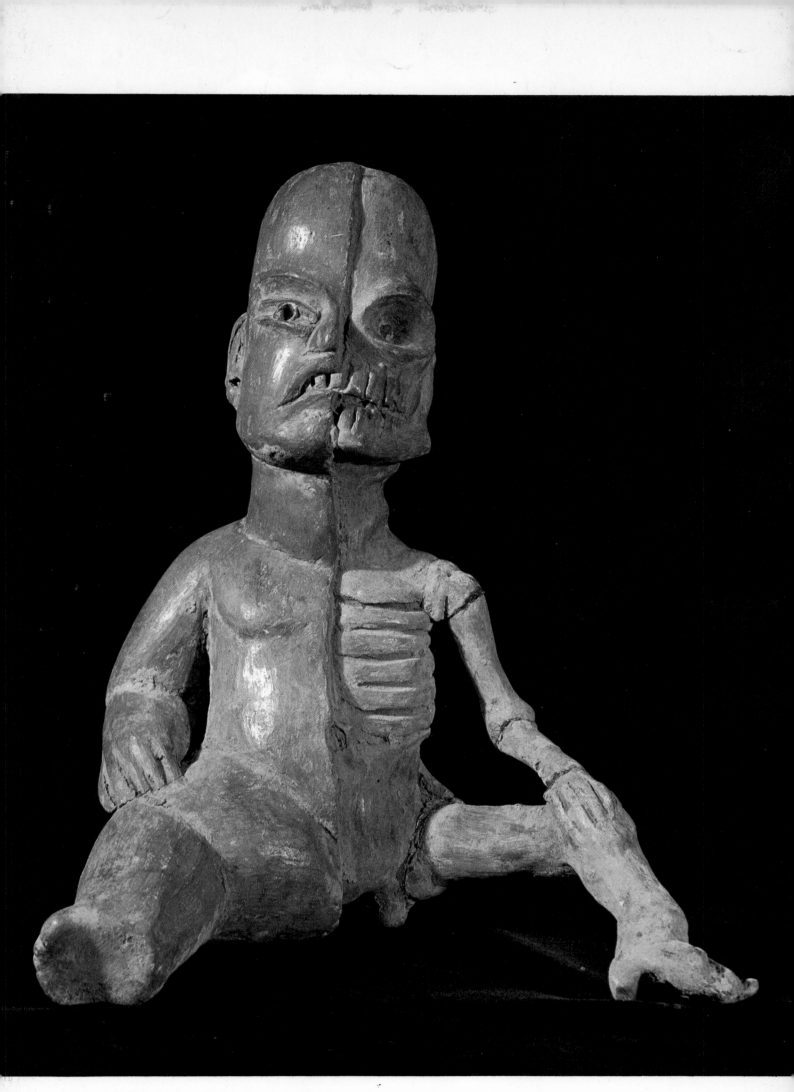

Half flesh, half skeleton, this stunning sculpture
superbly expresses the eternal duality of life and death.

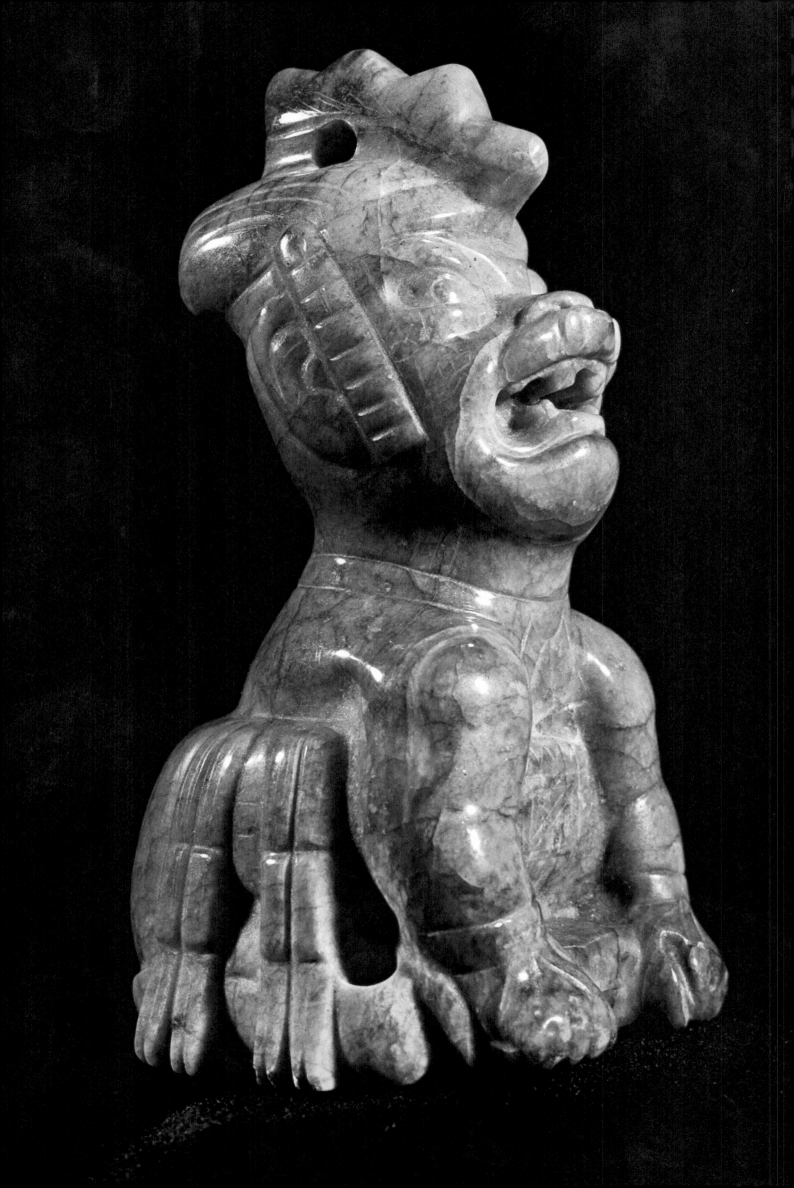

The Source of Ancient Cultures

Into the archaic life of the people of Tlatilco came a new culture brought by the Olmecs. With them came fresh motifs in pottery design. Traces of Olmec features began to appear in Tlatilco figurines. But the most noticeable effect was an increase in agricultural activity. The slash-and-burn type of cultivation, whereby the remains of the old crop are cut down and burned to provide space and fertilization for a new crop, may have been brought to Tlatilco by the migrants. We know the population increased. Tlatilco grew from a village to a large town.

Wherever they moved in Mexico, the Olmecs affected their environment. Along the coast at La Venta, at Monte Albán in the central Valley of Mexico (both early ceremonial centers), and in the Mayan regions of southern Mexico, their accomplishments are notable. So notable, in fact, that modern anthropologists are beginning to think that the ideas and craftsmanship of the Olmec people are at the base of each subsequent culture.

Large-scale stone sculpture and jade carving originated with them. Mirrors made of hematite (shown in miniature around the neck or placed in the eyes on many figurines) were an innovation. That they used mirrors for more than decoration is indicated by the concave surfaces carefully polished to optical smoothness. With such mirrors it was possible to start fires or flash signals. Their priests may have used them as magic to reflect and enlarge images. Ceremonial axes intricately carved from jade with human-animal figures were introduced. They were almost certainly the originators of the glyph, the pictorial symbol that led to the art of writing. There is proof they knew a considerable amount about agriculture and they were doubtless the first North Americans to develop irrigation systems for watering their land.

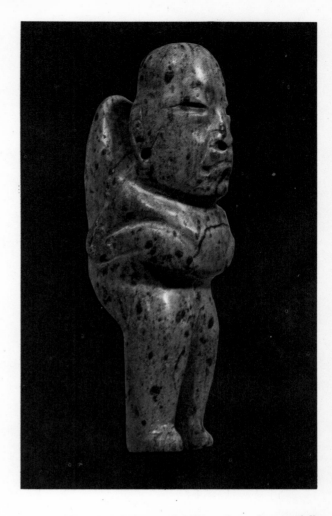

The Olmecs respected deformed people, especially hunchbacks, who were believed to possess magical powers.

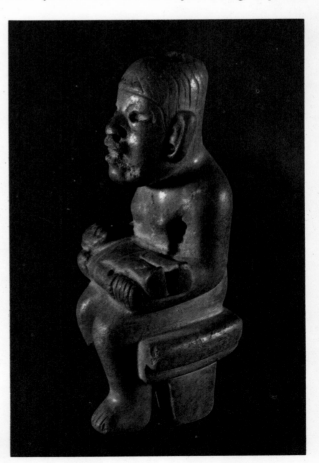

This tiger or ocelot, with some human and some animal features, is one of the oldest jade carvings in the New World.

Though small, this stone figure has a solemn majesty. It may symbolically represent an Olmec god holding mankind.

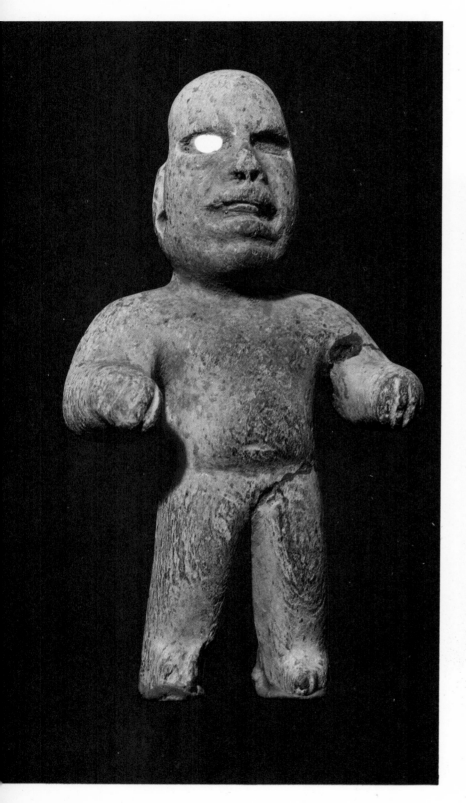

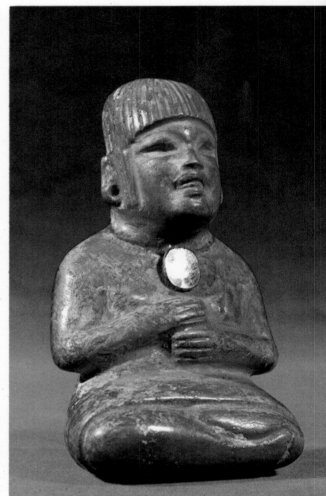

A plump, cheerful woman wears a mirror around her neck. Note how economically the artist shows her legs.

The Olmecs often used reflecting mica for the eyes of their statues, as in this square, broad-shouldered figure.

The jaguar was the *nahual,* or guardian spirit, of the Olmecs. The large felines that roamed, and still roam, the jungles of Mexico were believed to contain a divine spirit. In associating the human with the animal spirit, the Olmecs shared a belief common to ancient people on every continent. In Africa, Asia, Europe, and Australia men and women have believed their lives to be influenced by association with an animal native to their region. In Australia the kangaroo was thought to be related in spirit to the primitive people. It was believed the kangaroo had a human soul and could change into the form of a man and even cause a woman to conceive.

The Olmecs seem to have gone further than most early cultures, for they raised the jaguar not only to the status of a god but also to a god who created the peoples of the world. That they believed they were descended from the jaguar, or from a superhuman earth mother who mated with the jaguar, is revealed in sculpture and bas-relief. A deeply etched stone shows a cosmic mating of a human with a jaguar, and there are combinations of human and jaguar in myriad examples of Olmec art. They were indeed people of the jaguar.

Anthropologists have, for generations, observed that Olmec statuettes and stone etchings depict people with the mouth of a jaguar. But it seems clear from the evidence of hundreds of examples that the mouth of a jaguar was an Olmec facial characteristic. The Olmec people had a mouth slanting downward at the corners, a large upper lip with a clearly defined cleft, and a thinner lower lip, which is a distinct Asiatic type. They superimposed this human mouth upon the jaguar to give the animal a human look. As Miguel Covarrubias, the Mexican artist, anthropologist, and aficionado of the Olmecs, wrote: "When Indian babies cry, they show the upper gum and depress the corners of the mouth, producing a perfect 'Olmec' jaguar mouth."

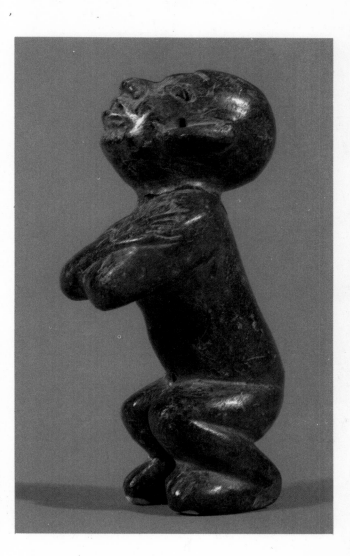

The Olmecs may have assumed this posture in the presence of their kings. Hundreds of these types have been found.

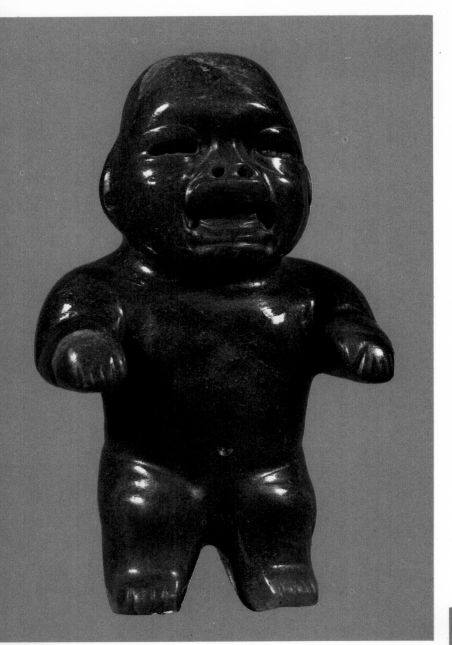

The jaguar of the Olmecs, a sometimes angry, sometimes benign great cat, has left its imprint throughout Mexico. In addition to the hundreds of representations of it in the southeast coastal heartland of the Olmecs, it is found far to the south within the Mayan temple of Uaxactún. To the west it is seen in the huge stone reliefs, called *danzantes* (dancers), of Monte Albán in the Valley of Oaxaca.

The jaguar was the most important of the pantheon of Olmec gods. The finely wrought jade figurines reflect the jaguar influence and give us some insight into the lives and minds of this formidable cultural group.

However, if we were to accept the evidence of the jade, jadeite, and semiprecious-stone carvings as realistic portrayals of the Olmecs (as we did at Tlatilco), we would be faced with a terrifying prospect. For a nation of dwarfs, giants, and eunuchs reveals itself in its art. Fat babies snarl like animals with faces more adult than infantile; dwarfs waddle on short, thick legs; bodiless giants, heads emerging from the ground, look out from heavy-lidded eyes. All of them are sexless.

No one knows whether this classic example of Olmec stone sculpture represents a snarling man or a weeping child.

A hollow vessel with a tail for a spout has the body, mouth, and ears of a jaguar but the eyes and nose of a human.

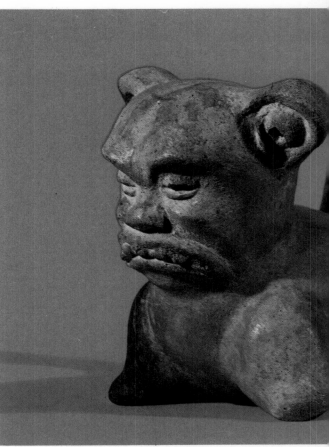

But fortunately, the art of a people does not always depict the society that created it. The Olmecs emerge as fantastically imaginative people whose art approaches the abstract yet tells a great deal about them. It shows that they combined a mystical with a logical approach to art. Some of their statuettes are of short, powerful men with round faces similar to those of their descendants living in Mexico today, but others reveal a deep sense of the mystical. The many figurines representing sexless dwarfs may well have been representations of a mischief-making elf, or *chaneque,* known throughout Mexico, Central, and South America for its cunning and ability as a troublemaker. Indeed, *chaneques* seem to have existed in every part of the world. They are the leprechauns of Ireland, the *ljeschie* of Russia, the jinns of the Muslims, the little sexless men (*semangat*) of the Malays.

In contrast to these little men, the Olmecs created giant heads, perhaps the largest full-round sculptures cut from stone. But whether in the delicate carving of precious jade or the shaping of a twenty-five-ton rock, the people of the jaguar showed a fine sense of style.

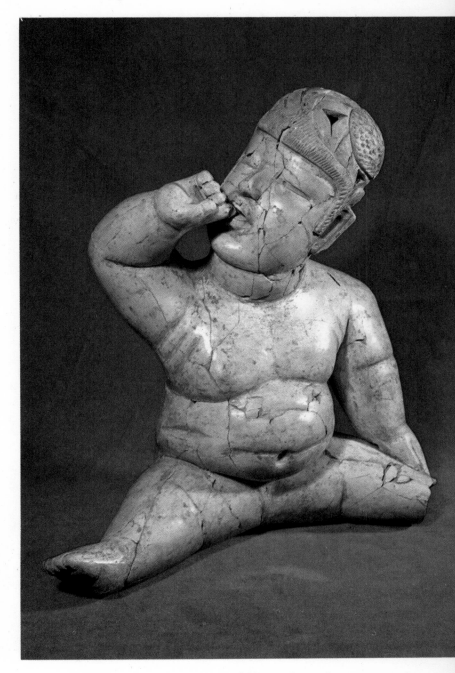

Olmec artists loved to create child-man figures in clay like this one with its chubby body and babyish pose.

Of Giant Heads

The sacred city of the coastal Olmecs, La Venta, was built on an island beyond a swamp in the province now called Tabasco. The fertile coast forms a deep crescent curve there, leaving a swampland inundated by the Gulf of Mexico. In this inaccessible retreat the Olmec ceremonial center arose. Platforms made a base for temples, bringing the priests closer to the sky. Colossal heads representing men or gods were carved from basalt rock, each head weighing fifteen tons or more. The feat was more difficult than the building of the pyramids of Egypt because there is no rock on or near the island of La Venta.

With extraordinary ingenuity, these ancient people devised broad rafts, loaded the tremendous stones onto the craft, and floated them through rivers, rivulets, and swamps for sixty to a hundred miles to their sacrosanct island. On the island the stone was shaped and carved with exquisite precision. Massive heads over nine feet high were sculptured to look down upon the people with typically Mongoloid eyes.

Not all of the colossal sculptures of La Venta are of heads. In timeless stone a larger-than-life goddess of fertility holds out a child; a huge boulder with deep-cut bas-relief shows a king with his club-scepter, and the ever-present jaguar god seems to spring out of large, warm, grayish-brown stones.

Proof that the Olmecs were not a peaceful people is found in many stelae, the huge slabs of stone with many scenes chipped out to show Olmec warriors battling against their enemies. Clubs, spears, and axes were used; and some warrior figures appear to be wearing a half-gauntlet made of stone, somewhat like brass knuckles. The helmets carved on the colossal heads (making them look much like a modern football player) were almost certainly the

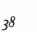

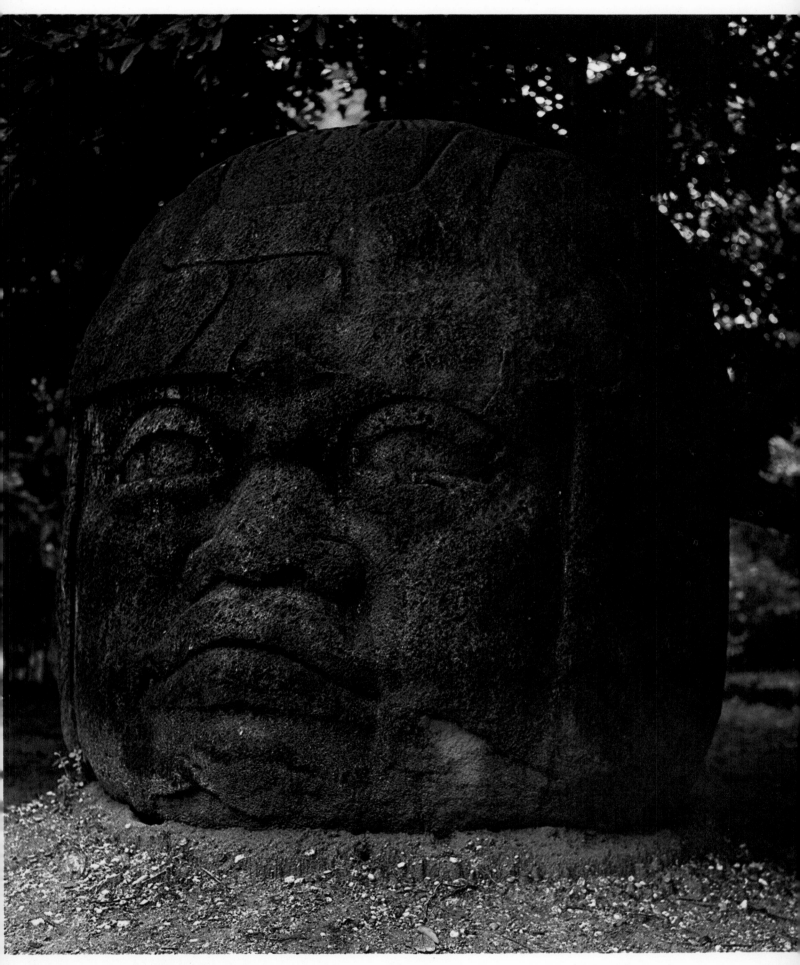

The colossal heads of the Olmecs, at twenty tons, were the largest sculptures in the Western Hemisphere. Each was hewn from a single stone brought by raft from as much as 100 miles away, and each had distinctive features.

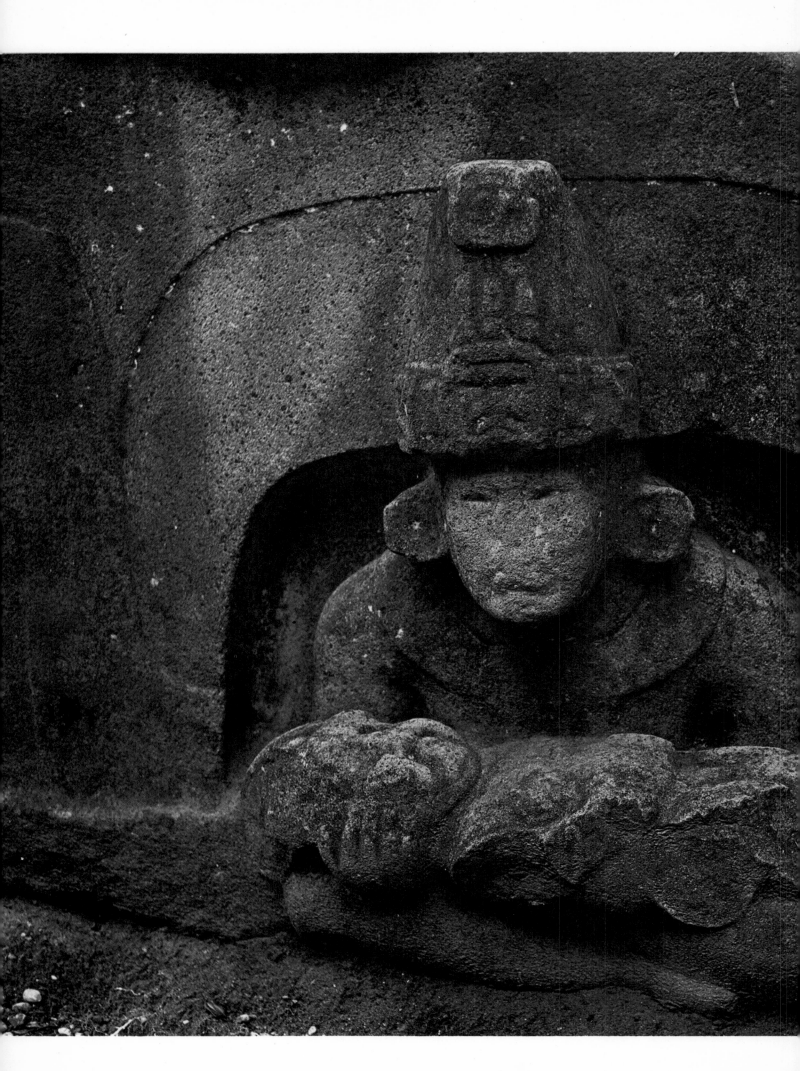

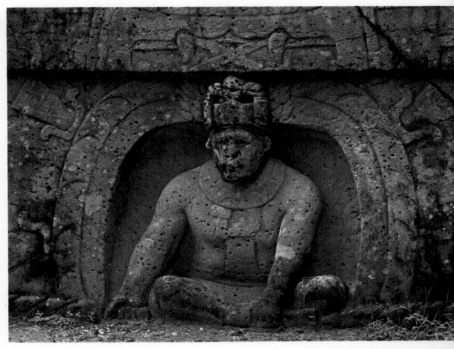

The powerful figure above, probably a king, wears a crown of leaves and feathers. His hands hold rope and dagger.

In this moving sculpture, twice life size, a mother holds her child tenderly and leans protectively over it.

fighting men's protective head armor. Their sculpture proves conclusively that they were a vigorous people and it shows their culture was sometimes spread by force.

Class distinctions were evident at La Venta. The temples were built for the priestly caste, who must have been part of the Olmec elite. Direction of the building was doubtless in their hands, for it took effective organization to handle the thousands of workers who transported the stones, constructed the temples rock by rock, and carved the gigantic statues. The images left in the enduring rock indicate that two types of men lived at La Venta. One was the short, powerful type represented in most of the artifacts. Another group of Olmecs were portrayed as tall men with long heads and aquiline noses. They may have been the elite.

Today the island of La Venta shows little sign of its prehistoric magnificence. Oil wells and offshore rigging have almost obliterated traces of the Olmecs. But La Venta has been preserved. The giant heads, the great stone altars and stelae, have been moved to a new La Venta, also located in a fertile jungle area, near the city of Villahermosa, less than sixty miles from the first sacred city of the Olmecs.

Los Danzantes

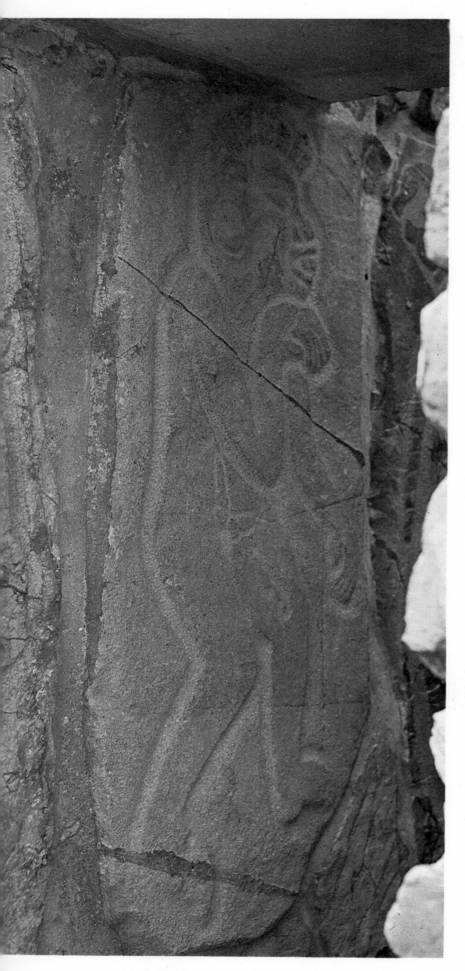

No sculpture in Mexico has given rise to so much conjecture over its meaning than the so-called dancers of Monte Albán. Created in rock some 600 years before Christ, they show a distinct Olmec influence. More than 140 clearly defined humans are depicted—every one in a different attitude. The faces of most show definite Olmec characteristics, especially in the deep slant of the mouth, thick nose, and helmet-type headdress with chin strap.

They come to life like animated anatomical drawings of Europe's Middle Ages. Some seem to have been bisected to reveal the intestines, glands, and muscles; but also revealed as part of their torsos are etched heads and shoulders of gods or kings. In one *danzante* a curved line representing liquid comes from the head of a god drawn on a man's chest. It joins another stream which flows from his sex organs. The streams curl outward together to create what looks like the forked tongue of a serpent. It is as if god and man have merged to create a symbol of the life force.

The concept of the stream of life is illustrated in dancer after dancer. From the genitals come flowers, symbols of wind and water, and intricate scrolls of unknown meaning.

Different ages are pictured, from quite young men to old and almost toothless ancients. All are etched in the full cycle of human attitudes. They are seen walking, falling forward and backward, and crawling upon their hands and knees; others seem to sleep curled up in the fetal position; many are standing with legs wide apart and arms hanging at their sides; some squat on their heels; others sit with one hand resting comfortably on a knee; some kneel with arms extended. Almost all are in motion.

In the first period of Monte Albán, the *danzantes* stood like a frieze around the base of the first temple. Later, other structures were built over them. Today at Monte Albán, some *danzantes* are seen as building blocks in older temples while others stand against a background of ancient stones.

The danzantes, or dancers, of Monte Albán in Oaxaca— among the most mysterious of all the carvings in Mexico.

An old, helmeted hunchback crawls along on hands and knees, part of a frieze that bordered the ceremonial temple.

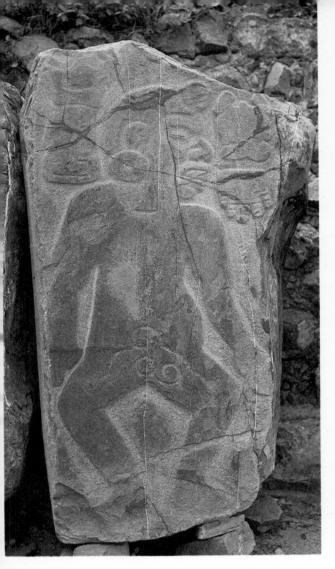

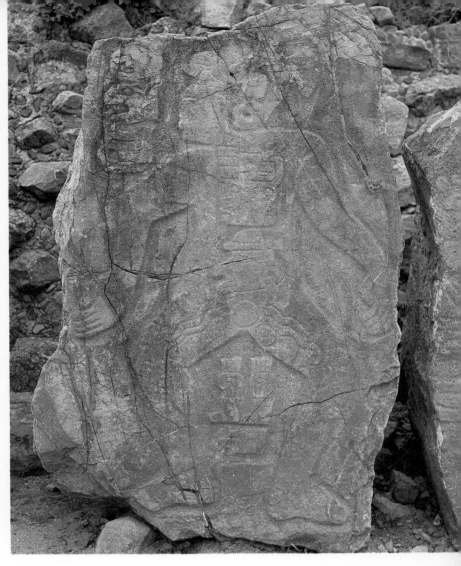

One hundred and forty of these figures have been found. Here the genitals appear as spirals in an X-ray effect.

The head of a god is carved on the chest of this dancer. Below it a second head may represent the sun deity.

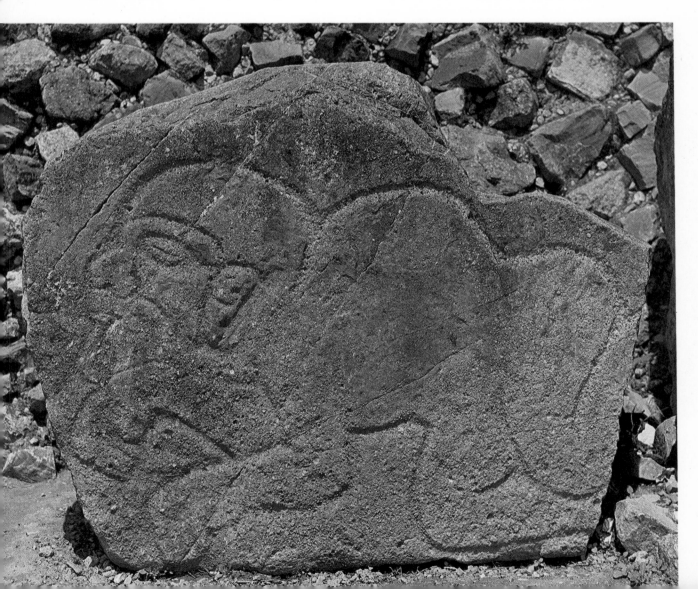

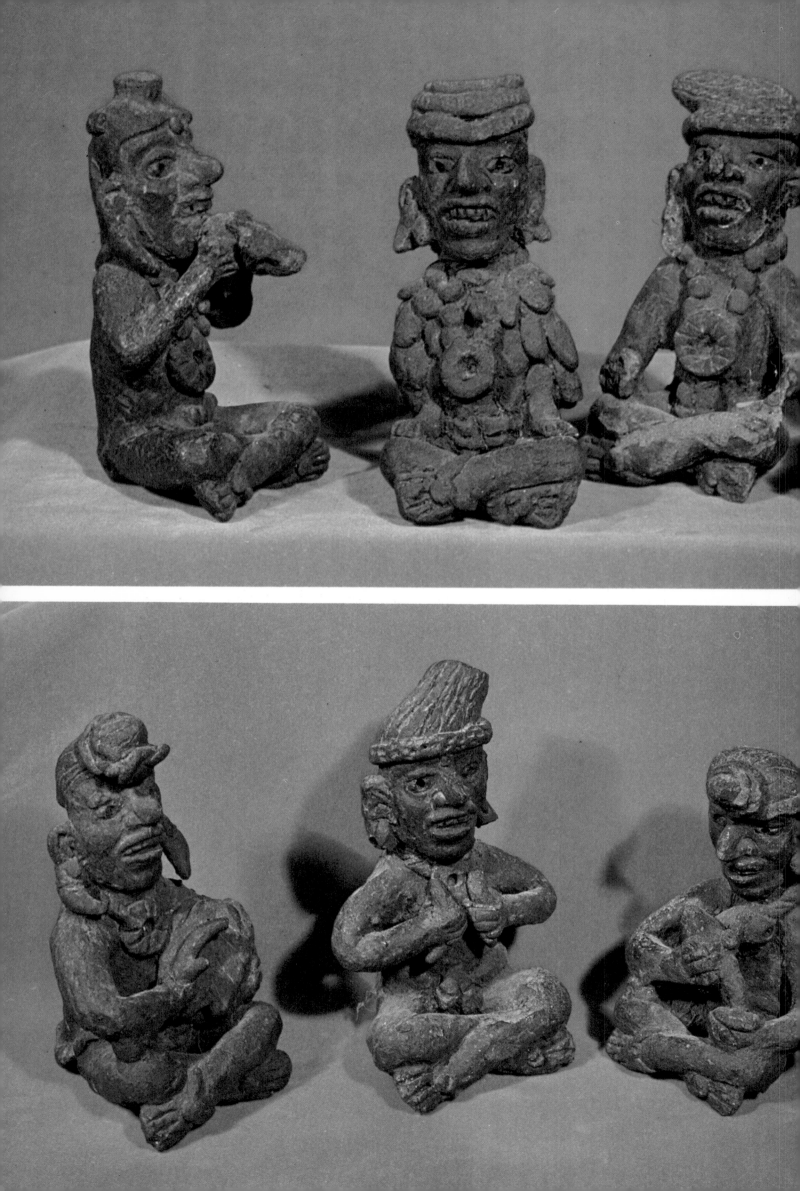

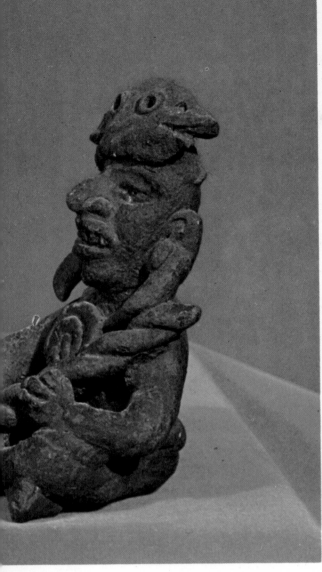

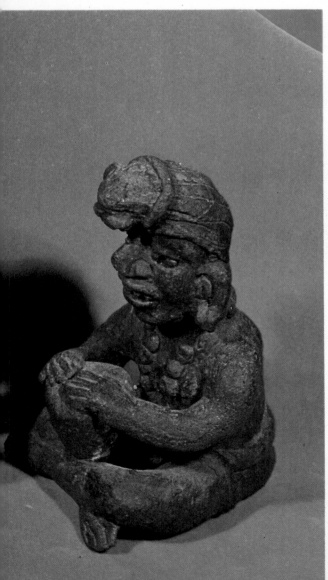

Musicians, Dancers, and Acrobats

Long before there were ceremonial rites with dancers and musicians in attendance, the earliest people of Mexico found ways to express themselves in sound and movement. It is probable that their first instruments were derived from seashells, ranging from the small ones that could be used as whistles to large conch shells that sound like trumpets when blown vigorously. To make a whistle or a shell trumpet, it was only necessary to break off, or cut off, the small end of the shell. The sound of such a conch-shell trumpet can be heard for great distances. It is still used for signaling and as a musical instrument by many primitive peoples in the Caribbean and in Central and South America today.

It is possible that the seashell also served as a model for another kind of instrument, for the serrated spine of the shell and its hollow-sounding chamber give off an interesting staccato sound when scraped with a stick. Indeed, the seashell probably served as a model for the *güiro,* still used by many Latin-American orchestras.

The earliest true drums that we know of in Mexico are the *huehuetls,* the water drums, and the *teponaztli.* The *huehuetl* was created from a hollow log with an animal skin stretched across one end. A section was cut out of the opposite end so the musician could relax or stretch the skin by the pressure of his arms or legs on the sides of the drum, thus changing the pitch. A large gourd or calabash was used to make the water drum. The gourd was cut and a thin strip of hide stretched across the top to

Six musicians and two singers form an ancient orchestra. Instruments include clay pipe, rattles, and turtle shells.

(Overleaf) A few authorities speculate that this shows headshrinking, but most think the face represents the sun.

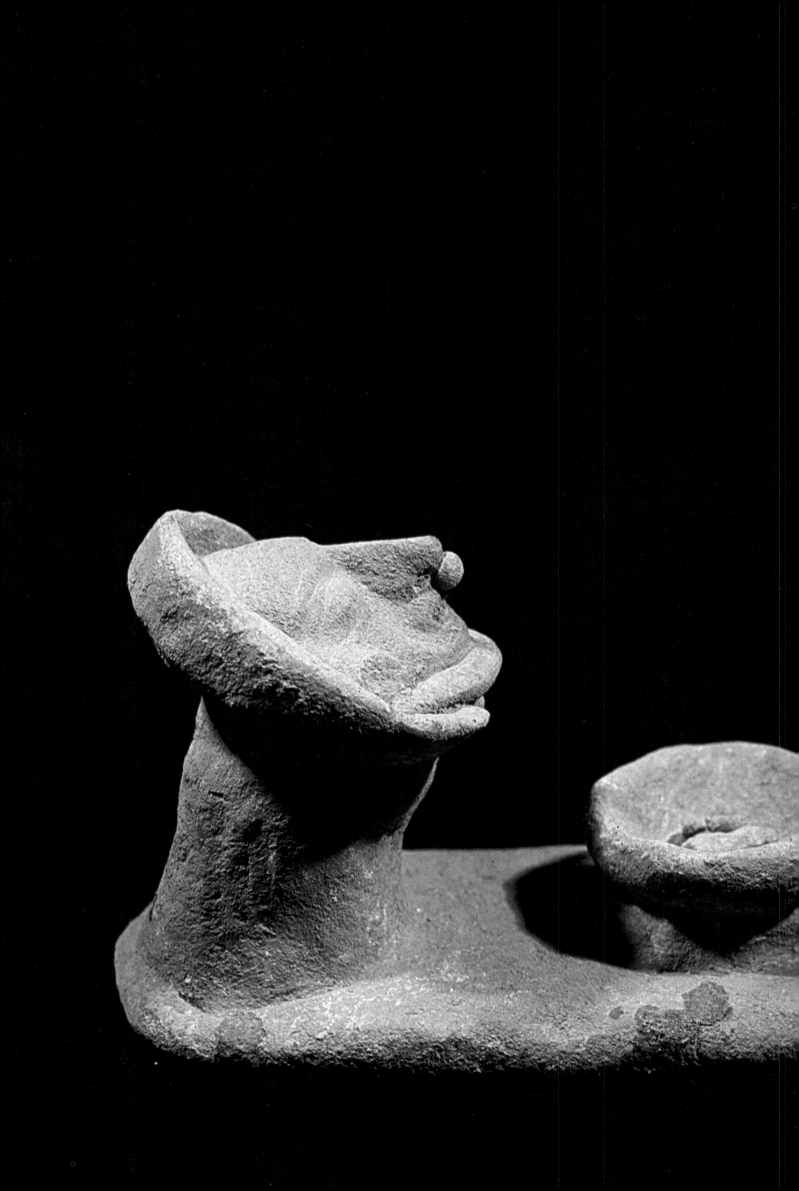

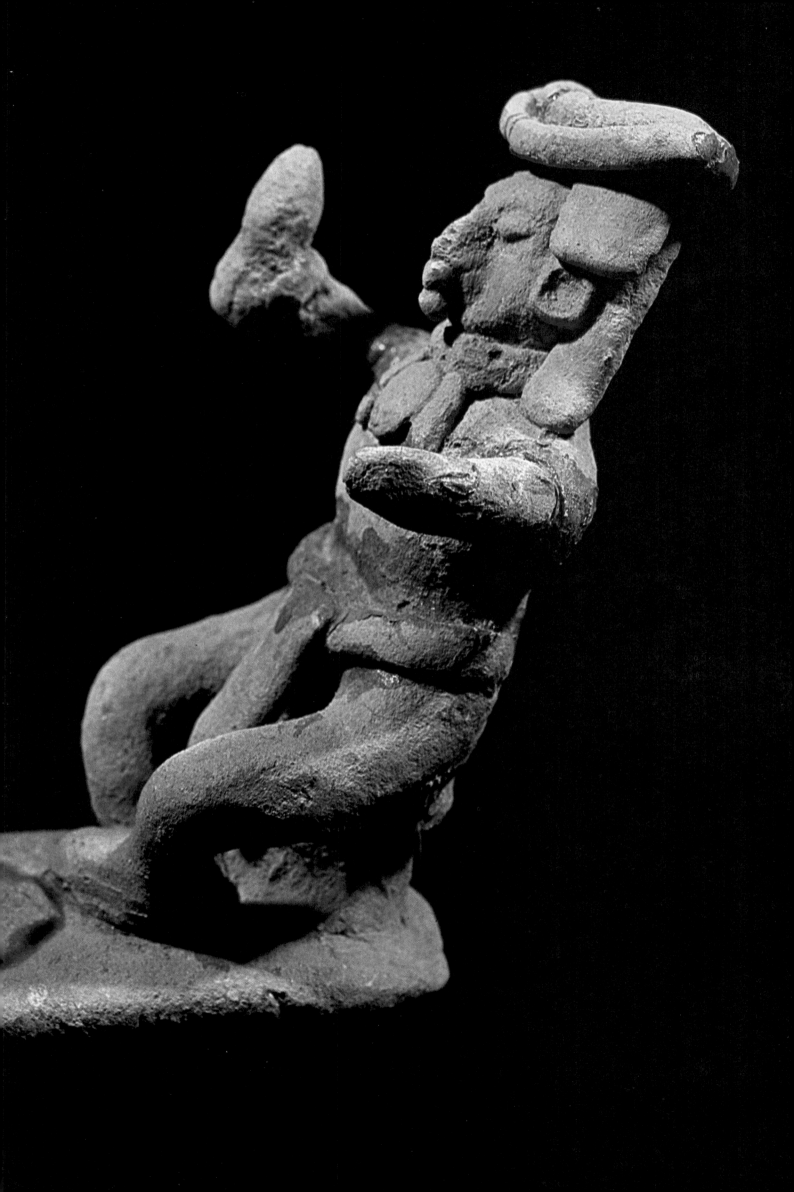

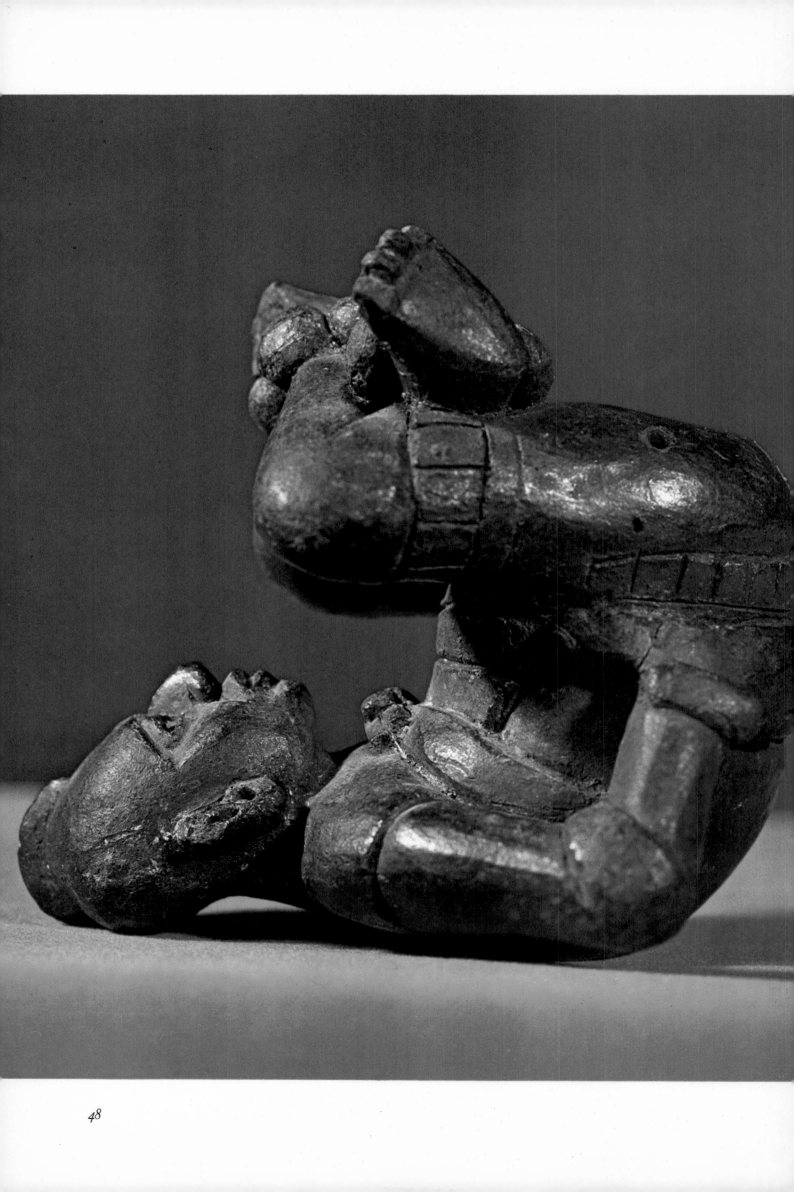

48

close it. Water could be poured in or out through a small gourd or shell that was attached to a hole in the side; this acted as a funnel. The pitch of this ingenious drum depended upon the amount of water introduced. The *teponaztli* was also a hollow tree trunk, but instead of being stood on one end, it lay flat, with two tongues, or languets, on the top. When these were struck with a rubber-tipped mallet, two different sounds were produced. There were various types of *teponaztli;* some were made with a small incision in the top of the log, making the drum vibrate when struck.

Earlier soundmakers were projections of hand clapping. In many excavations flat pieces of wood, turtle shells, and flat stones were found, which may have been held in the hand and beaten together, producing the earliest drumlike sounds. In some of the preclassical figurines, men and women are seen hand-clapping, striking shells together, and shaking hand rattles. Rattles (*matracas*), which belong to the percussion group of instruments, were made by

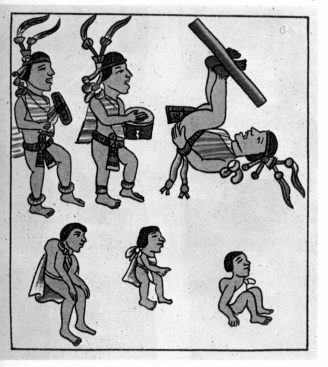

Foot jugglers were in great demand as entertainers. The sculpture at left dates from A.D. 300. The picture above, a detail from a later Aztec picture book or codex, shows how logs were balanced and juggled to musical accompaniment.

selecting and drying gourds. The rattle was produced when the seeds dried and broke loose within the gourd. Other rattles were made of dried butterfly cocoons filled with small pebbles. These were, and still are, worn on ceremonial occasions by the deer dancers from the region of the Yaqui River. Early potters made rattles in the forms of human figures and of animals, but these were probably used to amuse children. They did not make a loud enough sound to be used in public gatherings.

As percussion instruments developed from hand clapping, pipes and flutes evolved from the human voice, the sound of wind, and the song of birds. The earliest pipes were simple reeds, but they were followed by reeds with holes bored to make more than one sound possible. Whistles and pipes of clay were also made by the early Indians in the form of birds or animals and men. The simpler pipes led to others that could produce a series of five, six, or even seven sounds, although most had finger holes that enabled the player to produce five tones. There were also double flutes that, when played together, produced a chord.

As musical instruments became more complex, they were made part of processions and ceremonial rites. Dancing, which in the earliest days may have been confined to simple fertility rites, grew more complex as groups of dancers, as well as individuals, became part of the religious ritual.

In *A History of Ancient Mexico,* Fray Bernardino de Sahagún, after learning as much about earlier customs as the old men of the Aztecs could tell him, wrote:

"Those who furnished the music for dancing were stationed within the house called Calpulco so that the dancers and musicians could not see each other. . . . All the people of the palace even the warriors, old and young, danced in other parts of the courtyard, holding each other by the hand, and winding in and out wriggling in snake fashion. . . . Among these warriors one could also see maidens dancing, very well painted, and their arms and legs adorned with red feathers."

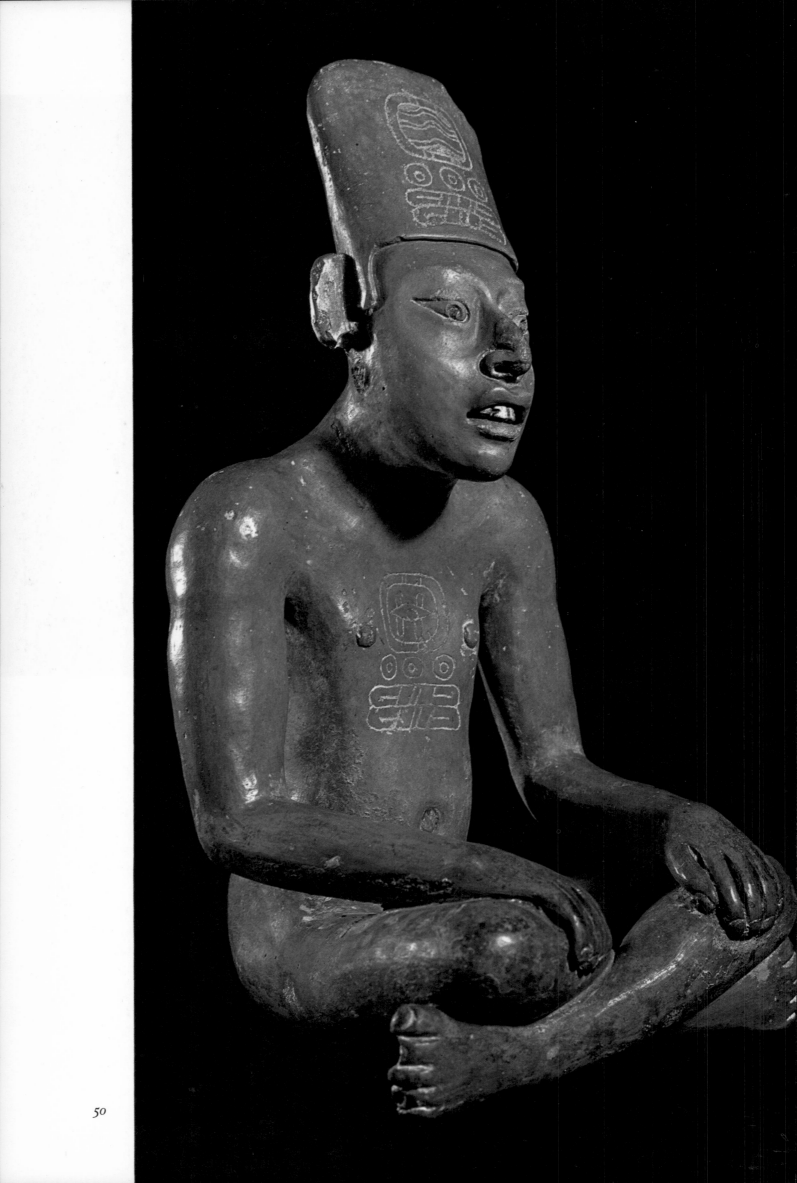

Birth of the Gods

We cannot understand the art or history of the ancient people of Mexico if we think of their beliefs and their gods as myths and legends. For the myths were a daily reality to them. Their belief in their gods was complete, not as symbols or abstract ideas, but rather as forces that directed their way of life.

How did these first migrants to Mexico find their gods? Some were brought from Asia, not as clay objects or figurines, but as traditional beliefs handed down by their ancestors. In the New World, new gods became necessary to cope with their new environment. As an example, we know that in the Neolithic period, portions of Mexico suffered great droughts. For man to survive, rainfall was a necessity. When the survival of a race is at stake, no idea is too fantastic, no sacrifice too great. No man among them could make rain. So the rain god came into being. The water did fall from the sky to nurture the earth and the living things within the earth—and kept man alive.

Out of the earth came the serpent, from whose dwelling place came the water that sustained life. He lived within the ground where roots of trees and plants gave proof of fertility. He came to represent the rain god as living within the cradle of fertility but sometimes seen upon the surface of the earth.

The enemy of the serpent was the eagle. This giant bird dominated the heavens and was the only creature brave enough to attack the snake. The conflict between these representatives of the two primary natural forces could only be resolved if they became one god of earth and sky. So the *quetzal* (bird) and the *coatl* (snake) became one, Quetzal-

Reminiscent of Egyptian sculpture but more flowing, this apotec figure is inscribed twice with the date 13 Flint.

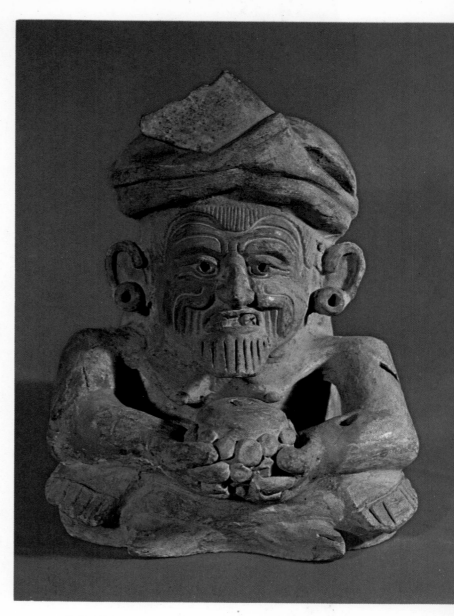

Called "the old one," this is a Monte Albán version of the household fire god. His hands cup an incense burner.

coatl, the feathered serpent, the most revered and most impressive of the ancient gods.

But even such a dual god would not be enough to give a sense of order to the fearful elements of nature. Other gods were needed to stand between man and the overwhelming natural forces too great for him to understand. From this need the pantheon of Mexico's nature gods was created, each with a realistic representative, in animal or human form, upon the earth.

The early Mexicans made many representations of their gods in ceramics, painting, stone engraving, and sculpture. Because they created images that they believed in, it is no wonder that the sensitivity of the forms and the reality of their being affect us today.

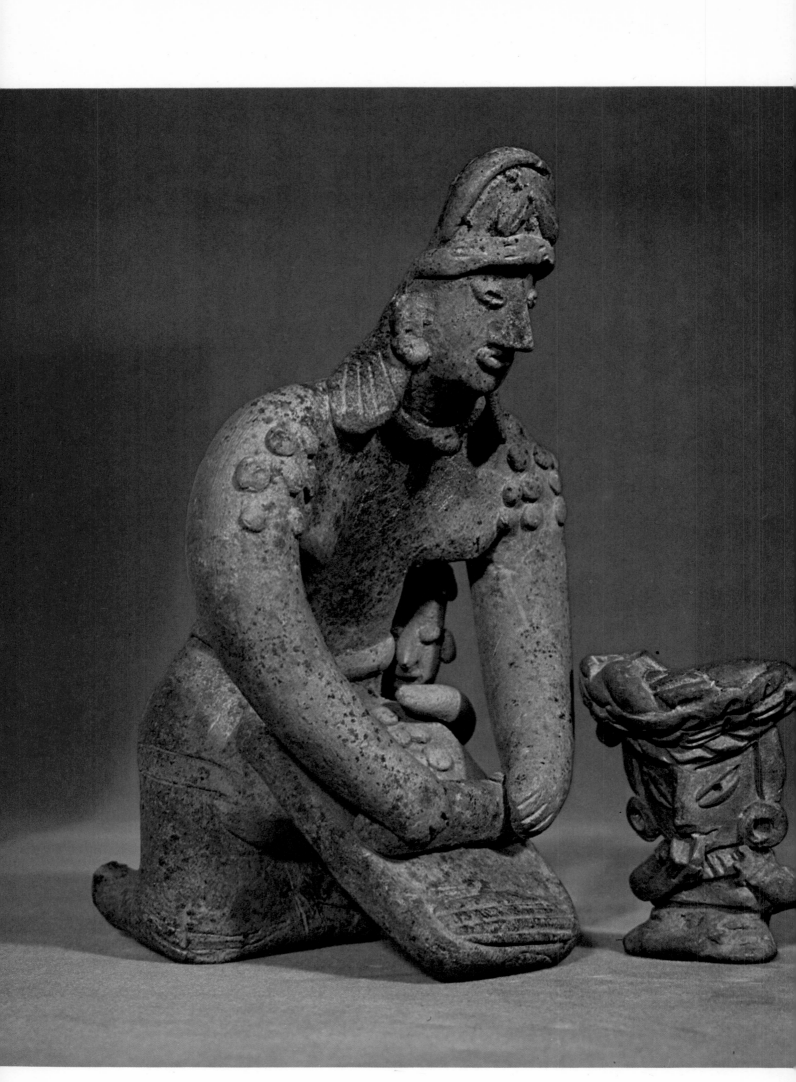

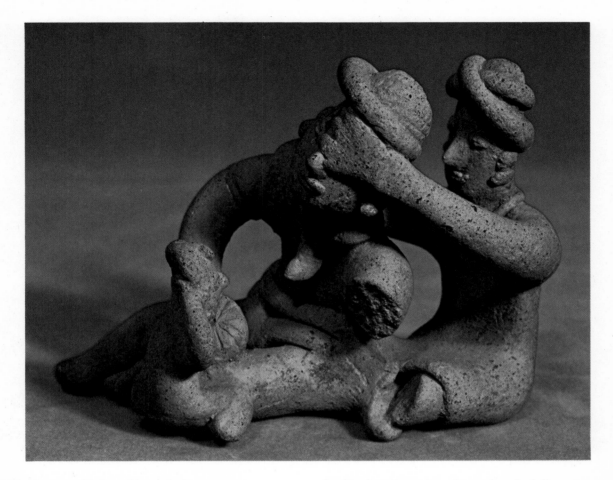

A child takes a tortilla from his mother's metate, *a stone implement still widely used. Other figure is eating.*

In this charming group, the mother playfully covers her husband's eyes while he dandles the baby on his knee.

Out of the West

Some of the enigmas of prehistoric Mexico may be solved when the western region, so far almost unexplored, yields its secrets. The vast area that is referred to as western Mexico includes the present states of Sinaloa, Nayarit, Jalisco, Michoacán, Colima, and Guerrero, as well as some regions of Guanajuato and of the state of Mexico. The northern border is the state of Sonora. The western Mexican states run southward along the Pacific coast down to the state of Oaxaca, which is no longer considered western but part of central Mexico.

It is a land of mountains that rise above 10,000 feet, volcanoes both quiescent and extinct, deep valleys, and steep canyons (*barrancas*), some as deep and as spectacular as the Grand Canyon of the United States. This variety of terrain adds beauty to the region, but at the expense of accessibility. On the east the Sierra Madre Occidental separates it from central Mexico. A small but equally rugged range, the Sierra Madre del Sur, isolates it from the south.

Yet its inaccessibility is not the only reason for its neglect by archaeologists. Although many minor cultures seem to have flourished in the west, no single great culture emerged that compares with the Olmecs at La Venta, Teotihuacán, or Monte Albán. Nor has there been any dramatic evidence of original hieroglyphic writing or of mathematical calculations. Perhaps it is because of these considerations that the surface of the west has hardly been scratched.

Yet we do know that cultures arose and fell in the west. Some were similar to each other, especially those in the states of Nayarit, Jalisco, and Colima. But others, in Michoacán and Guerrero, show important differences, partly because of their contact with bordering cultures.

The greatest number of influences from outside the western region are found in Guerrero, the southernmost of the western states, where the Olmecs left their imprint on large numbers of jade

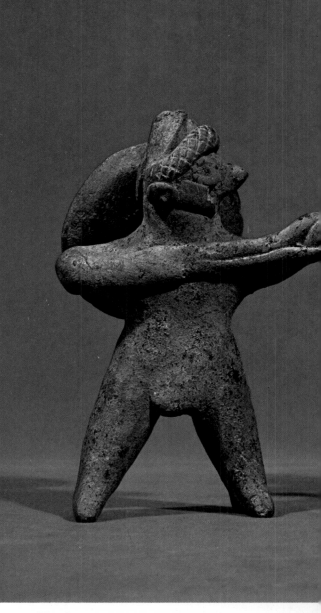

Warriors often fought helmeted but otherwise nude, as these whistle toys show. Fighter at far left carries sling.

and jadeite objects and figurines. That there was some communication with the city-state of Teotihuacán is evident in the considerable number of stone masks carved with the typical triangular face identified with the Teotihuacán culture. Such masks, as in Egypt, in India, and in other ancient cultures, were buried with the dead. It is interesting that in the Guerrero burials, as in others in Mexico, these masks simply reflect characteristics of the clan rather than portraying features of an individual. This was also true of the masks of Egypt.

But, compared to the vastness of western Mexico—its Pacific coastline is over 2,900 miles long, as great as the distance across the United States—the influence of bordering cultures is relatively small. Indeed, there is more evidence of early contacts with cultures far to the south (in Central America) and later far

to the north (with the Hohokam Indians of the Arizona desert) than with the interior of Mexico.

It is almost certain that the art of metallurgy was introduced from the south along trade routes that may have been traveled by canoes or rafts hugging the Pacific coastline. To the north there is a natural corridor leading to what is now the northern boundary of Mexico, the Arizona desert.

But metallurgy came at a comparatively late date. The small figurines that reveal the life of the people of the west seem to belong to the preclassical period—before the birth of Christ. Most of this early art of western Mexico takes the form of ceramic statuary in a full range of sizes. The full-round figurines vary from one-third life size to others so small that three or four can be held in the palm of the hand. They were made of clay, then baked and often painted.

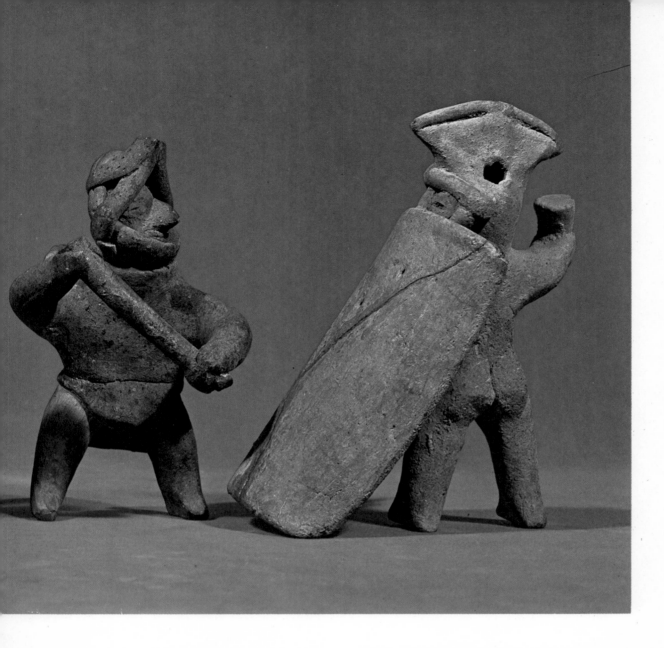

Realistic figurines of men, women, and animals tell more about the mores of the western people than does the art of any other region. Yet these views of daily life are not photographically real. They are often daring in concept and detailed in execution, and humor and irony are shown in the relation of these people to their environment. The artists who created the images delve deeply into the nature of the people as well as their activities.

All the human values are portrayed. Joy and love are graphically expressed in a group sculpture showing a father fondling his child on his knee while the mother has crept up behind him, putting her hands over his eyes in the ageless "guess who" gesture. In another group sculpture a mother prepares *tortillas* on a *metate* while her child mischievously reaches from behind her back to steal one. A sensitive view-

A noble or cacique of about the time of Christ is carried on an elaborate, luxurious litter with a curved canopy.

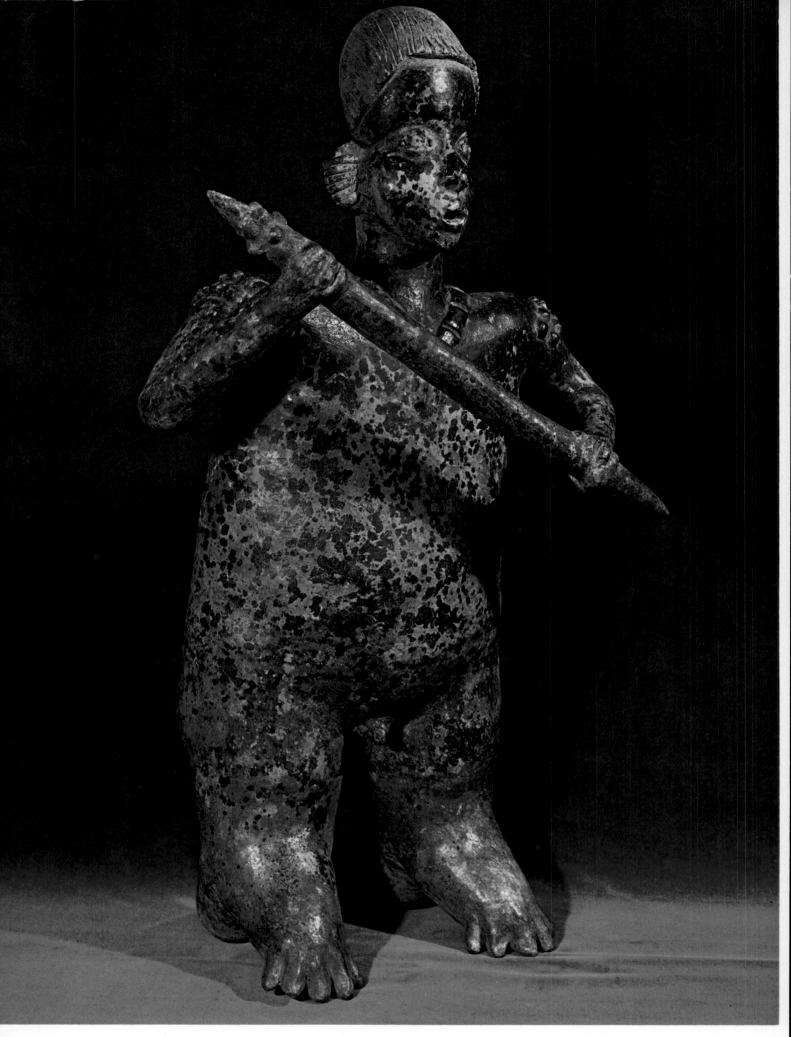

Clubs like the one carried by this Nayarit warrior
were still being used by the Aztecs twelve centuries later.

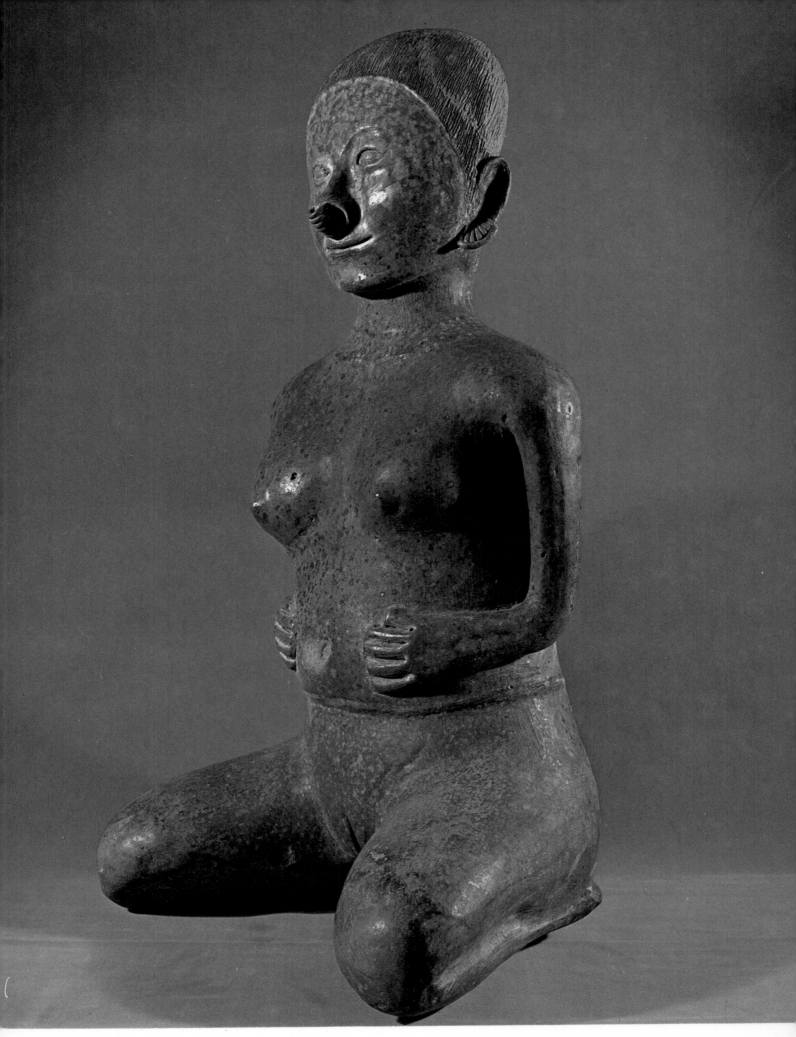

*A beautiful girl of the third century A.D., plainly
proud of her pregnancy, smiles as she touches her abdomen.*

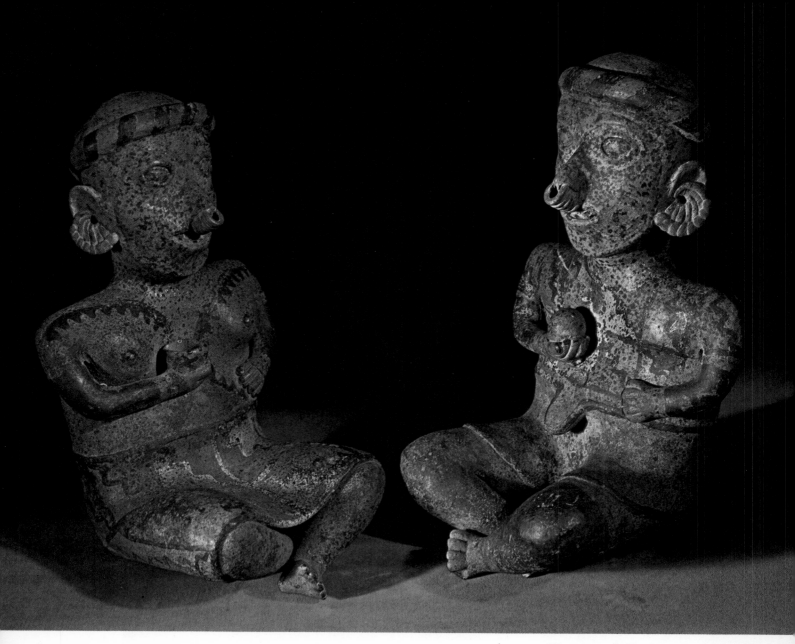

point is maintained even when unpleasant types are depicted; an obviously vain aristocrat views himself in a mirror; a fat, saucy figure of a female gossip leans forward to repeat the latest scandal; warriors seemingly go into battle cheerfully, with every detail of their weapons, headgear, shields, and smiling faces carefully delineated.

Thus far, most of the "human interest" objects found in western Mexico come from the states of Nayarit, Jalisco, and Colima. In Nayarit we find a very highly developed ceramic art of exaggeration that borders on caricature. Feet, noses, head shapes, and genitals are shown completely out of proportion to the bodies. Faces are flattened and stomachs sag. Various stages of disease are shown. Rib cages of emaciated men and women, probable victims of famine, stand out like the bones of a skeleton. Some are reminiscent of the famous statue, "The Fasting

Buddha of India," which was created in the second century of the Christian era.

Fortunately, the artists of Nayarit left a graphic picture of both the customs and the costumes of normal-looking people. Shirts with short sleeves reach to the waists of the men. Women are usually naked, but sometimes wear a short grass skirt or wrapper around their hips. Perhaps the most unusual aspect of Nayarit preclassical sculpture is that both men and women are often shown with their genitals exposed. But, like the women of other ancient cultures, such as Tlatilco, even though naked, the figurines show that the women of Nayarit wore a headband, dressed their hair carefully, and wore one or more nose rings, large earrings, and a necklace.

The warrior figurines of the Nayarit culture are especially interesting, for they wear both chest armor

and protective helmets. The armor is lightweight and woven from vegetable fiber. Many of the ancient warriors carry clubs and are often shown in the position of a ballplayer ready to swing his bat. Another even more important weapon was the *atlatl,* a type of sling from which a short spear could be accurately hurled.

South of Nayarit lies the province of Jalisco. Figurines found there are contemporary with those of Nayarit and have much in common with them. But even though the people are shown in many of the same occupations, the artistic style of Jalisco is markedly different. Human types are treated much more sympathetically, usually without distortion. Elongated heads are shown, but they are not caricatured; they depict the actual shape of the heads of the Jalisco people, elongated by the binding they suffered as infants. Their noses must have been aquiline, based on their realistic figurines, and their

eyes were slightly protuberant. The lips of the Jalisco figures are thin and, whenever the mouth is shown open, the teeth are visible. Many interesting statuettes, made in both gray and brown clay, show women whose breasts or bodies have been painted or tattooed with simple designs.

The third, and perhaps the most artistic region of the west, is Colima, which takes its name from the twin volcanoes of that region. The ancient people of Colima lived in a cheerful, easygoing society with highly developed skills. Their ceramics are by far the most varied and perfected in western Mexico. There can be no question about the superiority of the Colima artist in freehand clay modeling. The late Diego Rivera, world-renowned Mexican artist, began a collection of Colima ceramics, which grew into one of the most important prehistoric collections of Mexican pottery in the world. Soon other artists, art dealers, and laymen became interested

The heads of both these Nayarit figures show evidence of flattening. She wears only arm and thigh bands and belt.

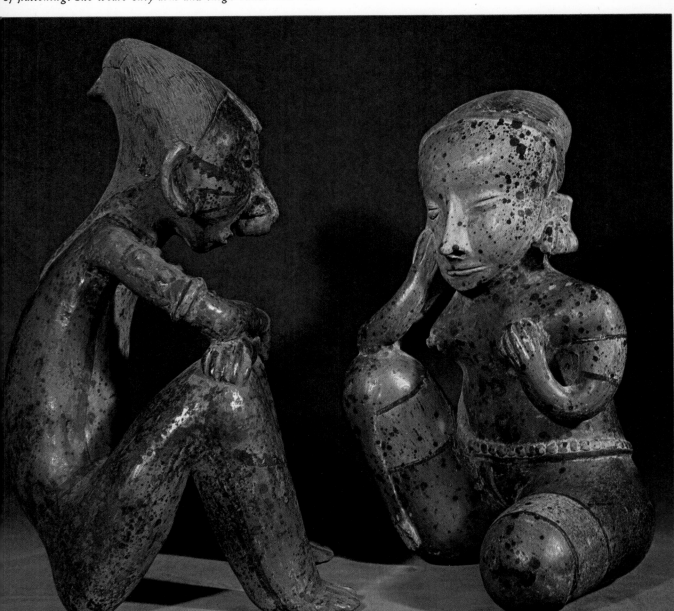

and the tombs of Colima were combed for relics. Today hundreds of authentic ones may be seen at the Rivera Museum in Mexico City, called Anahuacalli, designed by Rivera's close friend, the artist-architect Juan O'Gorman.

But cultural activity in western Mexico was not confined to Nayarit, Jalisco, and Colima, for the west was also the homeland of the Tarascan people. Like so many emerging clans, their origin is obscure, yet it is known they occupied, from an early date, territory southeast of Colima in the state of Michoacán. Tariácuri, one of their rulers, is usually given credit for their consolidation as a people and the founding of the Michoacán empire. By the time of the Spanish conquest, the Tarascans had formed an independent nation able to exist on equal terms with the Aztecs.

In the Mezcala valley of the state of Guerrero, which is considered by archaeologists as western Mexico, there is an area of significant cultural development. Here figurines, masks, animals, and ornaments carved out of hard stone have been found. Miguel Covarrubias suggests that this region may have been the birthplace of the ancient Olmecs, for many objects clearly show Olmec characteristics. Indeed, the masks and stone statuettes have simplified lines that are strongly reminiscent of the very early Olmec style. Moreover, there are traits in common with other early cultures. Two-headed figurines similar to Tlatilco and Colima styles have been found. There are stone vessels exactly like those of the Hohokam culture in Arizona; similar objects, closely related, have been found in Peru.

This would seem to indicate that a simple Mezcala style, which reached as far north as Arizona and as far south as Peru, antedates the Olmec style. But it is too early to draw any definite conclusions since archaeologists are just beginning to unlock the secrets of this vast and mysterious section of Mexico.

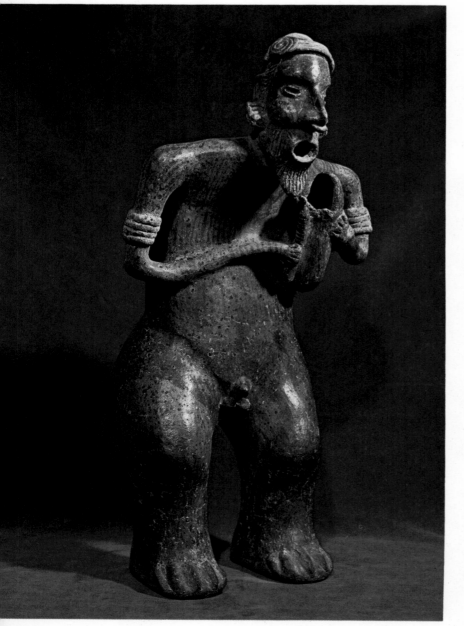

A sharp-faced old man sings and accompanies himself by scraping on a gourd. This Nayarit statue is two feet high.

A young man of Jalisco sits contemplating his image in a mirror. Such mirrors were commonly made of mica or obsidian.

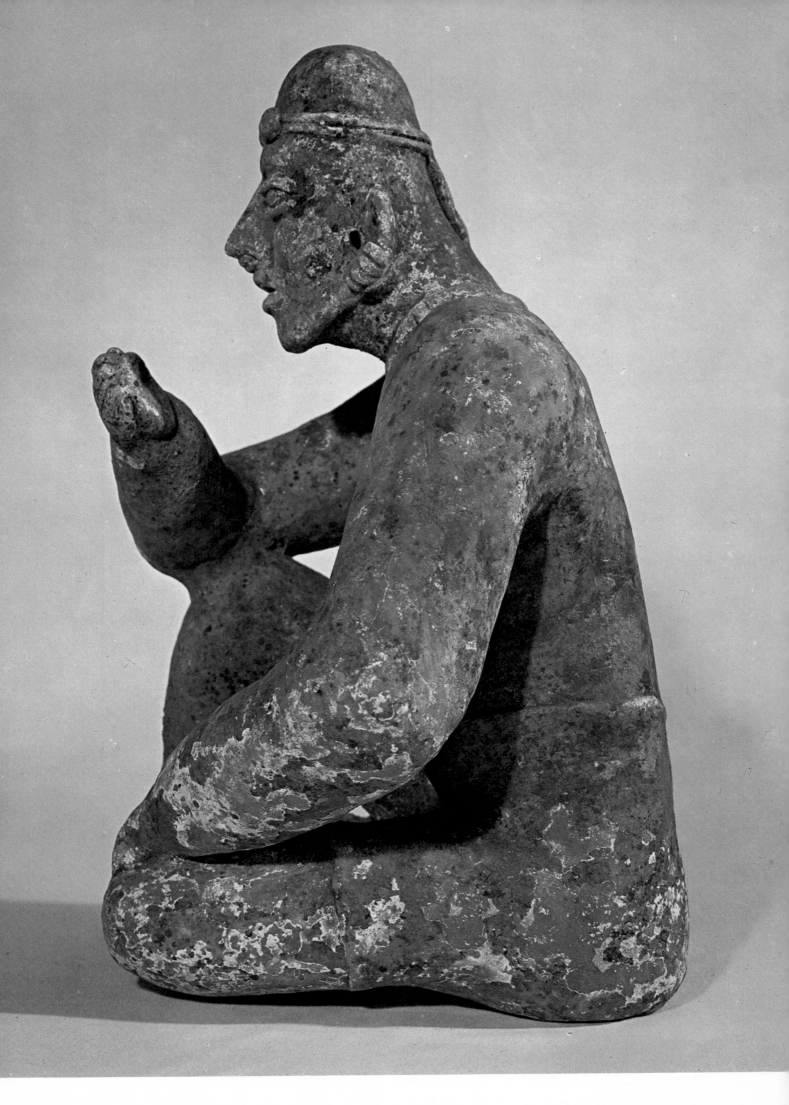

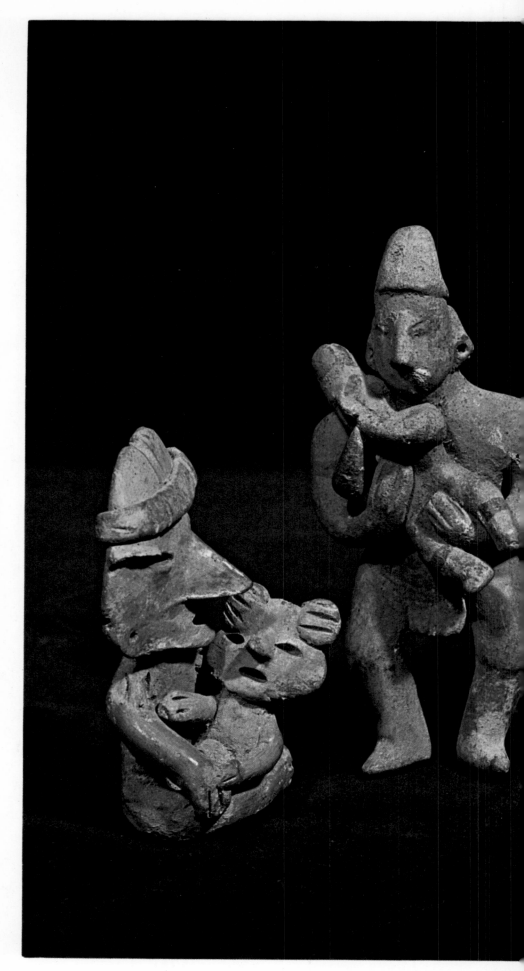

Anthropologists agree that Indian women were as loving and visibly affectionate with children as these ceramics

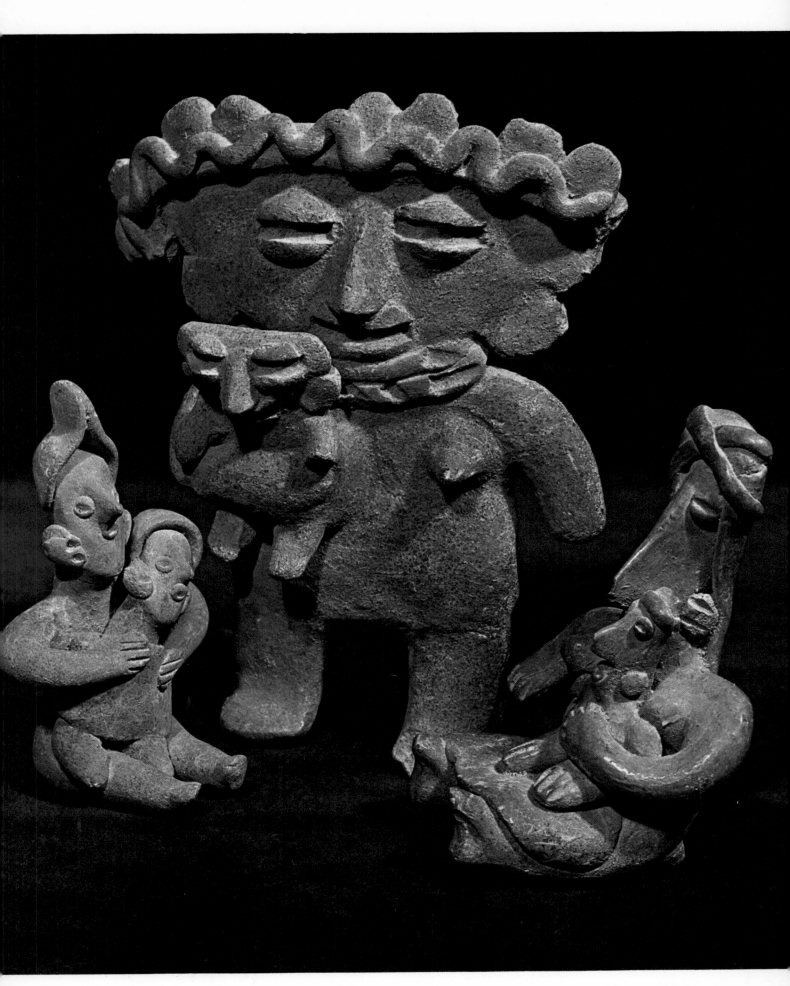

...rom western Mexico indicate. Second from left, a man ...olds his child awkwardly in the manner of men everywhere.

(Overleaf) Men retired to talk, eat, smoke tobacco, and drink pulque in special houses, where women were forbidden.

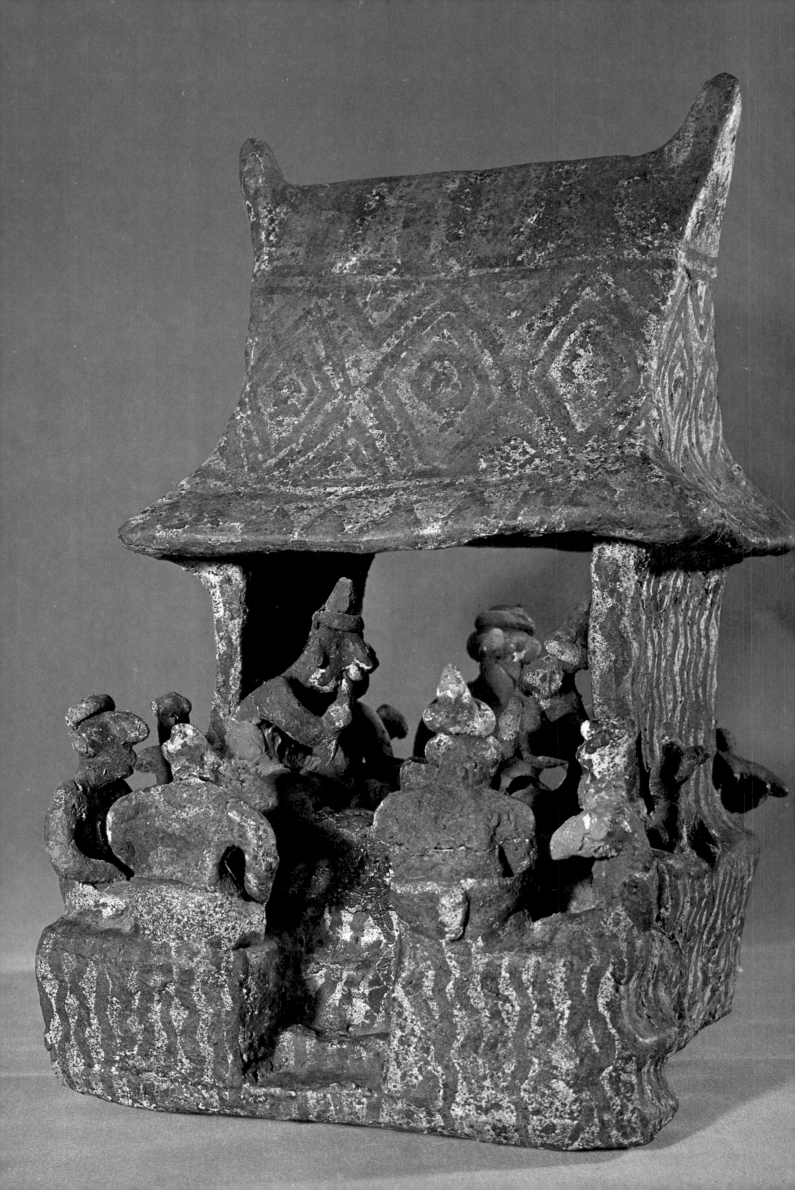

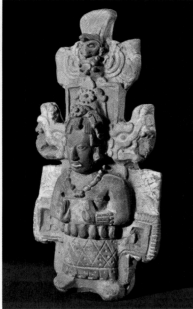

THE CLASSIC ERA

The classic period dawns with the rise of
Teotihuacán, Monte Albán, and Maya
civilization . . . their cycle of youth, golden age,
and decay. Theocratic governments in city-states
further major advances in arts and sciences.

HISTORICAL CHRONOLOGY		ART CHRONOLOGY	
	CENTRAL HIGHLANDS		*CENTRAL HIGHLANDS*
100 B.C.–A.D. 200	*Pyramid to Sun at Teotihuacán.*	*100 B.C.–A.D. 200*	*Teotihuacán style. Figurines with elaborate headdress.*
200–350	*Teotihuacán develops theocratic government.*	*350–650*	*Golden Age of Teotihuacán. Monumental stone sculptures of rain god and water goddess.*
350–650	*Apex of Teotihuacán. Urban center covers six square miles.*	*650–900*	*Ceramic urns and clay figures. Coyotlatelco and Mazapa ceramics.*
650–850	*Decadence of Teotihuacán. Internal dissention. Nomadic invaders destroy city.*	*350–600*	*Cholula temple with "Grasshopper Mural." Teotihuacán style.*
		500–900	*Temple of Plumed Serpent.*
	GULF COAST		*GULF COAST*
200–650	*Classic cultures in central Veracruz: ceremonial centers and priestly caste at Papantla, El Faisán, Remojadas.*	*200–650*	*Classic Veracruz style. Decorative stone objects in shape of horseshoes, axheads, and palms. "Smiling face" figurines.*
650–900	*Temple city of El Tajín, with pyramids and courts for sacred ball game, tlachtli.*	*650–900*	*El Tajín pyramid with deep niches. Sculpture of Huastecan "Adolescent Boy."*
650–900	*Huastecan culture with Teotihuacán influence at Tamuín.*		
	OAXACA		*OAXACA*
200–500	*Monte Albán becomes urban center.*	*200–500*	*Monte Albán style. Ceramic jaguars. Bat gods of stone and clay.*
500–900	*Golden Age of Zapotec culture. Metallurgical, medical, and dental advances; elaborate funeral ritual; temples with glyphs and frescoes; ceremonial ball game.*	*500–900*	*Monte Albán clay effigy urns. Tomb painting.*
	MAYAN REGION		*MAYAN REGION*
200–650	*Civic-religious centers at Miraflores and Palenque. Influence of Teotihuacán and Monte Albán.*	*300–650*	*Ornate classic Mayan style. Temple of inscriptions, stone stela, and sarcophagus at Palenque.*
650–900	*Congress held in Copán in 773. Astronomical knowledge and computation advanced.*	*650–900*	*Realistic murals at Bonampak.*
750–900	*Collapse of Mayan civilization.*	*500–900*	*Mayan classic architecture in Río Bec, Chenes, and Puuc styles.*
		700–900	*Jaina clay statuettes.*

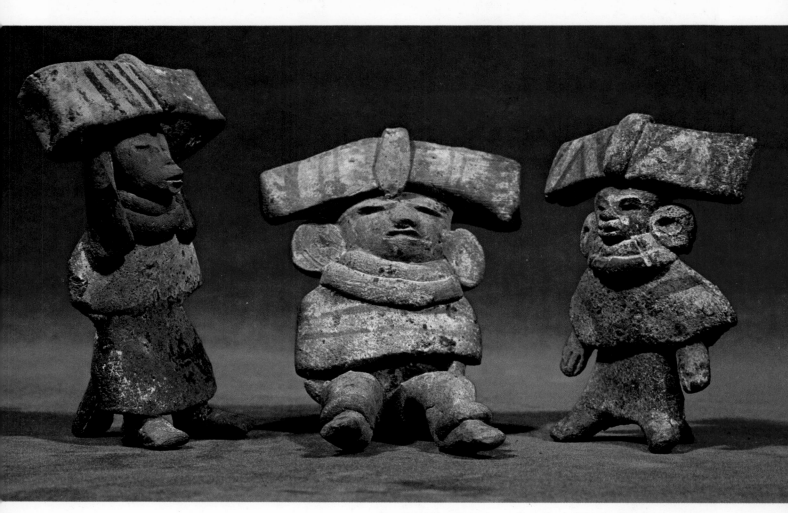

A noble of Teotihuacán, earliest city in North America, is flanked by women with shawls of a type still worn in Mexico.

City of the Gods

During the years that Christianity was born in Palestine, three cultures began their ascent in Mexico, into what anthropologists refer to as the classic horizon. This period in history reflected the rise of theocratic governments in central, south-central, and southern Mexico. A hierarchy of priests, representing the gods, led to the building of Teotihuacán, the first metropolis in North America, the rise of the Maya nation, and the unfolding of the civilization of Monte Albán.

The importance of the leadership of a priestly caste is apparent in the elaborate temples where the gods were worshiped, the detailed rituals that have come down to us, and the many representations of priests in painting, sculpture, and figurines.

Here a priest wears the fantastic costume of the quetzal, *the sacred bird brought from as far away as Guatemala.*

But if religion was the organizing force, contact and communication between different groups were not far behind. The religious centers offered not only a place to worship but also a place to exchange goods and, even more important, ideas.

It is difficult to imagine a gleaming city with wide thoroughfares, stone and wood buildings, and huge pyramids and temples existing in North America 1,500 years ago. Yet such a city was Teotihuacán, "the place where all go to worship the gods," the ancient metropolis only thirty miles from today's Mexico City. Its streets, if not paved with gold, were nonetheless paved throughout, covering an area of three square miles. Even today some of the pavements exist. Fragments show that colors were used in the paving and on the walls of the buildings. Ancient Teotihuacán must have surpassed most early cities of the world in beauty.

Surrounding the city are three volcanoes, now quiescent. Each played a part in the building of Teotihuacán. Its colossal pyramids and temples were built from the lava rock that poured from two of these volcanoes thousands of years ago. From the

67

third, Sierra Gorda, came the flagstones used for walls, aqueducts, and for the stone houses that lined the colorful streets. It is impossible not to admire the ability and energy of Teotihuacán's creators, even though we do not know who they were.

Legends of the Toltec Indians, believed to have later occupied Teotihuacán, tell of a great city built by a race of giants called Quinametzins. These myths doubtless arose when huge bones of extinct mammoths were uncovered, seeming proof that giants actually lived in that region. This belief persisted even after the Spanish Conquest. The thighbone of an elephant was carefully packed and shipped to the Spanish king, Carlos I (who was also Emperor Charles V of the Holy Roman Empire), as proof that supermen built the first metropolis in North America.

But if the men who built Teotihuacán were not giants, they built on a giant scale. Perhaps the most awe-inspiring edifice ever constructed in North America is their Pyramid to the Sun. Over 700 feet at the base, it rises to a height of over 200 feet.

Volcanic stone faced with plaster covers the entire exterior. A broad stone stairway leads from the base to a temple dedicated to Tonatecuhtli, the god of the sun, who was also the god of heat and plenty. Crowning the temple, a huge monolithic statue of the sun god faced the east. On the chest a gold breastplate created a brilliant beam of light as the sun rose. Our knowledge of this magnificent figure and the details of the temple come from the accounts gathered by the early Spanish friars who copied down the legendary knowledge of the Indians.

The inside of the pyramids was made of adobe block (clay mixed with water and sun-baked). Within some of these blocks and between them, the earliest figurine fragments of Teotihuacán were found. These first-period figurines are extremely stylized, with long slanting incisions used for eyes, round or square headpieces, and either simple straight limbs or legs and arms without joints that curve snakelike when folded. Even these earliest figurines cannot be considered crude. Jaguar feet with claws and snake rattles are part of the design.

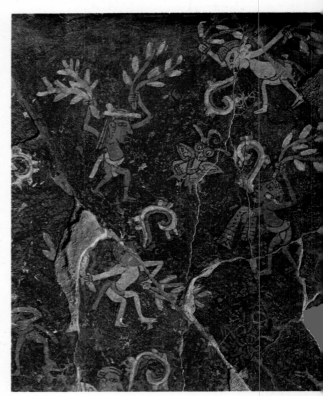

Above: In this vision of paradise, three men dance holding flowering branches. The spirals show their singing

Left: Ballplayers from opposing teams fight for the ball, which is at upper left, with colorfully decorated sticks.

Right: A player shouts and points to the goal as he kicks the ball. Some ball games became sacred rituals

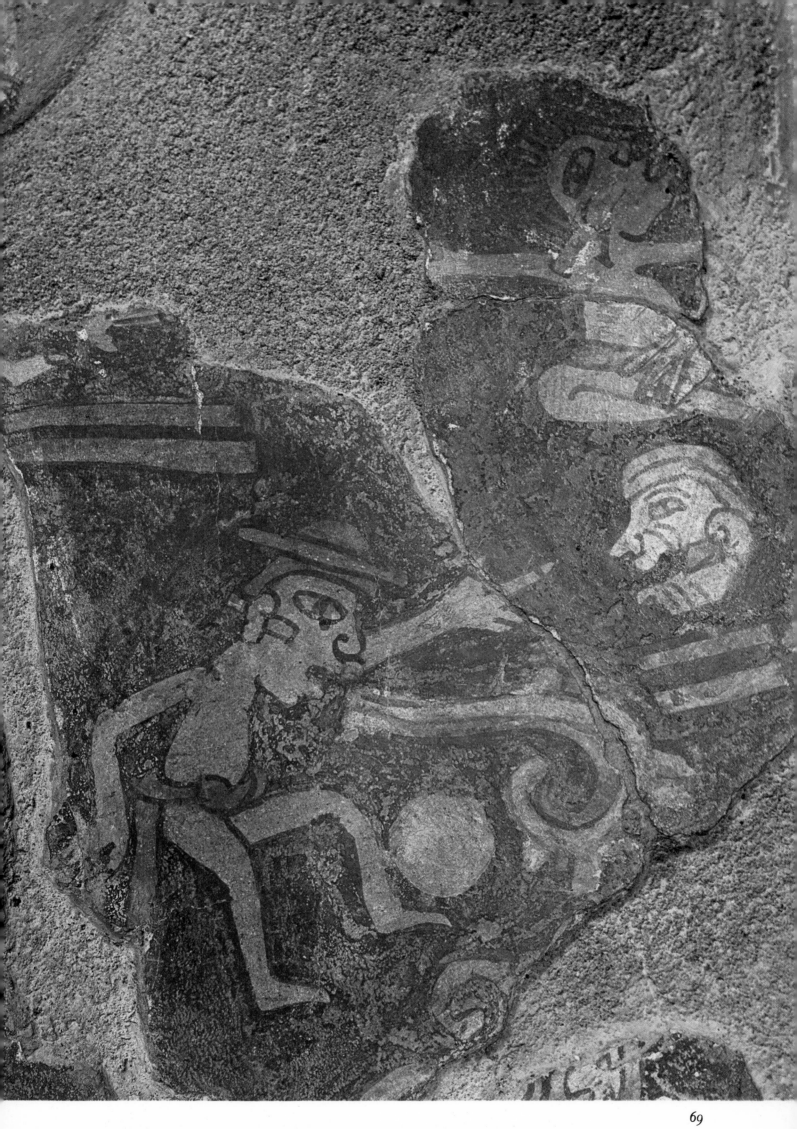

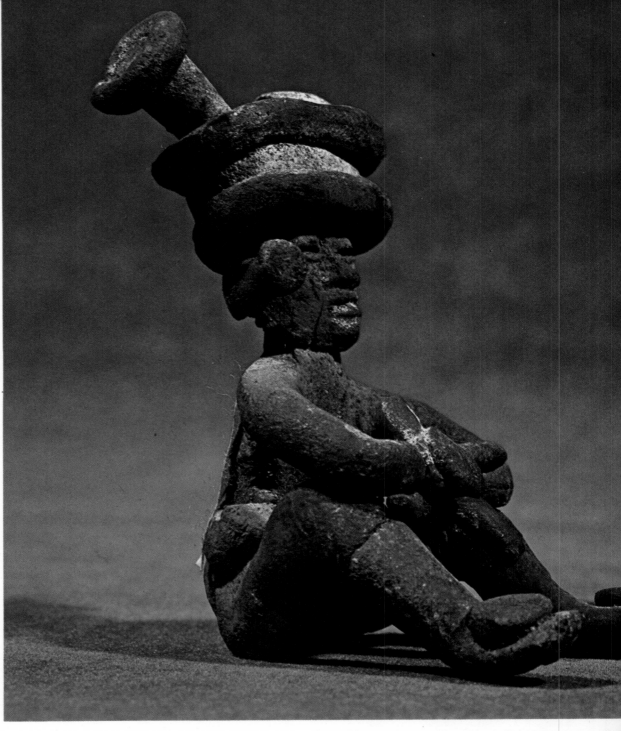

*These citizens of Teotihuacán lived in a city founded
some eighteen centuries ago. The man at left wears leg-*

That the people of Teotihuacán built permanently
and well is shown by the fact that not even the
Spanish conquerors, under their zealous Bishop Juan
de Zumárraga, were able to completely destroy the
magnificent structures of Teotihuacán.

Smaller than the monument to the sun, the Moon
Pyramid is the oldest structure in Teotihuacán. Like
the Pyramid to the Sun, there are indications that a
temple stood upon its peak. A spacious courtyard
was laid out on one side of the pyramid and a broad
steep stairway led upward. Occasional terraces broke
up the long ascending stairway leading to the top.

From this pyramid a broad thoroughfare, known
as the street of the dead because of the many burials
found along it, reaches to the area now called the
citadel, dominated by the six-tiered Temple of

Quetzalcoatl. This ancient structure is shaped like a
broad pyramid surrounded by low walls. The façade
is alive with symbols of Mexico's representations of
the serpent god; the plumed serpent identified with
Quetzalcoatl shows an outstretched serpent head
with two fangs exposed in the open mouth and the
headdress gives the impression of feathers. Alternat-
ing are heads of the fire serpent, carrier of the sun on
its regular trip across the sky. Design motifs include
seashells, wavy lines representing water, and circles
within circles.

We know that both the Pyramid to the Moon and
the Pyramid to the Sun were used as places of
worship to those respective deities because they are
mentioned by name in the early Nahuatl legends
that tell of the ancient civilization of Teotihuacán.

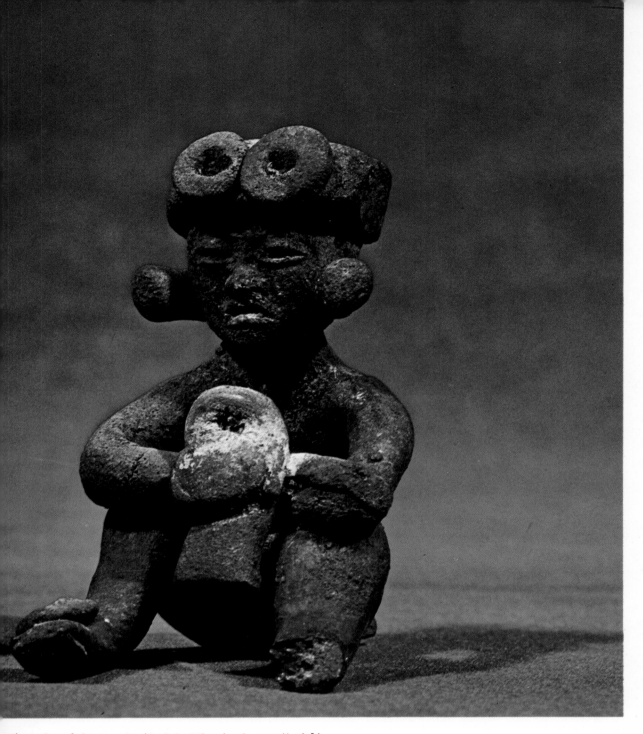

*gings, breechclout, and wide belt. The circular motif of his
headdress is echoed in the other's doughnutlike ornaments.*

From the evidence of the sculpture depicting the
feathered serpent, we can be sure this earth-sky deity
was also worshiped. Even though the city was in
ruins and uninhabited by the time of Moctezuma II,
he is known to have visited and probably worshiped
at the ruins of these temples.

Teotihuacán was rebuilt more than once, but its
greatest rebuilding seems to have been by the origi-
nal inhabitants rather than later cultures. During the
400 or more years that the Teotihuacanos occupied
the city, they increased the size of existing structures
and razed certain structures to build more advanced
edifices upon the ruins.

The city of Teotihuacán was unlike the previous
urban ceremonial centers such a La Venta and
Monte Albán, for it was not only an important

ceremonial center but offered permanent accommo-
dations for a reasonably large population (estimated
at over 25,000 people), much larger than any earlier
city in Mesoamerica. The major difference between
the two types of urban communities was that in the
earlier "cities" of La Venta and Monte Albán people
gathered from the countryside for ceremonial occa-
sions and for market days. The center, therefore,
had only limited accommodations for the priests and
their retinues. But at Teotihuacán, long rows of
individual houses, apartment-type houses, and many
palaces for the elite existed. A water system tapped
the nearby springs. Evidence of distinct social
classes, who lived in different districts, is apparent in
housing and figurines. This was a modern city in the
sense that it contained a central business and cere-

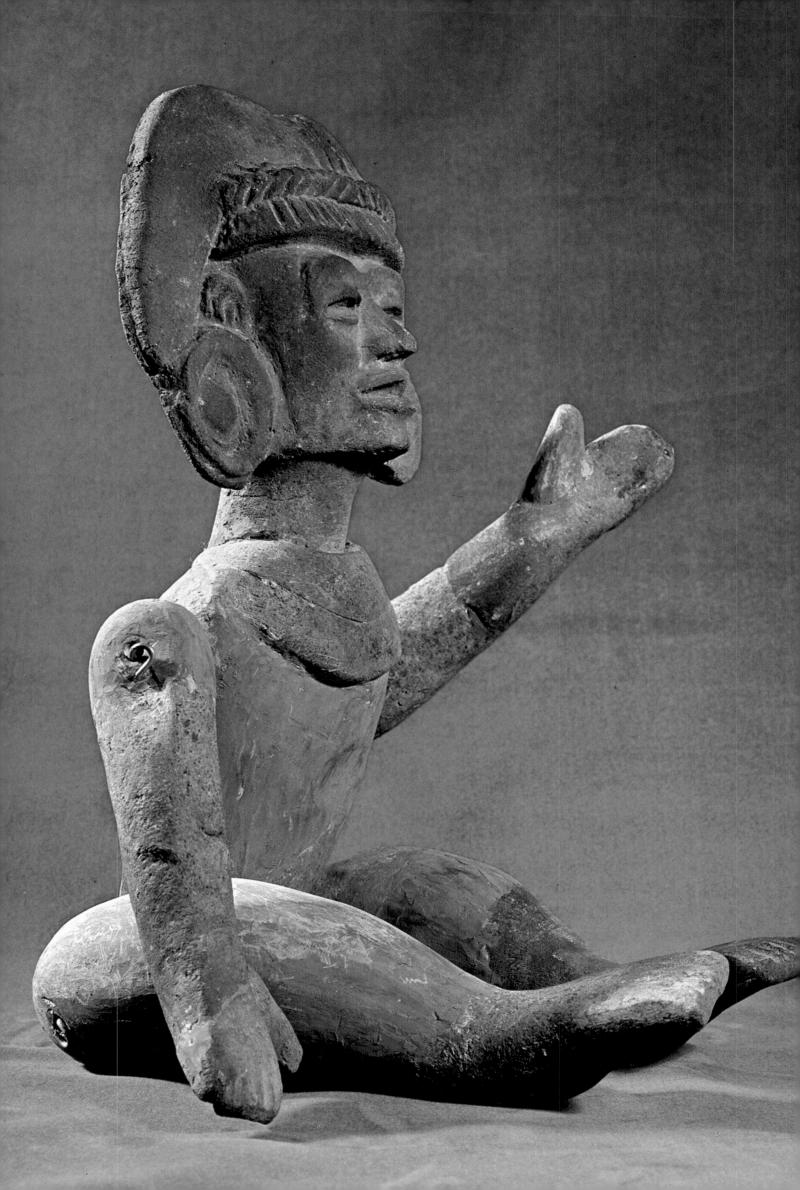

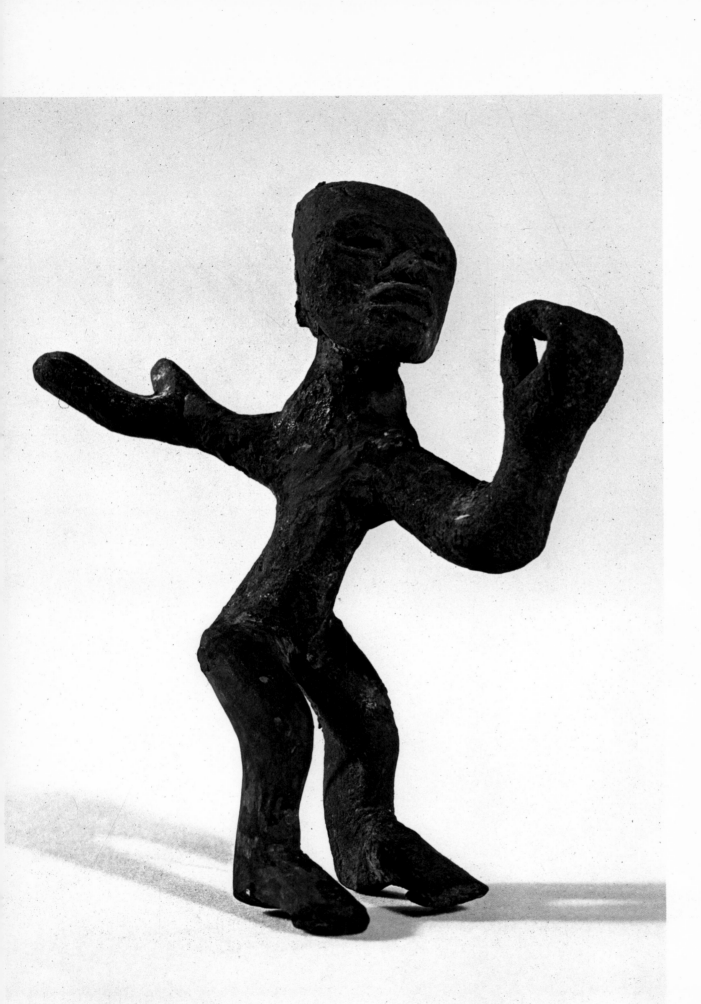

The circular ear ornaments of this figure, which has Despite the startling modern sensibility of the artist,
movable arms and legs, identify it as of a noble personage. this clay figure of a ritual dancer is over 1,000 years old.

monial center, a residential district spreading out from the nucleus, and a large suburban population that supplied food.

The residents of Teotihuacán used color everywhere and seemed to delight in the brilliant images with which the fresco painters decorated their walls. The paintings were usually of religious themes, but they were painted in a light, even gay, style. In fact, there are two distinct styles of paintings on the walls of Teotihuacán. They can be separated into formal paintings of gods and their symbols, and more realistic portrayals of men. The first included the corn god; Tlaloc, the god of rain; the feathered serpent; and others. Included in paintings of the gods are their masks, their garments, and their jewelry. In each case, symbols of their divinity and the things they influenced, such as ears of corn, flowing water, or shells, surround the respective deities.

The second kind of painting deals with man, and from these murals it is possible to glean some knowledge of the early residents of this primary metropolis. Murals show the citizens playing a kind of ball game with players hitting the ball with a stick and kicking it. In other murals men dance with moving branches while huge butterflies, almost as big as they are, fly among them. They wear a simple wrapper around the waist and through the legs with the end of the cloth hanging out behind. It resembles the Hindu dhoti. Most wear large earplugs and all dress their hair in a distinctive fashion reminiscent of the severe Egyptian hairdress.

In one large fresco we learn something of the aspirations of the Teotihuacanos. The scene is the paradise of the rain god Tlaloc. Having arrived in paradise, men are joyfully singing (as indicated by the scroll-like lines issuing from their mouths); while they sing, they dance among flowers and butterflies, swim in the rivers, and in every way seem to be enjoying in this painted paradise the same kind of things they enjoyed on earth. The painting shows in considerable depth the attitudes, even something of the philosophy, of these people. That they must have been contemplative is illustrated by the form and the attitudes of their clay figurines.

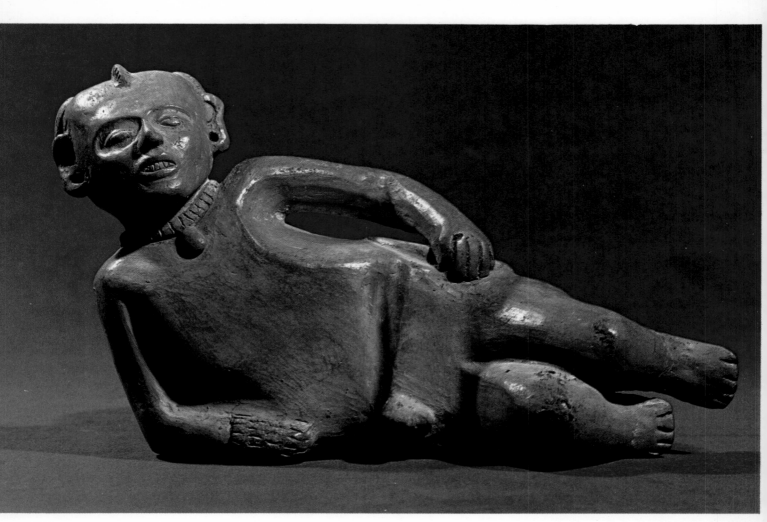

The polish on this drinking vessel in the form of a man is not a glaze. It was produced by rubbing with thin sticks.

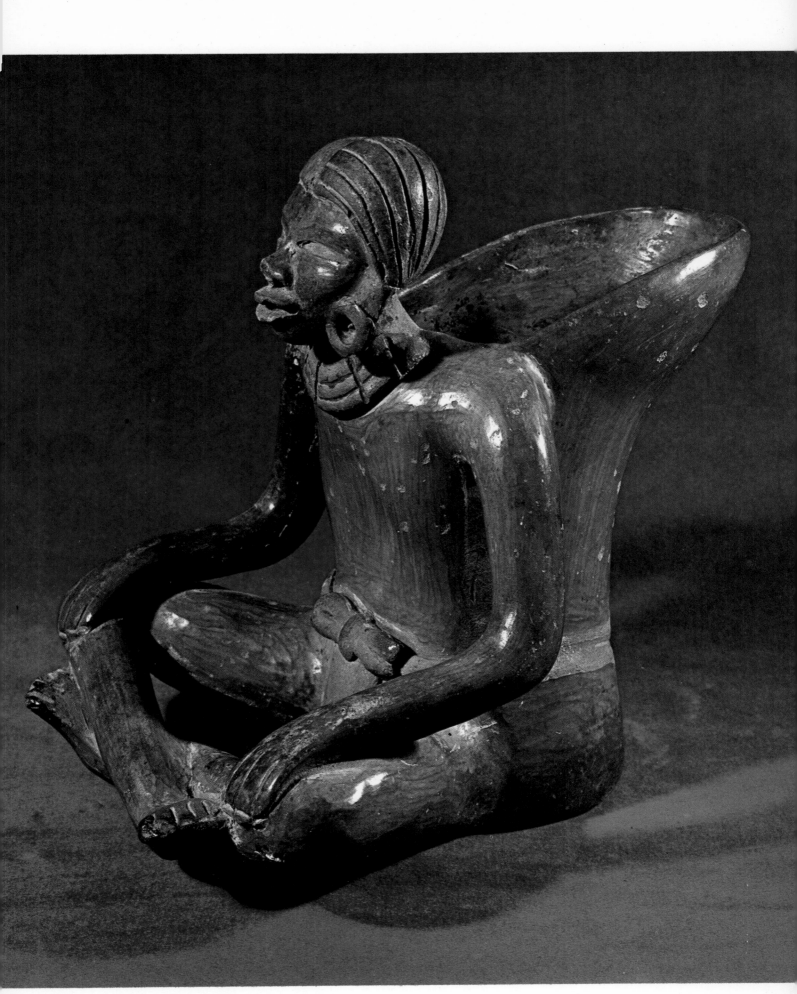

*Because temples were always built on high ground,
water had to be carried up to them on the backs of bearers.*

Here Yacatecuhtli, god of commerce, carries maize on his head, his back, and in one hand. He also carries incense bag.

The face paint and feathered headdress suggest that this magnificent mask belonged to a Teotihuacán priest or noble.

The variety and incredible number of these figurines indicate their importance and widespread use as burial offerings. Because of the affluence of the society and the great demand for these miniature replicas, an original was first made, then a clay mold. By this early mass-production method, hundreds of figurines were produced and distributed throughout the region. Many of these ancient molds have been found in modern times by residents of the Teotihuacán area, with the result that replicas of the ancient figurines are for sale at low prices. But, because they are made in the original molds, anthropologist Ignacio Bernal points out, they are only half fake.

Seated figures are always shown in positions of grace. Faces have a serious but reflective air. Heads show wide foreheads, aquiline noses, and regular, well-formed mouths. There is none of the snarling-jaguar, baby-face look of the Olmecs. Some of the heads of Teotihuacán are very similar to realistic sculpture of heads today. This is not true, however, of the masks for which Teotihuacán is also famous. The same serenity is apparent, but all of the masks show a triangular face with finely etched features.

The placidity is even true of their larger statues, though only one of great importance has come down to us, the gigantic stone figure now known as the "Goddess of Water." Cut into the huge stone

features, with its solid arms and short legs that serve as a base, is a timelessness; like the great Buddhas of India and Burma, it reflects serenity and peace. The "Goddess" is made from a single square of rock, eight feet high and weighing some twenty-four tons.

It is probable that the Teotihuacanos were indeed a peaceful people. Warriors are not represented in their figurines and there are no signs that the city was fortified. One of the few indications of any weapons found (other than the sharp obsidian points used for spears and darts) are the clay pellets used in their blowguns. These were primarily used for hunting birds.

Because it was the greatest city of its time, with an influence that radiated hundreds of miles, the Teotihuacanos probably felt no need for defenses. It would seem to them there would be no people capable or desirous of destroying such a great culture. Yet, although the greatness did last for some 500 years, the first metropolis of North America was dramatically and violently destroyed, its buildings wrecked, its statues overturned. The identity of its destroyers is not known. But no invader could completely destroy such timeless magnificence. Although its people are long since gone, the great city of Teotihuacán still stands, a monument to the energy and ingenuity of Mexico's first great builders.

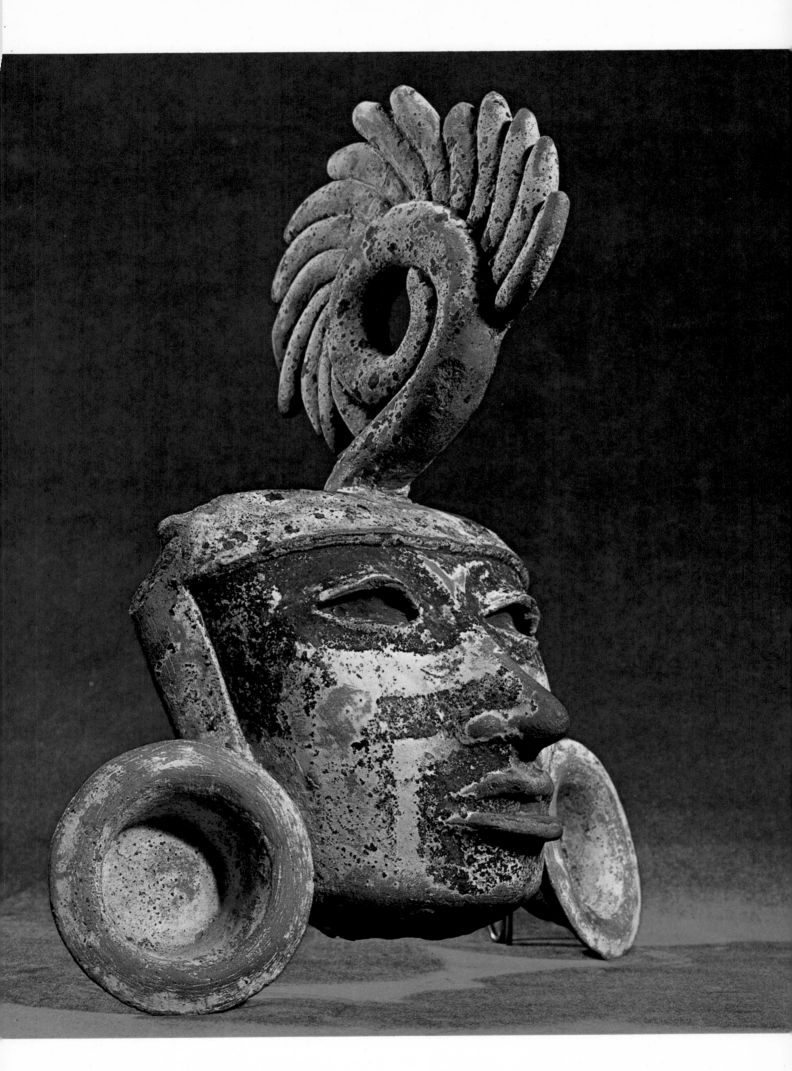

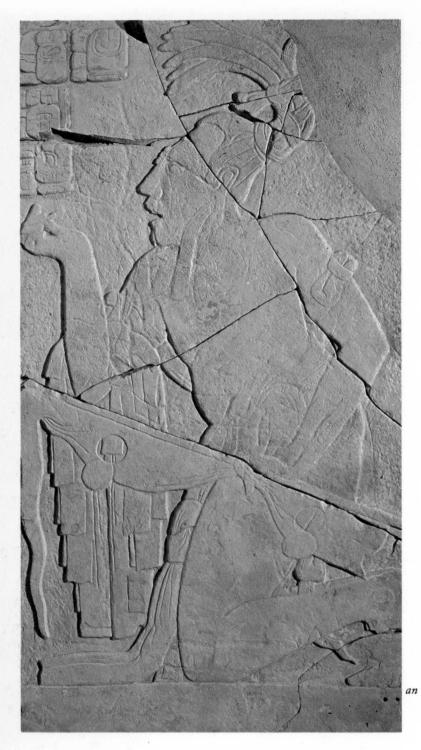

A Mayan scribe kneels to write. His right hand holds an awl or sharp instrument, his left a roll of parchment.

The Maya–Classic Greece in North America

During the period of Mayan classicism, Rome was beginning its slow process of decay. Classical Byzantine art, which flourished during the late Roman Empire, was at its peak. Buddhist art was emerging, and this was also the period of classical Indian art.

While great strides were being made in Europe and Asia in art and architecture, they were beset by wars. Rome was sacked by Alaric and later plundered by the Vandals. Attila and his Huns invaded western Europe. Toward the end of the era Mohammed was born and the Arabs began an epoch of conquest. By contrast, in Mexico the arts and sciences seem to have developed under comparatively peaceful conditions.

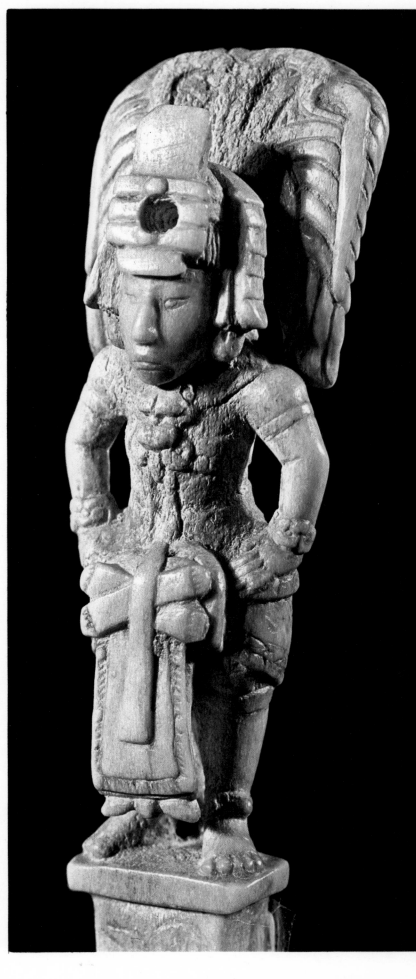

This miniature sculpture of an early Mayan chief in a flowing headdress was carved from the femur of a jaguar.

Unlike Europe and Asia, the Maya progressed without the use of metal, without the wheel, and with no contact with more advanced civilizations (except for their prehistoric contact with the Olmecs). Yet the Maya made perhaps the most important contribution to the arts and sciences of the early Americas.

In this discussion of Mayan civilization, certain basic factors should be kept in mind, such as shifts in population, the spread of outside culture into the region, and the speed at which Mayan culture devel-

oped. In the earliest stage Mayan art belongs to the preclassical, but, between A.D. 300 and 650, it is truly classic. In form and structure a mature sense of beauty and design is apparent. Nor is imagination, the third important element in great art, lacking.

True recorded history begins in Mexico with the classic Mayan civilization. Not only did these talented people bring into being an art and architecture that rival that of classic periods throughout the world but also they devised an accurate 365-day calendar some 1,300 years before our modern calendar was announced by Pope Gregory in 1582. Their use of the zero in mathematical calculations antedated that of the Hindus by a thousand years; they recorded their early history in hieroglyphic writing on hundreds of stone slabs.

The roots of the Maya dig deep into the past. That they were influenced by formative cultures around them is apparent, for we know that they learned to record time and to use hieroglyphic writing from their neighbors to the north, the Olmecs. Yet in their cultural achievements they surpassed all of the previous civilizations in Mexico. Mayan art and archi-

tecture combine the purity of the classical Greek with the serenity and sensitivity of ancient India.

The Maya people were, and are, a distinctly different type from other Mexican Indians. Shorter than most, they are broad in stature and belong to the brachycephalic (short- or round-headed) group classification. Scientific measurements show that even today the Maya people are the most round-headed in the world. This would seem to indicate that there was comparatively little intermarriage with other groups and that they maintained a degree of isolation for many centuries.

The country of the Maya embraces three distinct geographical regions: a mountainous area in Guatemala and western El Salvador, a dry and flat plain with little foliage in the northern part of the Yucatán peninsula, and a tropical rain forest extending across the states of Tabasco and Chiapas. This last region, usually referred to as *tierra caliente,* is a steamy, hot jungle of rivers, lagoons, and swamp where heavy rains flood the countryside seasonally. Literally hundreds of species of trees, including mahogany, ebony, rosewood, divi-divi, and Spanish

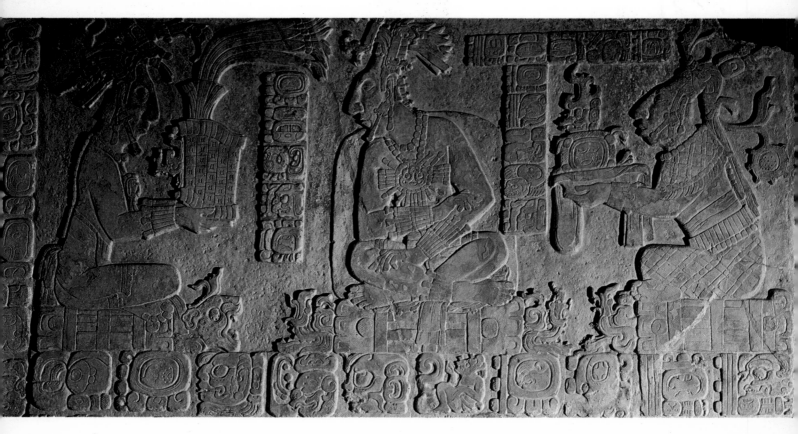

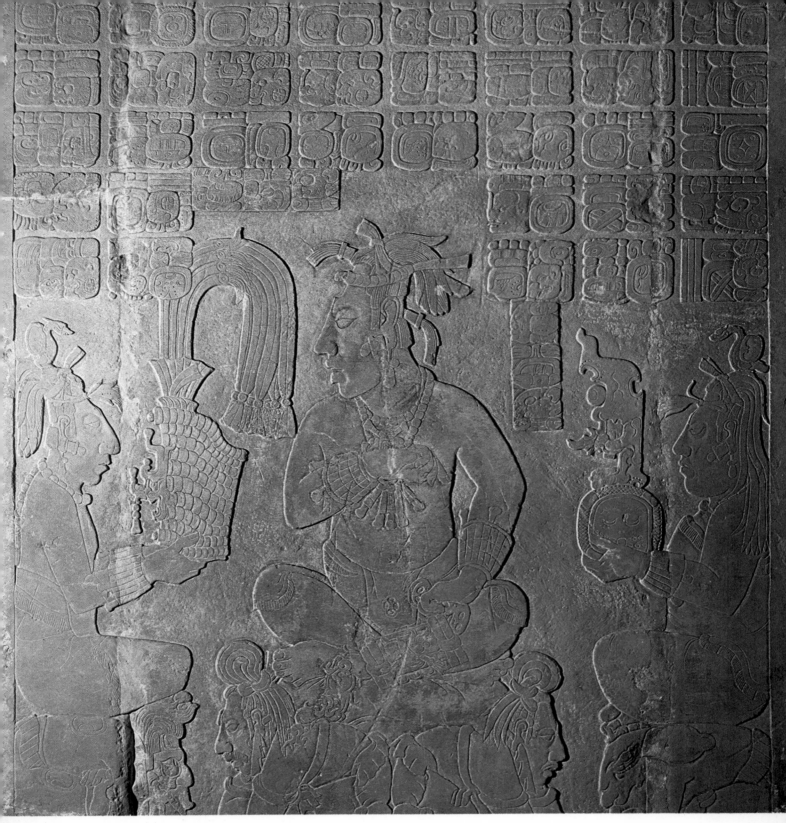

*In this intricate bas-relief, a priest of the sun cult
nd a priestess of the rain god flank the Lord of Palenque.*

*A priest and priestess wear birds in their hair while
a king sits on a throne of slaves. Carvings indicate dates.*

:dar cover the low-lying hills and broad valleys.
his wild tropical flora forms a magnificent back-
round for the classic Mayan ceremonial temple
rchitecture that rises above the forest. The *tierra
iliente* marks the westernmost penetration of the
[aya; here they came in closest contact with the
arlier Olmec civilization and built the impressive
eremonial centers of Bonampak, Comalcalco, and
alenque.

Still a model of what a Mayan religious center
oked like, the sacred city of Palenque is located in
the foothills of the Sierras in the state of Chiapas.
The roads approaching it are excellent. Today, from
the city of Villahermosa, the drive can be made com-
fortably in two to three hours.

To enter the Palenque region is to step into the
mist-shrouded past. Jungle colors, ranging from bril-
liant yellow to chartreuse and jet black, form a con-
trast to the gleaming white temples. From a distance
the structures do not appear to be ruins but look as
though they have been recently occupied. There is
an air of permanence that reflects the ingenuity and

the engineering ability of the builders of the temples and courts. The impression is that the residents will gather again soon for a festival or a market day. Even though the edifices are empty of priests and worshipers, there is no vacuum. And yet the jungle has moved in to decorate the buildings in its own special way. Miniature green trees, ferns, and lianas grow out of the courts where ball games were played. Bright-green shoots push their way through cracks in the magnificent bas-relief stucco figures which are among the most beautiful examples of this type of art in the world. But the jungle encroachment has not covered these larger-than-life relief sculptures. Realistic men and women in stylized poses stand in easy, dignified attitudes, ornate helmets erect, their capes and tunics falling in graceful folds around them. Such figures, showing aristocratic men, rulers, and priests, line the walls and courts of some twelve temples.

The Temple of the Inscriptions, noted for its unique design motifs and graceful figures, is also the site of the most spectacular burial chamber in North America. The crypt is located deep in the base of the pyramid. It can be reached only by a climb up a stairway of approximately 100 steep-rising steps to a temple at the apex. Once at the top, one descends an equally steep incline to the subbasement, where the tomb of a great king, or king-priest, is revealed.

The burial is eighty feet below the floor of the temple and five feet below the level of the building itself. Guarding the crypt are stucco relief figures representing nine priests, each bearing the shield of the sun and the scepter of the rain god. They are believed to represent the Bolón-ti-kú, the lords of the night and of the underworld.

Within this ornate crypt is the largest sepulcher ever unearthed in the Americas. It consists of a monolithic sarcophagus ten feet long and seven feet broad, with a fitted cover twelve and a half feet

long. Carvings of men, animals, and flowers decorate the sides. A stone lid with magnificent reliefs covers another cavity that is sealed by a polished stone slab fitted with absolute precision. Within was found the skeleton of a tall man, between forty and fifty years of age, almost entirely covered with jade ornaments. As in many of the Mayan burials, the bottom of the sarcophagus, the winding sheet, and other objects had been painted red with cinnabar. The skeleton still wore a diadem of jade disks. His earplugs consisted of several pieces of jade. Around the neck was more jade carved in serpentine forms and in the shapes of fruits and flowers. A breastplate consisted of several rings of tubular jade beads, and he wore ten rings, one for each finger. Over the face a jade mosaic mask, with eyes fashioned of shell and irises of obsidian, had been placed. In his hand was a large piece of jade and another jade bead was in his mouth. Two jade figurines, one of them represent-

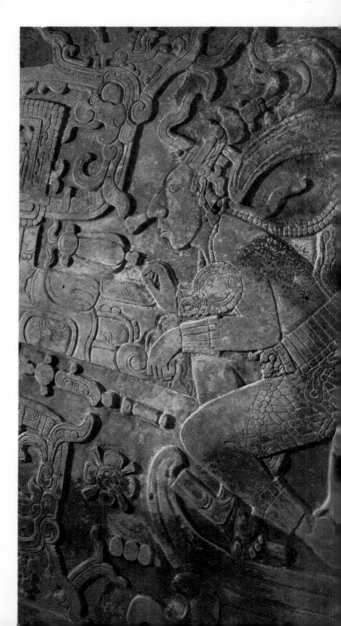

A youth crouches amid snakes and symbols in this detail from a crypt in the Temple of the Inscriptions at Palenque.

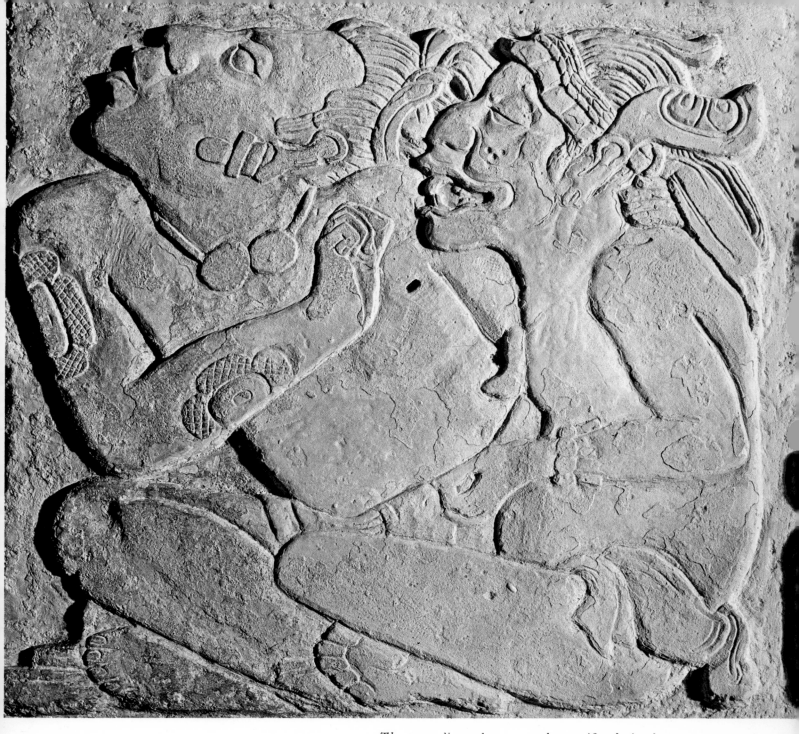

The strong diagonal movement here typifies the freedom of Mayan art. The figure at left has zero signs on his arm.

ing the sun god, were in the tomb to accompany the personage on his journey. Outside the burial entrance to the crypt was a sealed passageway, and the remains of several youths were found there. It is obvious that they were sacrificed at the time of the burial to serve as guardians and companions to the king.

At least twelve temples have been discovered at Palenque, and in addition there is a great palace, a complex of buildings set upon a platform 300 feet long by 240 feet wide. It is built in an intricate architectural pattern of chambers, corridors, and inner galleries and courts. Outside passageways lead from one section to another. In the southwest patio there is evidence of a steam bath and there are three latrines, one of them provided with a drain. The palace is lavishly decorated with stone relief figures on the outer pillars and even on the steps of the inner stairways.

Some sixty miles from Palenque, but much less accessible, lie the ruins of Bonampak, the second most important religious center in the central zone. In addition to handsomely carved statues, Bonampak is noted for its colorful frescoes, murals that

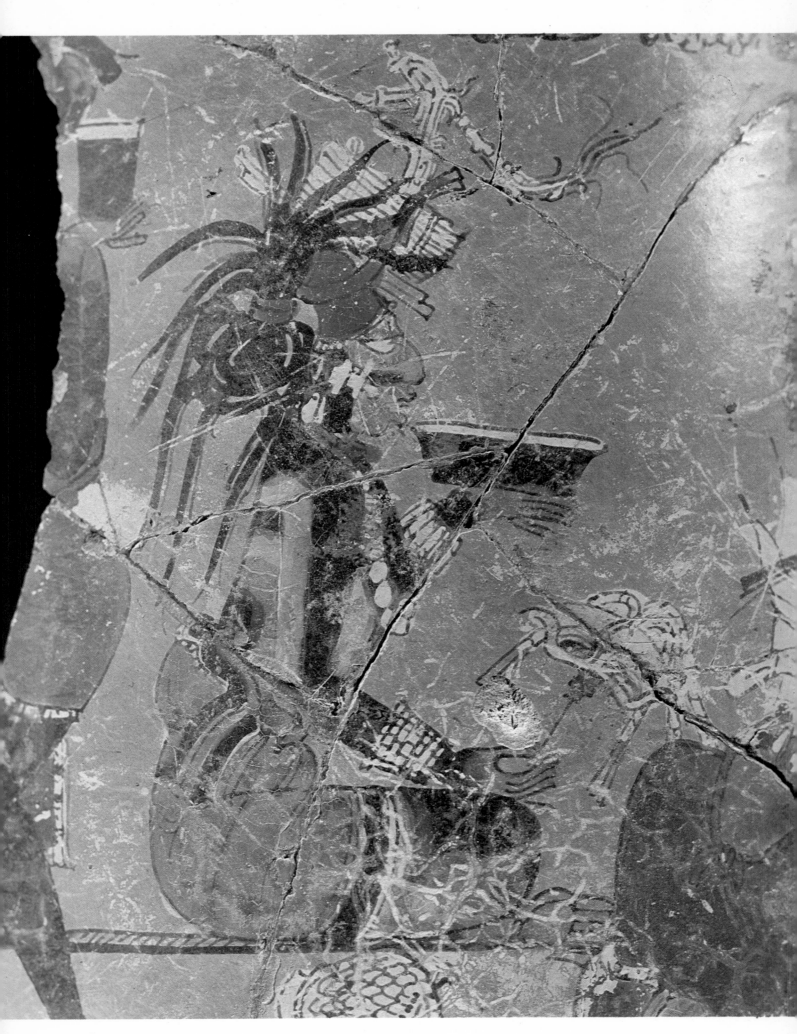

reveal that the Maya were not entirely a peaceful people promoting the arts and sciences, as was once thought, but a nation of warriors as well. One of the largest paintings shows the judgment and sadistic punishment of prisoners. Another depicts a violent battle. In it warriors fight hand to hand with knives and spears. Other evidence of a warlike spirit is indicated by the thousands of obsidian spear points that have been found at every site occupied by the central Maya. They must have been precious, for no obsidian exists in the central region. Traders must have traveled to and from the distant highlands to secure these essentials of warfare.

Jade, gold, and copper ornaments also came from remote regions. The gold and copper objects were brought from Central America; jade, considered more precious than either, from as much as 1,500 miles away. Intense trade with nations both near and far was an important part of the economy of the Maya nation.

Local trading was done on festival or market days. Whole families moved in from the surrounding countryside to the urban center. Thousands assembled in the spacious plazas to buy and sell pottery, both utilitarian and ornamental, deer hides, cotton cloth and cotton quilted material (which was used by the warriors as armor), salt, honey, turkeys, and ducks. Slaves were an important commodity and were brought to market along with other trade goods. Cacao beans, from which margarine and cocoa were produced, were a much-used medium of exchange. Other articles of great value used as currency were jade disks and the colorful feathers from parrots, macaws, toucans, pelicans, cormorants, and especially the gorgeous quetzal bird, whose plumage was highly prized.

On a festival or market day the plazas were busy with movement and brilliant with color. The Maya love for color extended from their art to their clothing. Garments of the common people were brief, the style simple, but always colorful. Average men wore little more than a loincloth of brilliant solid shade or

An opulently costumed member of the Mayan ruling class sips from a bowl in this fragment of a delicate vase.

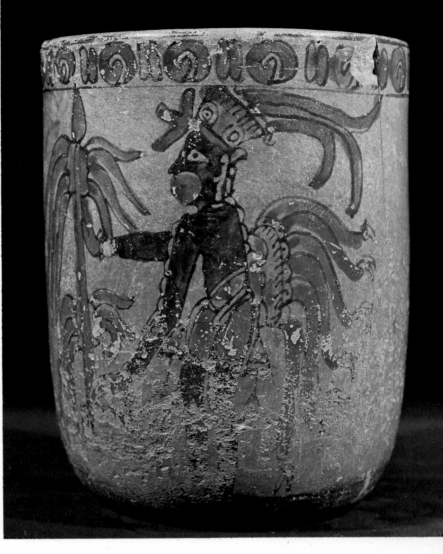

Mural-like paintings of priests covered the delicate orange vases which were a uniquely Mayan form of pottery.

a dhotilike garment, a single wide piece of cloth wrapped around the waist and drawn up between the legs. These, too, were dyed in bright hues. Men of higher castes and the priests and nobility wore square cloaks of cotton or dressed animal skins. (The jaguar was a favorite but was worn only by the elite.) Long feather cloaks reached to the ankles; bodies were painted or tattooed.

An essential part of the costume of the elite class was jewelry. Bracelets jangled on wrists and ankles. Ropes of jade became necklaces. Leggings, rising from the ankle to the calf, were made of jade beads strung in rows.

85

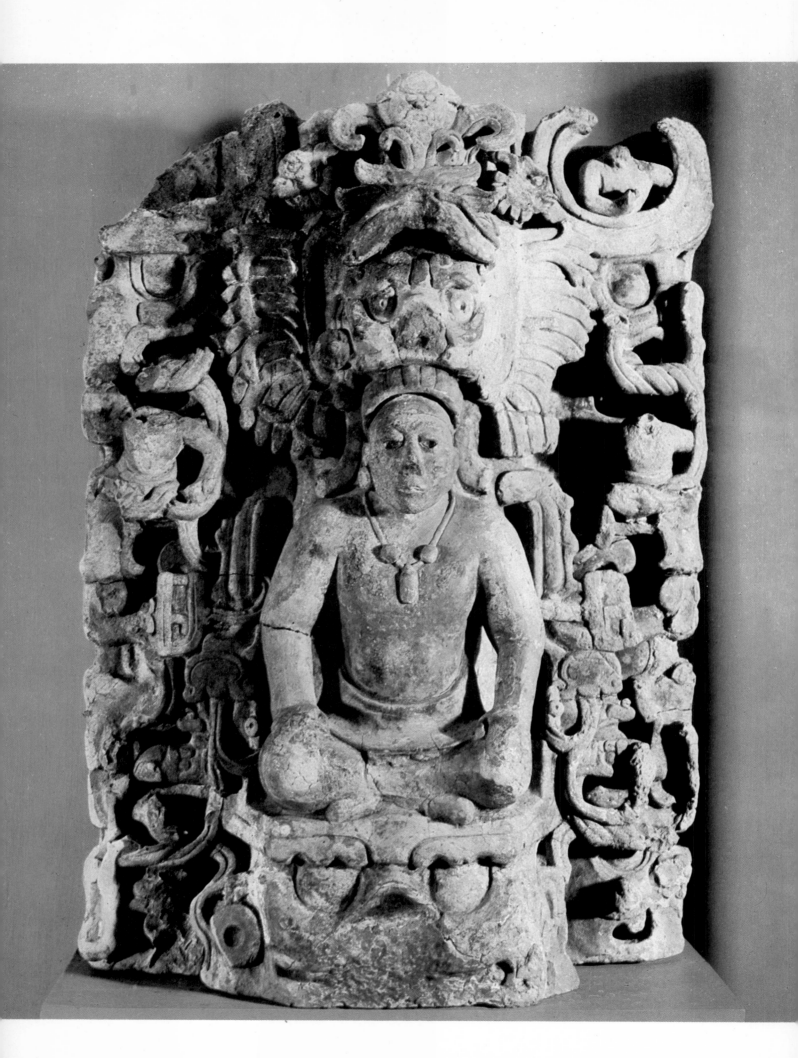

The greatest attention was paid to the head. To prepare the head for the type of headdress and the kind of beauty most admired by the Maya, infants had their heads bound before they were a week old. Two smooth boards, one on the forehead and one on the back, were tightly bound. This forced the baby's head to grow in an upward direction, changing the contour from round to long. The board on the forehead flattened it; no curve existed at the brow line and the nose followed a continuous line from forehead to nose tip. Some anthropologists have written that the Maya may have changed the shape of their noses, either by an operation or by the addition of putty under the bridge of the nose, but this was probably unnecessary, since the nose of the Maya is naturally high-bridged, and this is likely to have been exaggerated in their art. It is interesting that in the Ajanta caves of east India, gods are sculptured with the same high-bridged straight nose as the Maya.

Higher castes wore their hair long and dressed in elaborate styles. Important priests and nobles affected headdresses and helmets that can only be described as bizarre. Some were made in the shape of animal heads; others represented birds or flowers. To top off the headgear, brilliant sprays of precious feathers were added.

Women's clothing was simpler. They are shown wearing a short skirt slit up both sides. Breasts are uncovered. Nose plugs and lip buttons were common. Like the men, women were tattooed on their bodies, but not on their breasts. Teeth were filed to give a saw-toothed effect. There is little evidence in the frescoes, bas-reliefs, or figurines that women occupied an important place in the social scale. Whenever women are shown in long dresses and elaborate coiffures, they are goddesses. Mayan women were excellent weavers of cloth, as is shown in paintings of the garments of the goddesses and the robes, tunics, and kilts of the men.

A god of the Maya, reminiscent of a Chinese Buddha, sits with his head haloed by the upper jaw of a jaguar.

The man's hollow potbelly is filled with seeds, and his long, thin legs serve as a handle for this humorous rattle.

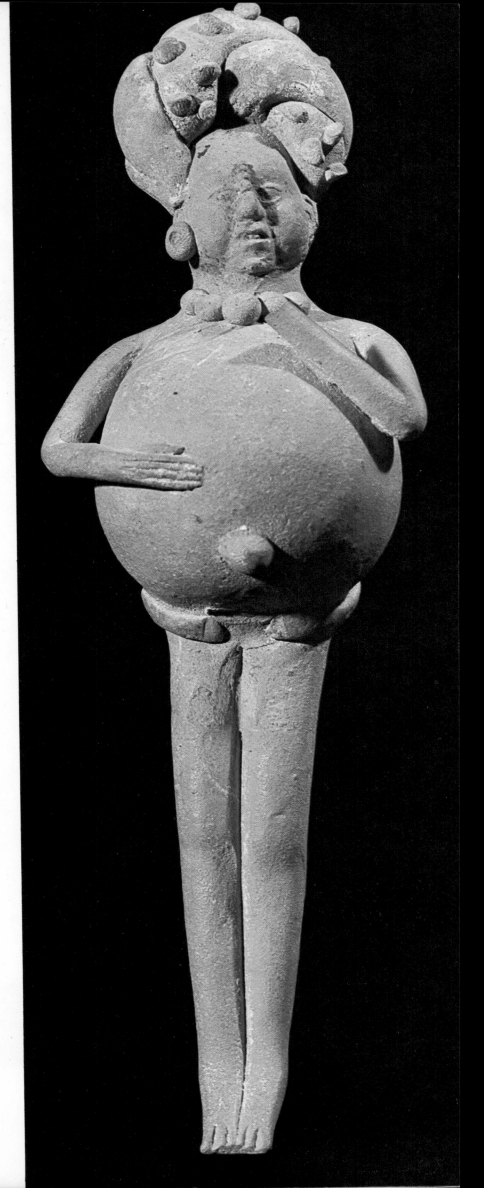

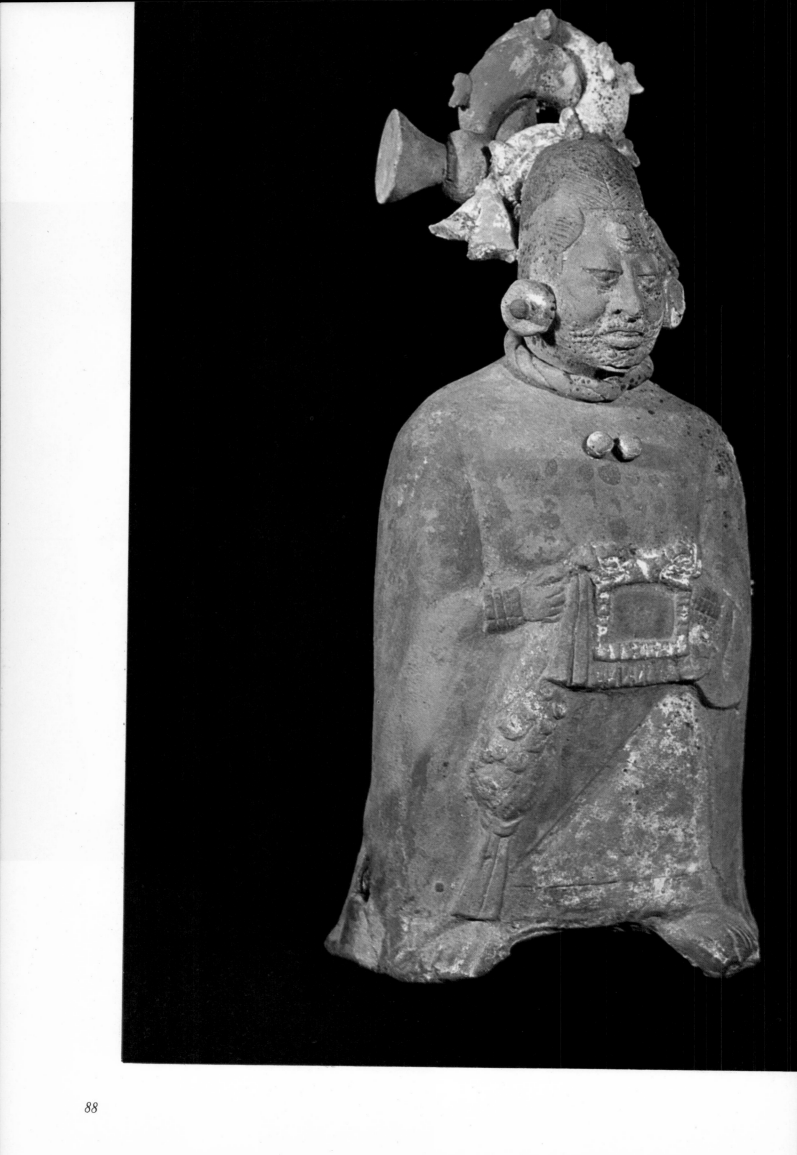

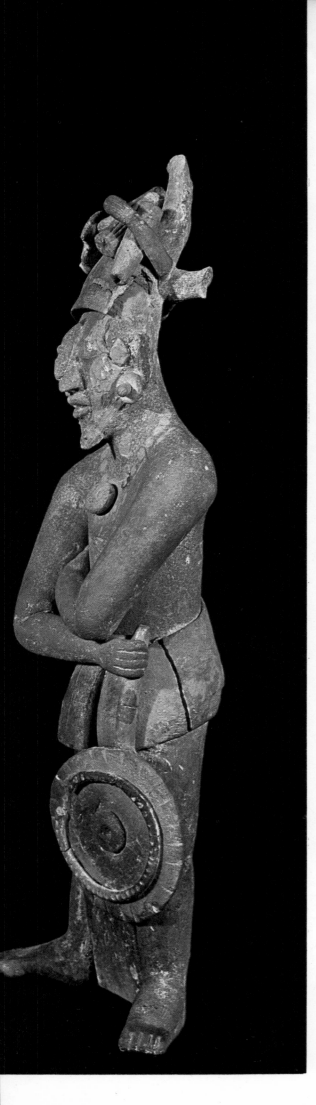

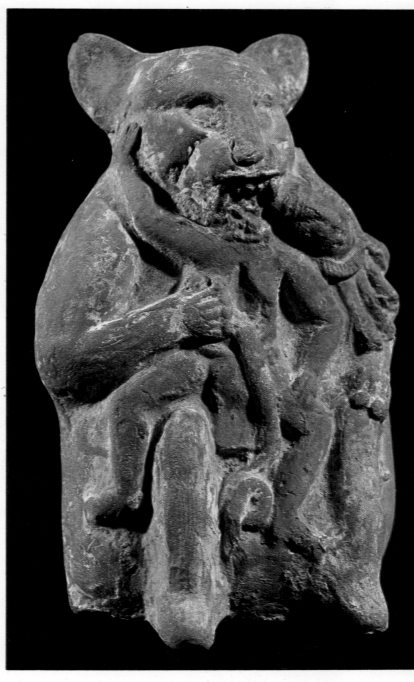

A man, hideously decapitated and disemboweled, is devoured by a huge jaguar that has opened his back with its claws.

The face of the richly garbed figure at left is scarred, either for sacrifice or vanity. The man carries a fan.

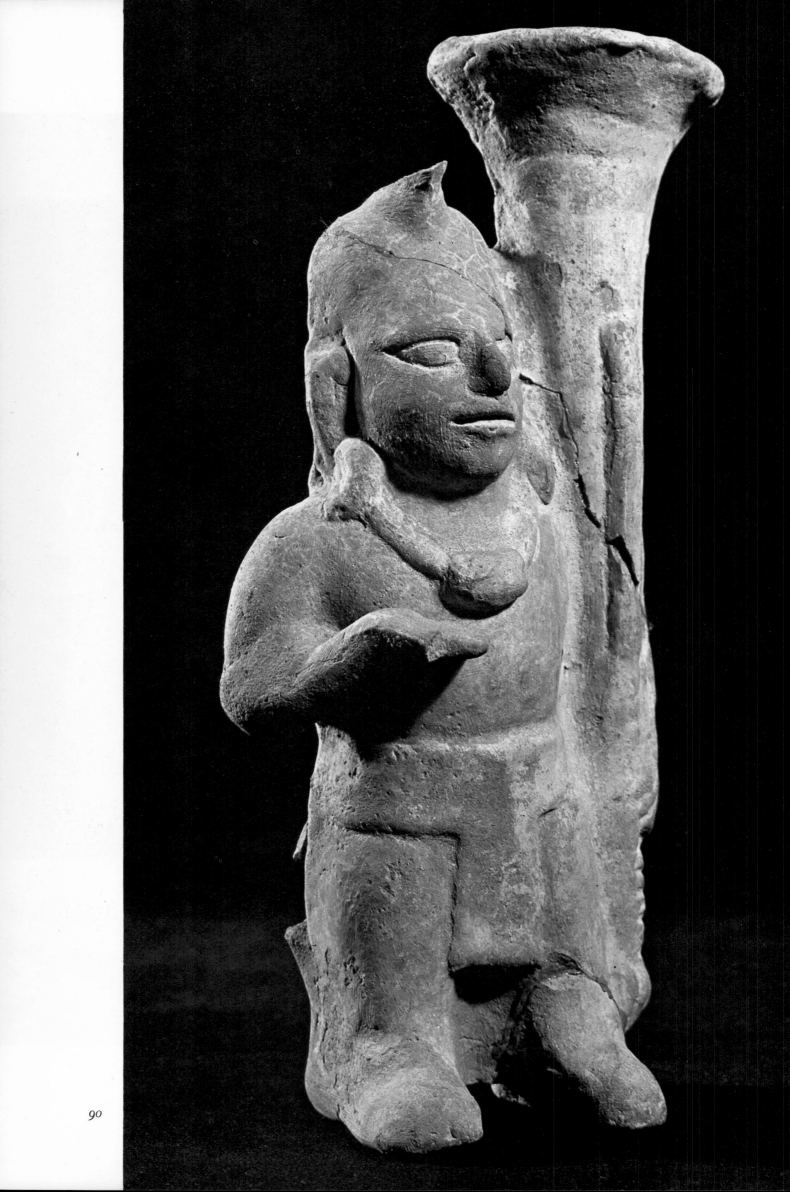

The life cycle of the Maya began with a ceremony when a child was born. The second event in his life was a kind of baptism. It was called a rebirth (*zihil*) and a ritual was performed for groups of children born on the same day. Present were priests, godfathers, and godmothers. Drums were beaten to drive out the evil from the courtyard where the ceremony was held. As each child approached the high priest in the center of the court, he was handed maize and incense to throw into a burning brazier. After all the children had thrown the maize and incense into the fire, it was taken, along with a bowl of wine, away from the ceremony. White cloths were then put upon the children's heads as they approached the priest and confessed their sins. He gave them his blessing and sprinkled them with water. Then nine sharp raps were given on the forehead of each child with a bone object. Perfumed water was spread on their faces and toes. After the ceremony, food was prepared for the children, priests, parents and godparents.

The third celebration was held at the time of marriage. The family of the young man presented gifts to the bride's parents, and his mother made clothing for the bride and groom. When the husband had agreed to live and work for the father-in-law for a specified time, the wife agreed to prepare the food and drink for her husband. If all were satisfied with the arrangements and gifts, the nuptials were held at the home of the bride. The actual wedding consisted of a dinner presided over by the priest, who shared the meal with the parents and the young couple.

The Maya do not seem to have practiced polygamy, but divorce and desertion were frequent. Not only was marriage between first cousins condoned, but at certain times and in some Mayan regions it was obligatory. Punishment for adultery was much harder on the men than the women. For the female, the loss of her lover, disgrace, and ostracism were considered adequate. But the man was bound and turned over to the injured husband, who had a

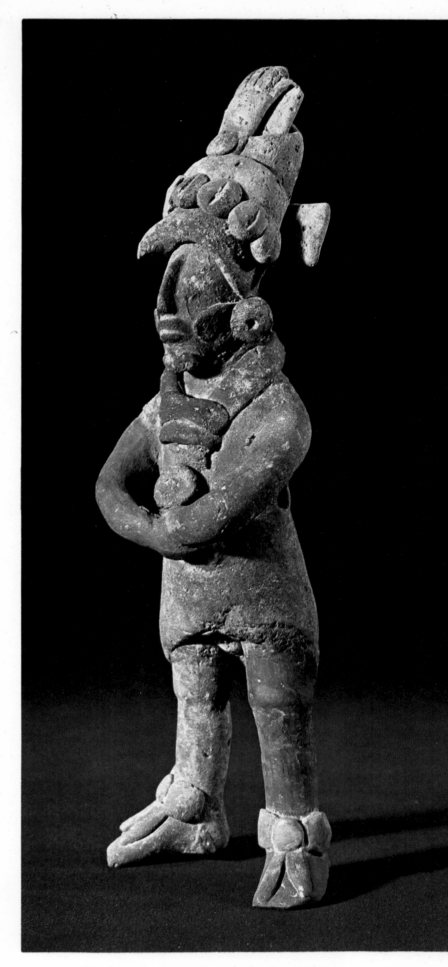

This colorful figure, with its huge trumpet-shaped object and maxlatl, *or hip wrap, may be a court musician.*

Dignity and poise are shown in the elegant figure of a nobleman. His headdress and boots indicate his status.

choice of killing him, usually by dropping a stone on his head from a height above, or forgiving him. Both alternatives were practiced.

The education of the children up to a certain age was entirely in the hands of the women. To assure obedience they pinched the children's ears or arms, rubbed chili peppers on them, and even burned them for serious offenses.

Men and women ate separately even at banquets. Tables were laden with roasted corn, chili peppers, and cocoa; stews made of game, fish, or fowl; squash, corn soup, tortillas toasted on hot stones; and a liquor distilled from honey, water, and the bark of the *balche* tree. Each guest received a gift: a cloak, a cup, a chair, or a piece of jewelry. After the banquet the men drank and told stories until their women came to take them home. There was dancing following these banquets, but it was done entirely by men. Women had dances and drinking parties of their own.

An important element in the social life of the Maya involved reciprocal banquets. It was considered a gross insult to attend a banquet and not give one in return. Even if the guest of a previous banquet should die before returning the obligation, his family was later expected to give the feast on his behalf.

Strict accounting was required of inherited possessions. The oldest son was the heir; if he was a minor, a guardian acted for him until his majority. Such guardians were expected to account for every detail of the inheritance. Middle children seem to have been the most neglected, for the youngest man of the family was greatly respected.

Among common people farming was the primary occupation. Each had a plot assigned, but common land could also be worked. Families helped one another to sow and harvest maize, squash, peppers, and beans. Bees were kept and beekeepers were a respected caste. Turkeys, ducks, and curassows (the oversize turkeylike fowl of Mexico and Central America) were domesticated. Yet it was, at best, a feudal system of plantation life. Every family was forced to share its crop with the nobility and priesthood. Hunters were required to deliver up part of their game. Salt was gathered from great distances away and a portion supplied to the ruling class.

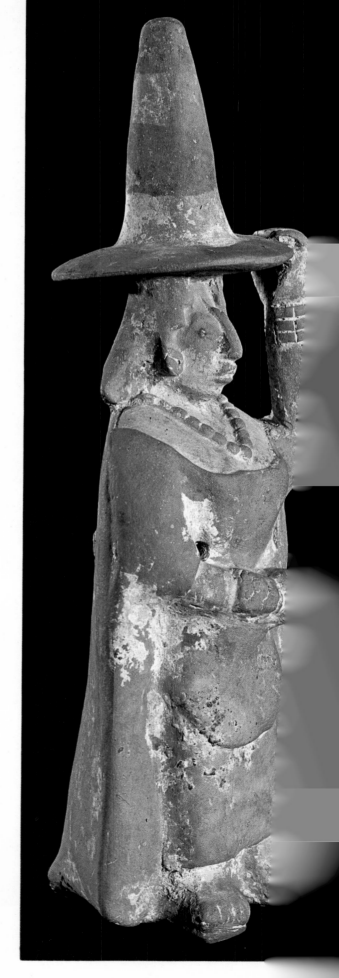

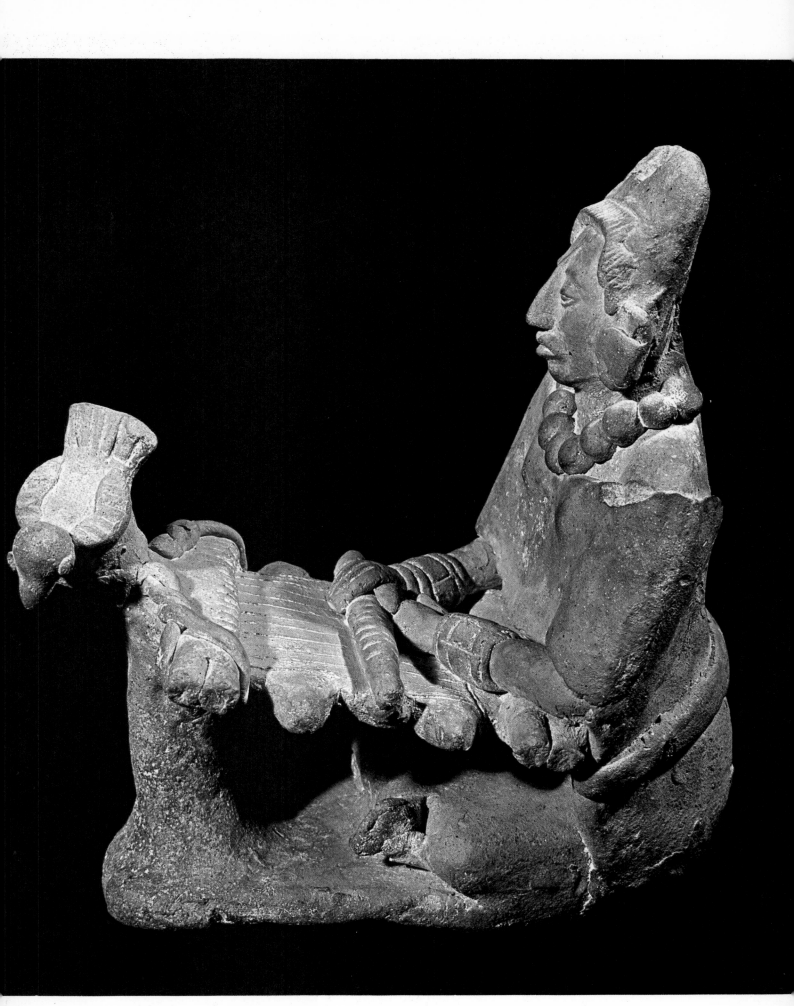

This high-caste Mayan woman of about 1,000 years ago strongly resembles a New England pilgrim father.

One end of the loom is attached to the woman's waist, the other to a tree trunk. Mayan women were skilled weavers.

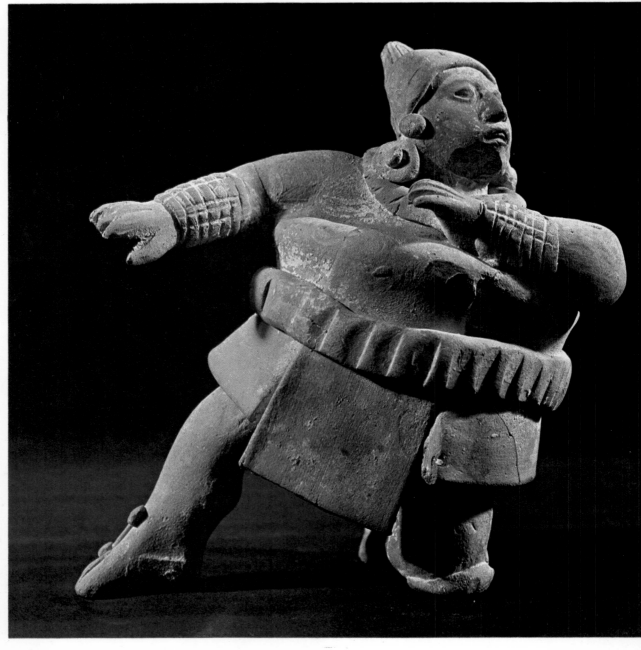

A Mayan ballplayer wears a thick protective belt, gauntlets, and leggings in this superb action sculpture.

Punishment for disobedience or lack of conformity was common; the punishment for theft was slavery. Slaves seem to have been generally well treated. This was not true of distinguished or brave prisoners of war. They were used for ritual sacrifice; the others became slaves.

The intimate details of the life of the Mayan people come from three primary sources. The earliest are their picture-symbol books, called codices. These were produced by Mayan artists and intellectuals before the Spanish Conquest. Pictures and symbols were drawn on both sides of bark paper (or on deer hide) and the pages folded, accordion style, in the shape of modern books. The Dresden Codex

is the most important of these; it is now at the Library of Dresden, Germany. In it Mayan scientists foretold the dates of eclipses far into the future. It also relates myths and identifies Mayan gods and goddesses. Two other codices are known. From the three it has been possible for scholars to comprehend Mayan mathematical genius. The codices reveal that the accuracy of their calendrical charts was phenomenal. Among other movements of the heavenly bodies, they observed and recorded in detail the movement of the planet Venus in its relation to Earth. Their margin of error in its synodical revolution was only one day every 6,000 years. Their ability as forecasters enabled them to create the most accu-

rate calendar of their time, either in the Old or the New World. It had a twenty-day month and an eighteen-month year. Five days were added (which were considered unlucky) to make the 365-day year.

The second important source is *Las Cosas de Yucatán*. This large volume of information about the Maya was compiled after the Spanish Conquest by the Bishop of Yucatán, Diego de Landa. As Fray Bernardino de Sahagún and Fray Diego Durán recorded the legends, history, and daily life of the Aztecs, Landa did for the Maya. He could go further back into history than Sahagún and Durán because of the long Maya history written in hieroglyphics that his native informants could read.

The third important primary source of Maya lore is a book known as the *Popul Vuh,* the sacred book of the Quiche Indians, a Maya-speaking tribe of Guatemala. *Popul Vuh* means simply "written pages" in Maya. It is a history by a native after the Conquest. The beginning of the world is related, including the difficulties the gods encountered when they created man. The work is divided into four volumes. The first two and most of the third deal only with myths and legends of the gods. The book of creation tells how the world began. The end of the third book and the final volume, part fact and part fantasy, tell the history of the Quiche nation. A free translation, first from Maya to Spanish, then from Spanish to English, reads:

"This is the tale of how all was suspended, all was calm, silent, motionless, quiet, and all the heavens were empty . . . there was nothing which made a sound in the sky. There was nothing that stood, there was only the sleeping water, the peaceful sea, alone and tranquil. Nothing was endowed with existence.

" 'Let there be earth,' they cried. 'Let the void be filled. Let the water go away and spill out and the earth arise.' So they spoke. 'Let there be light, let there be morning in the sky and on the earth. There will be no glory or greatness in our creation until human beings exist, until man is formed.' "

To populate the earth they created animals, but were unhappy with them because they could not talk and thank their creators. Their first manlike creatures were made of clay, but because they lacked the ability to think, the gods destroyed them. The next men were made of wood, but the wooden humans were so immoral and irreverent that the gods caused a great flood. Rain poured down incessantly and the waters rose, destroying them. The few who escaped became small monkeys, sent by the later Indians to be the ancestors of those in the forest of Guatemala today.

Only after the third creation did man survive. The

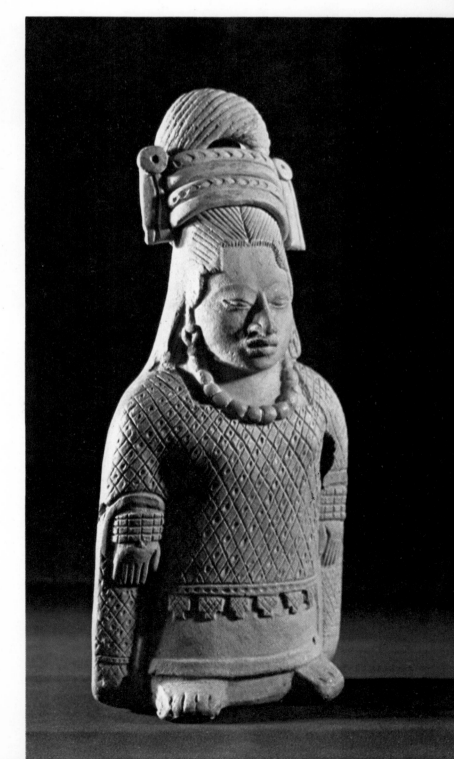

Amazing Mayan hair styling is shown in this figure of a high-caste woman wearing the traditional huipil dress.

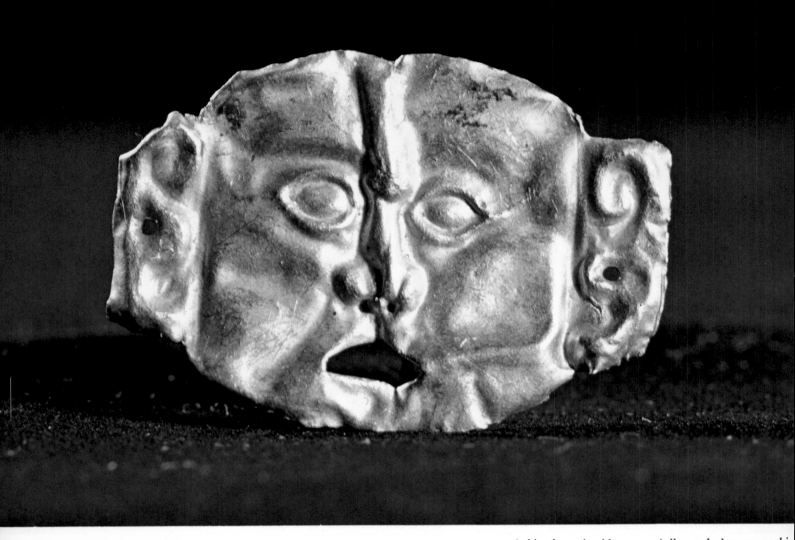

account continues, the gods "went on speaking of the creation and shaping of the first mother and father, of yellow and white maize they then made his flesh. Out of maize do they make the arms and legs of man. Only maize was used for the flesh of our first fathers."

But before man was created, the *Popul Vuh* tells a long and confusing story of divine twins who come down to earth and perform a series of Herculean tasks. They overcome a giant, then kill his two sons, the earthquake gods. The first is overcome by turning him into stone and then placing a mountain on top of him. The other is poisoned. Many of their adventures are reminiscent of those of the twin gods of the Dahomey people of Africa or the twin gods of the American Winnebago Indians, the major difference being that the Winnebago twins were not involved in a morality legend concerned with overcoming evil spirits on the earth but were rather ethereal adventurers in human form, free of the fears that stifle the enterprise of man.

The pantheon of gods of the Maya was large and varied—yet all performed a useful function. Ah-Puch, god of the underworld who controlled the dead, was pictured as a skeleton. Associated with him was a god of sacrifice, who wore a streak of black down each side of his face. The god of the heavens was a wrinkled old man with a sparse beard, a high-bridged nose, and only one tooth. The sun god, Kinich Ahau, who gave light, created warmth, and made the crops grow, can be recognized in sculpture by his large square eyes and jaguarlike features. The most attractive of the gods is the young maize god, who wears a maize plant in his headdress. Without his bounty, famine resulted. He is only found in the early Mayan period. The most important and most numerous of the Mayan gods were the rain gods known as Chacs. These are both one god and many. Four chief Chac gods controlled the rain and were associated with a specific color and a point of the compass: east was red; north, white; west, black; and south, yellow.

There were few goddesses among the Maya, and by far most important was the moon goddess, wife of the sun. Her duties included overlooking and ministering to women in childbirth. She was also the goddess of medicine. According to the ancient legends, it was believed that at one time she and her husband, the sun, lived happily upon the earth and that there she invented the art of weaving.

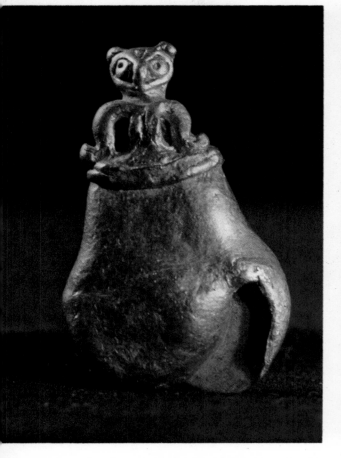

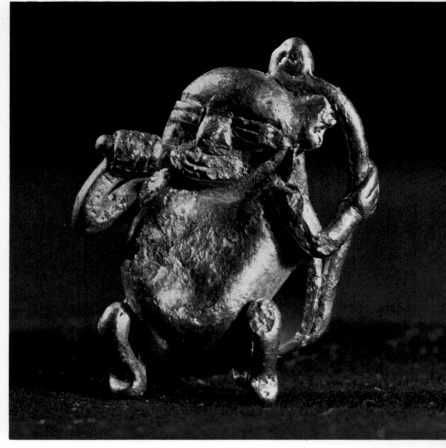

A stylized owl decorates this pear-shaped gold ornament found at Chichén Itzá in the state of Yucatán.

This grotesque gold ornament depicts an apelike creature which holds its tail in one hand while eating with the other.

The old gods remained powerful over the years of the classic period, even though new ones were brought when the Itzá, a Toltec-influenced tribe, moved into the Mayan region that became known as Chichén Itzá, about A.D. 1000. There is a famous legend that tells how the priest-king of the Toltec nation, a man whose name was Quetzalcoatl (named in honor of the feathered serpent god, known throughout central and southern Mexico), soon after abdicating, or being banished, rafted down the rivers into the Gulf to the country of the Maya. There is definite archaeological evidence for such a migration, for the Itzá brought to the region of Chichén many Toltec traits. It is possible in this ancient city to separate a group of buildings constituting Old Chichén from the Toltec-influenced section. The Caracol (snail), a unique structure, shows the earliest Toltec influences. It was constructed as an observatory. The bas-reliefs refer to the Toltec god-king Quetzalcoatl. The building now known as the Castillo (castle) has ramps that are completely covered with relief sculpture of serpents' heads. Columns with snakes writhing upward line both sides of the entrance.

But the best-known and most sensational aspect of Chichén Itzá is its sacred well. Not a true well, it is a *cenote,* a place where the surface of the earth has collapsed exposing an extensive underground water hole. Here the most important sacrifices of objects, of animals, and of humans were made. A long series of scientific expeditions have brought up from the well many of the most important finds in Mexican archaeology. Gold pieces from Central America, jade ornaments, belts encrusted with gems, and hundreds of skeletons have been dredged up.

For two hundred years the Itzá ruled; then toward the end of the twelfth century a major war broke out between Chichén Itzá and the nation of Mayapan. It is written in the Maya chronicles that the war was precipitated when the ruler of Chichén Itzá abducted the bride-to-be of the ruler of Itzamal, a neighboring state. The ruler of Mayapan, Hunac Ceel, a resourceful warrior who had survived the sacrifice of the sacred well, led his army against the nation that had tried to drown him. The Itzá were badly defeated and dispersed to the south into Guatemala. But Chichén Itzá remained a sacred city, and devout Mayan men and women made pilgrimages to the famous well even after the Spanish Conquest.

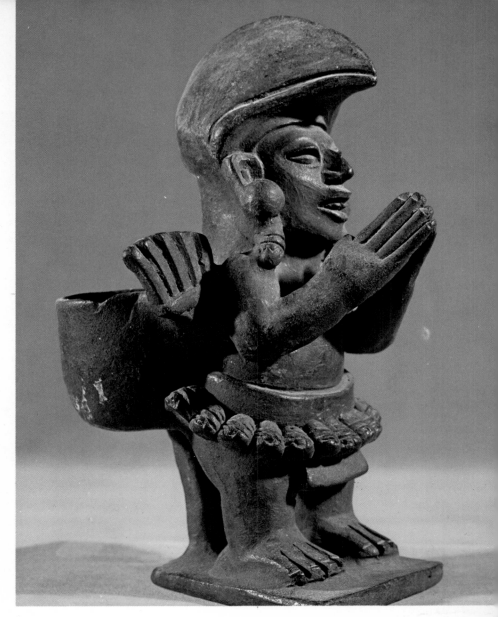

With its birdlike costume of beak headpiece and wings, this figure from Oaxaca looks as if it is ready to fly

Between Earth and Sky— the Valley of Oaxaca

The culture of Mexico in its classic period was confined neither to the Maya in the south nor to the urban city-state of Teotihuacán in mid-Mexico. A high civilization arose, which seems to have received its impetus from early Olmec culture, in the region now known as Oaxaca. On the west it borders the state of Guerrero, on the east the state of Veracruz, on the north the state of Pueblo, and to the south the state of Chiapas. It is a mountainous region with small valleys among the jagged peaks. Three of the

largest valleys join in the center of the state; they are known as the Valley of Oaxaca. It has been an area of continually evolving Mexican cultures for more than 3,000 years.

Because of the fertility of the soil and a mild climate with adequate rainfall, it is probable that the domestication of edible plants began in Oaxaca at a very early date, possibly earlier than in any other part of Mexico. Indications are that maize was cultivated over 6,000 years ago. But for some 3,000 of these years the development of community life was very slow. The most important evidence that we have is the sacred urban center known as Monte Albán, located on a peak 1,181 feet above the present city of Oaxaca. Here a culture destined to be one of the most important in Mexico began its rise about

The jaguar may have been domesticated. This almost life-size sculpture shows the great cat with a bow around neck.

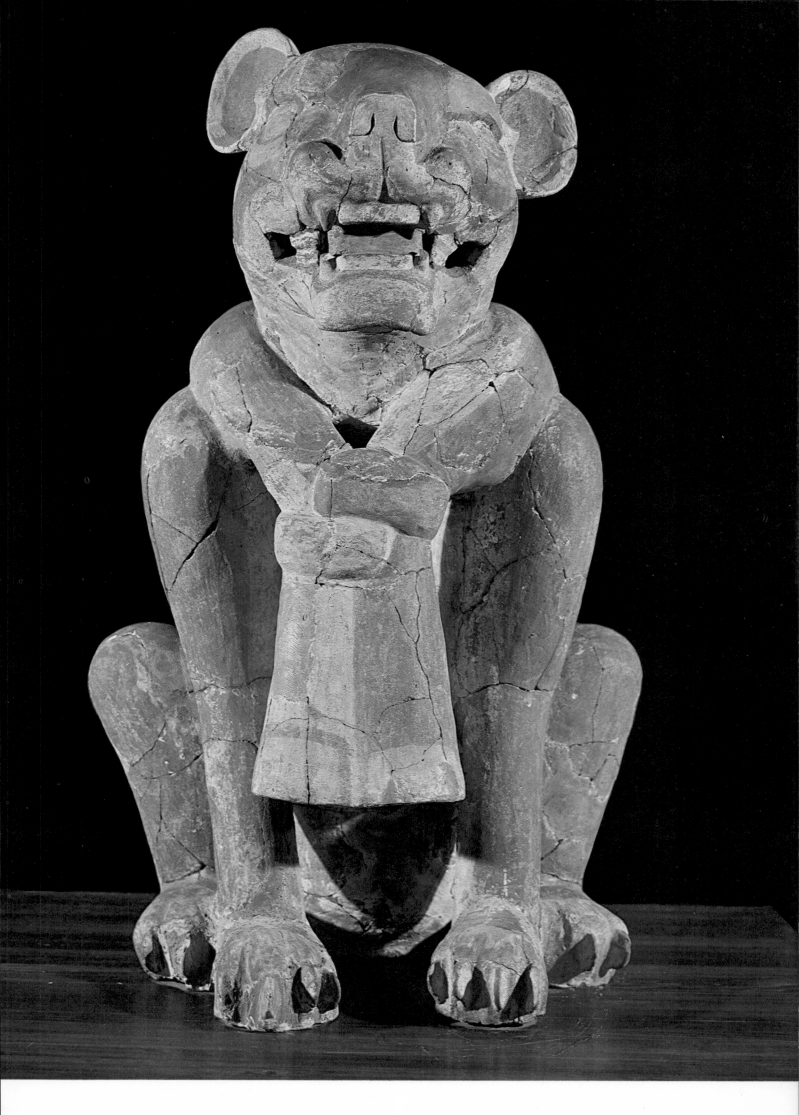

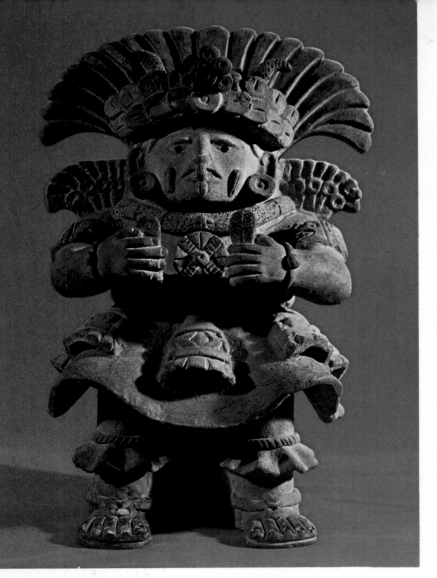

Captives were sometimes skinned or flayed. The priest of Xipe-Totec, the flaying god, wore the victim's skin.

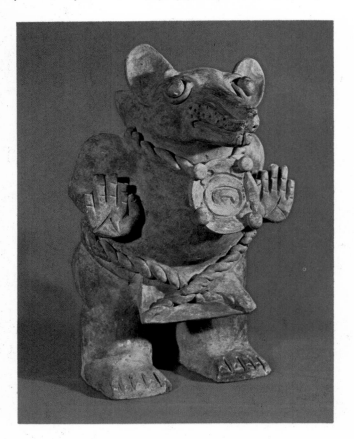

Part weasel, part man, this ceramic comes from Monte Albán, one of the most impressive ruins in Mexico today.

800 years before Christ. It was contemporaneous with the Olmec culture on the east coast, but so far it has been impossible to tell whether the Olmec culture began in the Oaxaca Valley and radiated outward or whether Olmec influences from the north, east, or west found their way to Monte Albán.

The "dancers" of Monte Albán discussed in the first chapter are part of its Olmec heritage. But Monte Albán development continued along distinctive and original lines until it reached its classic stage under the Zapotecs, beginning about A.D. 200 and lasting some 800 years. In the early years of the classic period, Teotihuacán influence is strong in ceramics, art, and temples, showing that there must have been considerable intercourse between the two urban centers, or that they had a common heritage.

But any similarity between the two ancient urban centers of Monte Albán and Teotihuacán is in details of decoration and in ceramic art. For Monte Albán was a city dedicated entirely to the glory of the gods. Unlike Teotihuacán, there were few, if any, dwelling places for a large urban population. As befits a formal religious center, all of the edifices take the form of pyramids, monuments, and temples. All of the main structures are on the top of the mountain, as though the designers, artisans, and even the laborers were intent upon being in close communion with their gods. There is a severity in the over-all design of Monte Albán, a sense of spaciousness that gives it an ethereal quality. The structures seem to float as if they were as much a part of the sky as of the earth.

Later structures were put on the foundations of earlier ones, but this rebuilding is unnoticeable in the over-all effect achieved by the Zapotec architects. At no time were temporary or makeshift structures built to interfere with the grand design.

Temples and pyramids were covered over with stucco and brilliantly painted. It became a city of light, with the dark majesty of the high mountain ranges acting as a backdrop for its magnificence. The Zapotec architects planned so well that, even though it takes in an area of some fifteen square miles, there is a feeling of intimacy and warmth about the ruins even today.

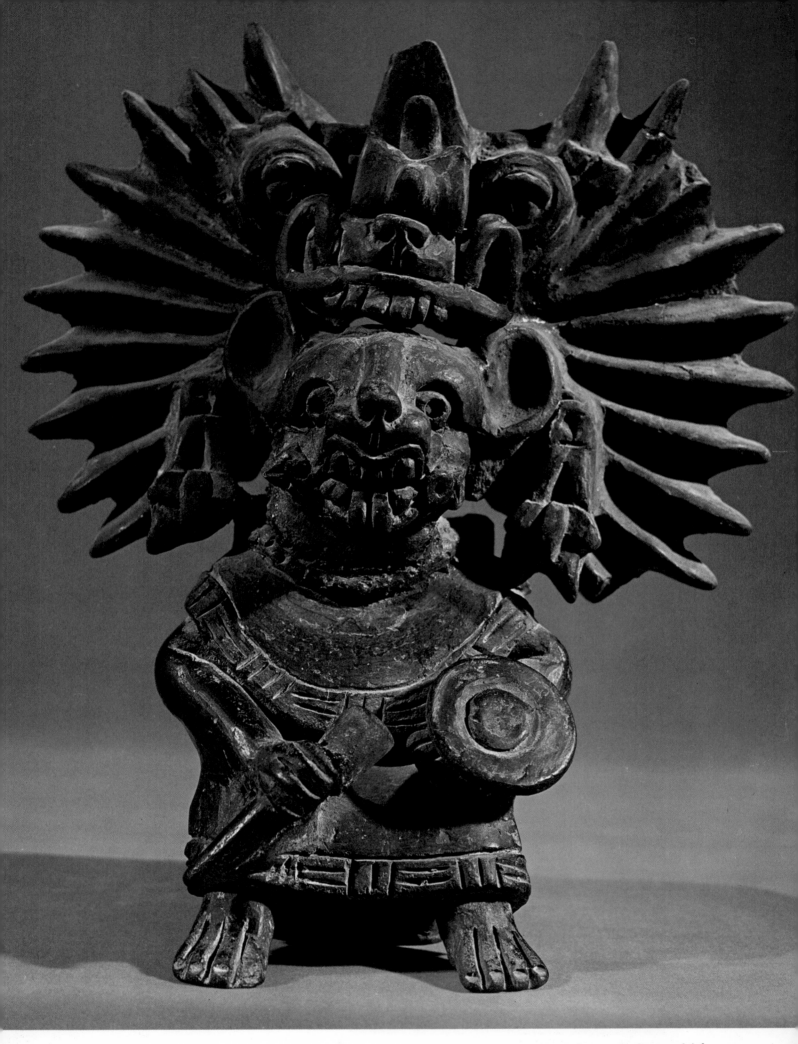

The bloodsucking teeth of the vampire bat are plainly
visible in this sculpture of an elaborately masked goddess.

Dr. John Paddock has pointed out in the recent work *Ancient Oaxaca* that the physical labor involved in constructing this urban center was staggering. There was no water on the mountaintop and no way to get it there for drinking purposes or for building construction except to carry it up 1,200 feet in jars. In addition, the building and maintenance of such an extensive religious capital required the services of thousands of priests, artists, architects, and their apprentices, thousands of laborers and servants —and all of them would have needed adequate food and water.

It seems a miracle that the pyramids, temples, observatories of Monte Albán could have been built at all. There were no draft animals, no wheels, no metals. There was an extraordinary organization of human resources. Because there are no signs of revolt at Monte Albán and few signs of punishment or sacrifice, there must have been great willingness on the part of the people to follow the leaders who inspired and directed them.

Monte Albán was more than a center for religious assembly and pilgrimages. It was also the first true necropolis in North America. The sides of the mountain were honeycombed with caves, said by the Zapotecs to have been the original homes of their ancestors. Into these caves, over many hundreds of years, the dead were interred. In addition to these, long rows of tombs were arranged in parallel lines flanking the spacious ceremonial plaza. Over 200 such tombs have been excavated. Many archaeological finds of the highest order have been found in these ornate crypts and have revealed much of what we now know about the Zapotecs. The most famous is known as La Tumba Siete (Tomb Number Seven), discovered by the father of Mexican archaeology, Alfonso Caso. Among the treasures that he found hidden for over 1,000 years were carved objects of jade and turquoise and exquisitely worked gold and silver.

The Zapotecs either used a preliminary burial place and waited until the body had decomposed or else disinterred it after a specific number of years, for many of the skeletons have been found to be painted

The skin of a victim covers the face of the flaying god Xipe-Totec in this gold pendant made by the Mixtecs.

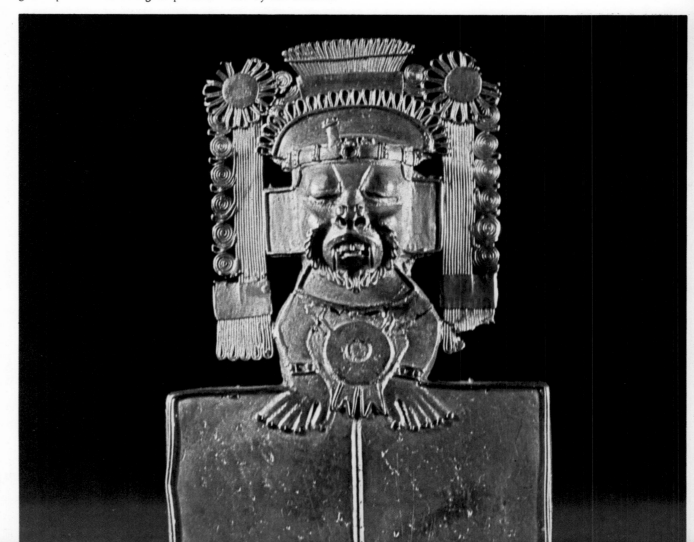

with cinnabar. This practice of painting the skeleton is also known in China and in ancient Scythia.

The artists among the Zapotecs used their time and energy in creating urns picturing the gods to be placed within the burials. Indeed, there have been so many funerary art objects unearthed that it was obviously a primary concern of the art community to supply them. The urns took the form of the nature gods revered by the Zapotecs. The chief deity, Cocijo, the god of rain, was usually shown with a circle of snakes near his mouth or around his neck. His tongue was forked, the sign of the lightning. In some statues his forked tongue extends all the way from his mouth to his lower chest. He seems related in certain details of his appearance to Tlaloc, the rain god of Teotihuacán. The youthful god of the maize crop, Piato Cozobi, can be identified by the corn plant either carried on his back or shown in his headdress.

Almost every major tomb had within it an urn representing the bat god, a squat figure with legs crossed and hands resting on the knees, much like the lotus-seat position shown in statuary of the Buddha. There the resemblance stops, for the motif of the bat god's headdress and shoulder ornaments is the spread wings of the bat. He is sometimes shown with two teeth protruding vampire-like from a thick-lipped mouth.

The god of spring appeared in many forms, but always as being flayed or skinned. He was called Xipe-Totec and, although he was later known to the Aztecs and other clans, it is probable that he originated with the Zapotecs. Some urns show him wearing a mask of human skin with two long black stripes running down either side of his nose, yet he was not a god of terror, but rather of rebirth. That the god of springtime should be represented as wearing a new skin seems entirely reasonable. Spring is the time when snakes come out of the earth and shed their old skin, when there is a renewal on all the earth. When the priest who represented Xipe-Totec wore the skin of a sacrificial victim, it was not a ritual of horror but a symbol that the person had been reborn.

Expert craftsmanship is revealed in this gold pendant of a solar disk circling a god whose lower body is a bell.

(Overleaf) Beating on a hollow turtle shell, this prehistoric musician is singing to his own accompaniment.

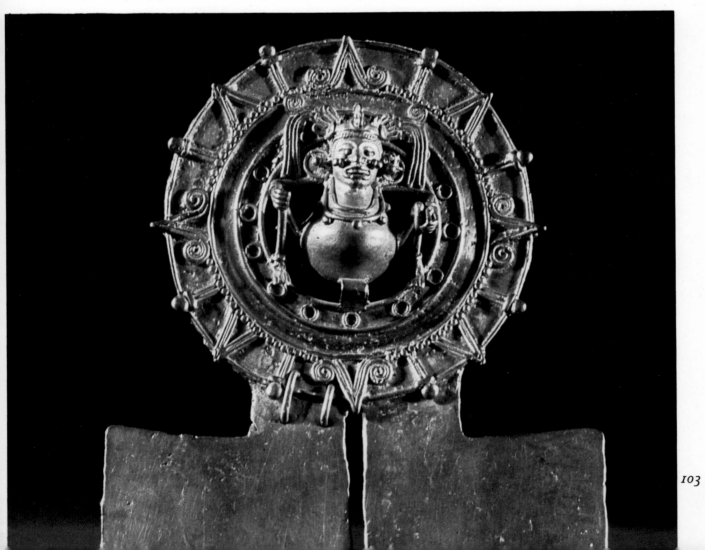

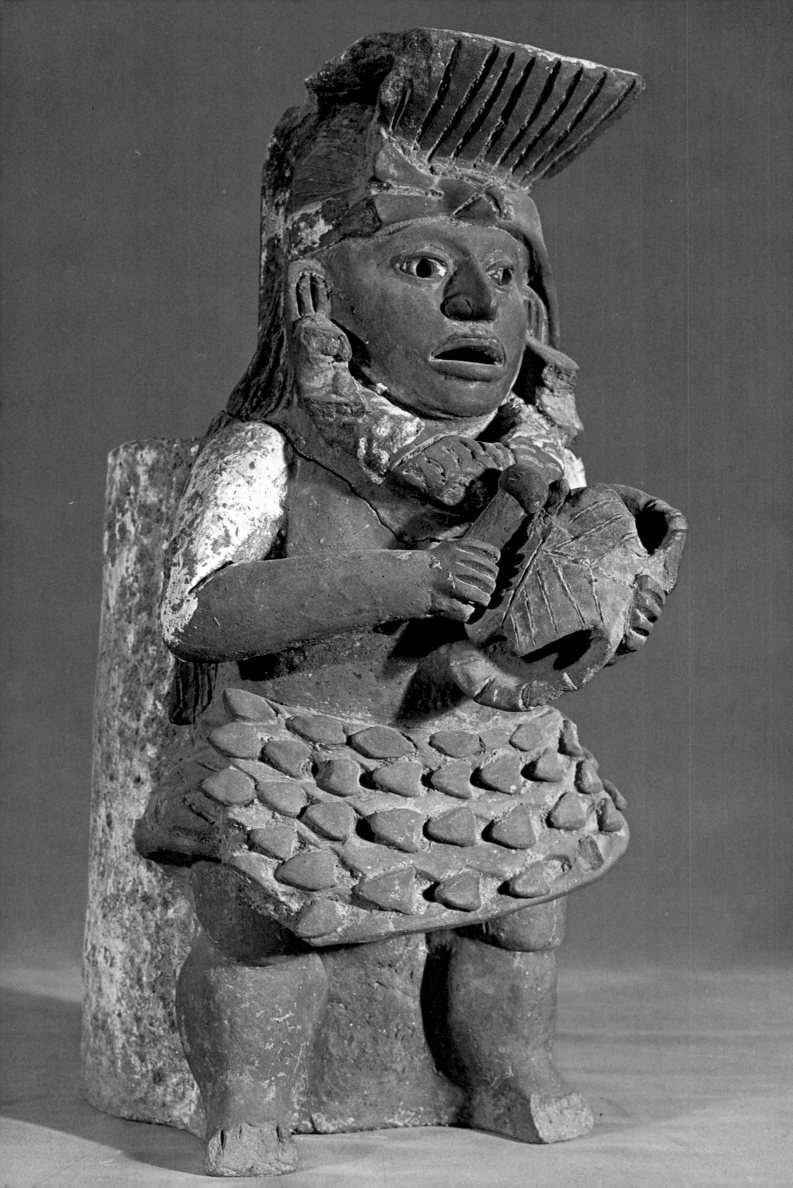

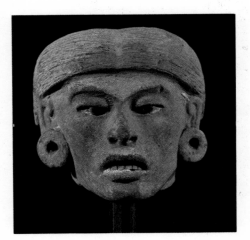

900-1300
THE NEW CIVILIZATIONS

Semibarbaric nomads from the north found new civilizations on the ruins of older ones. Quetzalcoatl, priest-king of the Toltecs, brings peace and encourages the arts in his capital at Tula. Mixtecs fuse their culture with that of Monte Albán.

HISTORICAL CHRONOLOGY	ART CHRONOLOGY
CENTRAL HIGHLANDS	*CENTRAL HIGHLANDS*
900 *Toltecs led by Mixcoatl overrun centers of Teotihuacán civilization.*	900–1000 *Toltec style initiated. Effigy of Quetzalcoatl dated 980 carved on rock near Tula, Mazapan, and Coyotlatelco ceramics at Tula.*
947 *Birth of Ce Acatl Topiltzin, better known as Quetzalcoatl.*	1034 *Temple of the "Lord of Venus," with basalt caryatids and snake columns. Bas-reliefs of jaguars, coyotes.*
980 *Quetzalcoatl establishes Toltec capital at Tula and constructs ceremonial center.*	1049 *Ball court with stone rings.*
999 *Internal crisis forces flight of Quetzalcoatl to Gulf Coast. Matlacxochitl takes throne and establishes lineage of Warrior Kings.*	1077 *Painted murals of serpents. Carved walls of priests in procession. Plumbate pottery, plaques of jadeite, clay effigy vessels. Basalt giant monoliths.*
1034 *Nauhyotzin reigns as emperor of vast Toltec domain.*	
1049 *Tula governed by Matlacoatzin.*	*GULF COAST*
1077 *Rule of Tlicohuatzin.*	900–1200 *Tajín style. Elaborate "paddle stones" at Jalapa. Toltec and Mixtec styles contribute to Totonac culture.*
1098 *Huemac heads empire.*	
1168 *Tula overrun by nomadic Chichimecs.*	*OAXACA*
1200 (ca.) *Xólotl, chief of Chichimecs founds Tenayuca.*	900–1200 *Mixtec style. Stone tile mosaic on buildings. Low relief carving in wood and stone. Mixtec gorgets of cast gold. Alabaster bowls, rock-crystal skull, semiprecious stones. Painted tripod bowls. Large standing clay sculptures.*
1232 *Chichimecs establish city of Texcoco.*	
1247 *Aztecs enter Valley of Mexico and settle in Chapultepec woods.*	
GULF COAST	*MAYAN REGION*
900–1200 *Toltecs invade coastal area.*	900–1200 *Maya-Toltec style. Toltec motifs predominate at Chichén Itzá and Uxmal. Caryatids support altars. "El Castillo" pyramid. Red Jaguar throne of limestone. Frescoes in Temple of Warriors.*
OAXACA	
900–1200 *Mixtecs from the Oaxaca mountains move south to Monte Albán and northward to Cholula. Metallurgy advanced.*	
MAYAN REGION	
900–1200 *Toltecs conquer Mayan city of Chichén, renaming it Chichén Itzá. Build new religious and cultural center.*	

Classic Veracruz

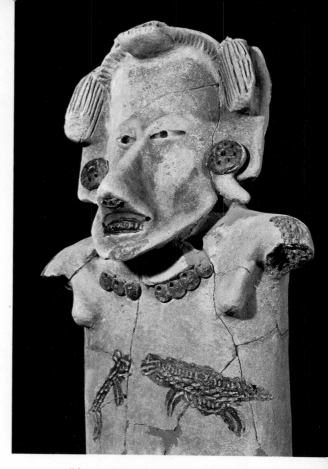

Bizarre figure has two small animals painted on the chest. The style is typical of the Totonacs of Veracruz.

The arts blossomed in the late classical period in the central Gulf Coast region that is now covered by the state of Veracruz. Near the town of Remojadas, artifacts have been found which indicate that two art forms were developed, each reflecting different aspects of the people who created them. Both are dramatic, but in one the people are serious, while in the other they are gay. In the solemn ceramics the men and women pose like orators with legs spread and arms gesticulating and demanding attention. Some are sculptured standing on a platform. Others hold onto a rail or ride in a cart as though they were meant to be miniature re-enactments of ceremonial processions. A high percentage of these figurines is of women and the most noticeable characteristic is a black patch covering the entire mouth and spreading to the cheeks and chin. They wear the *quexquemitl* (a short rounded cape), covering the shoulders and hanging to the waist, and with it a brief skirt. Around their heads they wear a wide band sometimes decorated with a bird on the front, feathers rising from it. These figurines are small, generally under eighteen inches high; but the people of this region also created huge, hollow figures which, like the smaller ones, stand in majestic poses and wear elaborate clothing and ornaments.

In contrast to these dramatic effigies are thousands of others with smiling, laughing, grinning faces. The earliest seem to have a somewhat fixed smile, but between A.D. 300 and 600 the hesitant smiles became broader and the figures began to grin and laugh. In no other civilization and in no other country has there ever been such artistic exuberance. Happiness is expressed in every face. With arms extended, they look as if they are about to embrace each other. Joy is shown in their cheerful eyes and on their smiling lips. Men and women, boys and girls, are shown in various everyday attitudes. Dancers hold rattles to accompany themselves. Most men wear the simple loincloth with a small embroidered square apron. They are shown as though stopped in the middle of a gesture, laughing uproariously with elbows bent, hands up, palms forward, and bodies inclined slightly backward. They are also shown seated in a way that indicates they were on miniature swings.

These figurines must have been representative of the people of that time. From the flattened triangular shape of the heads, it appears that the tribal group who made the figurines bound the heads of their infants, but in a different shape than that of the Maya. Instead of the head growing upward into the Maya sugar-loaf shape, the Remojadas heads are flattened front and back. The result is a perfect triangle, a very wide forehead with the face tapering to a point at the chin.

For a long time, only heads of these smiling figurines were found. Then, as excavations were made near the town of Tierra Blanca, thousands were discovered, some with bodies intact. But for every one found whole, there were hundreds, perhaps even thousands, of heads with the bodies fragmented. So many were broken that it is evident they were ritually destroyed when used as burial offerings. This shattering of the vessel that accompanied the dead is a very ancient custom known in both China and India. It is possible that in Mexico the being, or soul, of the individual was thought to have been lodged in the head, for, in the case of the smiling figurines, the heads are rarely broken.

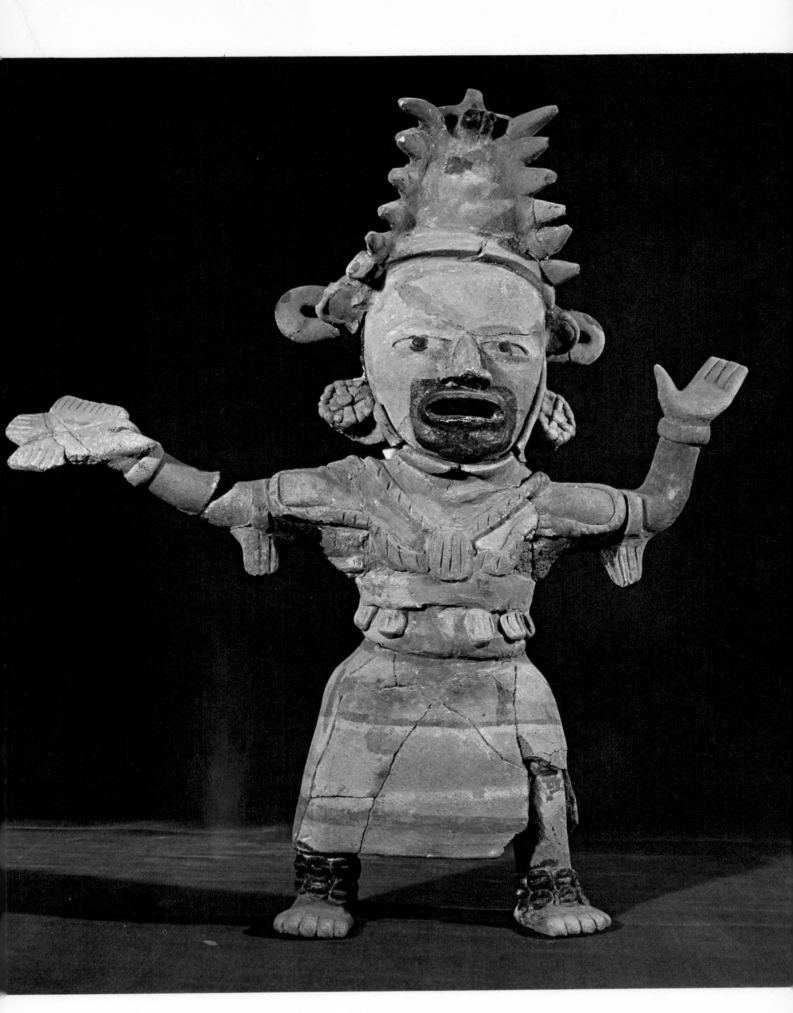

Posing like an orator addressing an audience, this
lychrome statue represents the Totonac goddess Cihuateteo.

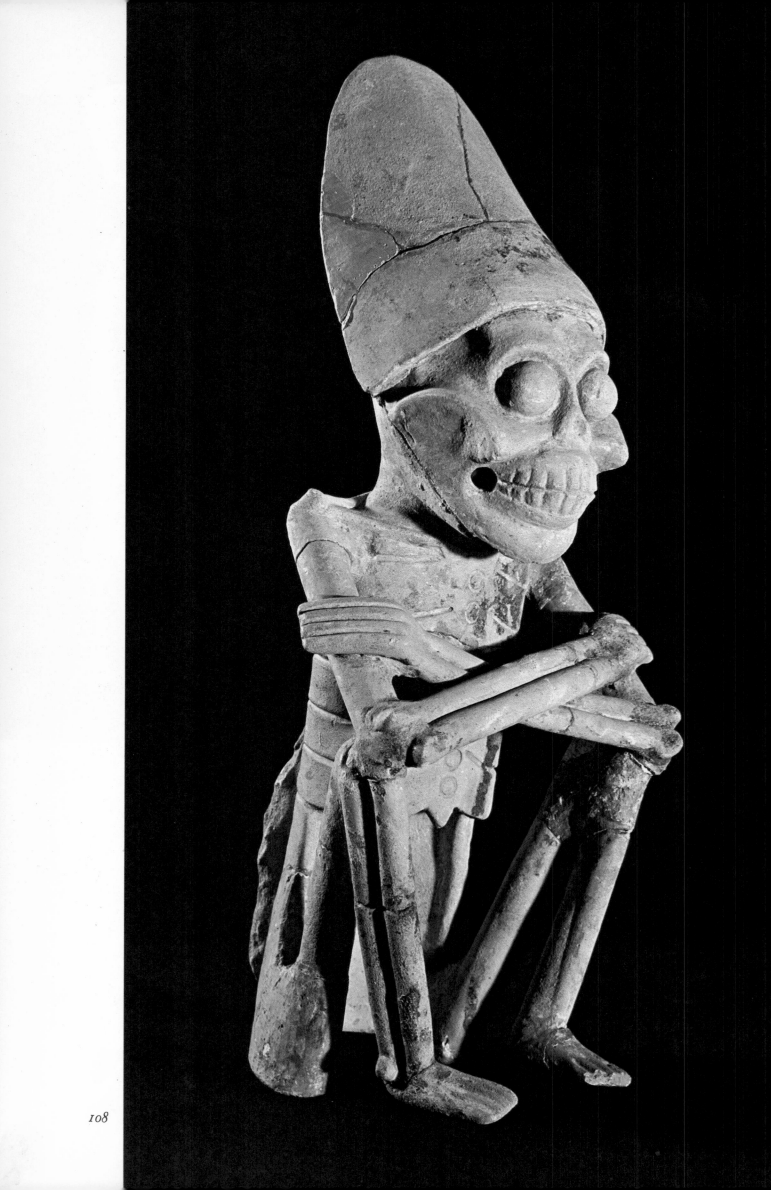

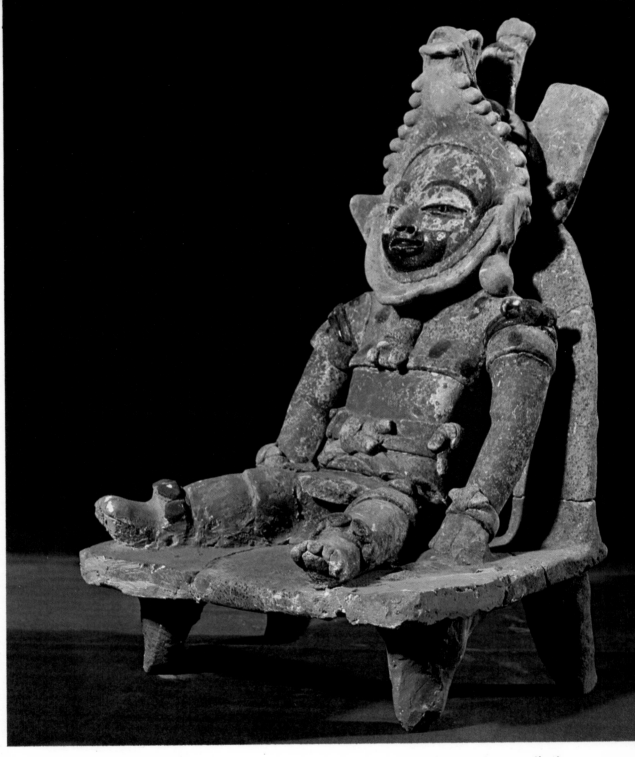

Mictantecuhtli, the lord of the dead, was also the custodian of the bones of all past human generations.

A Totonac warrior has mouth and eyebrows outlined with tar, and reclines on a four-legged chair or throne.

Many of the smaller laughing figurines were designed to be used as whistles. They give off a high, flutelike sound, perhaps meant to represent speech or singing. Great makers of toys, rattles, and whistles, Remojadas artists also made animal toys with wheels that could be pulled about. Yet the wheel as a means of transport was unknown throughout Mexico. It may be that, after creating it for their toys, they could see no other use for it. Mexico had no draft animals to pull vehicles, and log rollers placed under stones too heavy to be dragged by teams of men would have been more useful than wheeled carts.

The Veracruz people of this time built important religious centers in the jungle, the most significant of which is El Tajín in northern Veracruz, five miles southwest of Papantla. It was laid out as an enormous complex of buildings covering a total of more than 1,000 acres, although most of the buildings are located within a 146-acre area. It reached its peak toward the end of the classic period, between A.D. 700 and 1000.

There they built pyramids and temples upon which they carved men with eagle heads and dancers in motion, and indicated their advanced culture by using engraved bar-and-dot numerals.

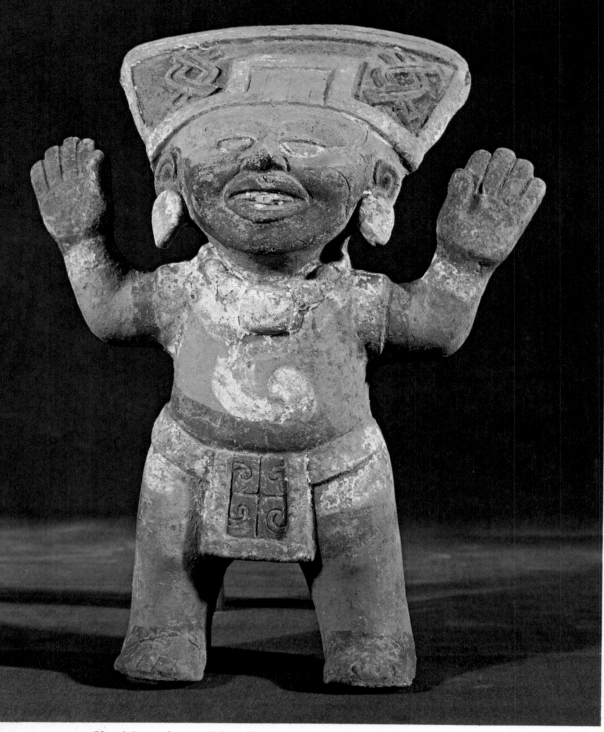

Cheerful man has symbols of life and movement on his head-piece. Hundreds of such laughing figures have been found.

The most impressive building at El Tajín is known as the Pyramid of the Niches. From a symmetrical square base it rises sixty feet into the air, narrowing at the top where the ruins of a temple still stand. It is built in six tiers like a wedding cake, and a single broad stairway leads to the temple. Decorated with square niches cut into the sides, it has a checker-board appearance when the sun slants across it. There are said to be 365 niches, perhaps one for each day of the year, though some archaeologists have counted more, others less.

Like the Mayan cities of the south, it was deserted at the end of the late classic period and became lost as the fast-growing jungle flora enveloped it. It was not until the year 1785 that it was rediscovered.

This fecund region was the source of the rubber which found its way to all parts of Mexico. The Nahuatl word for rubber is *olli,* a name that was given to the ancient Olmecs, who also knew rubber and, in earlier days, lived in the adjacent area. The Olmecs probably made the first rubber balls that were used in the ritual ball game throughout Mexico. The game was highly developed at El Tajín and became an obsession with the people of the classic Veracruz culture.

An elderly woman sat for this realistic portrait in clay. Her headdress is almost Arabic and she wears a lip plug.

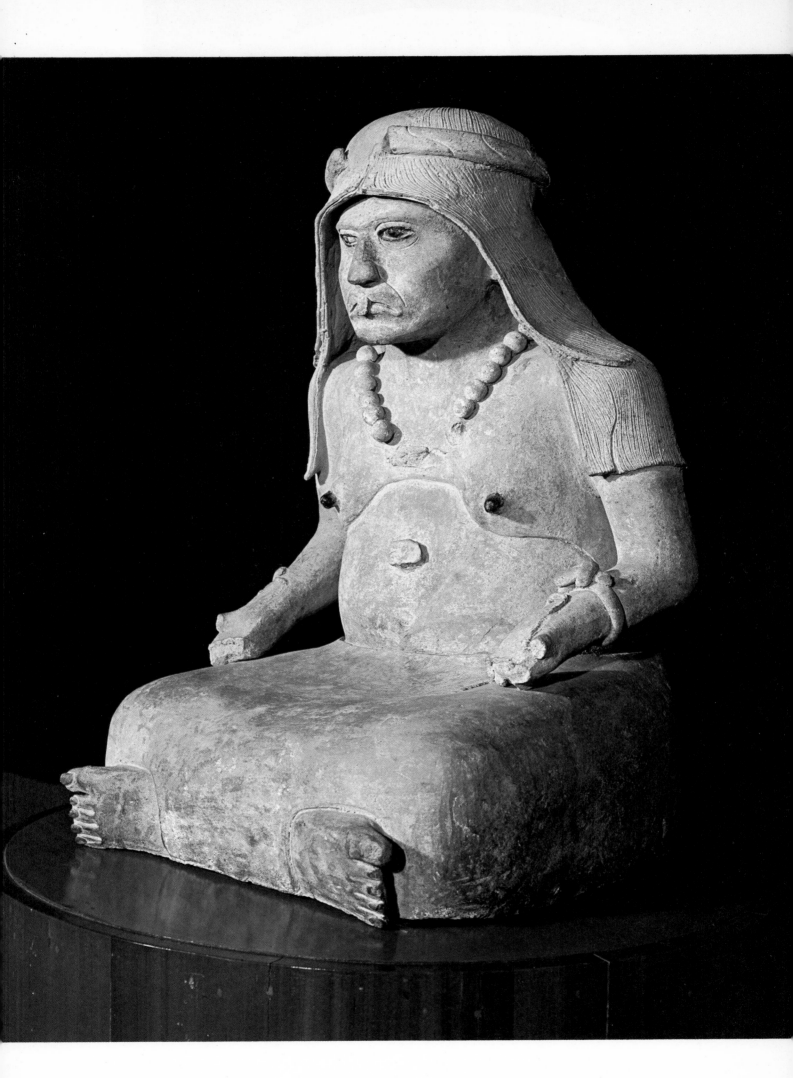

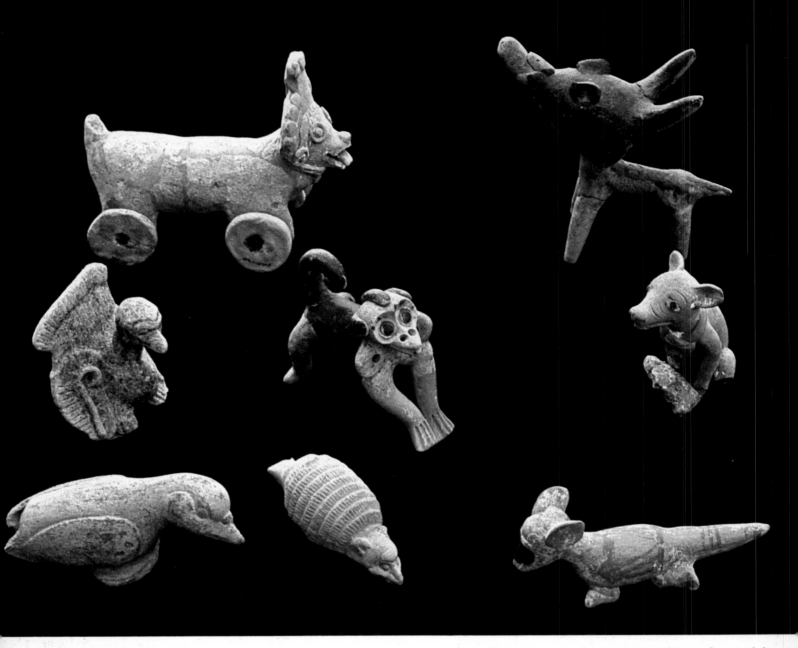

Monkeys, doves, dogs, armadillos, turkeys, and deer are among the many animal figures the ancient artists created

The sacred center of El Tajín had no less than seven ball courts, one of them 197 feet long—two-thirds as long as the modern soccer field. In most regions, if not all, the rules did not allow the player to touch the ball with his hands. It had to be propelled by elbows, hips, knees, and possibly the feet. A glove is shown on the hands of players in some relief engravings. It was either worn to protect the player's hand from the stone playing ground or used in certain regions to propel the ball.

Bernardino de Sahagún, in his description of an Aztec ball game (called *tlachtli* in the Nahuatl language), relates that players were sometimes so badly bruised and swollen, either from falls on the ground or from the impact of the hard rubber ball, that blood had to be let to reduce the swelling.

A most revealing drawing of Aztec ball players was made in the year 1529 by Christopher Weidtz, a German artist who visited the court of Charles I of Spain. There he sketched Indians who had been brought from Mexico by Cortés a year earlier. The ball players wore belts, padded trunks, a strap holding a kneeguard, and hand gauntlets. In this drawing, one player has hit the ball with his hip; the other is about to strike it with his head.

The size of the court, number of players, and the rules varied from region to region. In the southern regions the court was bounded by two walls with a stone hoop in the center of either side through which the ball was moved.

To understand the ancient ball game, one must first forget modern baseball. It had little resemblance to any modern ball game except for some elements of soccer and basketball. It is probable that it was not at its inception a sport at all, but rather a sacred rite based upon the movement of the ball or the sun crossing the sky. The object of the game was to propel a solid rubber ball from one end of the rectangular court to the other. A game could be won

by putting the ball through the hoop or driving it into the opponent's territory.

A complete set of stone objects, their use unknown (until the distinguished anthropologist Gordon F. Ekholm identified them), grew up in classic Vera-cruz as a result of the cult of the sacred game. Hundreds of horseshoe-shaped objects, usually referred to by anthropologists as "yokes," were found to be stone replicas of the heavy belts worn by ball players to keep the midriff from injury. Odd-shaped stone objects with a paddlelike depression (some of them shaped like the basket used by jai-alai players to catch a ball) are shown in pictures of ball players as a kind of protruding belt buckle. These may have been lightweight wooden accessories worn in the belt and used to strike or deflect the ball. A third object, called an *hacha* (ax) is believed to have been used to mark scores. These could also have been rewards to winning players.

That the game was a matter of life or death is made clear by a number of stone engravings at El Tajín. Three ball players and a judge are shown. One player, who is wearing knee pads, wristlet, heavy belt (*yuga*), belt ornament (*palma*), necklace, helmet, and breast protector, is holding back the arms of a player who is seated. He, too, wears protective helmet, belt, *palma,* and knee pads. A third player, similarly attired, holds a stone knife to the throat of the seated player. Behind the knife wielder sits a judge with the symbol of authority, a scepter or club, in his hand. From this picture it has been suggested that the losing captain may have been sacrificed at the end of the game.

In the ball court of the Maya city of Chichén Itzá, some 800 miles from El Tajín, a bas-relief shows two ball players opposite one another, between them a round disk decorated with a skull. The figure on the left holds a knife in one hand and the decapitated head of the player in the other. The headless player is shown with seven snakes sprouting from his severed neck. The scene is repeated in part at El Tajín, where a seated player, his head severed, is shown with the motif of the seven snakes rising from his neck and shoulders.

The meaning of the seven serpents protruding from the beheaded body is far from clear. The answer may lie in ancient India, where, in a fourth-century sculpture, the god Vishnu sits upon the body of a serpent while seven serpents rise behind his head forming a halo. In twelfth-century India, the serpent mother wears seven serpents as a headdress.

But why should ball players be killed? Was it a method of obtaining men of proven bravery for the ritual human sacrifice? Or was the sacred game a way of making important decisions affecting the entire nation? One chronicle explains that players sometimes bet all their possessions and even their lives on the outcome. This may be the most reasonable explanation. For we know from the large amounts of gold, silver, jade, cacao beans, and other precious possessions that changed hands (one king bet and lost a large part of his kingdom) that it was the most popular ceremony and sporting event in ancient Mexico.

The early civilizations of Mexico used the wheel for toys. But strangely, it was never used for transport.

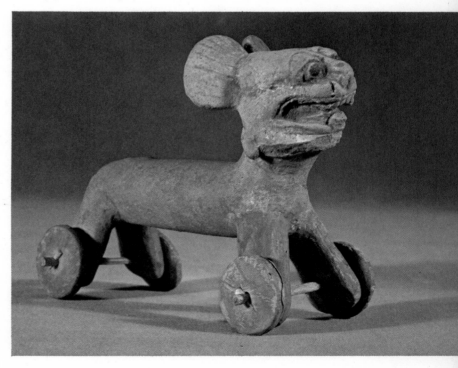

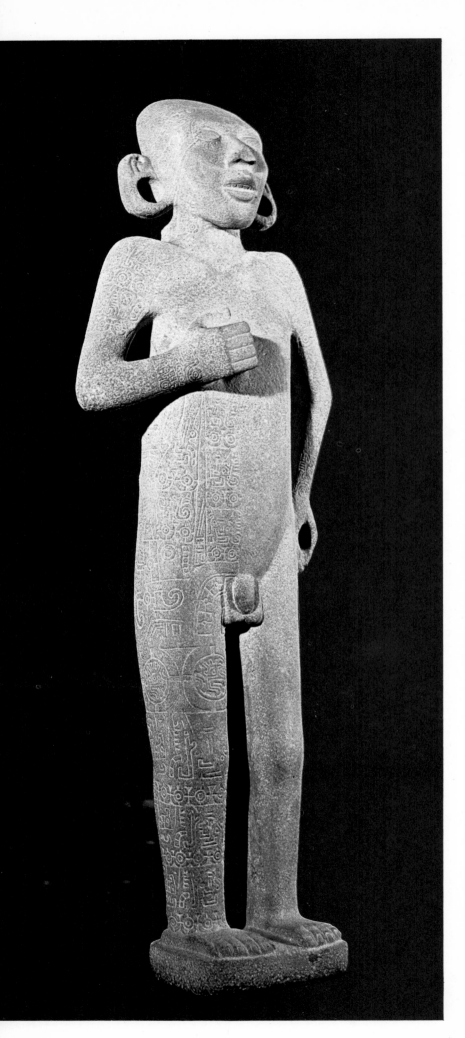

The Huaxtecs

Near the modern city of Tampico along the muddy Pánuco River that flows into the Gulf of Mexico, live the Huaxtec Indians, who today carry on a tradition of pottery that dates back over two thousand years. Descendants of the Maya, they broke away from the main body in prehistoric times. Originally the Mayan-speaking people occupied the coastal regions of the Gulf of Mexico from Guatemala in the south to the Pánuco River region in the north, a distance of more than seven hundred miles. When Olmec and related cultures moved into the coastal regions, they drove a wedge separating the northern group, who became the Huaxtecs, or northern Maya peoples. The Maya of the middle coastal regions were driven out by more belligerent cultures, but the Huaxtecs, who have a legendary reputation for being a war-loving nation, were unconquerable. As a result, they became isolated in northern Veracruz, but retained many of the ancient Maya customs. The heads of their infants were bound; they lived on a similar staple diet of maize, squash, and chili; and their language is in the Mayan linguistic family.

But in time the difference between the Huaxtec and the Maya became greater than their similarities. Wearing apparel tended to be simple rather than ornate. Both men and women often appeared naked. To their basic diet they added fruits, chocolate, vanilla, and a great variety of seafood. Cotton became

An almost life-size statue of a youth carved from sand stone shows that skulls were flattened and teeth sharpened

a most important crop. Liquor was made from the maguey plant as well as from honey.

Chroniclers among the Aztecs presented the Huaxtecs as immoral, obscene, and often drunk, but the Aztecs were their enemies. Actually, their religion is one of the earliest known in all Mexico. A goddess of sex and fertility, Tlazolteotl, was their most worshiped deity. The maize god Cinteotl was another basic god. It has been conjectured, based upon archaeological findings, that the wind-sky-earth god, Quetzalcoatl, may have originated with the Huaxtecs.

While the earlier preclassical cultures were disappearing around them, the Huaxtecs made a surprisingly effective transition to the classical horizon. Within the time frame of A.D. 600 to 900, they reached considerable heights in the construction of dams and reservoirs. A well-defined type of Huaxtec architecture was marked by round temples which they elevated on mounds or platforms as protection from frequent floods. The artists of the Huaxtecs had a considerable range, both in the type of materials they used and the size in which they worked. Small pieces of turquoise were effectively used to create exquisite mosaics. Miniature animals, turtles, monkeys, and dogs were carved from bone, alabaster, or obsidian. Shells of every size were used to make individual pieces and as parts of intricate mosaic murals. One of these shows a priest of the god Quetzalcoatl, clothed in elaborate ceremonial costume, in the act of piercing his tongue with thorns, a common act of worship (penance) among both priests and laity. But their greatest contribution to the culture of Mexico was their large, almost life-

On his back he carried an image of the wind god, which may indicate that he is a young priest of Quetzalcoatl.

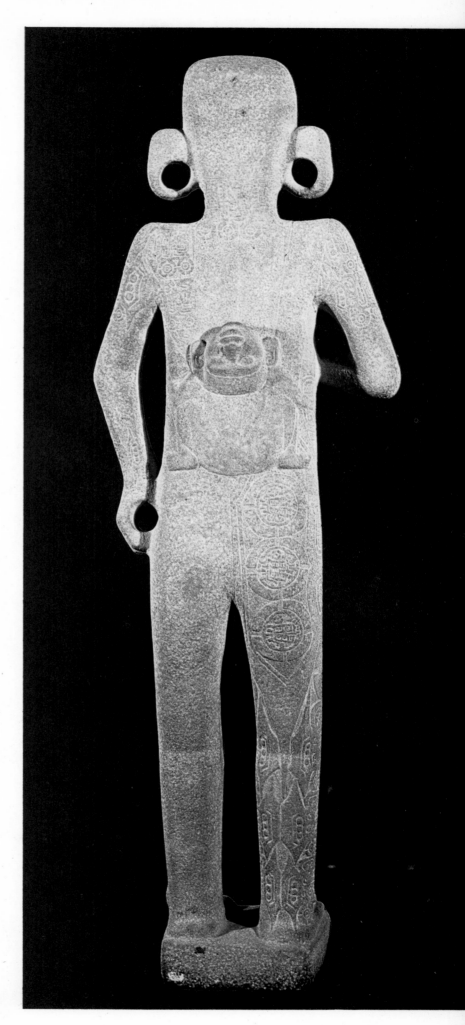

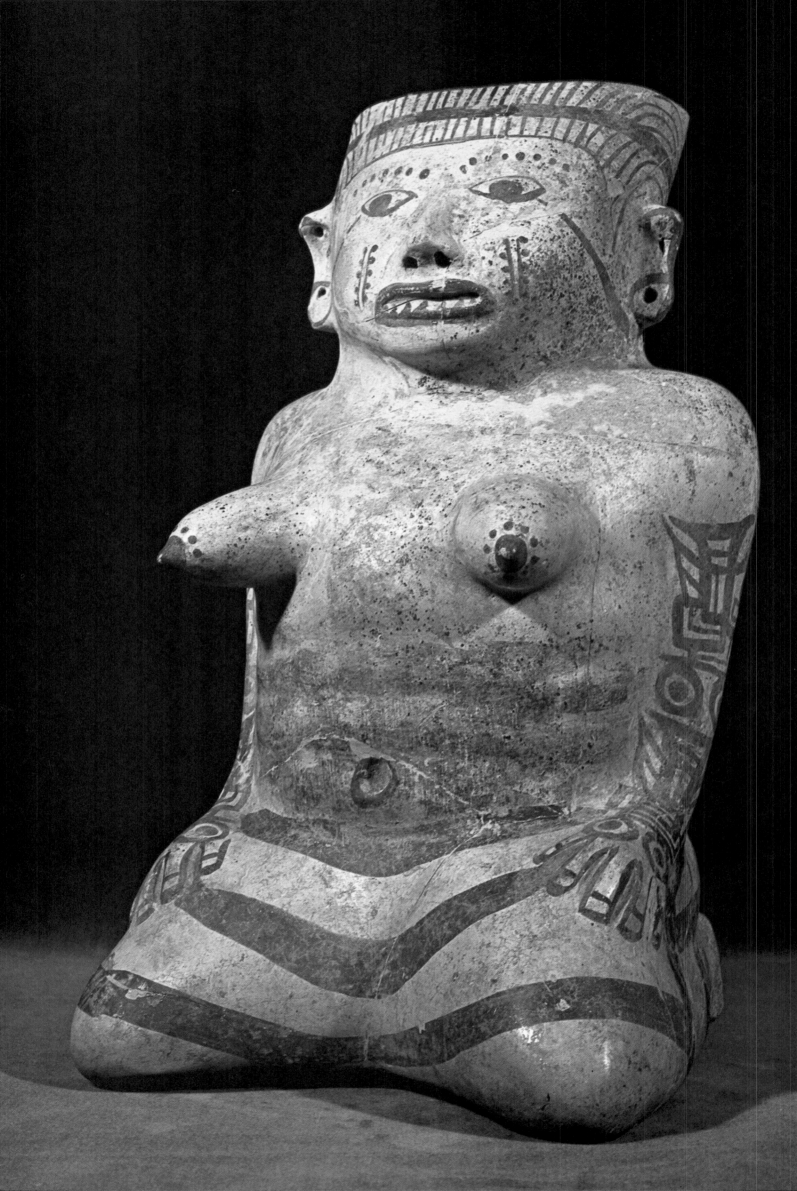

size, cream-colored sculpture which took the form of men, women, and anthropomorphic gods.

Generally realistic and classic in concept, the Huaxtec statues have an aesthetic quality completely different yet on the same artistic level as their cousins, the Maya, of the south. One such internationally famous statue, "The Adolescent," is as much a model of the classical style in ancient Mexican art, as the figure "Standing Youth" in the New York Metropolitan Museum of Art is of seventh-century Greek art.

The reputation for militarism among the Huaxtecs is well documented. From childhood, boys were trained like the Spartans. Fasting and sleeping on the ground, they also hardened their bodies by carrying packs over rugged terrain on forced marches. The rigors of the weather were faced in the nude. Regular war games played an important part in their lives. Youths, adults, and even very young children played at taking captives. When going into battle, the wooden rattles on their helmets and large metal rattles on their backs made a great clamor and terrified their enemies. Above the uproar made by their rattles, horrible threats were screamed at the enemy to frighten them. The Huaxtec warriors, with their teeth filed and painted black, their bodies tattooed and stained in different colors, were so awe-inspiring that most of their enemies fled on sight. One group of warriors carried shields and short flint-

A Huaxtecan woman of 500 years ago is portrayed in a ceramic sculpture that even shows the abdominal muscles.

This abstract female figure portrays Tlazolteotl, the Huaxtecan goddess of the moon, love, and childbirth.

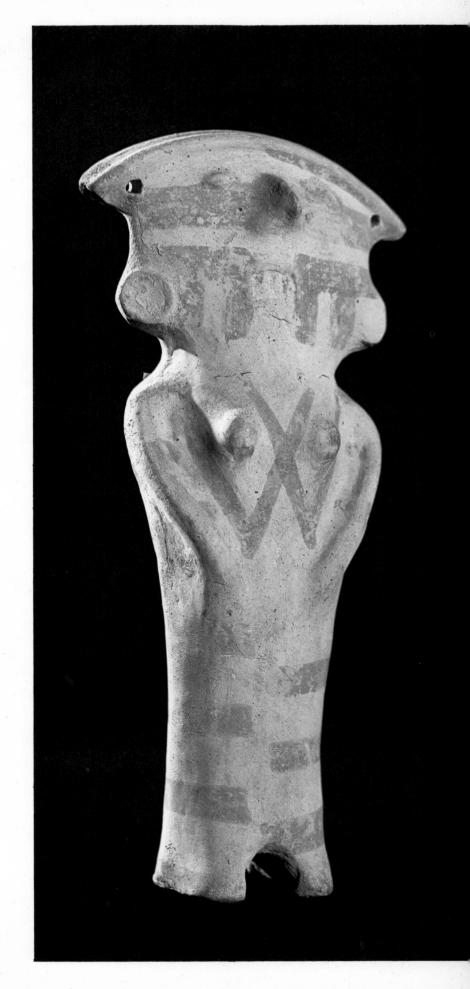

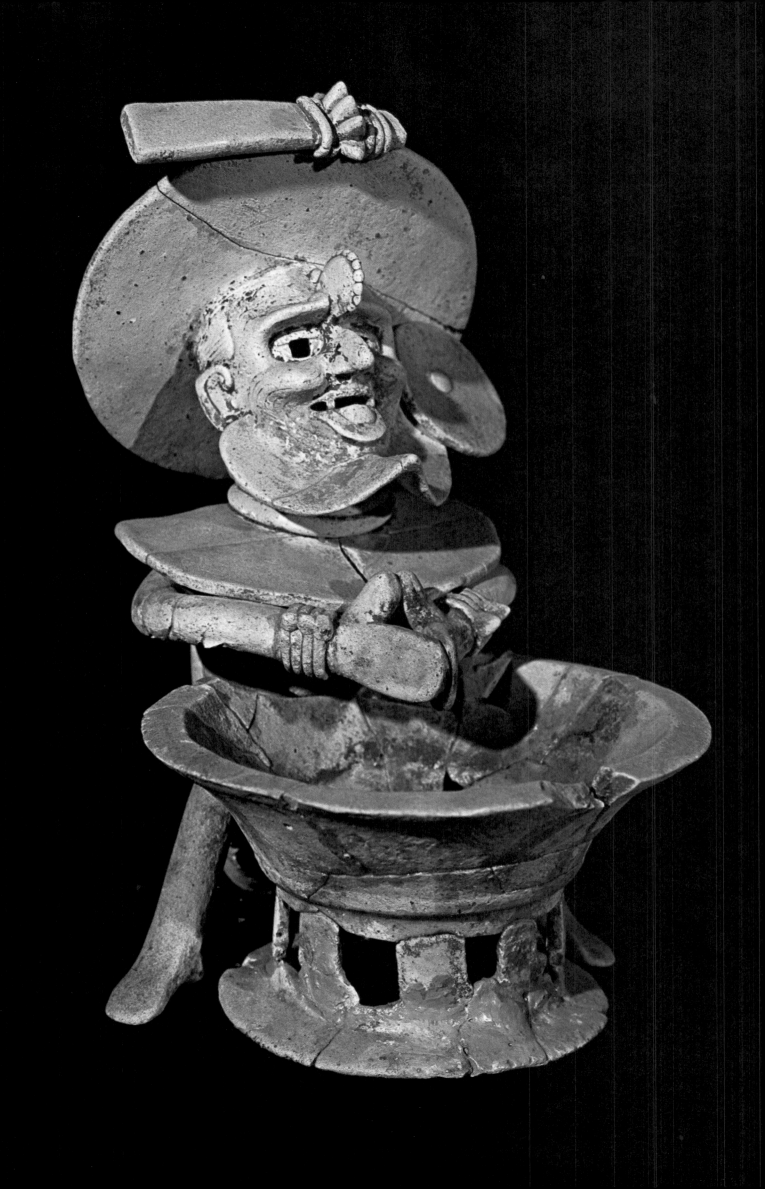

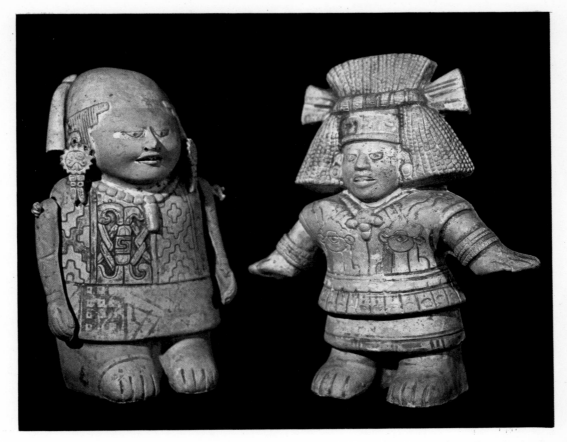

The fire god, Huehueteotl, made of clay, looks like a Spanish don as he warms his hands over a large brazier.

These rattles may have been used by priests in rituals. The one at left shows symbols of the sun and rain gods.

tipped spears, which were hurled with deadly accuracy by an *atlatl,* their spear-throwing device. Another used bows and arrows, the arrows tipped with a poisonous herb.

In the year 1451, according to Aztec historians, the Huaxtecs instigated a war by killing a large number of Aztec traders. When this news reached Moctezuma I, he gathered together his warriors and those of his allies. Then began a long march from Tenochtitlán to the Pánuco River, a distance of some two hundred miles. It was the Aztecs' first campaign against any except adjoining nations, and the king planned it carefully. Each of his warriors was sworn not to retreat or to take a step backward even if faced by twenty enemies. Upon sighting the foe, the most experienced fighters were directed to lie down in a semicircle in the high grass that covered the field. The remaining soldiers were formed into groups and each seasoned warrior was in charge of a youth who would fight next to him. When the Huaxtecs charged, yelling and making a great din with their rattles, Moctezuma's advance guard slowly gave way, drawing the enemy within the circle of the men hidden in the tall weeds. Once

inside this ambush, there was no escape. The chroniclers relate that all were killed or taken prisoner. Even the inexperienced youths returned with Huaxtec captives.

After the battle, the victors advanced on the capital of the Huaxtecs, burned the temples, and killed many men, women, and children. According to Fray Diego Durán, the Spanish chronicler, all of this was done because the Aztecs were determined to remove the Huaxtec people from the earth. Yet, like earlier invaders, they failed. The Huaxtec rulers, priests, and nobles offered tribute, including many valuable commodities hitherto rare among the Aztecs, such as fruits, cacao, cotton cloth, and smoked fish. The Durán account then tells how hundreds of brave captives were sacrificed at the Aztec capital, Tenochtitlán.

A few years later, in 1486, the Huaxtecs rebelled. The Aztecs again gathered their allies and reconquered the country, now led by King Ahuizotl. The Aztecs adopted some of the Huaxtec gods, sacrificed thousands of their warriors, and exacted heavy tributes over the years. But the Huaxtecs were never a completely conquered people.

Tula and the Toltecs

In the mountain and desert lands north of the Valley of Mexico, in a vast region that reached to the present borders of the United States, there lived hundreds of tribes of seminomadic Indians. Among them were a great number of clans called the Chichimecs (People of the Dog), so called because they used the dog as their identifying symbol.

A splinter group, the Toltec Chichimecs, more warlike, energetic, and ambitious than the others, pushed their way out of the rocks and sand of their homeland to become the most important unifying force, both in politics and the arts, of the postclassic period in ancient Mexican history. Led by Mixcoatl (Cloud Serpent), a brilliant tactician with incredible colonizing ability, they conquered most of the people living in the area immediately north and west of the present Mexico City. Much of the story of the rise and fall of the Toltec Empire is reflected in the real and legendary history of the son of Mixcoatl, Topiltzin Ce Acatl Quetzalcoatl (Our Prince One Reed Bird Serpent).

Mixcoatl consolidated his gains and built a capital at Culhuacán. His wife, Chimalma, who gave birth to a son, came from an important family of the Tepotzotlán region. Neither she nor the king lived to see the child. She died in giving birth and Mixcoatl

was assassinated before his heir was born. The year was A.D. 947, and since the boy was born on the day of Ce Acatl, which means One Reed in the Nahuatl language, he was given this name, as was the custom. Mark it well, for this day and year is related to the fall of Mexico to the Spaniards more than 500 years later.

Little is known of the actual childhood of Ce Acatl except that he grew up with his aristocratic grandparents in Tepotzotlán. The god Quetzalcoatl was worshiped and the young prince adopted the belief of his mother's people. While still a young man, he became a priest of the god Quetzalcoatl and added this name to his others. Either before or after his elevation to the priesthood, he was recalled by his people, the Toltecs, to occupy his father's throne. He accepted, but first found the place where his father's remains had been buried, moved them to a place known as the Hill of the Star, and erected a temple to Mixcoatl's memory.

Accepting the throne of the Toltecs turned out to be easier than occupying it. The reigning king, who had been the assassin of Quetzalcoatl's father, did not give up without a struggle. In a personal battle between the two, the young priest killed the king, thereby avenging his father's death. He then became the ruler and high priest of the Toltecs. His first major act seems to have been the founding of a new capital, which we know as Tula. There, about fifty air miles north of Mexico City, he built a capital dedicated to the peaceful pursuit of the arts.

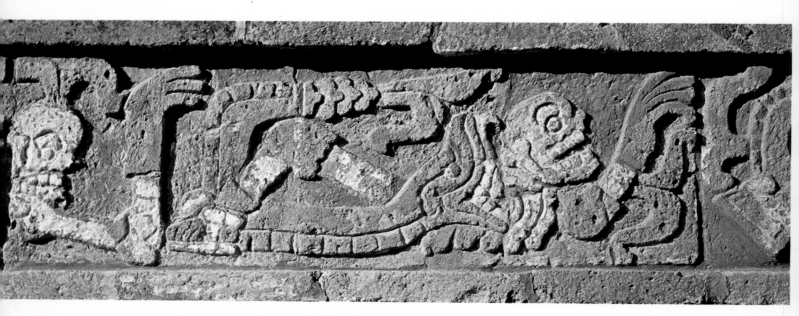

A serpent devours a skeleton symbolizing the planet Venus in this detail from the Wall of the Serpents at Tula.

Giant warriors still stand atop the pyramid at Tula. On their chests are stylized butterflies, the Toltec emblem.

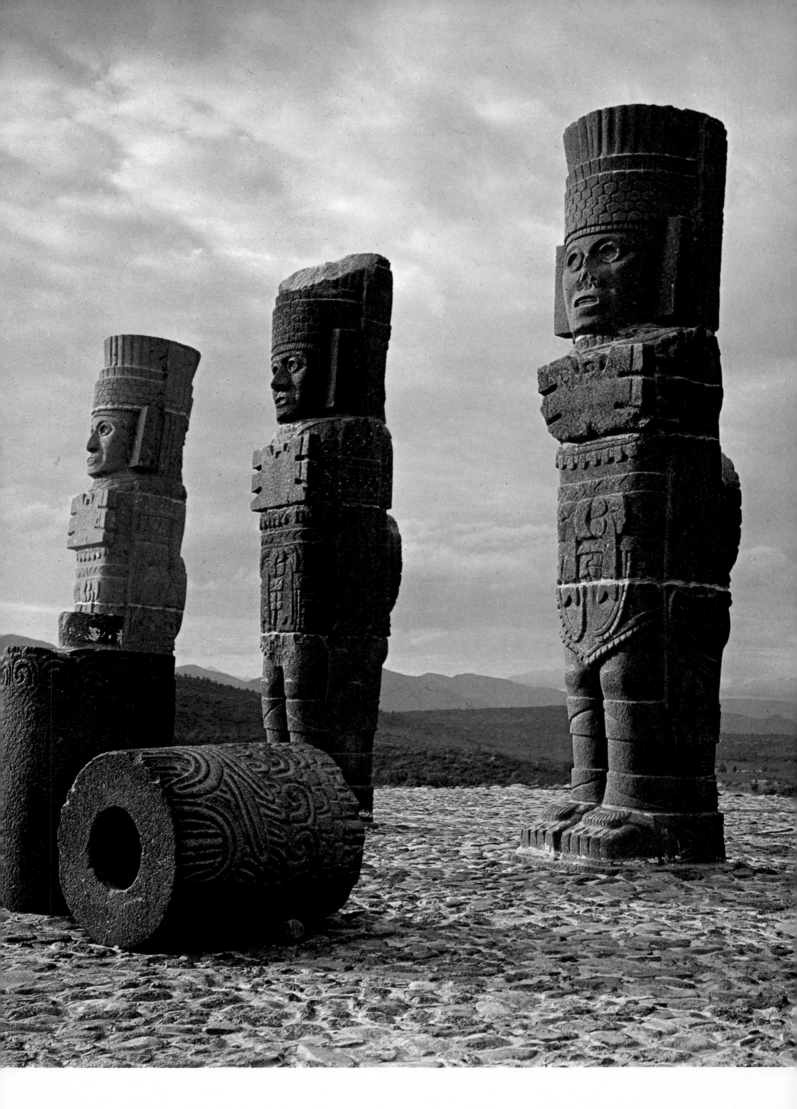

Now, for the first time, Quetzalcoatl is revealed as a man of ideas and ideals. The ancient chronicles relate how he spent much time in meditation. Out of his solitude he brought a new concept of religion to his people based upon his conviction that the purpose of man was to create. He based this thought upon his belief in a single creative god force, all other gods being but manifestations of the supreme god. He taught that, because this god created the earth, sun, and sky, man in his smaller way should create what he could. Quetzalcoatl taught that the dual god, male and female, is one; lord of that which is both near at hand and far away; supreme giver of life and death.

The ultimate good, the priest-king preached, was the attainment of wisdom. The virtues that would lead to wisdom were abstinence, personal sacrifice, and meditation and creativity. A brief excerpt from a longer poem handed down by oral tradition reads: "The guardian of their god, their priest, his name was also Quetzalcoatl." The poem continues: "He demands nothing, except serpents, except butterflies,

which you must offer him, which you must sacrifice to him."

The Toltecs of his time followed these teachings especially in the domain of creativity. They became known as artisans who could work in every form. No task was too difficult for them. The word Toltec itself came to mean "builder," "cultured person," or "creator." Under Quetzalcoatl's leadership the Toltecs were responsible for an artistic renaissance that spread over the central valley. They made a superior type of pottery (now known as plumbate) with a glaze so hard that it could not be scratched with sharp objects. They shaped vessels of every size in the forms of animals, birds, and reptiles, including snakes, toads, turkeys, quail, jaguars, tapirs (they are now almost extinct), armadillos, and deer. Bowls and pitchers in the shape of men, women, and gods were exquisitely crafted.

Their temples, though not as large or as ornate as those of nearby Teotihuacán, revealed the Toltecs as architects with a well-developed sense of form. Four such temples were dedicated to the god

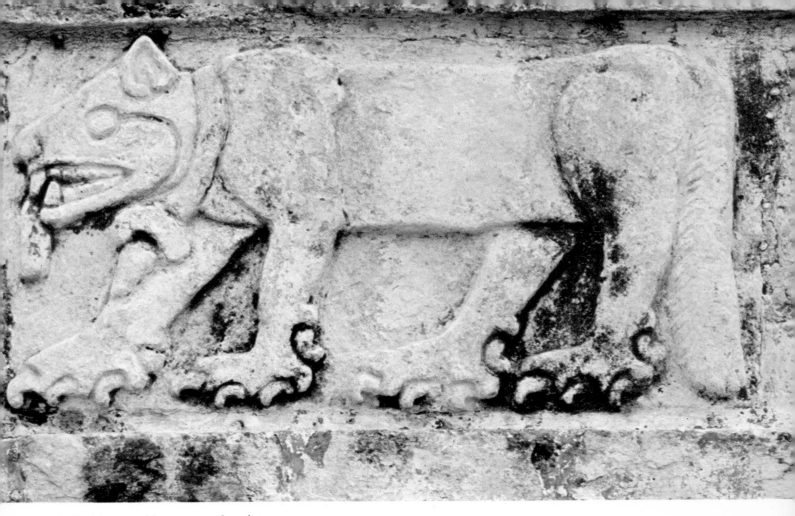

Stylized jaguar with enormous claws is seen on an outdoor wall that surrounds the main pyramid at Tula.

In a colorful frieze, unfaded after 600 years, merchants of Tula still march laden with their trade goods.

Quetzalcoatl and a likeness of his earthly representative, Ce Acatl Quetzalcoatl, was etched in rock on a hill above the city. It shows him in the costume of a king holding a scepter with a glyph drawing of "One Reed" above the figure. The background of this carving reveals a stylized snake, with a large forked tongue extended; feathers are etched around the neck and head and grow out of the long, sinuous body.

As priest-king, Quetzalcoatl was a commanding figure. He had fair skin and was bearded. These facts, like the date of his birth, were to assume importance in the ultimate fate of the ancient civilizations of Mexico.

Quetzalcoatl ruled for at least twenty years. During this time there was peace throughout the region. Tradesmen prospered as they distributed the fine Tula pottery for miles around. Metal found its way into the kingdom and the art of metallurgy made the craftsmen and artists more famous. New temples arose and the political influence of the Toltecs was felt throughout central Mexico. But in the year 999, Quetzalcoatl was compelled by stronger forces, both religious and militaristic, to abdicate the throne and

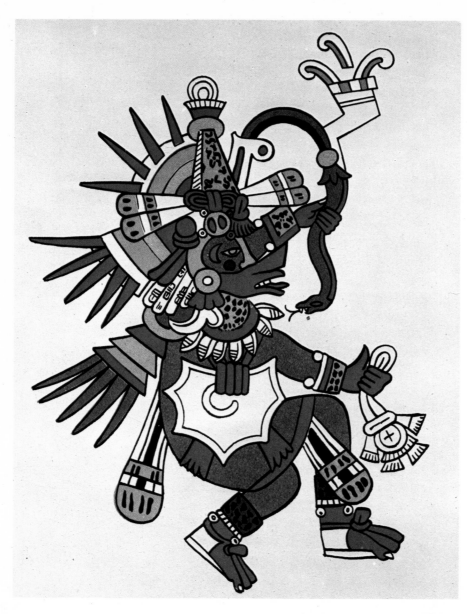

Quetzalcoatl, legendary priest-king of
the Toltecs, dances in this painting from a Mixtec codex.

to leave Tula. At this point the history of Quetzalcoatl the man ends and the legend begins.

The legendary account originates when his father, Mixcoatl, was exploring the valley of Tepotzotlán in the state of Morelos southeast of Mexico City. Startled by a figure who suddenly appeared, he quickly strung his bow and loosed a series of arrows. The figure, however, turned out to be a woman who raised her hand and deflected the shafts. He took her as a wife to his capital and named her Chimalma (Shield Hand). The pregnancy of Chimalma was said to have been caused when she swallowed a jade bead; from this seed, Topiltzin Ce Acatl was born.

As a young man his strength and wisdom were tested when, like Theseus in Greek mythology, he agreed to meet a dragon that demanded a youth be sacrificed to him each year. Ce Acatl took the place of the person selected. Upon meeting the dragon, he

let himself be swallowed up. Then, with a copper knife concealed on his person, he cut the monster from inside and freed himself, thus freeing his people from their yearly tribute. This part of the legend may mean that a human sacrifice was demanded as tribute by a neighboring clan and that the prince, by attacking the tribute-demanding ruler, succeeded in stopping the practice.

After becoming high priest of the god Quetzalcoatl and king of the Toltecs, he battled much of his life against the militant factions that demanded conquests and human sacrifice. As priest-king, Quetzalcoatl had a series of legendary battles with the sorcerer-priest Tezcatlipoca (Smoking Mirror)

In the ceremony of the sunrise a Mixtec priest performs a
complex ritual which includes symbols of eagle and jaguar

whose right foot was a shining mirror. Smoking Mirror sent devils in the form of harmless old men to urge the abstainer Quetzalcoatl to drink a liquor (pulque) made from the maguey plant. After much urging, he finally dipped one finger into the liquid and tasted the drink. He found it good and was coerced into drinking more until his vow of abstinence was broken. While he was in a drunken state, a woman was brought to seduce him. Awakening, he realized he had broken his vow of continence as well as that of abstinence. Other magical spells cast by his enemy filled him with shame and disgust when he looked at his own face. Sadly he burned his palaces, buried his art treasures in the nearby mountains, and, before leaving, turned the fertile cacao trees into cacti and banished the birds from his kingdom. But he promised someday to return to lead his people.

His legendary journey across deserts and mountains has been recorded by Sahagún. As he crossed the high volcanoes, his retinue of dwarfs and cripples died of the cold. After incredible hardships, and a sojourn in the pyramid city of Cholula, he reached the coast of southern Veracruz. There he built a raft of intertwined snakes and sailed away to the south.

Now the legend becomes enmeshed with the history of the cities of Chichén Itzá and Mayapán in the land of the Maya. For in the same decade that Ce Acatl abdicated, a vigorous leader and high priest appeared, called by his followers Kukulcán, which is the Maya word for Quetzalcoatl. Whether there was actually any connection between the two historic men is doubtful, but there is proof, as we have noted in the story of the Maya, that the Toltecs did come to Chichén Itzá bringing with them a culture born in Tula.

Under the leadership of Quetzalcoatl's successors, the Toltecs of Tula became more involved in wars, human sacrifice, and almost continuous political conflict. Within 150 years from the time that Quetzalcoatl departed, Tula was destroyed by a new group of barbarians who overran a decadent and debilitated nation.

(*Overleaf*) *The destruction of the great city of Tula is a mystery. But its outline in ageless stone still stands.*

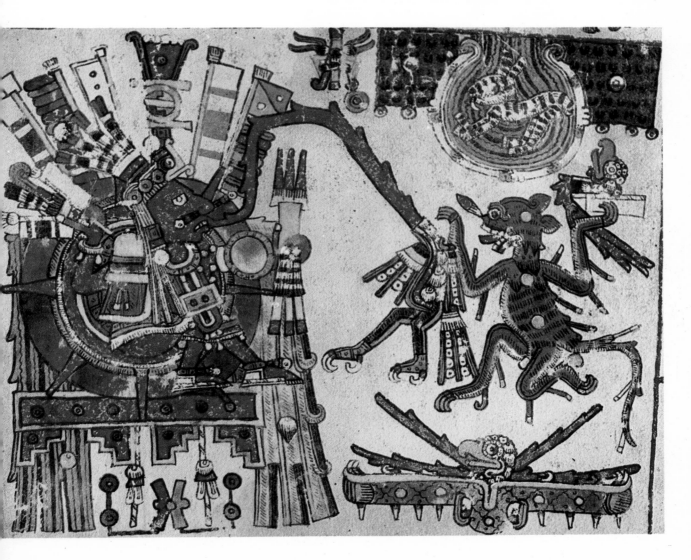

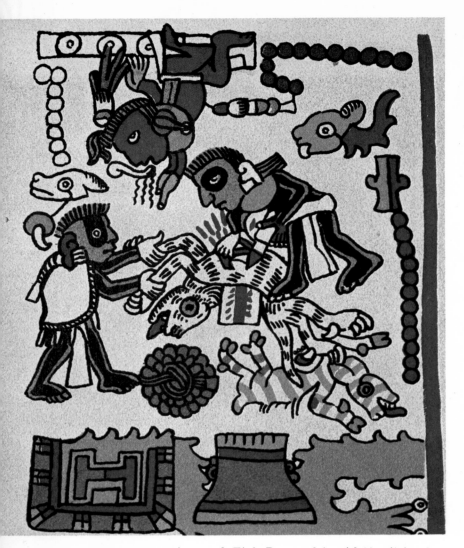

As a youth, Eight Deer, on left, with identifying deer-head and eight circles, skins an animal he has just killed.

The Mixtecs

A people whose beginnings are lost in time, like those of the Olmecs, once lived in the southern regions of the present state of Pueblo and the northern part of Oaxaca. It is a high country made up of jagged mountain peaks, lofty plateaus, and small, deep valleys. This, in the sixth and seventh centuries, was the home of the Mixtecs.

They were a vigorous nation and developed a distinctive culture. They had their own language, which is still spoken by their descendants. After the founding of their first dynasty, Tilantongo, they began a series of conquests that took them north to where the magnificent ruins of Cholula stand. There they contributed to the raising of the largest pyramid in the world. Its massive base covers some twenty-five acres, more than any pyramid in the world. It rises 180 feet above the ground. The gigantic cone is made up of seven superimposed structures. An unknown people began it; subsequent cultures moving in added to it. Within the huge pyramid are some five miles of tunnels. Recently the government of Mexico has illuminated these so that it is possible to enter them and to see the painting that lies deep in the core, within the innermost of the seven pyramids. The frescoes depict, among other subjects, grasshoppers (*chapulines*) with skull-like faces.

There is overwhelming evidence of the worship of Quetzalcoatl in the sculpture and in the frescoes, and it has been conjectured that, when the priest-king Ce Acatl Quetzalcoatl left Tula and the Toltecs, he may have joined with a Mixtec group.

That the Mixtecs lived both north and south of their early Pueblo-Oaxaca homeland is borne out by the history they themselves set down in a series of intricately drawn symbol-picture manuscripts. With deep insight and discipline, they created within a unique art form hundreds of folios dealing with the movement of the stars, the creation of the world, sorcery, the genealogies of their kings and priests, and the history of their nation.

As a man, Eight Deer has grown a beard and is shown in full warrior regalia. He wears a jaguar-head helmet.

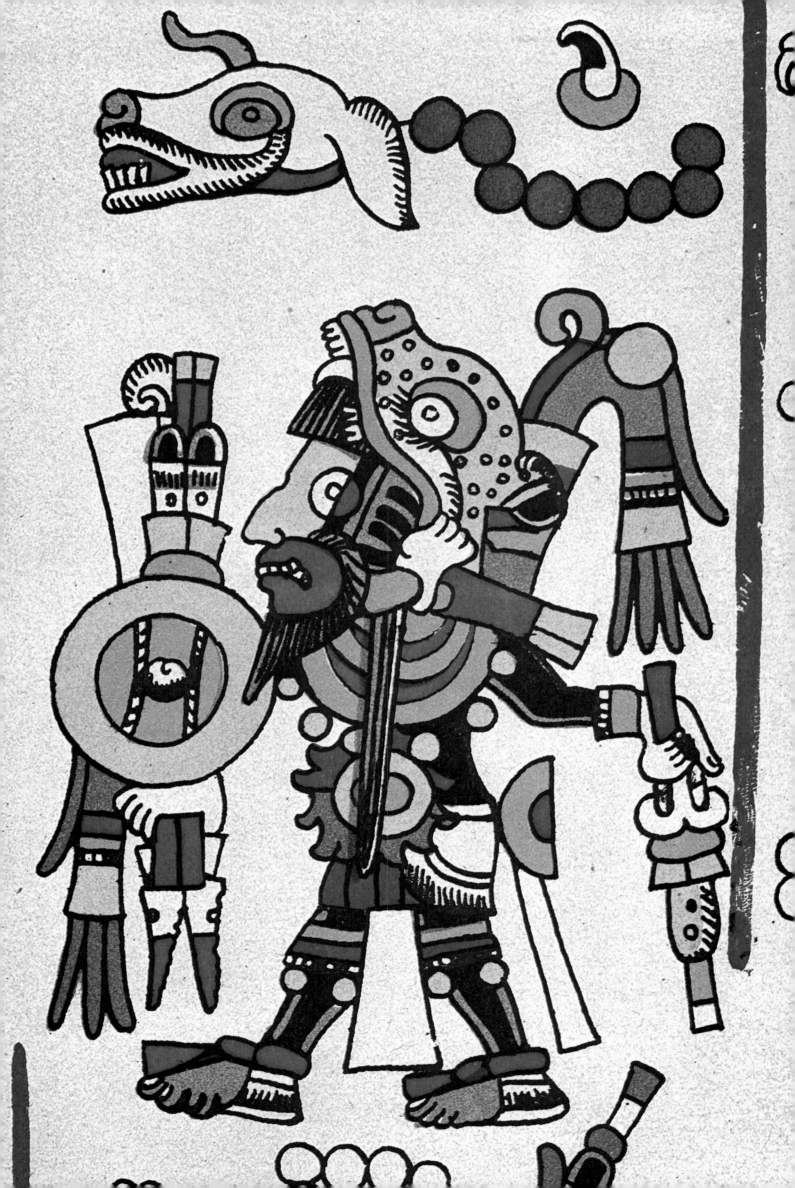

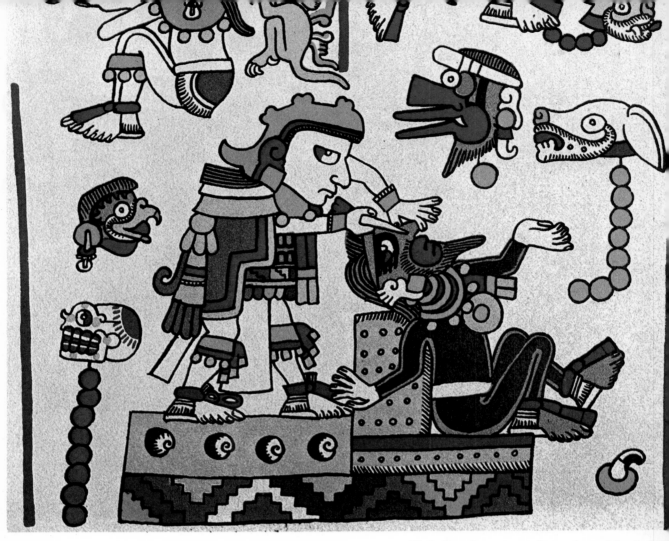

Eight Deer has an operation performed by the high priest allowing him to wear the jeweled nose plug of a king

They painted their "books" on thin sheets of cured animal skin. Storytelling scenes were rendered in brilliant colors. Yet the information recorded was of paramount consideration in the design and pattern of each page. For it was necessary that characters be easily identified, the time of the event noted, and the site of the happening shown. In addition to their historical value, the rhythmic and sequential flow, combined with the subtle handling of color, make these Mixtec manuscripts works of art.

The pages fold one over another in accordion fashion. Seeing them stretched out in a single line can be confusing. But, after one has learned the meaning of some of the key pictures and unfolded the pages one by one, different characters emerge. For example, a great hero-warrior-king, Eight Deer "Tiger Claw," is always shown with eight circles attached to a deer head and adjacent to it a drawing of a tiger's claw.

The saga of Eight Deer, as recorded on the parchment, tells us that he was a prince who took his first name, Eight Deer, from the day on which he was born. As a youth he became a great hunter. Pictographs show him killing and skinning wild animals, including the jaguar. From the picture history we

know he was taken on war parties by his father, the king. On the pages of the ancient manuscript (which are now called codices) we see representations of military exploits and the many enemy warriors that he captured.

A major activity of Eight Deer was the consolidation of the scattered Mixtec city-states. In picture after picture he is shown conferring with his warrior chiefs and subchiefs. Within a comparatively short period, he welded the Mixtecs into a single nation. Then other groups similar in beliefs and language were brought into the Mixtec federation. This was not accomplished exclusively by persuasion. On numerous occasions Eight Deer gathered his warriors and set out to do battle to add new territory to his empire.

His most successful technique, however, was intermarriage with the daughter of an important neighboring chief. This method of conquest was a pattern that had been followed by Mixtec leaders for generations. Eight Deer had at least four wives and possibly five, all princesses of different nations. From a religious or moral viewpoint there was no problem, for polygamy was commonly practiced by the Mixtecs. Their diplomatic intermarrying (which, of

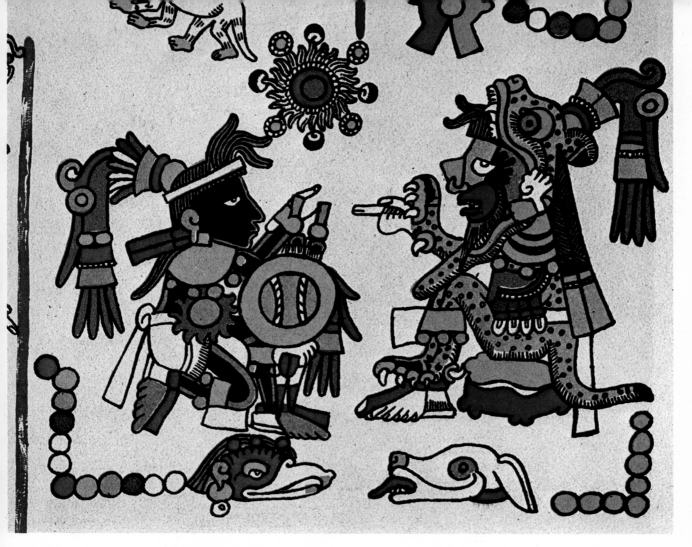

As Mixtec king, Eight Deer, on right, negotiates treaties with a tribal leader whose name is Twelve Dragon.

(Overleaf) Warrior captures a prisoner, symbolized by being grasped by the hair and with tears flowing from his eyes.

course, was also successfully practiced by European and Asiatic countries) gave a sense of continuity to the succeeding Mixtec dynasties. It also made it possible for Eight Deer to expand the borders of his country without the hazards of armed conflict.

An event of first importance occurred in the life of Eight Deer in the year 1045, when he visited Tula, which was still the capital of the Toltec Empire. Only forty-six years had elapsed since the abdication of the great priest Ce Acatl Quetzalcoatl. There at the hands of the high priest, called Eight Skull "Jeweled Vulture" in the manuscript, Eight Deer submitted to the painful ceremony of nose piercing to receive the sacred nose jewel, symbol of kingship. A week later, the codex indicates, he had recovered from the painful operation, for, on the day of Seven Rabbit, he is shown in kingly regalia wearing his nose jewel for the first time.

The picture histories continue to show and tell how more and more territory was added by Eight Deer to the Mixtec federation. They also visually describe what has become something of a mystery in Mexican anthropology—a visit by Eight Deer and the king of Tula to an important personage who is said to have lived on the Hill of the Sun. That he

must have been of great importance is indicated by this visit of two kings. It may well have been on the Hill of the Star, the place where Ce Acatl Quetzalcoatl buried the remains of his deified father. Yet neither the identity of this king nor the place visited has been discovered.

The Mixtec nation grew larger, yet never became powerful enough to satisfy Eight Deer. This dissatisfaction ultimately cost him his life. Displeased with the manner in which the country governed by one of his wives was being administered, he mounted an offensive action against it. During the ensuing battle he was captured. His wife, queen of the province, must have been unsympathetic, for at the age of fifty-two years, having rounded out the sacred time cycle, Eight Deer became the most important ruler ever sacrificed to the gods.

Within one hundred years of the death of Eight Deer, the Mixtecs moved in force into the central valley of Oaxaca. They moved as a conquering army, for it would have been impossible to live off the country without subduing settlements along the way. We know, however, that a diplomatic marriage was consummated between a Mixtec and a Zapotec nation and that shortly afterward Mitla and Monte

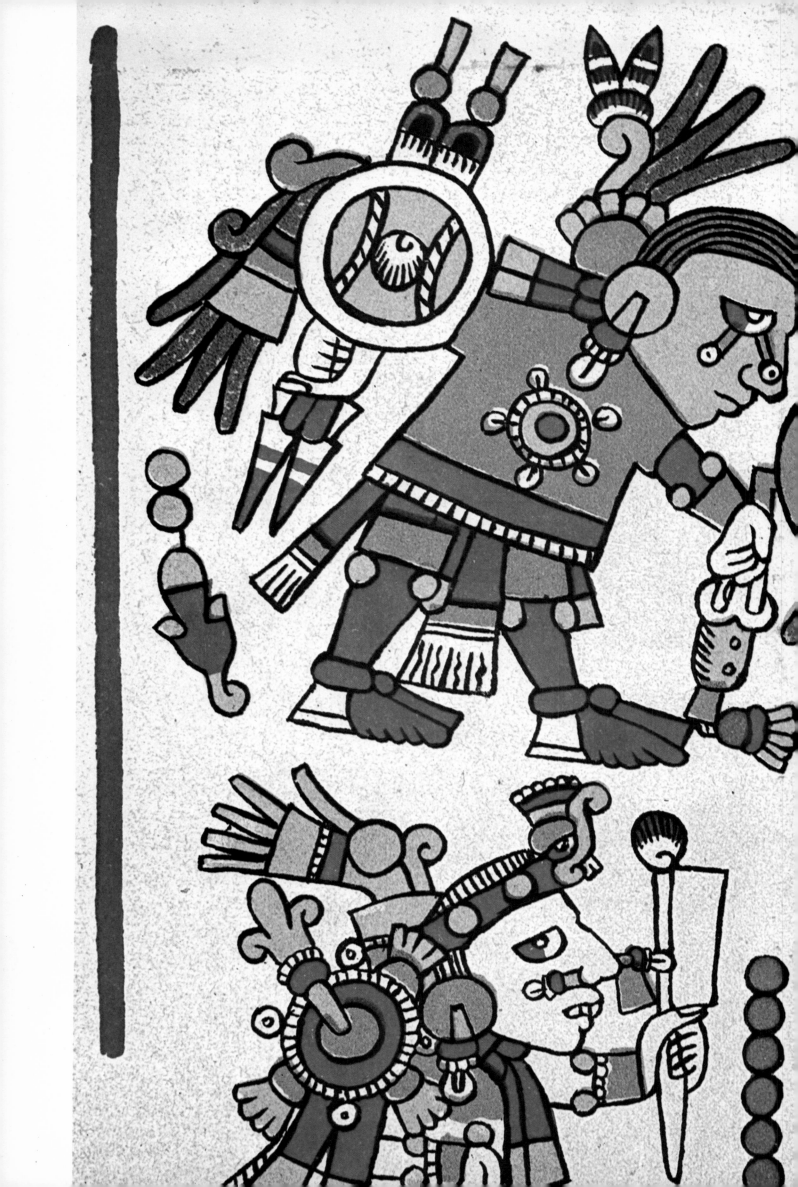

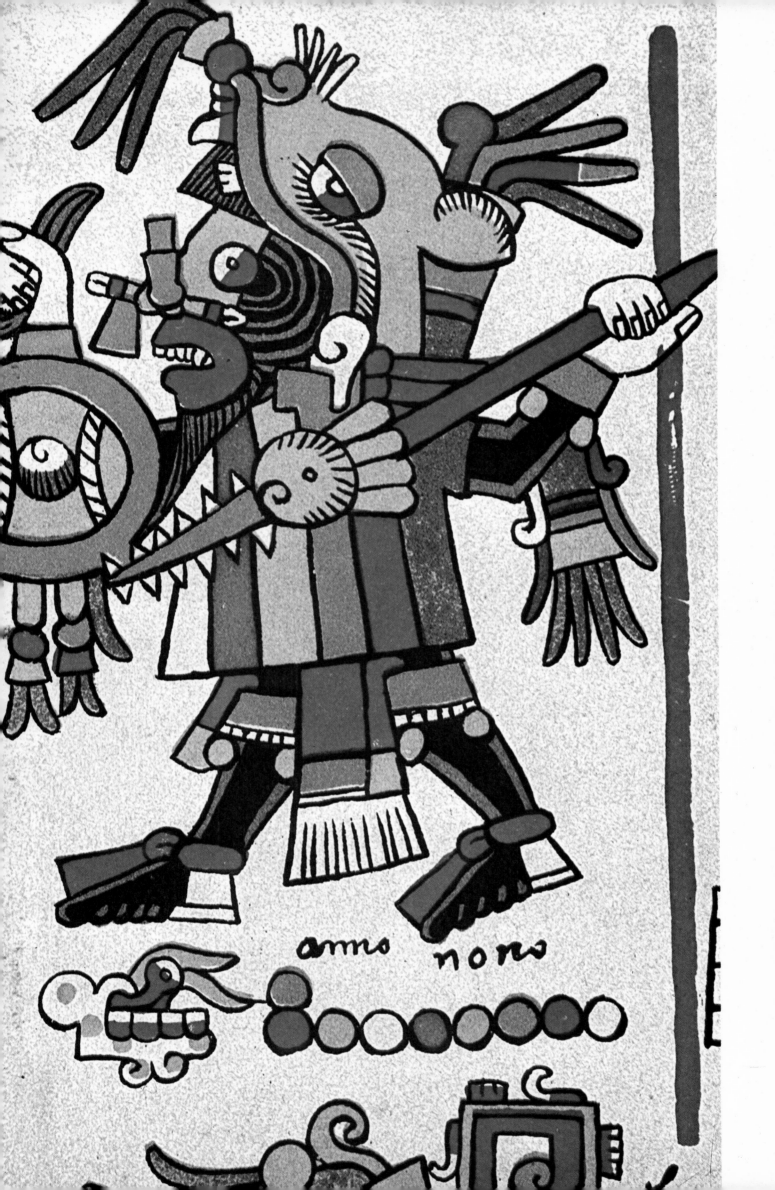

anno nono

Albán were occupied by Mixtecs. Evidence of their occupation is shown in the murals at Mitla. But the most dramatic proof of the Mixtecs in Monte Albán was made by Alfonso Caso when he excavated and analyzed the burial offerings of Tomb Seven. The construction of the tomb was Zapotec, but, if no other evidence existed of the artistic superiority of the Mixtecs over any of the later civilizations of Mexico, it is to be found in the exquisite burial offerings in this crypt. Polychrome ceramics of thin, highly polished clay were found next to mosaics of turquoise; intricately worked gold and silver ornaments; carvings made from rock, crystal, amber, obsidian, and coral; pearls (one as large as a plum); and thirty-five animal bones carved with tiny relief etchings representing Mixtec mythology. The finds in Tomb Seven are only one example of the outstanding artistic ability of these mountain people. By the eleventh century they had developed an artistic excellence that had few characteristics of earlier cultures in it. Mixtec goldsmiths created the most important work in that precious metal in all Mexico. They had no peer in the field of ceramics or turquoise mosaics.

Unlike the Toltecs and earlier cultures that rose and fell, the Mixtecs continued their military and artistic evolution. When the new barbarians, who became the Aztec nations, swarmed over central Mexico, the Mixtecs were sometimes defeated in battle and many of their states paid regular tribute to the Aztecs. But in the arts they retained their preeminence.

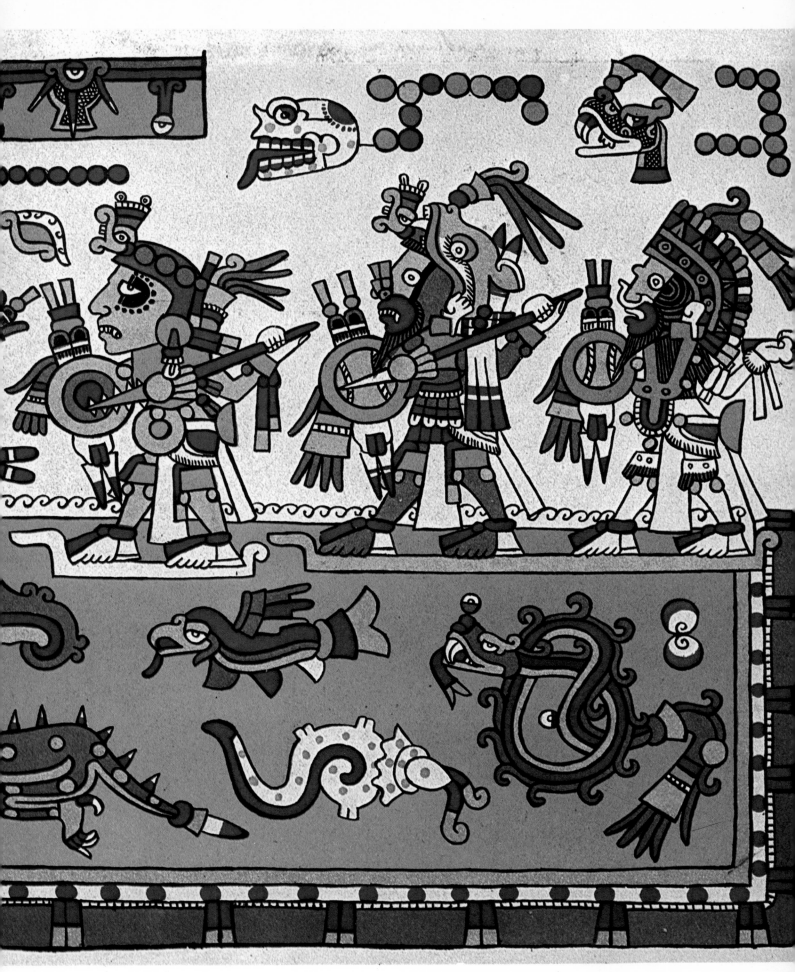

*Three canoe-borne warriors cross a lake to attack an
island. Grotesque sea monsters seem to inhabit the lake.*

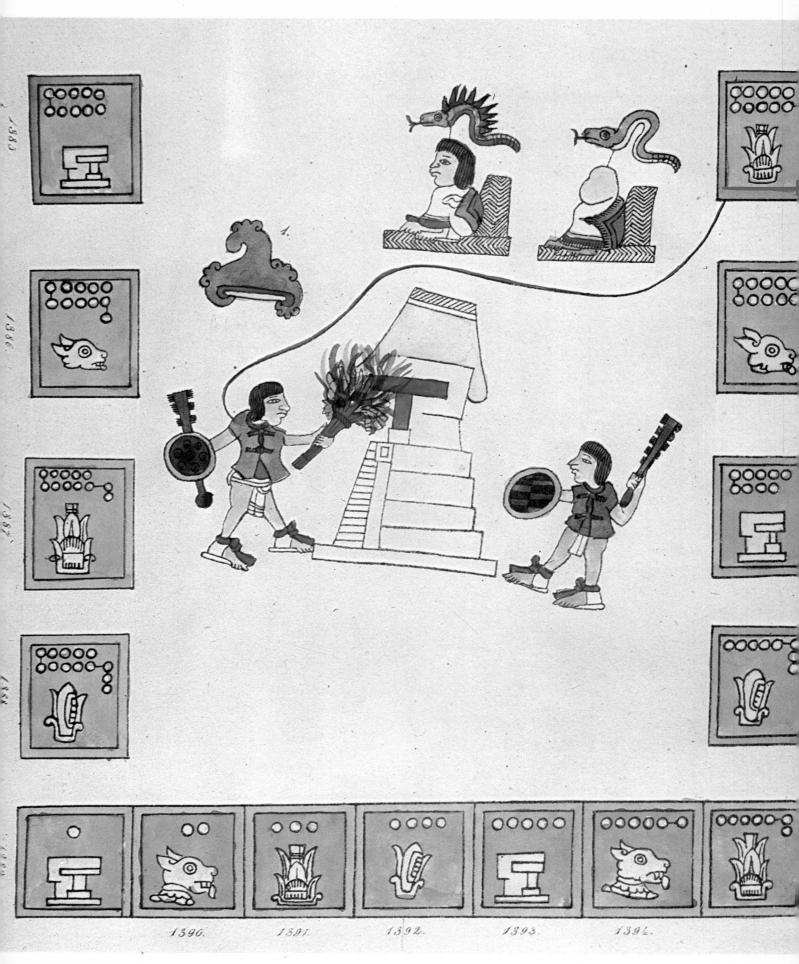

*The burning of the temple indicates the end
of a 52-year cycle. The date symbols were translated later.*

1300-1525
THE AZTECS

From humble beginnings, the Aztecs, within one hundred years, become a great empire in the thirteenth century. During the leadership of the counselor Tlacaélel and under the influence of the ally poet-king Netzahualcóyotl, literary, religious, and political traditions flower. Succeeding kings Moctezuma I and II add territory and prestige to the nation. The empire falls to Spanish conquistadors under Hernán Cortés.

HISTORICAL CHRONOLOGY		ART CHRONOLOGY	
1325	Tenoch, Aztec chief, founds city of Tenochtitlán on islands in Lake Texcoco. Builds temple to war god.	1335 (ca.)	Tenayuca pyramid with balustrade of serpents.
1396	Huitzilhitl governs in Tenochtitlán. Chinampas, floating gardens, add new agricultural land.	1396 (ca.)	Figurines in Aztec-Mexica style.
		1425 (ca.)	Pottery in Tlatelolco style. Aztecs of Tenochtitlán adopt artistic traditions of their neighbors.
1427	Emperor Itzcoatl adopts aggressive policy. Causeway constructed to mainland.		
1440	Moctezuma I spreads Aztec domination to Puebla, Veracruz, and Morelos. Tribute exacted from conquered tribes. City water supply via aquaduct from Chapultepec spring.	1440 (ca.)	Aztec art influenced by artisans and objects from Puebla, Veracruz, and Morelos. Codex Borbonicus, an Aztec pictorial manuscript. Codex Tonalamatl, an Aztec almanac—both undated. Folding deerskin books (codices) of the Mixtecs.
1469	Axayacatl carries rule to Oaxaca. Aztec army defeated in west by Tarascans.	1450 (ca.)	King Netzahualcóyotl, patron of the arts in Texcoco, promotes oral literary tradition.
1472	Netzahualcóyotl, poet-king of Texcoco, dies after illustrious reign.	1469 (ca.)	Development of Aztec-Mexica sculpture. Calendar Stone (1479).
1486	Emperor Tizoc, unsuccessful in military campaign, is poisoned.	1481 (ca.)	Stone of Tizoc records conquest. Statues to earth goddess, rain god, corn goddess, moon god.
1489	Ahuitzotl dedicates twin temple to rain and war gods. Thousands sacrificed. Aztec armies penetrate Mayan domain.	1486 (ca.)	Apogee of Aztec culture. Twin temple to rain and war gods built in Tenayuca style. Head sculptures of sister of war god and eagle knight.
1502	Coronation of Moctezuma II. Series of bad omens plague reign.	1502 (ca.)	Tribute roll of Moctezuma. Mosaic masks, featherwork. Carved wooden drums. Statue of Xipe-Totec (1507). Moctezuma's headdress.
1507	Beginning of a new fifty-two-year calendrical cycle. Fire Ceremony celebrated.		
1519	April 13. Cortés lands on beach south of Veracruz with army of 555 men and 16 horses.	1519 (ca.)	Moctezuma's treasure sent by Cortés to king of Spain. Two six-foot disks, one of gold and one of silver, representing the sun and moon; gold necklace with emeralds and garnets; gold scepter studded with pearls.
1520	Cortés recived by Moctezuma in Tenochtitlán.		
1521	Moctezuma killed. Cuauhtémoc leads Aztec defense. Tenochtitlán falls.		
1525	Emperor Cuauhtémoc executed in Izancanac, Chiapas.		

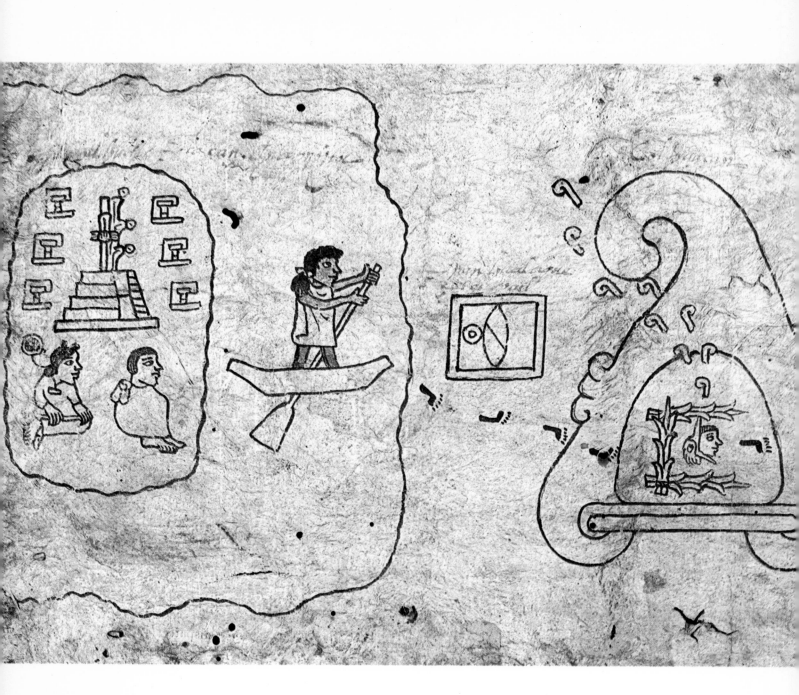

The Aztecs

Between the years 1423 and 1440 the Aztecs forged the most powerful empire ever known in Mexico. After defeating the countries surrounding them, they had formed a political alliance destined to make them even more powerful during the coming years. Their king, Itzcoatl, born of a union of a former king with a slave girl, was an energetic and able warrior. But as important in the task of empire building was his remarkable counselor Tlacaélel. Because he chose to remain a shadowy figure as adviser to Itzcoatl and to his successors, this philosopher, diplomat, poet, and lawgiver is little known. But his influence is evident in the successful wars that brought about permanent peace treaties with

Netzahualcóyotl, king of Texcoco and ruler of the city-state of Tacuba. As soon as the country was secure, Tlacaélel—recommending the establishment of a class of nobles, relatives of the ruler, and awarding lands and titles to them—created a feudal aristocracy.

Tlacaélel was a philosopher of war. To struggle, to fight, was a way of life to him. He taught that the Aztecs were destined to become the rulers of all Mexico; that they were the chosen people, children of the sun. This was not an original thought, since the idea of keeping the sun alive can be traced to a religious concept of the Toltecs. But the Aztecs believed, as the Toltecs did, that in the early days of creation, when the world was in danger of destruction, the gods sacrificed themselves in order to keep the universe from final dissolution. If the gods gave their blood to save men by keeping the sun in the

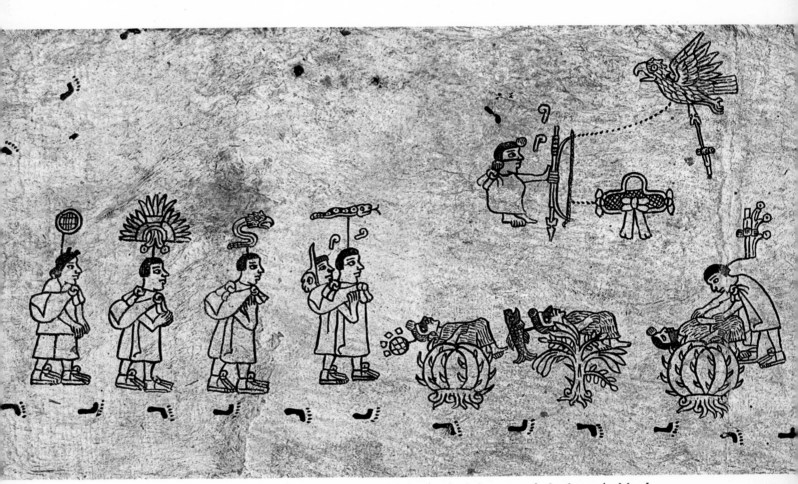

The Aztecs travel from their legendary island, ztlán, toward a mountain from whence sounds come.

Four priests lead the way to the land promised by the god Huitzilopochtli, whose image is borne by the first priest.

cy, how could men do less? Or again, if the lifeblood of men came from the sun, it would follow that the sun needed the lifeblood of men to keep the cycle going. To put it another way, the life of the un was conceived to be in the blood and hearts of nen. Only in man was there a worthy seed of life hat could keep the sun from dying.

Tlacaélel brought these earlier concepts into sharp ocus. It became the unshakable belief of the Aztecs hat through multiple human sacrifice the life of the un could be lengthened. Faced with the problem of upplying numerous sacrificial victims, Tlacaélel nd the ruler Itzcoatl arranged for the Aztecs and heir allies to fight what were called "flower wars." here was nothing poetic about them except their ame. Campaigns were directed against the states of laxcala and Huejotzingo, not for conquest, but as eadly war games practiced against these weaker

states for the sole purpose of taking captives to be sacrificed to the sun. Because the Aztecs could identify themselves as descendants of the sun responsible for its survival, they thought of themselves as representing light and goodness. Conquests for captives became holy wars against the powers of darkness.

Tlacaélel, originator of the policy of war and sacrifice, lived through the reign of Itzcoatl and into the time of Moctezuma I, grandfather of Moctezuma II. Offered the kingship more than once, he refused it. Although he was a very old man after the death of Moctezuma I, he was again importuned to become the ruler. According to the chronicles of Durán, he said:

Certainly, my sons, I thank you
and the king of Texcoco.
However, come hither:
I ask you to tell me,

during the eighty or ninety years
that have passed since the war of Azcapotzalco,
what have I been? In what place have I stood?
Have I then been nothing?
Have I ever put a crown upon my head?
Or have I ever used the royal insignia which
　　the kings use? . . .
Have I unjustly condemned the delinquent to
　　death
or pardoned the innocent?
Have I not been able to make lords
and unmake lords as I have determined and
　　decided? . . .
Then King I am and such have you held me to
　　be;
Then what more of a king do you wish me to
　　be? . . .

Believing at this time the Aztecs had reached an important point in their history, he advised that the books of the Aztecs and the nations that they had conquered be collected and destroyed, and that new histories be written in the light of more recent achievements. A reference to this event appears i the *Codex Matritense*, in a passage which reads:

Their history was preserved.
But then it was burned.
When Itzcoatl reigned in Mexico.
A resolution was taken.
The lords of the Mexicans said:
it is not fitting that all people
should know these pictures.
Those who are subject, the people,
will be spoiled
and the land will be twisted,
because many lies are preserved in
those books
and many in them have been held as gods.

After the destruction of the ancient books, Tl caélel supervised and dictated the new view of th Aztec past. According to the version of Aztec histo as rewritten in the time of Itzcoatl and Tlacaél (and that is all that we have to refer to except fe certain archaeological finds and oral reminiscences

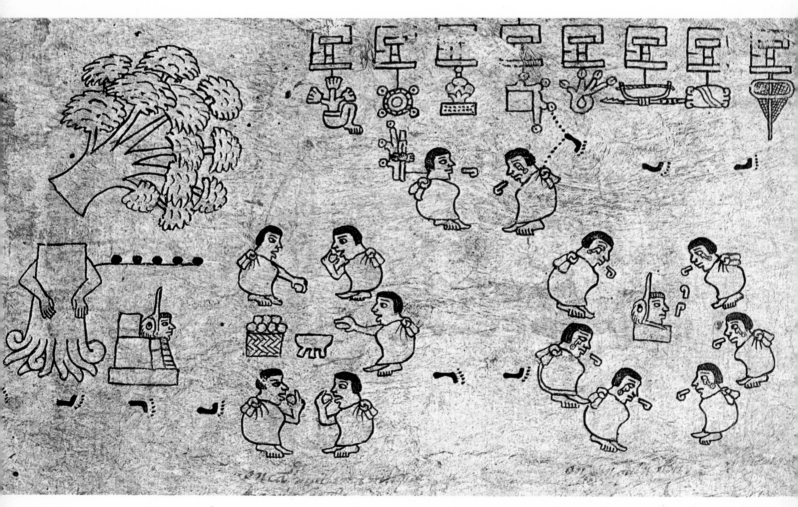

When the Aztecs stopped before reaching the place where the high priest wished them to settle, he urged them on.

In the legend of Tenochtitlán, now Mexico City, the Azte sought an eagle on a cactus and there founded their natio

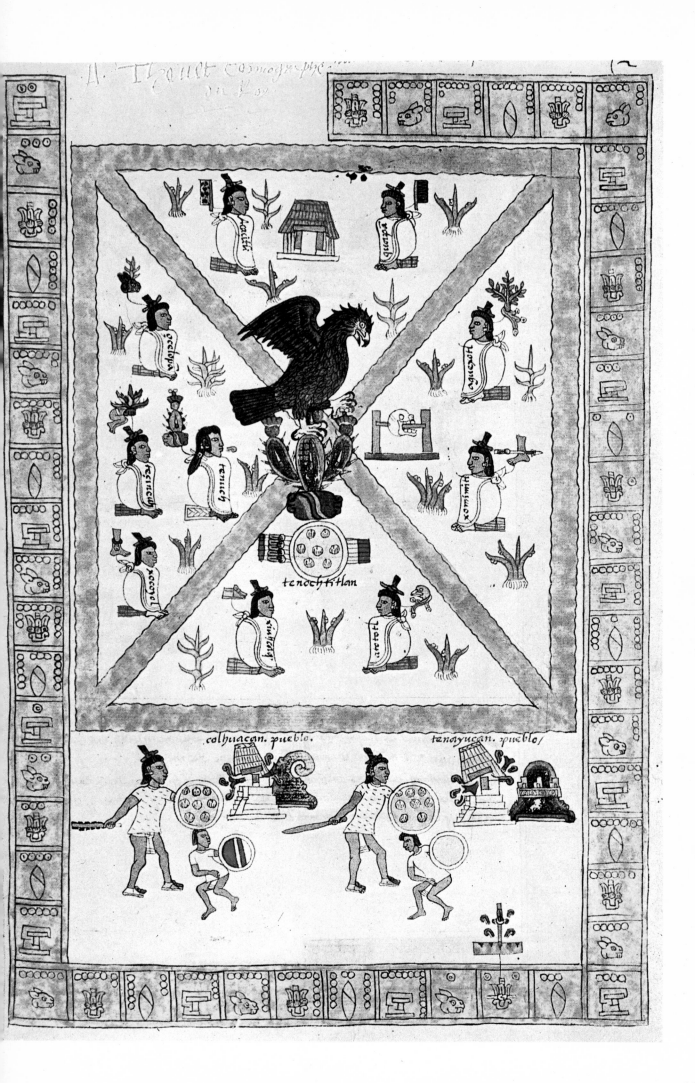

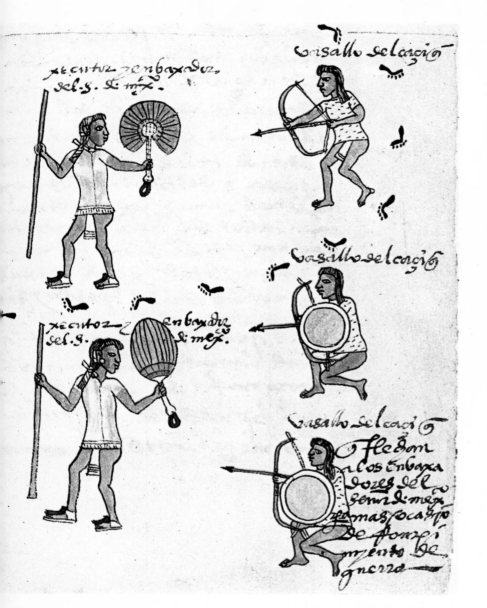

*Aztec warriors with bows and arrows provoke war.
The Spanish conquerors later wrote on these picture scrolls.*

through the Toltec cities and their ability to wit
stand invasion from the north decreased, a ne
wave of seminomadic people advanced led by a ch
called Xólotl. Like the earlier Toltec-Chichime
from the north under Mixcoatl, these Chichim
tribes poured into the Valley of Mexico in despera
search of fertile land, easier hunting and fishin
and, finding these essentials to life, then absorb
the earlier cultures. After overrunning the northe
outposts of the Toltecs, various tribes continued
move south. Some settled at Lake Texcoco. Othe
stormed into earlier Toltec settlements, killing, te
rorizing, conquering, and becoming integrated wi
earlier migrants.

Watching and waiting, without taking part
these conquests, was the small tribe of Aztecs. Th
were living either as serfs or mercenaries of t
Toltecs on the northern outposts of that nation,
migrating from the northern border into Tolt
territory as that empire decayed. After they settl
on Lake Meztliapán (Moon Lake), another nar
for Lake Texcoco, they came to be called the Azt
Mexicas; from them, Mexico was to inherit its nam

As a small and insignificant tribe, they had on
four priests and, as shown in the picture story
their migration, each priest carried a bundle. T
basis for the belief that they came from an island
seen in the first picture in the manuscript describi
the migration. In it a man sets out from an island
a canoe. Four priests carry their religious possessio
The first priest's bundle contains a statue of the
god, called Huitzilopochtli, unknown in Mexi
until this time. According to the legend, there liv
a widow with grown children who was known to
of high moral integrity. One day, while cleaning t
temple of the gods, she picked up a ball of feathe
and put it in the top of her dress between her breas
Some months later she realized that she was pre
nant. Soon her daughter and all her many so
knew of her condition. Believing that she had b
come an immoral person, her children agreed to k
her. She was greatly frightened, but an inner voi
told her not to fear. As the daughter and so
approached to attack, she gave birth to a full-grow
warrior carrying a long sword and a serpent's he
which flashed lightning. This was the god Huitzil
pochtli and, in the form of the deity, he destroye
those who would destroy his mother.

the Aztecs came from the island of Aztlán, a loca-
tion so far unidentified. It is from this reference that
they were called Aztecs. However, it is important to
remember that the only source is the picture record,
"The Peregrination of the Aztecs," drawn at least
one hundred and fifty years after the small tribe had
moved into the lake region of central Mexico. It
seems possible that the concept of being an island
people may have come from the Texcoco locale and
that an earlier island home did not actually exist.

From the evidence available, it seems that the
origin of the Aztec clan most likely began when the
Toltec Empire disintegrated. As dissension spread

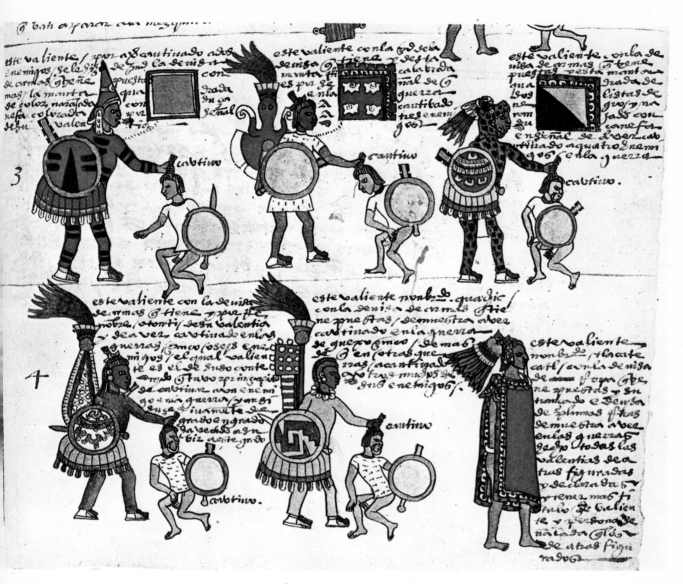

Aztec warriors receive trophies for capturing prisoners on the pages of this codex named for viceroy Mendoza.

But this allegory was more than a legend and more than a myth to the Aztecs. They believed their god Huitzilopochtli to be their invincible protector. The narrative has been interpreted to read that the widow represents the earth mother, Coatlicue, from which all things are born. The daughter is the moon and the many sons and neighbors signify the stars in the heavens. The god Huitzilopochtli is the sun who, when he appears, kills the light of the moon and the stars.

In the early stages of their migration, even after their arrival in the Valley of Mexico, the rise of the Aztec clan was slow. Though they were a Nahuatl-speaking people, they were unable or unwilling to integrate with other settlements. From the north they wandered south, leading a nomadic existence. Wearing only fiber loincloths and fiber sandals, and carrying small bows and stone knives, they found their way to the hill of Chapultepec, now known as

a great park in Mexico City, where they stopped for some years. During this period they adopted the calendar of earlier cultures and set up some rudimentary stone structures.

But their peaceful life at Chapultepec did not last. They were attacked by the Tepanecs and the people of Culhuacán, the ancient home of the Toltecs. The tribe was almost destroyed. The remnants were allowed to live in a snake-infested swamplike area north of Mexico City. According to one ancient chronicle, the king of Culhuacán gave them these lands hoping the thousands of snakes would kill them. But the chronicle relates that the Aztecs were happy when they saw the great profusion of snakes. Soon they had caught, roasted, and eaten them.

After the incident of the snakes, more than one chronicle tells of what is perhaps the most revolting incident in Mexico's ancient history. Feeling that his people were strong enough to survive a battle with

144

the people of Culhuacán, and also wanting to keep the warriors fit, the god Huitzilopochtli (sounding much like Tlacaélel speaking) advised his Aztec chiefs that, if they would dominate the valley, they must provoke a war. To do this he directed the chiefs to ask King Achitometl for the hand of his virgin daughter in marriage to the Aztec cacique. When the king agreed and sent his daughter to prepare for the marriage, Huitzilopochtli instructed his priests to kill and skin the young girl, dress a priest in her skin, and place him in a darkened

room. Then he told them to invite her father and his court to the wedding feast. King Achitometl arrived, bringing valuable gifts. He was taken into the darkened room, but, when the fire was lit to burn the sacred incense, he was shocked to see not his daughter but a priest dressed in her skin. As Huitzilopochtli had predicted, the king immediately declared war against the Aztecs. They were badly beaten and forced to retreat from the region.

Huitzilopochtli, through his priest, spoke again. Now he instructed his people to move on until they

This is a visual record of tributes the Aztecs collected from their subject people. It was painted on bark paper.

Every eighty days tribute was collected. Such tribute included animal skins, costumes, birds, fabrics, and food.

145

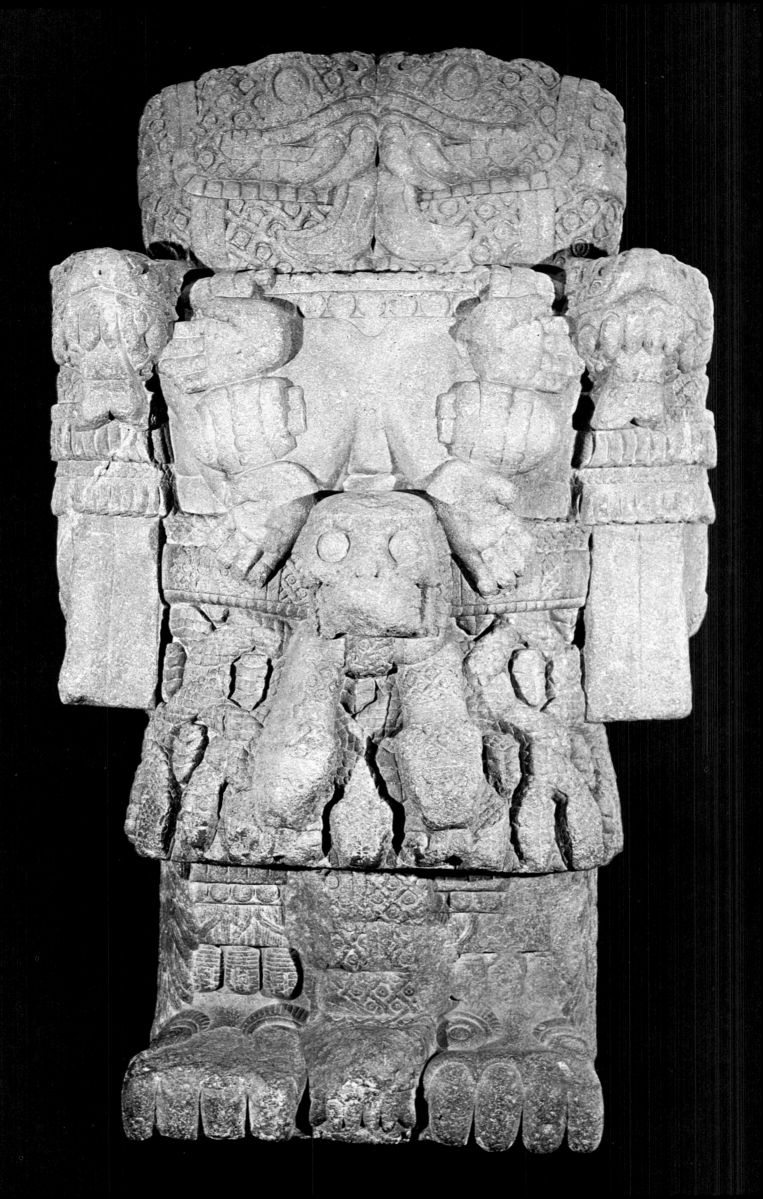

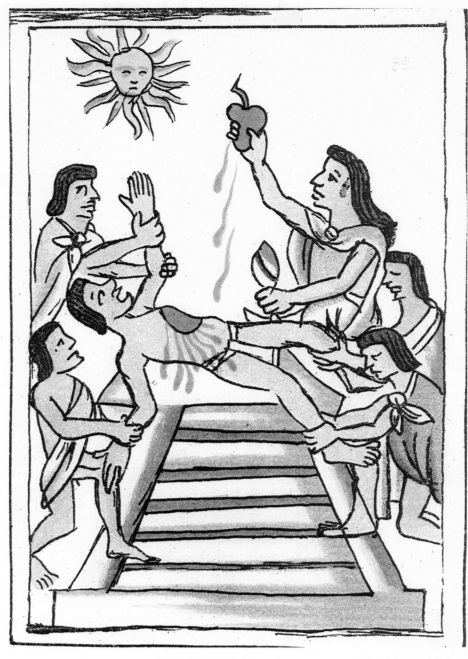

With the sun—whose life the Aztecs believed depended on the blood of man—looking on, priests perform a sacrifice.

found a place where an eagle stood on the top of a tall cactus tree. On that spot they would found a nation that would expand to become the greatest in Mexico. Forming into three groups, they searched the swampland. As the god had predicted, they found a tall prickly-pear cactus with an eagle making its home in the top of it. In its claws was a serpent. They greeted and paid homage to the eagle, which it is said bowed its head acknowledging their presence.

The place where their priests had led them was a piece of high land in Lake Texcoco. An island, it was completely defensible on all sides. In addition to

This huge statue of Coatlicue, mother of the Aztec gods, is one of the most awe-inspiring of all Aztec works of art.

its security, it had the added advantage of bordering on three different nations. On the south was Culhuacán, occupied by the last of the Toltecs; on the west was its nearest neighbor, Azcapotzalco, home of the Tepanec people; to the east, was the kingdom of Texcoco. The Aztecs occupied a strategic position, for they could ally themselves with any one of the three against the others, which, over a period of years, they did.

But the choice of an island as a place to build their city was especially fortuitous for another reason. It is hard to imagine, considering all the migrations and conquests in ancient Mexico, that people and goods moved entirely on foot. No horses, no wheeled carts, no oxen, not even dog sleds were known. So an

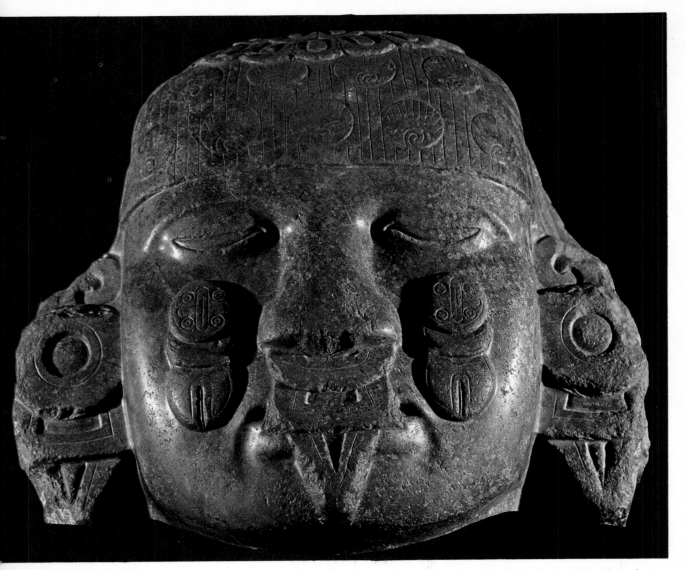

The moon goddess Coyolxauhqui, depicted in this sculpture, was chased from the sky each morning by the sun god.

island city with canals serving as main thorough-fares gave the Aztecs a great advantage over land-locked communities. Canoes made communication throughout the nation and with other nations com-paratively rapid. Even the acquisition of raw mate-rials and food supplies was made easier.

Upon settling on the island of Tenochtitlán, named for their legendary leader Tenoch, their first concern was to obtain stone and wood with which to build houses. In their wanderings the Aztecs had become expert at warfare and at food gathering. Now, to build their city, they offered these skills. They became mercenaries and tribute payers to their neighbors the Tepanecs. In return they took back stones, wood, and other material from which they built their modest temples and houses.

It is said that they invented the art of growing fruits and vegetables on man-made islands, called *chinampas,* when they were forced to pay tribute to

Culhuacán. This type of agriculture was known earlier cultures, but the Aztecs raised it to a high a There was no room in their island city to grow t produce they needed. So, as they cut their canals facilitate transportation, they took the layers water roots, reeds, and other growths, packing the into a solid mass until they reached the bottom the swamp. Then from the canals and other swam areas they dredged up mud and spread it on top the matted vegetation. In this moist, fecund eart seeds flourished. Gardens soon surrounded t island. To keep the mass from moving about, w low trees were planted around them. As the tops became depleted, fresh mud was spread over the to This form of cultivation is still used in the so-call floating gardens near the village of Xochimilc where they were first planted by the Aztecs. In dramatic demonstration of their ability as hortici turists, the chronicles relate, the Aztecs once pa

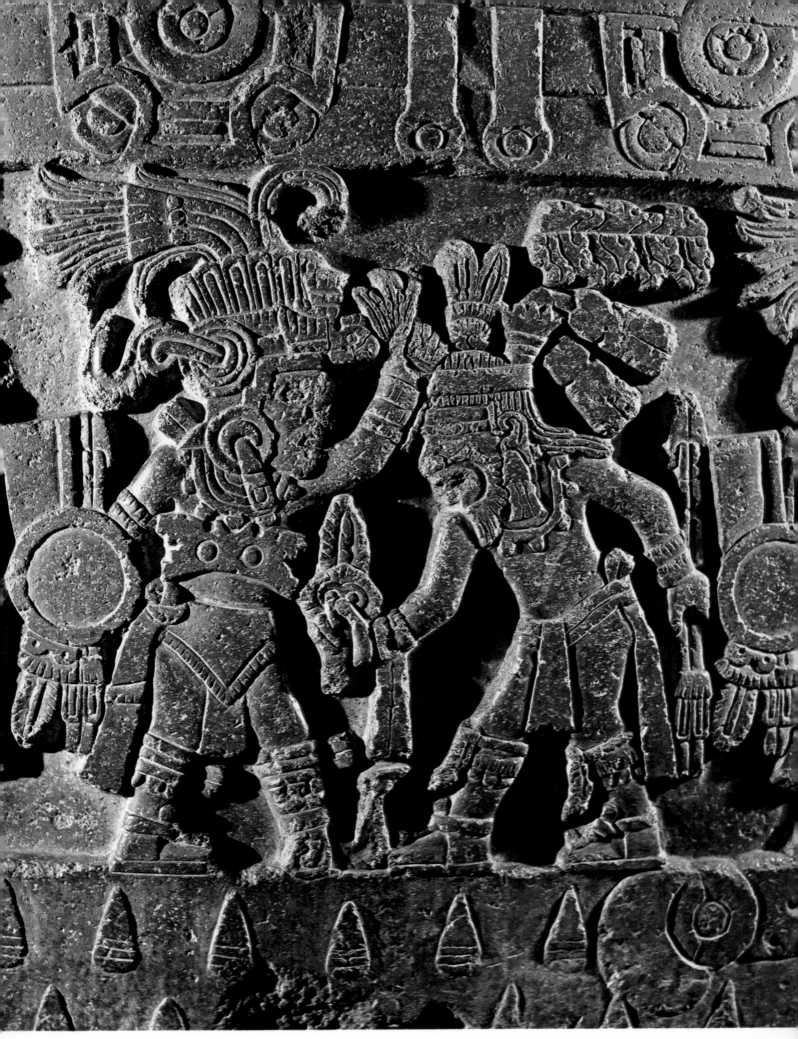

Tizoc, king of the Aztecs in the 1480's, was a great
warrior. This enormous stone commemorates his victories.

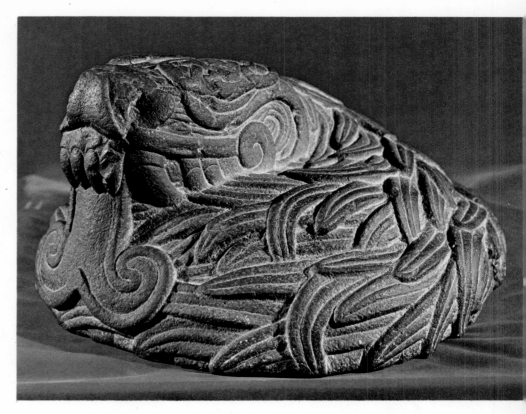

The god Quetzalcoatl was known to many early cultures. Here he is sculptured as a coiled feathered serpent.

tribute by floating an island, laden with ripe grain and fruit—and with domesticated ducks laying eggs —to the Tepanec mainland.

Much has been said about the warlike attitude of the Aztecs, but little attention has been paid to their diplomatic abilities. Yet from the time they formed a connection with the Tepanecs, each political move was carefully planned, with the result that they prospered without warfare until such time as they were strong enough to use force for conquest.

Their first political success raised their status to a higher level than that of tribute-paying vassals to the Tepanecs. Sending a humble delegation bearing expensive gifts to a rival power of the Tepanecs, the Culhuas, descendants of the ancient Toltecs, they complimented the deposed king of that country (who had been recently defeated by the Tepanecs) by asking that his grandson be allowed to come to Tenochtitlán to rule them. The former ruler acquiesced and Acamapichtli became their first king. This move had two results. It put them on a friendly basis with a power that might later be used against the Tepanecs and, more important, it set up a royal Aztec dynasty that reached all the way back to the days of the great Toltec kings. Now the recently uncivilized outcasts had a defensible homeland and the beginning of a noble ancestral lineage.

While building their own nation, the Aztecs were busy fighting the wars of the Tepanecs. But the Aztecs were by no means full partners. As late as the year 1414, they were little more than serfs of the Tepanec nation. As land and people throughout the valley fell to the combined power of Tepanec and Aztec, only the kingdom of Texcoco held out. But finally the king of Texcoco, Itlilcochitl, was trapped and named his son, Netzahualcóyotl, ruler in case of his death. He was right in assuming that his death was imminent. He withdrew to a nearby forest with a small group of followers and they fought to the last man against an overwhelming force. The chronicles then tell that, realizing that he could hold out no longer, the king spoke to his son, advising him to hide until he became strong enough to gather enough allies to recover his empire. The boy, hiding in the thick underbrush, watched as his father was killed. That this child was saved had a great influence on future events, especially for the Aztecs. Netzahualcóyotl (Hungry Coyote) was destined to become ancient Mexico's greatest poet as well as a political leader and philosopher of distinction.

While the warrior king of the Tepanecs, Tezozómoc, made every effort to find and execute Netzahualcóyotl, the boy had many friends and relatives. With their help, he acquired an education as a king's son. Fortunately, by the time Netzahualcóyotl reached maturity, Tezozómoc was a very old man.

Symbolic abstract painting of serpents made by a pre-conquest artist. Snakes were a symbol of life to the Aztecs.

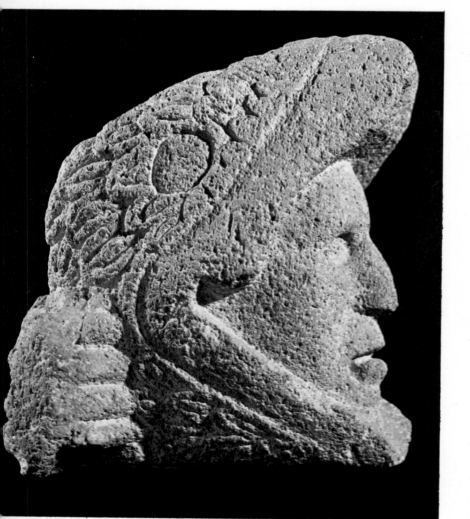

An Eagle Knight, member of one of the two important Aztec military orders, is realistically sculptured in stone.

When he died in 1426, his death gave an opportunity to the Aztecs and to Netzahualcóyotl's government in exile, and both took advantage of it.

The first to act were the Aztecs, who attacked their long-time allies, the Tepanecs. As a result of this action, Netzahualcóyotl was able to return to his rightful place as king of Texcoco. The Tepanec Empire was then divided between Tenochtitlán, Texcoco, and Tacuba, a city-state which had also allied itself with the Aztecs. The three city-states elected to unite forever. They agreed to pool their armies and to divide the spoils of conquest, with two parts going to the Aztecs, two to Texcoco, and one to Tacuba. During the period that followed, King Itzcoatl of the Aztecs adopted the title Culhuatecuhtli—Lord of the Culhuas—officially announcing the continuation of the ancient Toltec dynasty; while Tlacaélel, as we have seen earlier, developed a warrior-conquest policy for his people.

But it was Netzahualcóyotl of Texcoco who did the most for the development of the peaceful arts, which flourished as never before. He was a leader of multifaceted talent. As an architect, he planned the construction of aqueducts to bring fresh water to the region. His temples, palaces, and botanical gardens were an inspiration to the Aztec nation. Also, he was an original thinker, a philosopher and poet, whose reputation has come down through the ages to modern Mexico. At the bottom of his philosophy is his concern with the meaning of death and the possibility of everlasting life. More than once he wrote of the ephemeral nature of all things. One of his thoughts expresses it in this way:

> Only for an instant does the meeting endure,
> for a brief time there is glory. . . .
> None of your friends has root,
> only for a short time are we given here as
> loans,
> your lovely flowers . . .
> are only dried flowers.
> Everything which flourishes in your mat or
> in your chair,

nobility on the field of battle,
on which depends lordship and command,
your flowers of war . . .
are only dried flowers.

Even though he lived in a time when human sacrifice was at its peak, he avoided it as much as possible within his kingdom. He was a man of his time and participated, though primarily as an adviser, in the campaigns of the triple alliance. Yet, unlike the other kings and conquerors, his greatest satisfaction seems to have come from an awareness existing between himself and the forces of nature. He searched for, and may have found, some reason for being, for he wrote:

> Finally, my heart understands it:
> I hear a song,
> I see a flower,
> Behold, they will not wither!

Netzahualcóyotl lived for seventy years—through the reigns of Itzcoatl and Moctezuma I. His advice and personal popularity helped to keep the coalition strong and successful. After his death, the Aztecs took over the leadership of the alliance.

At the peak of its power, the social aspects of Aztec society reveal an inflexible moral code and a society under complete control by its governing class. Social mores, laws, and rules of conduct were more rigid than those of the Puritan settlers of New England two hundred years later. Any act of immorality, which included drunkenness, adultery, homosexual practices, prostitution, and even speaking indecently, was punishable with severe penalties and, in the case of adultery or drunkenness, by death. Pride, self-indulgence, individual initiative were vices. The follower of traditions, who lived within the laws of the gods and the laws of the state, was rewarded. The disobedient, dissolute, and self-indulgent were punished.

The same standards seem to have been applied to slaves, freemen, nobles, and warriors. In the case of nobles, lineage was of prime importance. Nobles

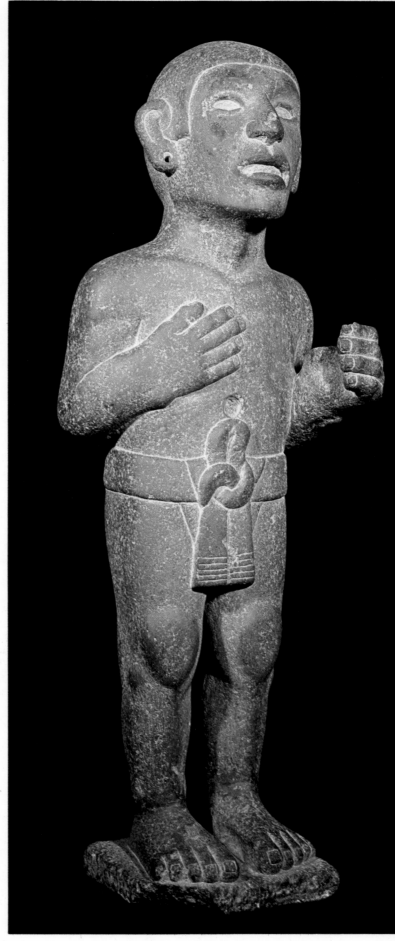

An ordinary Aztec, a simple worker or farmer, is shown as he actually lived, barefoot and clad only in a breechclout.

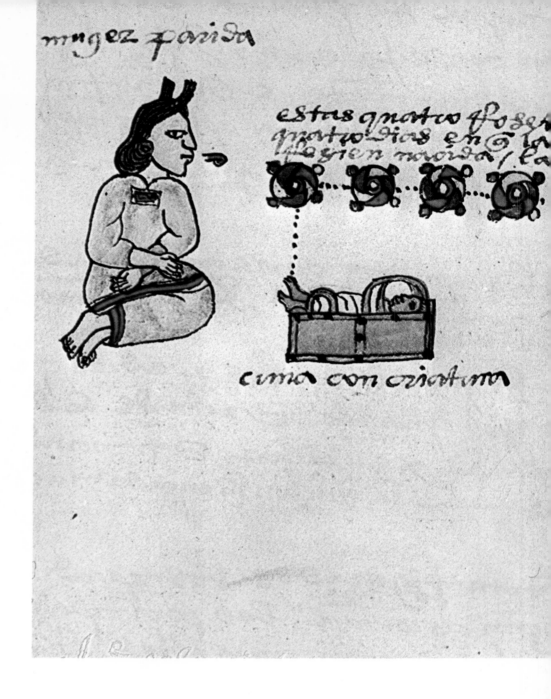

owed obedience to the traditions laid down by their gods and previous rulers, and they were expected to be merciful, compassionate, and withdrawn from the pleasures of life. It was their duty to take the lead, guiding the people in sober and industrious ways. The bad noble was one who oppressed his subjects, terrorized them, or lived in vice.

Besides drinking the intoxicating fermented juice of the maguey plant, a great pleasure of the Aztecs was the eating of hallucination-producing mushrooms. At special ceremonies and at banquets they were eaten raw. There is no evidence that any special control was kept over those who consumed them, although it was said that at some banquets no wine was served, but only a chocolate drink made from the cacao bean. In the chronicles of Diego Durán it is written that the people became highly excited and filled with joy; that they became more drunk than

with liquor. Visions appeared and the future was revealed to them, but, Durán adds, this was the work of the devil. Some of them, he relates, became so mentally deranged that they lost their senses completely and even took their lives with their own hands. The eating of mushrooms, however, does not seem to have been as severely punished as drunkenness caused by alcohol. However, it would also seem that mushroom eating was practiced only by the nobles, so excesses could be overlooked among them, while alcohol was too great a deterrent to obedience and good work habits to be tolerated in the masses.

Every activity of the individual was prescribed in the Aztec kingdom. There was an official in charge of every conceivable function. When a child was born, he was registered with a captain in charge of that district. For all male children, school was compulsory. For the common children, there was the

In an Aztec baptismal ritual, the grandmother bathes the newborn child and three boys call out its name.

telpochcalli, which was dedicated to Tezcatlipoca, god of sacrifice, where they studied religion and warfare.

The higher castes attended a more specialized school called *calmecac,* where the codices were read, the calendars studied. Emphasis was put upon oral learning, for much of the traditions and history was memorized exactly as handed down. Parents were responsible to the ward captain for their children's regular attendance.

A captain could have as many as forty families in his care. This meant that he was responsible for governing his district, assigning jobs (even the street and temple sweepers were organized), and government work such as building projects or canal construction. He was also in charge of collecting taxes.

Chiefs of the wards were not drawn from the noble class but were selected on the basis of their ability and connections. There is no question but that a large and powerful bureaucracy grew up that had much to do with making the administration of the empire effective. The classes included slaves, freemen-commoners, employees of the state (the bureaucracy), warriors, nobles who were warrior leaders and whose lineage entitled them to special privileges, the immediate relatives of the ruler, and the ruler himself. The good ruler was expected to be, according to Durán, a shelter for his people, their protector, who carries his subjects in his arms, who encloses them with his cape. His was the final responsibility both to the people and to the gods. Because he assumed these burdens, he was implicitly obeyed, but he too was subject to the wishes of the gods. The wishes of the gods became apparent in omens and superstitions that, because they ruled the king, also ruled the nation.

155

A father teaches his son how to carry firewood,
to load and handle a canoe, and to catch fish with a net.

156

Most girls' education concerned domestic tasks. A mother teaches her daughter to grind corn and to use the loom.

Moctezuma II, who ruled from 1502 to 1520, was probably no more nor less superstitious than the kings who preceded him or the people he governed. Yet this would mean that he believed that good and evil were forecast by the gods. When the old king Nezahualpilli of Texcoco, who was considered a necromancer, told him that he had foreseen the destruction of the Aztec cities in a dream, Moctezuma was deeply concerned, for he realized that there was little hope of changing the prophecy of the gods. It was impossible to turn away from a preordained fate. The ruler of Texcoco further prophesied that the Aztec armies would be defeated in a series of engagements before the final downfall. As each defeat became a reality, the king became more and more perturbed about the future of his country.

A short time after this, a most frightening omen occurred when one of the young priests awoke in the middle of the night and saw a comet flashing across the sky. He immediately awoke those around him, who also witnessed the incandescent object that seemed to point in their direction. Again, the king of Texcoco explained the meaning of the comet as a foretelling of the disasters that were to be visited upon the Aztec Empire. Diego Durán, who repeats this narrative from an earlier chronicle, then relates that Moctezuma said: "If only I could be turned into stone, wood, or some other worldly thing, rather than suffer the future. But what can I do except await that which has been predicted?"

Trying to find some good omens, Moctezuma ordered his chiefs in the various wards to report their dreams so that he might learn some clue about the future. Realizing that it was best not to commit themselves one way or another, they reported that they had no dreams. Moctezuma then asked that they question some of the very old people who had previously dreamed strange things. They were brought to him. When he heard some of their dreams, one that foretold the burning of the temple of Huitzilopochtli and another of the causeways being broken and a flood destroying the royal palace, the king became angry and discouraged, so much so that he threw his informants into jail and starved them to death. After this, no one wished to tell his dreams to Moctezuma. But he was filled with foreboding and found it difficult to sleep or to plan further campaigns against other territories.

At a wedding, the clothes of the bride and groom are tied. That night, bride is carried home by the matchmaker.

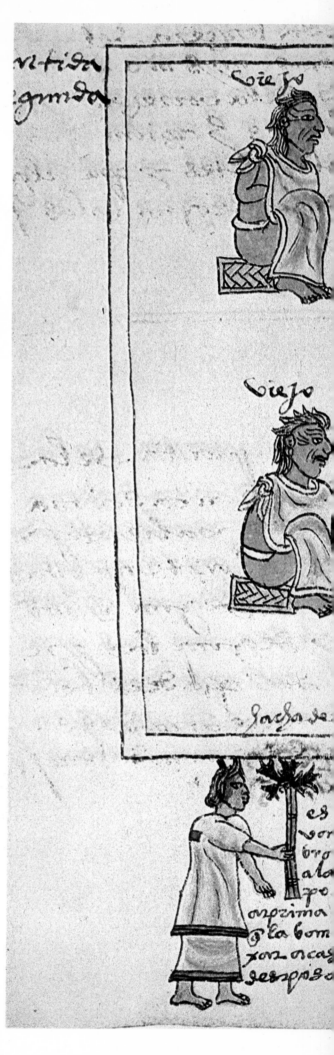

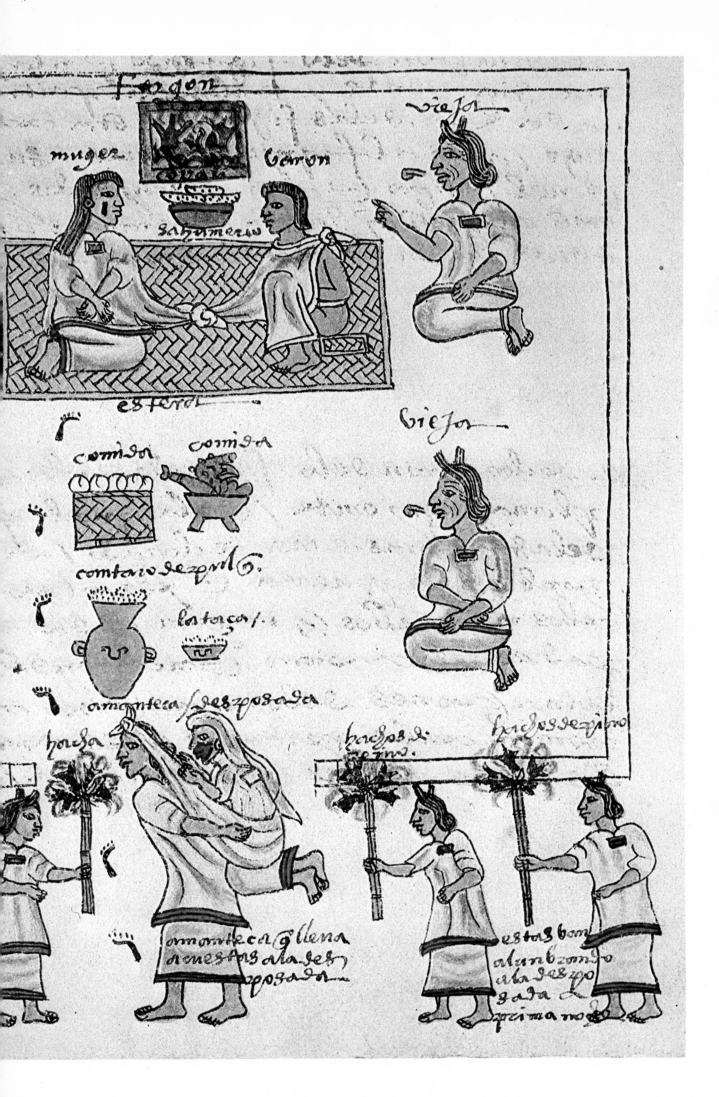

fogon

viejo

muger varon

sahumerio

esteral

viejos

comida comida

contario dexpul 16.

los torcas

amanteca desposada

hacha hachos de hachos dexpino
 pino.

ormanteca quellena aenestas ala des
posada

estas bon alumbrando ala des gada quima no

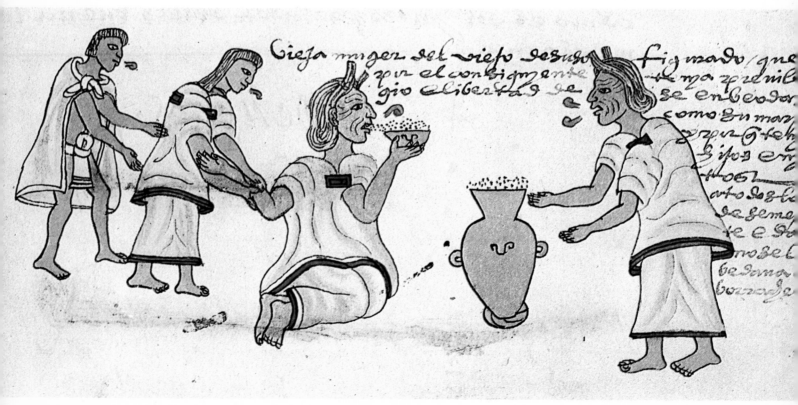

muger moça ğ se enbeoda ua con yno la matauan se gum lasleÿes yfueros delos señores de mexico/

estas dos figuras ac auto y enbẽrtas con roça de muestrã/ ğ el ğ tema accesso carnal con muger ca sada/ los matauan a ƥe dradas/ segun las leyes del señores de mexico/

ladron/matauonle apedra das segun la ley delos .ŝŝ. de mexico/

The girl has been executed for drunkenness; the youth stoned for stealing; the pair in the sheet killed as adulterers.

Older people who had had children could drink in mo eration. The liquor is pulque, made from the maguey cactu

Cieja muger del viejo desuƥa por el consiguiente gio libertad de

figuiado que ma ğ uiñ se enbeodar como su mar ğ te ƥe hÿos en el arto deſa de geme te e da no se beda na borracha

160

The Conquest

In the spring of the year 1519, an Indian runner from the Gulf Coast region appeared at the court of Moctezuma. He said that off the coast were two floating mountains and from them came strangely dressed men. They had skins paler than his own and were bearded. The calendar cycle indicated that it was the time of Ce Acatl, One Reed. Moctezuma, already beset by omens and oracles, now had to consider the possibility that Quetzalcoatl was fulfilling the prophecy he made upon leaving Tula 520 years earlier, exactly ten eras as the Aztecs measured time, and that he was returning to claim the ancient kingdom of the Toltecs, now the Aztec Empire.

As he had often done to obtain information about countries he planned to invade, the ruler dispatched observers disguised as merchants to verify the visions. Upon their return the leader described how he had climbed into a high tree in order to see. In the water, he said, was a great house and in it were men whose skin was pale. Long thick hair grew on the men's faces. They left their huge house to get into a big canoe from which they fished with lines and nets.

The news deeply disturbed the king. Feeling certain that this must, indeed, be the visitation of Quetzalcoatl, for he was said to have been fair and bearded, he instructed the most talented of his artisans to create gifts fit for the god. Messengers were sent to seek out the leader and to determine whether he was Quetzalcoatl by offering him the food of the country, cooked birds and game, fruit and chocolate, which, if he ate, would show he was familiar with the country and was returning to his homeland. After identifying the reborn priest-king, they should plead with him to stay away from Tenochtitlán (modern Mexico City) until his, Moctezuma's, death. Then he would be welcome to take possession and rule over the kingdom.

At the coast, the emissaries placed the gifts along the shore opposite the floating house. When the bearded men came to the shore, they watched from a hiding place. The Spaniards found the gifts and returned to their water-borne palace. The next morning the Aztecs, taking their food offering, sat at the place they had left the gifts. Soon a large

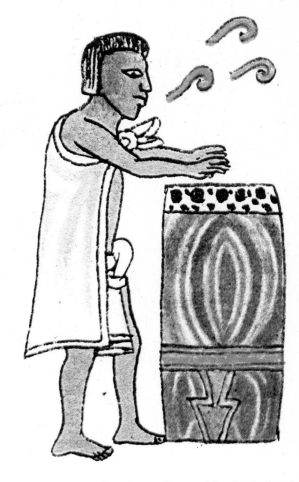

An entertainer beats a drum with a head of ocelot skin. The symbols issuing from his mouth show his singing.

canoe came and took them to the floating house. There Lord Teuoa and the emissaries from Moctezuma, ruler of the greatest empire in North America, met Hernán Cortés, representative of Carlos I of Spain, ruler of the greatest country of Europe.

This historic meeting occurred on Good Friday, April 12, 1519. During the next two years, four leading characters, three men and one woman, would play out dramatic roles in the conquest of Mexico. All three men, by training and experience, were adept in the arts of warfare. The woman was intelligent, able, and fiercely loyal to the man whose possession she became and to the Christianity that she adopted.

Oldest of these was Moctezuma. When the drama

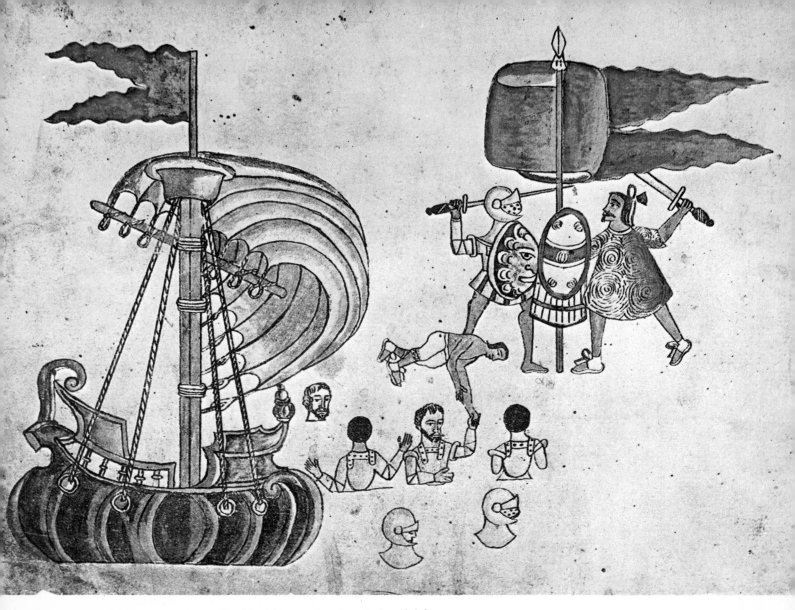

*Cortés' soldiers wade ashore in fanciful draw-
ing that shows armored conquistador battling Aztec warrior.*

began, he was forty-two years old, slim and muscu-
lar. Son of a king, he had been elected ruler because
of his success as a warrior and his knowledge of the
strategy of conquest. As emperor, he had led his
people for seventeen years and had greatly extended
the Aztec Empire, even sending expeditions into
Guatemala and Honduras. But he had made bitter
enemies among the other nations of Mexico.

Moctezuma was a capable ruler as long as he
could function within the traditional framework he
understood and believed. Because he was the leader
of the People of the Sun, he had become deified as
the high priest of Huitzilopochtli. This left him
isolated from other men. Only he, the king-priest,
could make major decisions, but only with the ap-
proval of the gods.

As a young warrior, Moctezuma had learned to
fight wars of conquest with superior forces: bowmen
with flint-tipped arrows, lancers with short spears
that could be propelled from a sling, and the
maquahuitl, a club with sharp blades of obsidian set

into the wood, some of the blades being larg
enough to cut off the head of a man. But he als
relied upon the terror that resulted from the thou
sands of captives who were sacrificed to the Azte
gods. Failure to pay tribute meant the sacrifice o
men and women. He ruled his empire through fea

Yet he was a gentle, quiet-spoken man to whom
the arts of peace meant much. His capital, Tenoch
titlán, was the most beautiful city in Mexico and
according to the first Spaniards to see it, more beau
tiful than those of Spain. A patron of the arts, h
employed artists and craftsmen who worked wit
fabrics, gold, and precious stones. Musicians playe
in his palaces. His botanical garden contained thou
sands of plants and flowers, many from faraway
regions. In the zoological garden were specimens o
all the fauna of Mexico.

Faced with the arrival of the god that he expected
accompanied by other gods who could kill with
flash like lightning and who rode on the backs o
huge and powerful deer, Moctezuma vacillated

The original banner of Cortés is one of the treasures of the historical museum in Mexico City's Chapultepec Park.

First he dispatched valuable gifts and requested that they leave. As the Spaniards continued to advance, his priests and wizards unsuccessfully cast spells to stop them. Finally, when he met these long-expected gods at the gates of his capital, he resignedly accepted his fate and offered Hernán Cortés his empire.

When Cortés made him a prisoner in his own city, he was dismayed. Had Cortés not taken this drastic measure, an almost bloodless conquest might have been possible. But while the emperor was in confinement, Cortés left Tenochtitlán. The Spaniards, led by hotheaded Pedro de Alvarado, seeing an opportunity to kill off the leading Aztec warriors, mercilessly massacred them as they danced and sang unarmed at a religious festival. From this moment the captive king had no influence. His death came a few days later, either at the hands of the Spaniards or from stones thrown by his angry people.

Directly responsible for the death of Moctezuma was Hernán Cortés, a powerfully built man of medium height, thick-haired and heavily bearded, who had been engaged in the art of warfare for almost half of his thirty-four years. Born in the town of Medellín, Spain, Cortés traveled to the Indies at the age of nineteen. In Cuba he acquired Indian slaves and became a successful rancher. The earlier expeditions of Córdoba and Grijalva that explored the lower Mexican coast and returned with gold objects inspired him. He convinced Governor Diego de Velázquez that he could lead a more successful expedition. The governor, avid for the riches of Mexico, first selected Cortés to lead the quest, then realized too late that the young adventurer was too strong a character to represent anyone but himself. Failing to stop him, he became a permanent enemy. When Velázquez sent men to arrest him, Cortés first defeated them in battle, then persuaded them to join him. When the Cuban governor sent deputations to Spain to undermine his authority, Cortés sent his own deputations to plead his case more effectively, for, with them, he sent gold and jewels.

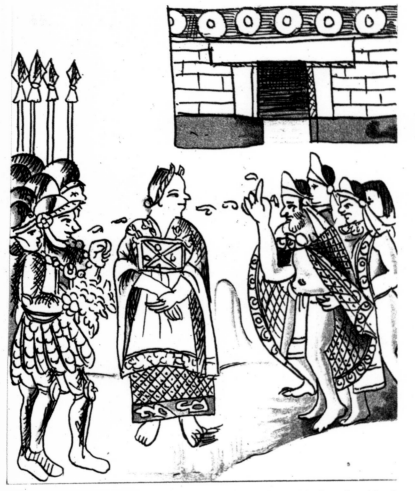

Spanish words reach ear of Doña Marina, Cortés' mistress-translator, then go out from her mouth to the Indians.

A firm believer in the Catholic faith, Cortés never questioned his right to conquer and bring the blessings of Christianity to the soulless heathens of Mexico. His king, who, in the year Cortés landed, became Carlos V, emperor of the Holy Roman Empire, was to Cortés the supreme ruler of the world. As a Spaniard, it was his duty to add wealth and substance to the empire. As a man, he was intent on building his personal fortune.

He believed implicitly in his own judgment. Upon meeting Moctezuma at the entrance of his city, Cortés could not believe that the emperor really meant to turn the nation over to him and he ordered his arrest. In a letter to Carlos V he wrote that it was his own decision to imprison the king, saying, ". . . I would have him either a prisoner, or dead or subject to the royal crown of Your Highness."

After Moctezuma's death, Cortés and his army of Spaniards were forced to leave the city. As they tried to go quietly in the night, they were discovered. That night the Aztecs killed and wounded many Spaniards. It was the greatest defeat suffered by Cortés. This night of retreat and death is known to all Mexicans as *la noche triste* (the sorrowful night).

From now on, Cortés took no chances. He used Indian against Indian. From the beginning of his march from the coast, he had urged the nations under Aztec control to refuse to pay tribute and to ally themselves with the Spaniards. In return, he promised them revenge, loot, and protection. Without these enemies of the Aztecs, Cortés could never have conquered Mexico. They dragged his cannon and fieldpieces through the deserts and mountains, carried and supplied food for the Spaniards, and battled fiercely, often in the vanguard. According to Cortés' figures, by the time he was ready for a final assault on Tenochtitlán, he had gathered 1,199 Spaniards, including reinforcements from Cuba and Jamaica, 84 horses, and 13 boats. His Indian allies numbered over 75,000. His success in gathering this great number of Indian allies was due in large measure to the woman who helped to make the conquest possible.

She was Ce Malinalli, known as La Malinche, meaning the Malin woman belonging to Cortés. She is even better known as Doña Marina, the name she received when she was baptized after being presented as a gift to Cortés by the chief of a tribe into which she had been sold by her mother.

After her birth in a Nahuatl-speaking region, her father, said to be a chief, died. Her mother remarried and sold her to a Mayan-speaking people. She spoke both the language of the Aztecs and the language of the Maya. Upon his arrival in Mexico, Cortés had heard of and located a Spaniard named Jerónimo de Aguilar, who had been shipwrecked eight years earlier and who had learned the Mayan language; therefore, it was possible for Cortés, through Doña Marina, to communicate in the two major Mexican languages.

Cortés at first gave her to his close friend, Alonso Hernández Puertocarrero. When Puertocarrero was sent to Spain to represent Cortés and his captains with all the gold (not just the royal fifth) that had been collected, Doña Marina became Cortés' mistress, as well as interpreter, and bore him a son. She gained the respect of the Spanish captains and was spoken of by Bernal Díaz as having "manly courage" and "never showing a sign of weakness even though she heard daily how we were going to be killed and eaten with chili." Her role transcended that of interpreter, for she knew the ways of the people and could advise Cortés when to be firm and when to negotiate.

After the conquest, she was married to a Spaniard, Juan Jaramillo. It is said that she and her husband became commissioners in the town of Jilotepec and that she lived into the mid-sixteenth century.

Cuauhtémoc, the last great character in the drama of the conquest, was twenty-six years old when his uncle Moctezuma was killed. The immediate successor, Cuitahua, died suddenly of smallpox after reigning only four months. Cuauhtémoc was elected ruler. Unlike Moctezuma, he did not vacillate, but decided to fight until every Aztec was dead. As Cortés advanced, Cuauhtémoc destroyed bridges and

Cortés, carrying lance, rides through the dead after battle at Cholula. The loyal Doña Marina walks by his side.

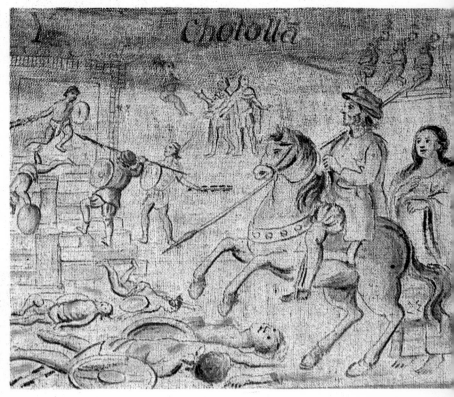

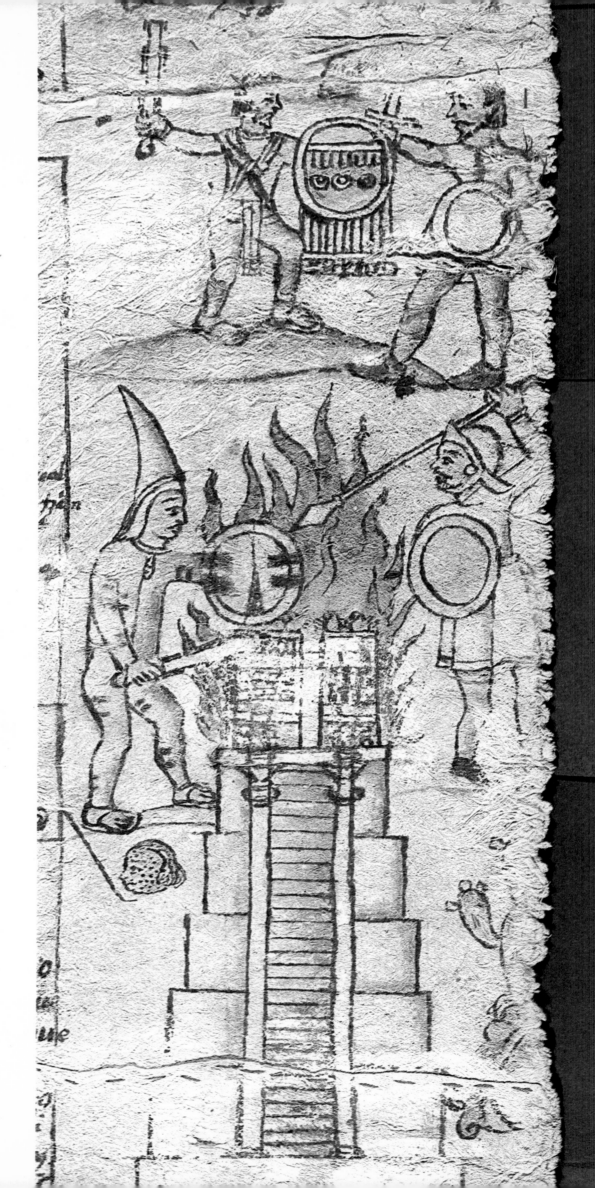

wrecked the causeway. Cortés retaliated by having his allies rebuild them so the horsemen could ride into the city. According to Cortés' figures, on one day alone forty thousand Aztecs died; on another, twelve thousand were slain; on still another, six thousand. The carnage went on. "We fought every day," wrote Bernal Díaz, "for seventy-five days." The Indian allies under Cortés' generalship were responsible for much of the slaughter, although many Aztecs died of starvation or in the fires set by the Spaniards.

Day after day Cortés, to save his own men and what was left of the city, requested Cuauhtémoc's surrender. Negotiations were held, but Cuauhtémoc used these delays to build up defenses and rally his warriors. Toward the end, dead lay piled in the streets and the canals were clogged with corpses. Still Cuauhtémoc fought on. He had no hope of victory. His hope was to kill as many Spaniards as he could and die with his people.

But he did not have this choice. As he directed the remnants of his army, Cuauhtémoc was captured. To Cortés, wrote Bernal Díaz, Cuauhtémoc said: "I have done what I was obliged to do in the defense of my city and my people. I can do no more. I have been brought before you by force as a prisoner. Take that dagger from your belt and kill me with it quickly."

Cortés refused his request. He had more important uses for the popular young leader. For the next three years he allowed him to continue as nominal emperor while the ruined capital was being rebuilt. Then Cortés, having decided to march from Mexico across Guatemala to conquer Honduras and unable to risk a Cuauhtémoc-led revolt in Mexico, took the cacique on his expedition. The harrowing trek across swamps and jungle sapped Cortés' strength and distorted his judgment. Believing a rumor that Cuauhtémoc was plotting against him, which may or may not have been true, Cortés rejected his plea of innocence. Cuauhtémoc was hanged with other suspects near the present border of Chiapas and Guatemala. With him died the long line of Aztec emperors that stretched back, though tenuously, to the ancient Toltecs.

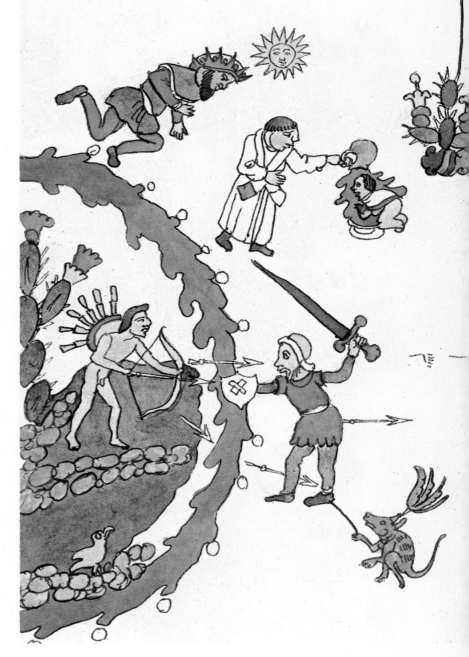

Painting by European-influenced Indian artist shows Aztec defending island, while a priest baptizes an infant.

Spaniards and Aztecs fight as a temple burns. Spaniards objected to human sacrifice, but often killed prisoners.

(11) quauhtemoctzin

ixiuhtzon

ixiuhyacamiuh

ixiuhhlma
techilnavayo

ytepotzoicpal

The last Aztec emperor, Cuauhtémoc, the "fallen eagle," was hanged four years after the fall of the Aztecs.

THE COLONIAL ERA

European civilization and culture cross the Atlantic to New Spain; silver and gold flow in the opposite direction. Some missionaries protect the cultural patterns of the conquered, while the Inquisition spreads the Catholic faith. Viceroys maintain stability for three centuries. The Virgin of Guadalupe appears to Juan Diego. Art, poetry, and philosophy epitomize the brilliance of New Spain.

HISTORICAL CHRONOLOGY	ART CHRONOLOGY
1524 Cortés welcomes arrival of twelve Franciscan friars in Mexico City.	*1519* Banner of Cortés.
1530 Wheat, grapes, olives, sugar cane, horses, cows, pigs, sheep, and goats brought to colony by Spanish settlers.	*1521* Cortés' map of Mexico City.
	1524 Peter of Ghent, relative of Carlos V, founds school of arts and crafts for Indian boys.
1531 Juan Diego has vision of the "Virgin of Guadalupe."	*1530* Construction of Cathedral of Mexico begun.
1535 First viceroy, Antonio de Mendoza, checks powers of landowners.	*1533* Royal and Pontifical University established in Mexico City, modeled after Salamanca.
1540 Coronado explores large area of North American continent.	*1558* Bernardino de Sahagún writes History of the Things of New Spain.
1541 Revolt of Indians in Jalisco threatens Spanish domination.	*1574* Jesuit School of San Pedro y San Pablo opened.
1542 Carlos I of Spain outlaws Indian slavery; restricts colonists' control over Indians.	*1580* Bernal Díaz del Castillo writes True History of the Conquest of New Spain.
1545 Las Casas establishes mission in Chiapas.	*1585* Murals of Huejotzingo, painted at Puebla, depict early missionaries.
1554 Bartolomé de Medina adapts new method for extracting silver.	*1604* Bernardo de Balbuena writes poem La Grandeza Mexicana.
1565 Abortive separatist plot led by Martín, son of Cortés.	*1620* Juan Ruíz de Alarcón, creole graduate of University of Mexico, becomes leading playwright in Spain.
1571 Holy Office of the Inquisition comes to Mexico City.	*1681* Carlos Sigüenza y Góngora refutes astrological superstitions in Libra astronomica y filosofica.
1682 Codification of colonial law published by Spanish crown.	*1693* Death ends brilliant career of Sor Juana Inés de la Cruz, New Spain's greatest poet.
1767 Jesuits expelled from New Spain.	*1716* Painting of Sor Juana Inéz de la Cruz by Miguel Cabrera.
1769 Padre Junípero Serra establishes Franciscan mission of San Diego in Alta California.	*1722* First newspaper, Gazeta de México, appears.
1789 Policy of "free trade within the empire" applied to New Spain.	*1783* Carlos III endows Mexico City Academy of Fine Arts, Botanical Garden, and School of Mines.
1803 German scientist-explorer, Baron von Humboldt, visits Mexico City.	*1787* José de Alzate edits Gazeta de Literatura.
1808 France invades Spain, provoking crisis in New Spain.	*1803* Equestrian statue of Carlos IV by architect and sculptor Manuel Tolsa.

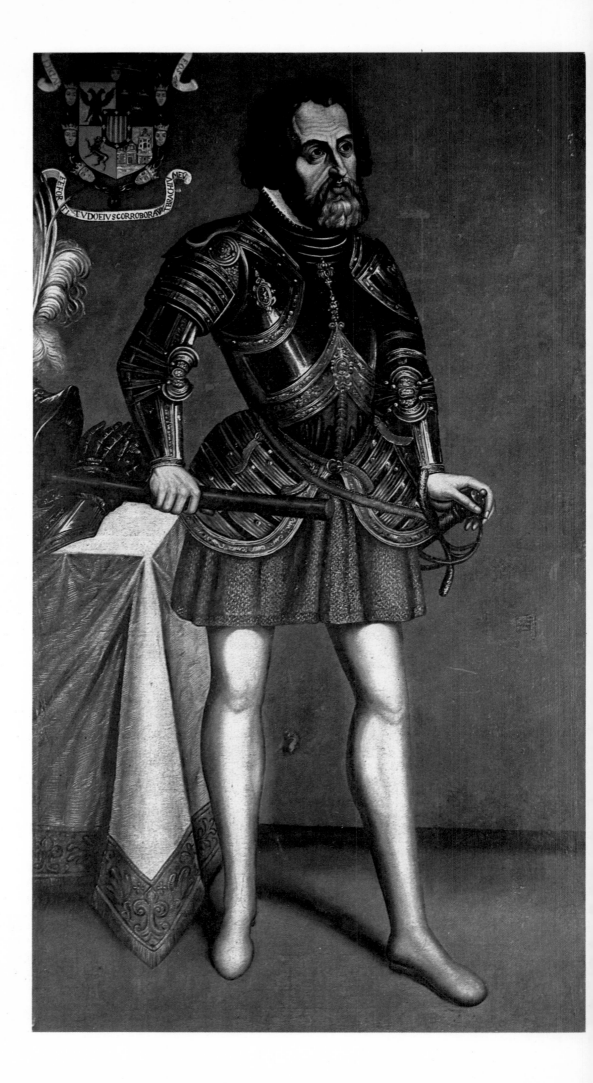

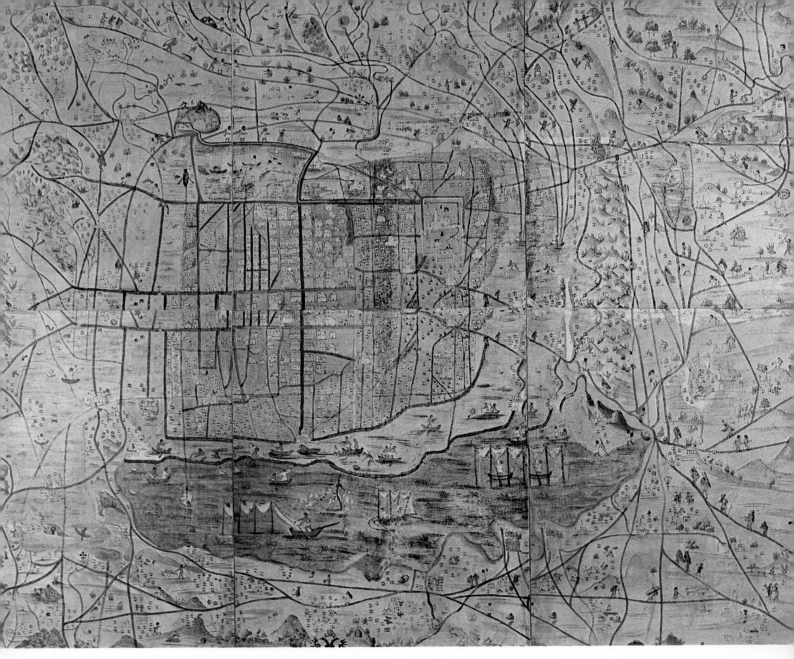

This likeness of Cortés hangs in a room at the Hospital de Jesús, which he founded, and where he was buried.

Lakes almost completely surrounded Mexico City at the time of the Conquest. Map dates back to the sixteenth century.

New Spain

From the staggering quantity of official records available in the Archivos de los Indios in Spain, the Archivos de Nueva España in Mexico, the compilations of history of New Spain made by Sahagún and the friars, the five letters of Cortés to Emperor Carlos V, the books of Bernal Díaz del Castillo, Francisco López de Gómara, and others, it is possible to prove that the Spanish Conquest was the most brutal in the history of the New World. But it is equally possible from the same original sources to demonstrate that the Spaniards were more enlightened and humane in their colonization than their European counterparts. In fact, considering the time, the fervor of religious belief, the prevalence of witchcraft and sorcery, the barbaric rules governing warfare, the political and social climate of Europe, the Spanish were relatively intelligent, efficient, and compassionate colonizers. This, of course, does not excuse them for their rapacity, but it will help to put Spain's conquest of Mexico in better perspective if it is known that the Portuguese, British, French, and Dutch colonized and enslaved with less efficiency and more brutality.

As colonial administrators and missionaries, if not as conquistadors, the Spanish developed a sense of responsibility toward the conquered which was unique for the time. The civil rights of the Indians were not only argued on both sides of the ocean but protective laws were passed. Nothing comparable to this took place in the imperialism of the other Euro-

pean nations. No body of civil legislation protecting the conquered peoples evolved. No meaningful effort was made to civilize the indigenous populations through education and religion, and no serious attempt was made by these colonizing governments to preserve the histories and customs of the Indians. Thus the Indian population and culture elsewhere in America was, in a matter of a few years, almost completely destroyed.

One way to decide whether a nation colonized well or badly is to examine the results to the native population, and it is to the credit of Spain that in her colonies the Indian peoples and the rich Indian heritage were not exterminated. In New Spain, education and Christianization of the Indian was a primary aim. Intermarriage was encouraged. Language, customs, and traditions were both imposed and absorbed. Within three hundred years the colony had the will and the strength to break away from the parent country. Within another fifty years it was able to elect a pure-blooded Zapotec Indian as president of its republic. No other colonial possession has ever shown such results.

Another way to evaluate the contribution of an imperial power is in terms of the cultural level of her colonial possessions, and in this respect Spain compares favorably with the rest of Europe. But the positive aspects of Spanish colonization are not generally known due to the vast propaganda developed and continued against Spain by her adversaries. In this propaganda, Spain is presented as the most benighted of the European colonial powers, and as prime evidence the Inquisition is cited as the horrible example of her violent policy.

Violence and confusion marked the Conquest. Here, Aztecs and a priest are hanged, Indians and Spaniards drowned.

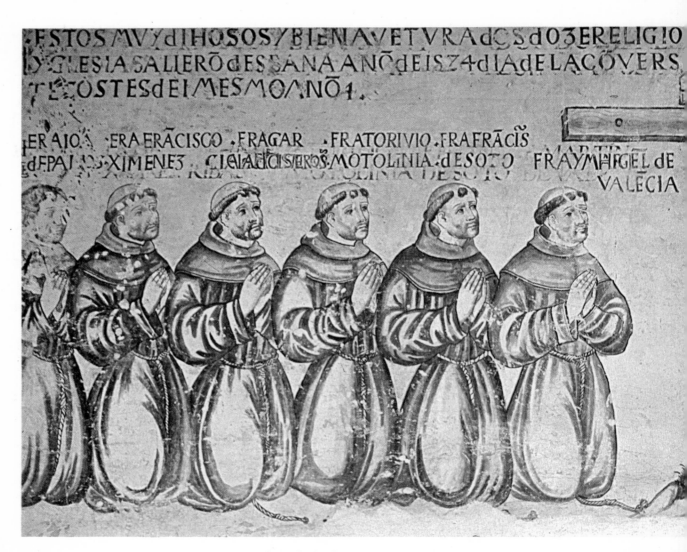

ESTOS MVyd IHOSOSY BIENAVETVRAdOSdOZERELIGIO
yGIESIA SALLEROdESSANA ANOdEI524dIAdELAÇOVERS
TEÇOSTESdEIMESMOANO1.

ERAIO. ERAERÃCISCO .FRAGAR .FRATORIVIO .FRAFRÃCIS
dEPAUSXIMENES CIGIAGISIEROS MOTOLINIA dESOTO FRAYMHÃGELdE
VALECIA

Twelve Franciscans who arrived in 1524 are here depicted in what is probably the oldest European mural in Mexico.

The pope authorized the Franciscan order to convert the Indians to Catholicism in this letter patent of 1523.

174

It is true that the Spanish burned heretics, that distinguished and intelligent men languished in jail, and that the Spanish were extreme in their prejudice and orthodoxy. But during the same era, it should be remembered, the British, Portuguese, and Dutch sold millions into slavery, and the British, French, and Germans, in the heyday of their witch-hunting, burned and tortured thousands. These inhumanities went ahead unabated throughout Europe, and actually only in Spain did efforts to abolish slavery make progress. In this period of relentless religious persecution, the records show that, during three hundred years of Spanish rule in America, less than one hundred persons were sentenced to death by the judges of the Inquisition.

One does not have to be an apologist for the Inquisition to point out that this institution had a moderating influence on the frequent waves of hysteria and fanaticism, and to indicate the differences between witch-hunting in England, France, Germany, and the English colonies and the situation which existed in New Spain. As elsewhere in the Spanish world, here it functioned as a high court with authority to examine and bring to trial moral transgressors. At least 90 per cent of its investigations, trials, and convictions or acquittals were concerned with such crimes against morals as bigamy, prostitution, sodomy, homosexuality, perjury, the practice of astrology, and blasphemy. None of these were crimes specifically against "the purity of the faith," nor were the punishments, in the framework of the times, unduly severe. The purpose of the Inquisition court, as set up by Philip II in 1571, was specifically to defend, protect, and maintain the purity of the holy faith and good morals. The power of the Inquisition was derived from the king, as head of the church in Spain, and, in a more tenuous way, from the pope in Rome. As in all courts, some administrators of the Holy Office were conscientious men; others were incredibly cruel and sadistic.

One crime rarely mentioned, but dealt with by the Inquisition, was the use of peyote, a strong narcotic derived from a cactus. Like the mushrooms mentioned earlier by Sahagún and Durán, the effects of

Indian artists like the one shown here were taught to paint in the European style by Spanish missionaries.

peyote were hallucinatory. Upon discovering its use by an increasing number of the Mexico City community, the Inquisition in 1620 declared it an act of superstition and it was condemned as being opposed to the "purity and integrity of our holy Catholic faith." However, the Indians who used it were not affected since they were outside the jurisdiction of the Inquisition's court.

In the years preceding the Inquisition, Carlos V, emperor of the Holy Roman Empire, was like a man with two heads on one body. As head of the Spanish Church, his religious authority was almost as great as the pope's (in Spanish affairs, greater). He was also the political leader of the greatest empire of Europe. After the Conquest, the emperor acted swiftly to impose his authority as both sovereign and spiritual leader in New Spain. The con-

quistadors, including Cortés, who had served their purpose, were paid off in land, tribute, and titles.

But Cortés found no peace, either of mind or body, in New Spain. Younger adventurers received licenses to explore Central America. Returning from his unsuccessful Honduras expedition, he found that his authority in New Spain had been completely undermined. He had even been declared officially dead. Journeying to Spain, where he hoped to be named viceroy or governor, Cortés received little satisfaction. The king awarded him the title of marquis and bestowed on him a huge land grant consisting of all of the Valley of Oaxaca, which at that time included the state of Chiapas and most of Guatemala. Upon his return to New Spain, he retired to Cuernavaca, where he supervised the construction of a magnificent palace which is still in

Indians were converted to Christianity by the thousands. Here the bishop of New Spain officiates at a baptismal rite.

xcellent condition. He did not, however, live in it or very long, but, between the years of 1527 and 535, directed a series of exploratory expeditions. Most of them brought him neither prestige nor dditional riches. Only one of the three ships he dispatched to the Philippines reached there, and it vas unable to return. Others of his ships were vrecked while exploring the southern Pacific Ocean. One of his captains explored Lower California and Cortés himself led an expedition across he Gulf of California (sometimes called the Sea of Cortés), but was unsuccessful in finding gold or in ounding a colony. His activities brought him in lmost continuous conflict with the viceroys. In January of 1540, at the age of fifty-five, he sailed back to pain. There he lived out his last seven years, neglected by king and court, and died while making

preparations for his return to New Spain. In his will he directed that his remains be buried in the country that he conquered. They now rest at the Hospital de Jesús, which he founded in Mexico City.

While Cortés was exploring the South Seas and the California coast, the friars of three orders, Franciscan, Dominican, and Jesuit, were busy bringing Christian order to the ravaged country. The first of these dedicated padres accompanied the early expeditions of the conquistadors. Most interesting among them was Fray Pedro de Gante, founder of the first mission school, the College of San José, where languages and fine arts were taught. Here Indian chants became Christian hymns. But the largest and most influential contingent arrived as a group on January 25, 1524, at the port of Veracruz, where the conquistadors had started their victorious march

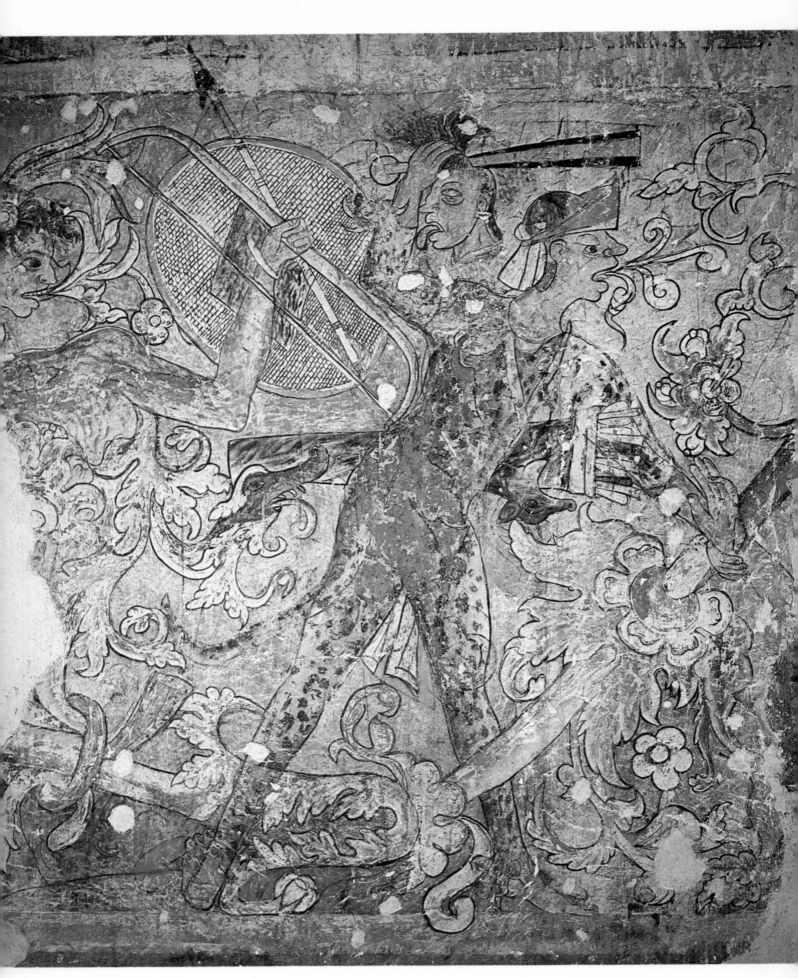

Painted on a church wall, this mural blends European realism with the native sense of color and abstract design

The Indian artist showed the horse, never before seen, with a man's head, hands holding weapons, and sandaled feet.

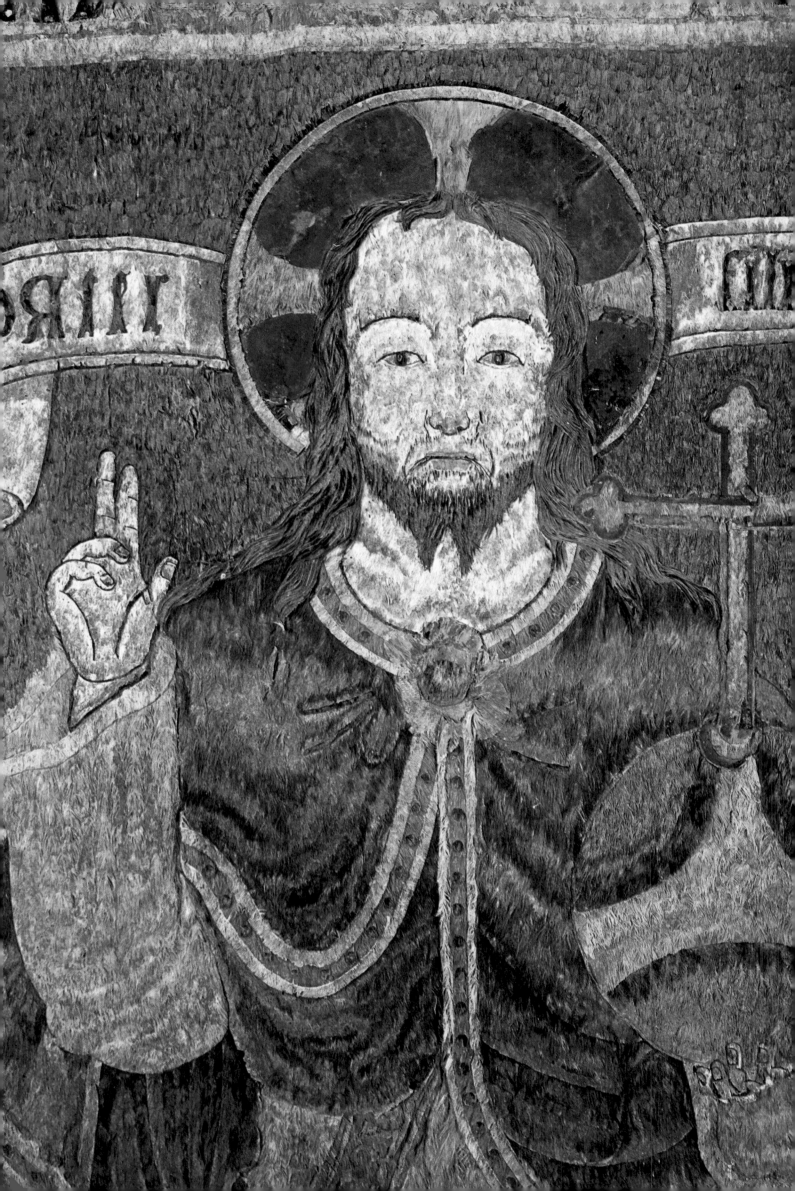

An Indian artist of the sixteenth century created this rendering of Christ in Majesty *entirely out of feathers.*

One friar tries to convert two apparently willing Indians while another protects his flock from attacking demons.

across the country. The humble friars numbered but twelve and were led by Padre Martín de Valencia. Wearing rough homespun garments, they elected to walk barefoot across the difficult terrain to Mexico City. All along the trail the Indians watched the slow progress of these men of peace, so different from the armed and armored soldiers on their huge horses. These were men they could understand. Their own priests had humbled themselves, had been celibate, and had upheld the moral laws. Soon the friars were accepted and respected. Conversion did not come overnight, but in those areas where the Indians had been conquered by force of arms, the battle for their souls progressed rapidly.

A great controversy was to arise in which two friars, both concerned with the welfare of the Indians, violently disagreed. They argued and published their views on the question of whether the Indian should be first conquered and then converted or whether conversion should be of their own free will. The friar who was to become the best known for his defense of the Indian was Fray Bartolomé de Las Casas, who took the position that the Indians should not be forced; that the missionaries should go among them and convince them through peaceful means. One of those who opposed this position was Fray Toribio Motolinía, one of the first group of twelve Franciscans who arrived in Mexico and an equally important figure in Indian affairs. He did

not oppose peaceful conversion, but advanced the argument that it was impractical. He buttressed his argument with examples of peaceful groups of friars who had been massacred by the native population in the West Indies before they had had an opportunity to see the advantages of the Christian religion. At first, Motolinía's view was to prevail, but Las Casas was in time to prove his point in 1536, when, accompanied by unarmed friars, he journeyed to northern Guatemala. There he peacefully converted Indians who had previously resisted the armed efforts of the conquistadors.

Las Casas and those who advocated peaceful conversion had to struggle against many obstacles. One of these was the establishment of a legal device used by the conquistadors to make claim to the territory of the Indians. It was called the *requerimiento* and it provided that, before any military engagement large or small with non-Christian people, a statement of principle must be read to them. In the message it was explained that God appointed St. Peter sovereign over the world and that one of St. Peter's successors (the pope in Rome) had assigned the islands and the mainland of the Ocean Sea to the Catholic kings of Spain. It explained that religious men who accompanied the army would teach the Christian faith, which, if accepted, would allow the Indians to retain their lands subject only to the laws of Christianity and the sovereignty of the Catholic

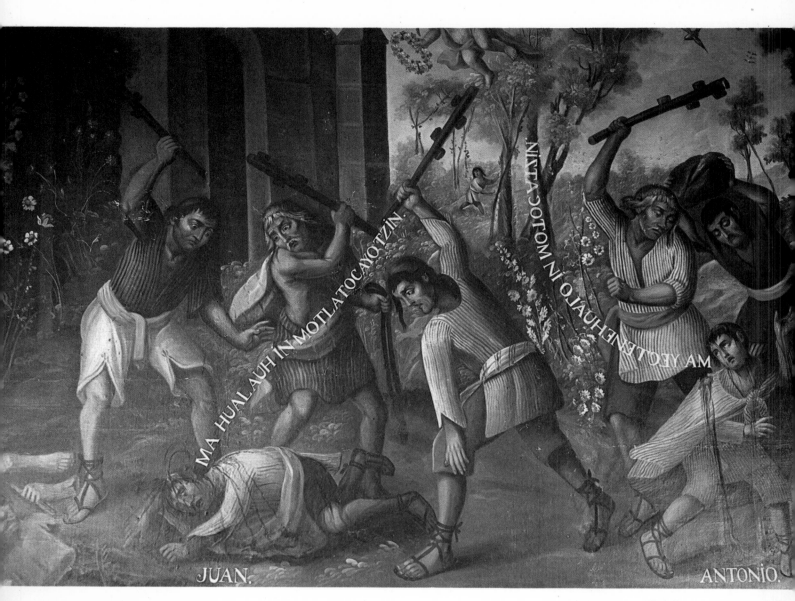

The first Indian-Christian martyrs were noble Tlaxcalan children. Pagan villagers clubbed them to death.

kings. It continued by explaining that failure to accept this peaceful offer would result in war being declared against them, and that their failure to accept the true God would place the fault upon themselves for the deaths and material losses they would be made to suffer.

Of course, the *requerimiento* was a theoretical justification of the Conquest. Hence it did not supply the means through which the conquistadors could extend their control over the Indians. This was accomplished through a more important legal device, the *encomienda*, a royal grant made by the crown to the conquistadors giving them the right to collect tribute from a designated group of Indians. The Indians granted in *encomienda* were not to be considered as slaves, nor even as vassals, but free men under the protection of the crown. But they were expected to pay tribute in return for protection

and education. The amount of tribute or personal labor required was subject to agreement between the king and the grant holder, who promised to protect, govern, and educate them. The *encomienda* system had been tried in Hispaniola and in Cuba and had worked well for the Spaniards in establishing their control over the Indians, and it was to work equally well in New Spain.

But this system was subject to many abuses since the *encomenderos* often exploited the Indians and managed their affairs through overseers. Fray Motolinía wrote: "As soon as the land was granted, the conquerors entrusted servants with the collection of the tribute and to look after their many affairs. These men resided, and still reside, in the villages and, even though they are mostly peasants from Spain, they are in charge of the land and order the native lords around as if they were their slaves."

'And," he continued, "they are the drones who eat the honey made by the poor bees who are the Indians. They are not satisfied with what these poor people give them, but keep demanding more."

In the early years, Motolinía continues, the overseers maltreated the Indians so badly, overworking them, sending them far from their land, and giving them difficult tasks, that many died because of them or at their hands.

The abuses of the *encomienda* system were, however, brought to the attention of the crown through the efforts of men like Las Casas, and by the middle of the sixteenth century the crown began the gradual abolition of the *encomienda*. By the seventeenth century most of the grants had been rescinded.

In this way the power of the landowning class over the Indians was checked, and the crown placed the administration of New Spain under crown officials. In 1535, Carlos V named the first viceroy (literally vice-king) to New Spain, Antonio de Mendoza. He was one of the best of the line of sixty-one viceroys who followed and who maintained a high degree of political stability over the next 275 years. A majority of these representatives of the crown were responsible, hard-working administrators. They represented not only the king of Spain in the fast-growing colony but, more important, the peoples of New Spain to the crown. Some of them added immensely to the territorial empire by extending the boundaries of New Spain through exploration. Viceroy Mendoza organized the famous expedition of Francisco Vázquez de Coronado, who penetrated as high as Kansas, discovering and claiming new lands in the north and east.

Another famous Christian martyr, the twelve-year-old son of the cacique Acxotecatl, was slain by his own father.

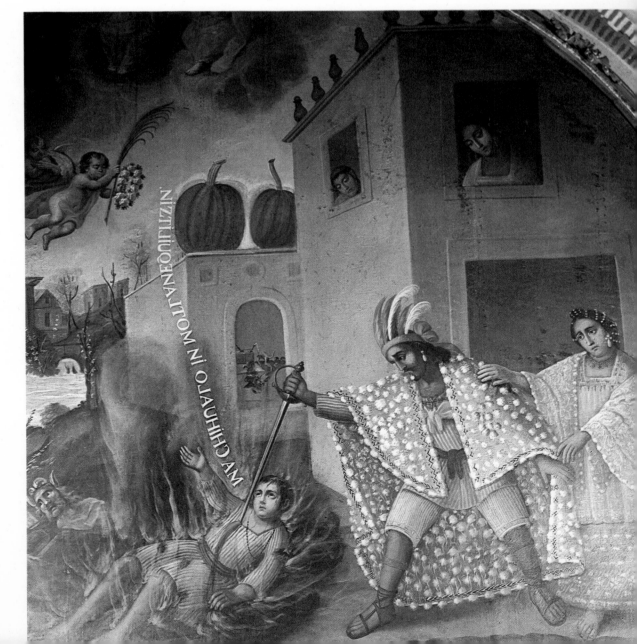

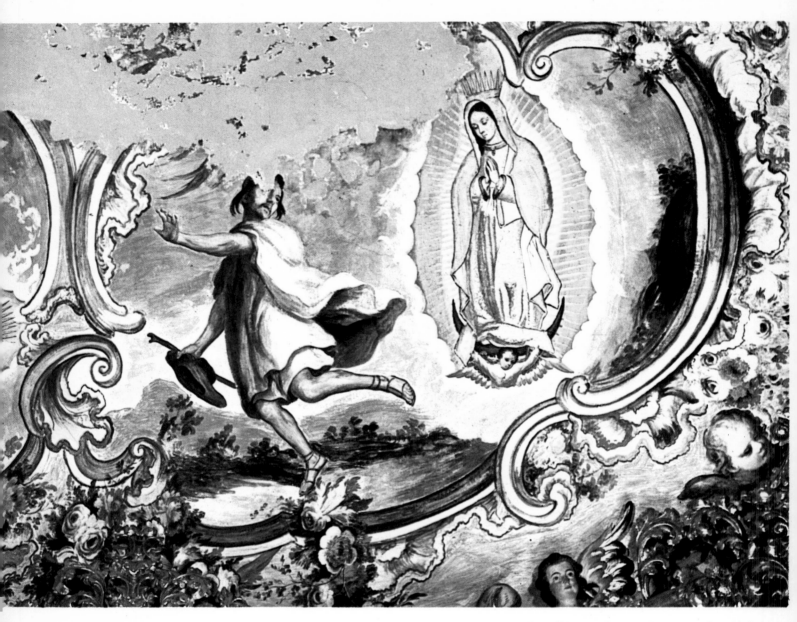

Juan Diego, only recently converted to Christianity, flees in fright as the Virgin of Guadalupe appears before him.

Virgin of Guadalupe

On a cold morning in December, ten years after the fall of the Aztec Empire, an Indian convert to Christianity saw a vision that has persisted in Mexican religious belief. According to his story, he was climbing the hill of Tepeyac in Mexico City when he heard a voice call "Juan Diego." He turned, astonished, and there saw a dark-haired madonna with bronze skin, draped in a long blue cape under which she wore a long white robe embroidered with gold. Her eyes cast down and hands in the position of prayer, she was bathed in a halo of brilliant sunlight. She said she was the mother of God and requested that he go to the bishop to announce that she wished a shrine to be erected in her honor on the hilltop.

Many versions of Juan Diego's extraordinary experience exist. But all have the following elements. He hears the voice calling his name and sees the vision who identifies herself as the virgin mother. She causes roses to bloom in the barren earth. Juan gathers them into his *tilma,* the long cotton shirt worn by the Indians, and goes to the palace of the bishop. The beautiful roses, so completely out of season, gain him entry to Bishop Zumárraga. In his presence, he opens his arms, the roses fall to the floor, and a likeness of the figure and dark face of the Virgin of Guadalupe is revealed on his garment.

This was the virgin to whose shrine in Spain

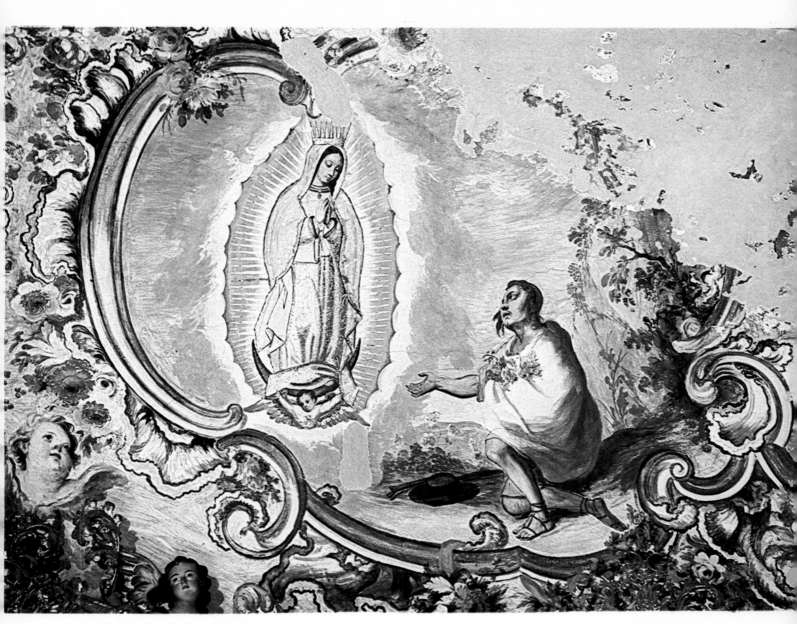

*As Juan kneels, she speaks and causes roses to grow
on the rocky hillside. Her shrine was built on the spot.*

Columbus made a pilgrimage after his first voyage. In 1528, Hernán Cortés had prayed there for the soul of a dead comrade in arms, Gonzalo de Sandoval.

The appearance of the Virgin of Guadalupe in New Spain caused a great sensation among both Spanish and Indians. The shrine she requested was soon built on the crest of the hill. There had previously been a temple to Tonantzin, an ancient goddess worshiped as "our mother" by the Aztecs on the same spot. In the years that followed a church was erected next to the shrine and in it, even today, pilgrims go to see the miraculous *tilma* of Juan Diego which is enclosed in glass high above the ornate altar.

Two hundred and twenty-three years later, after many proofs of her phenomenal cures to pilgrims visiting the shrine, she was declared by papal decree patroness and protectoress of New Spain.

The adoption of the Virgin of Guadalupe in New Spain gave great impetus to the teachings of the early friars. Other shrines were built, often on the ruins of temples of ancient gods. Churches, convents, and monasteries arose almost overnight, built by Indians under the direction of the friars, many of whom became architects and engineers through necessity. Decoration of the interiors of the churches became the province of Indian artists and craftsmen. Murals were painted on walls; plaster sculpture in bright colors decorated vaults and arches. In hundreds of churches and convents today, the influence of the padres is evident in the selection of subjects,

while the artistic spirit reflects earlier Indian cultures.

In the early days of Christian instruction, two distinct attitudes were prevalent. Some friars believed it important to utilize what was good from older religious forms and compatible with Christian patterns of worship. The fundamentalist members of the clergy insisted on a complete break with the past. But over the years the views of former groups have prevailed.

After the fall of Tenochtitlán, quarrels over the treatment of the Indians between the friars and the government reached such an impasse that Bishop Juan de Zumárraga and his followers directly opposed the authority of the *audiencia,* the administrative and legal group that represented the king. Zumárraga preached angrily to his congregation, of which Nuño Beltrán de Guzmán, chairman of the governing group, was a member. Guzmán became so incensed that he had his bodyguard drag the bishop from the pulpit. The congregation rose in defense of Zumárraga and warned the representative of the king against molesting him. In retaliation Guzmán censored the mail going back to Spain, which made it impossible for the bishop and his friars to plead directly to the king for justice toward the Indians. The bishop had a letter listing the injustices encased in a cake of wax, then put into a barrel of wine and smuggled across the ocean, where it ultimately reached the king. As a result, Guzmán and the *audiencia* were replaced.

Zumárraga is well remembered for his humanity, knowledge, and energy. He was founder of the University of Mexico; introduced the printing press, which he brought with him from Spain; and wrote the *Doctrina Breve,* a work that brought the humanistic thinking of Erasmus to the New World. In this work, one of the first to be printed in New Spain, he advanced the modern idea (after Erasmus) that the

In the sixteenth century, Mexican friars crossed the Pacific Ocean and tried to bring Christianity to Japan.

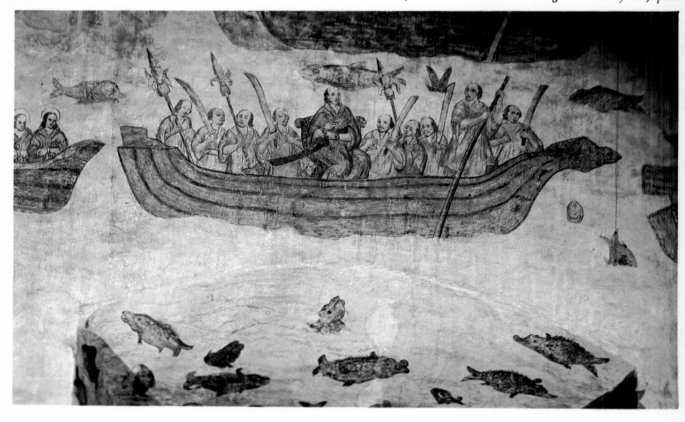

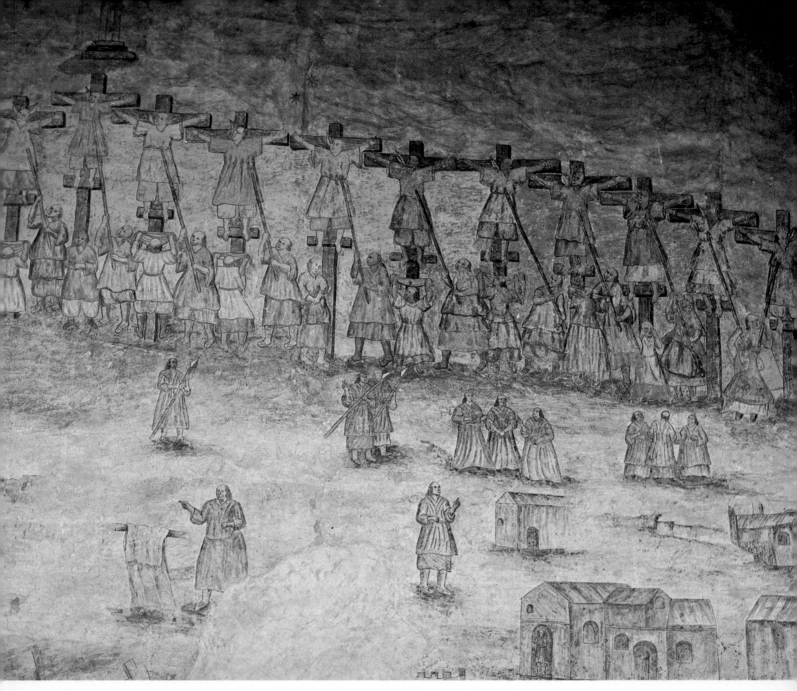

Japanese warlords crucified the friars. This mural depicting the grim event is in the cathedral at Cuernavaca.

holy scriptures should be translated into the languages in use among the people.

The native languages were a major obstacle to the education of the Indians. Yet the early friars immediately recognized the importance not only of teaching the Indians to speak Spanish but of learning their language, so as to obtain their regard and confidence more quickly. Proof of how diligently they worked is illustrated by the 141 books written on or about indigenous languages during the last three-quarters of the sixteenth century. Leader in this work was Fray Bernardino de Sahagún, whose *Historia General de las Cosas de Nueva España* is a

fascinating detailed work covering history, laws, customs, folkways, religion, and the arts. To accomplish this, Sahagún instructed a group of dedicated friars in the techniques of interviewing the keepers of the oral history and traditions—the *tlamatini*. He then went on to compile and write his great multi-volume work. Without his labors neither this book nor any comprehensive work on ancient Mexico could have been written. Yet he was only one in the long line of learned and sympathetic friars that stretched from the time of the Conquest through the sixteenth, seventeenth, and eighteenth centuries in New Spain.

(Overleaf) Merchants hawk their wares as Indians, mestizos, creoles, and peninsulares *watch the viceregal procession.*

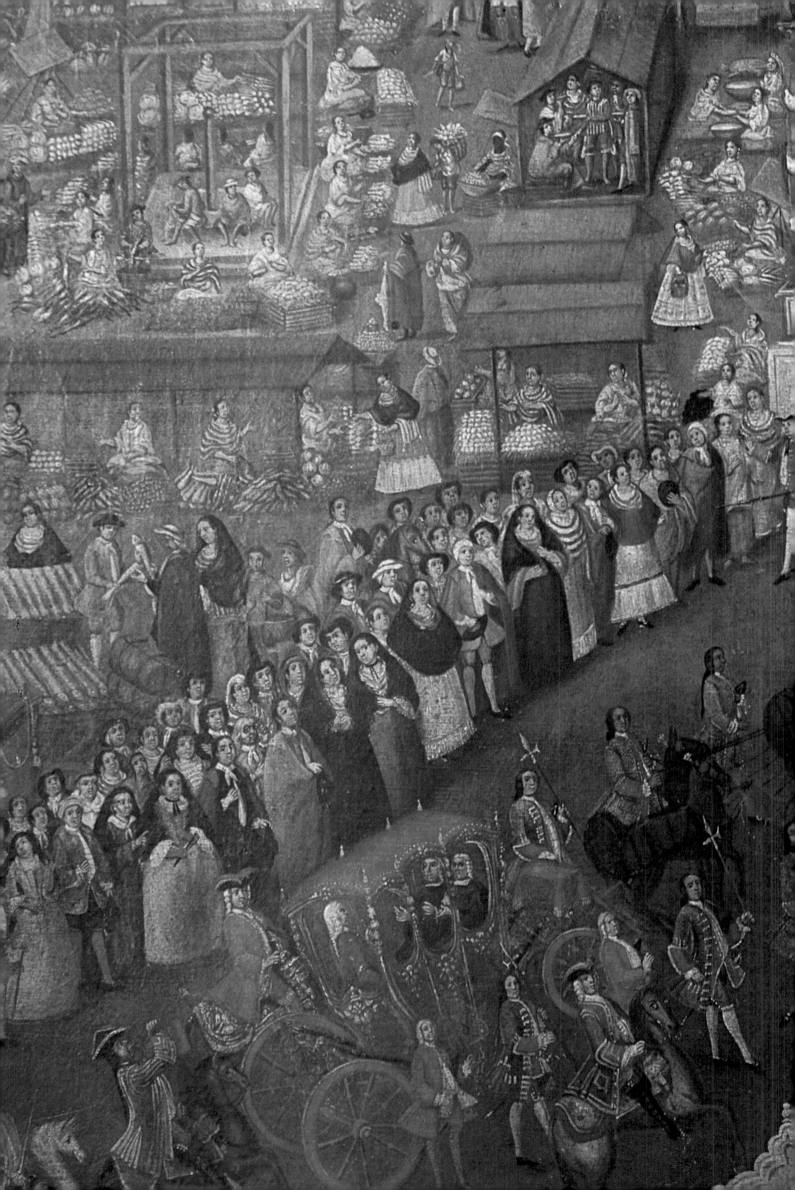

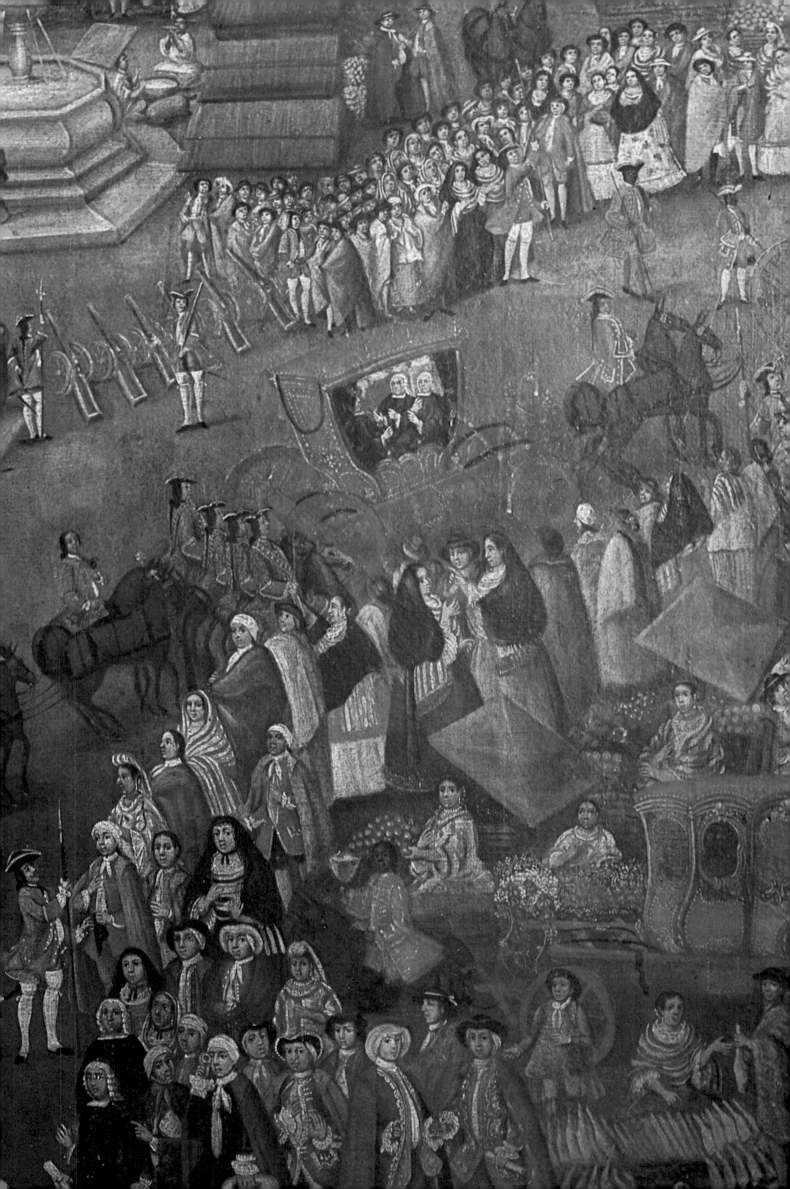

Mining

"Spaniards have a disease that can only be cured by gold," said Hernán Cortés, and, during the sixteenth and seventeenth centuries, the cure was extended to silver as well. The Indians had previously done little except surface mining, and that on a small scale. The adventurous settlers from Spain, having no desire to become farmers, concentrated on locating and operating mines. Legally, all mines belonged to the king, but in actual practice mineral rights went to the discoverers so long as the royal fifth was promptly paid.

Fray Motolinía describes the mines as being a great plague. "The gold . . . was the second golden calf, and worshiped as a god, and they come from Castile through many dangers to adore it. Now that they have it, please God, it may not become their own damnation." He wrote that the number of Indians who died in the mines exceeded by thousands those killed by the Spaniards with their Indian allies in the Conquest.

Alexander von Humboldt, who made an extensive visit to the mines in the latter part of the eighteenth century, mentions without comment that as many as 1,800 men worked below the surface in one mine, each carrying a small saddle on his back on which to carry ore. These men, he wrote, were known as little horses (*caballitos*). Humboldt estimated that in one year New Spain produced fifteen times as much gold as all of Europe and over fourteen times as much silver.

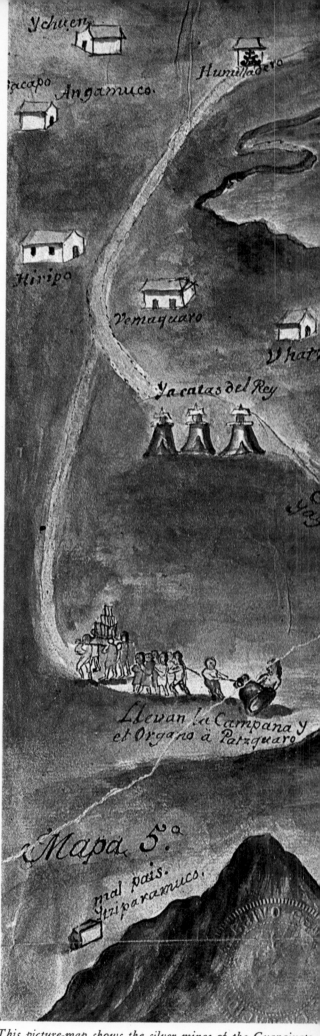

This picture-map shows the silver mines of the Guanajuato region. Mines like these vastly enriched the Spaniards.

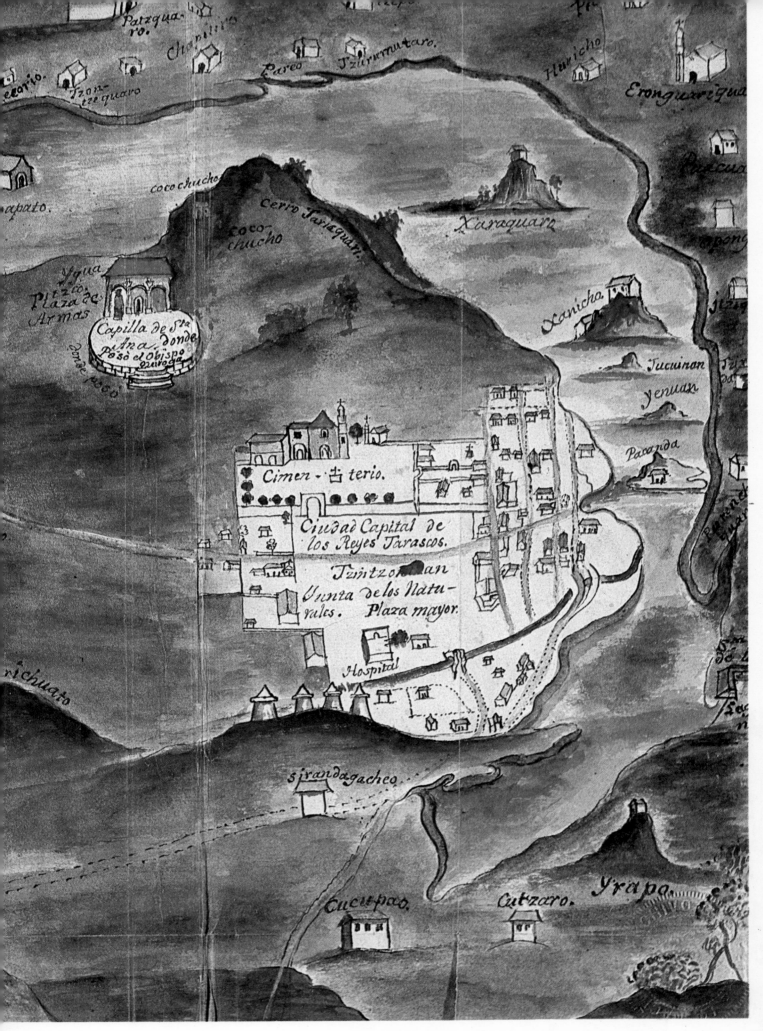

Text labels visible within the map illustration:

Patzquaro.
Chanitiro
Pareo. Tzicumutaro.
ecario.
Tzontzequaro
Havicho
Eronguarigua
apato.
cocochucho.
Cerro Tariaquari.
coco chucho
Xaraquarz
Pazcua
Ygua
Pitzco.
Plaza de Armas
Xanicha.
Capilla de Sta. Ana donde Paso el Obispo Quiroga
Jucuinan Yenuan
Pacanda
Cimen-terio.
Ciudad Capital de los Reyes Tarascos.
Tzintzontzan
Yunta de los Naturales. Plaza mayor.
rtchuato
Hospital
Sirandagacheo.
Cucupao.
Cutzaro.
Yrapa

A band of villagers moves the treasures of the cathedral
to the silver-mining town of Pátzcuaro above the lake.

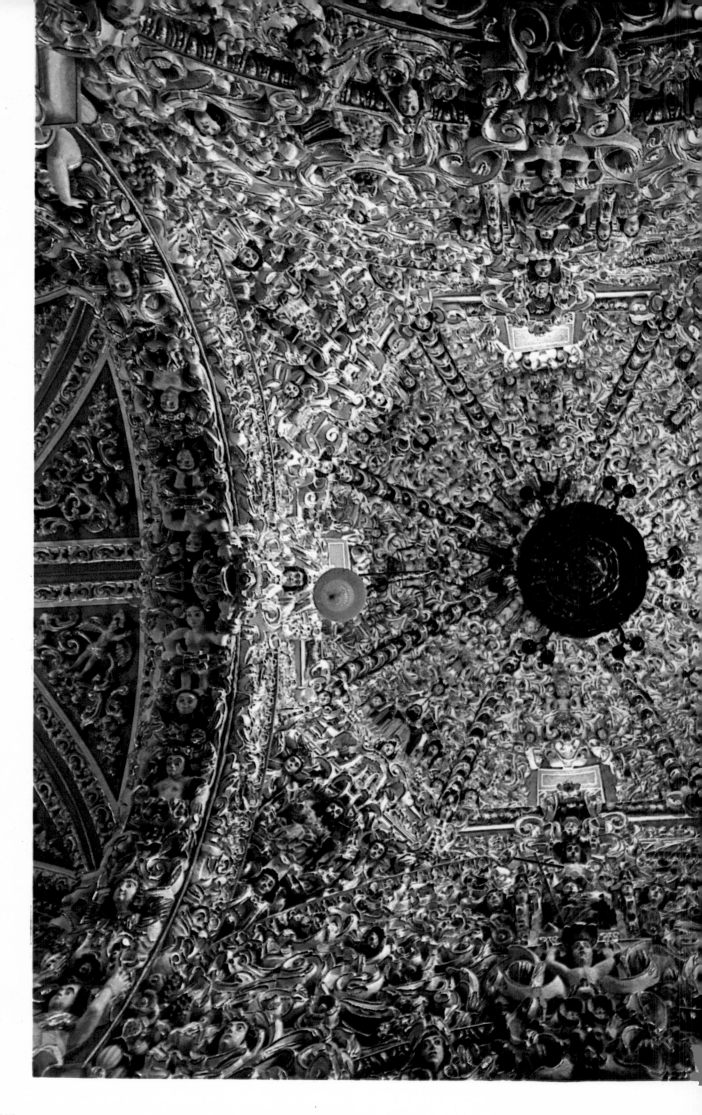

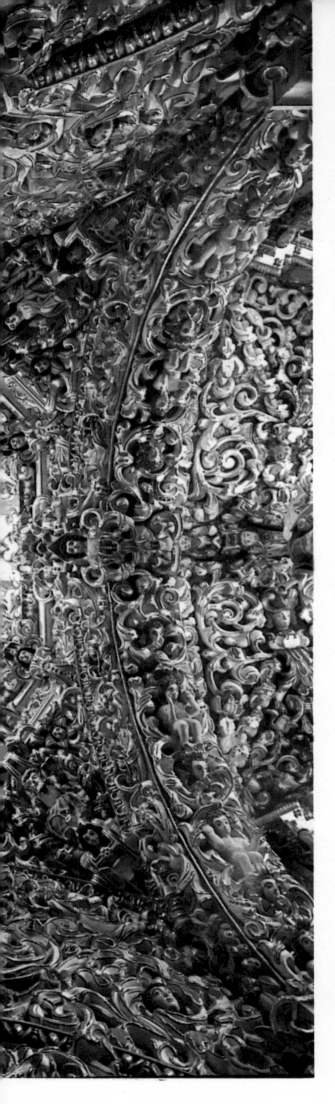

An Indian cherub in a feathered headdress guards a niche in the church of Tonantzintla in the state of Puebla.

An example of European sculpture in New Spain is this life-size statue of Don Pedro Ruiz de Ahumada at Tepotzotlán.

This church at Santa María Tonantzintla, with its intricate roof, is a brilliant example of Indian-European art.

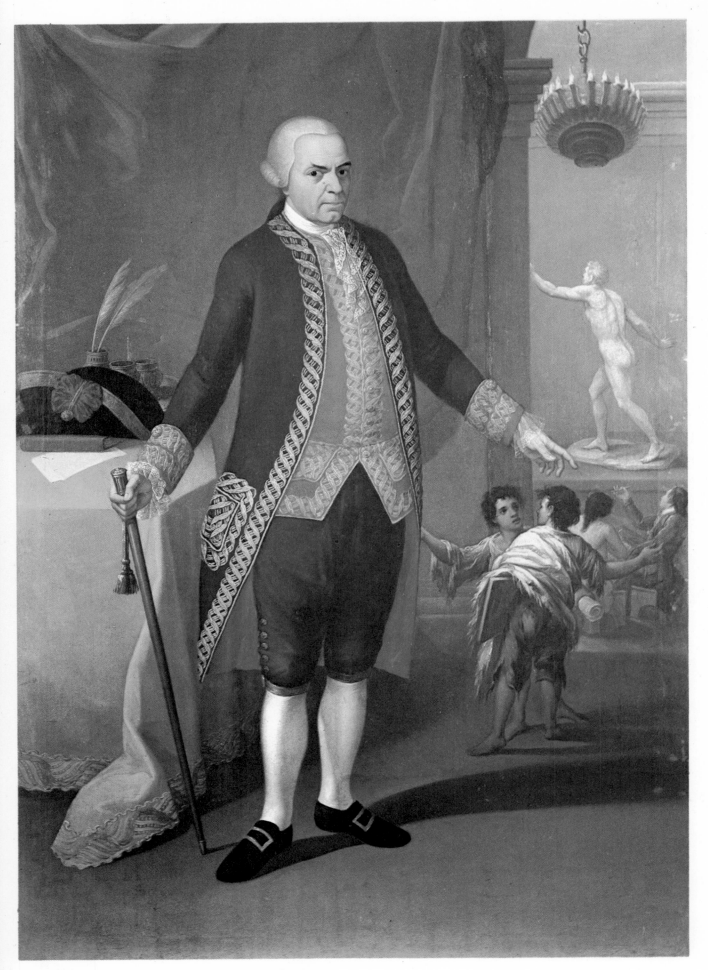

The Viceroy Don Matías de Galvez supported the School of
Fine Arts, where Indians and mestizos were taught painting.

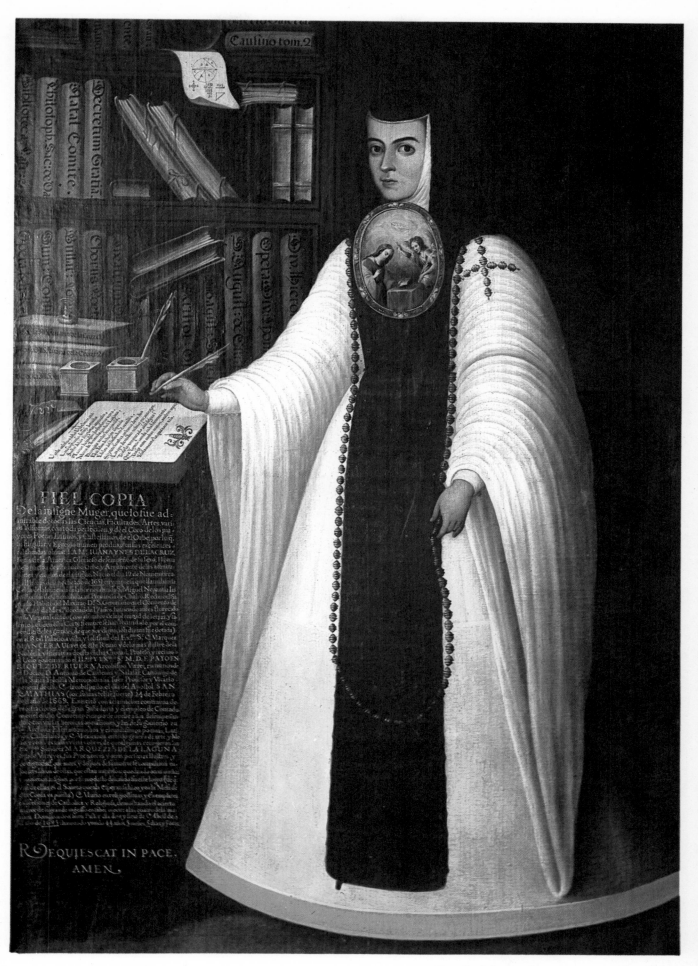

New Spain's most famous poet was Sister Juana of the Cross, a beautiful woman who spent her life as a nun.

Life and Art

Pictured on this page are two details from a typical chasuble embroidered with gold tissue and silk threads.

Priestly vestments in eighteenth-century New Spain were incredibly lavish. The church was the largest landowner.

In the closing years of the seventeenth century, after 150 years of Spanish rule, New Spain had reached an enviable cultural plateau. Indeed, in its city planning, architectural concepts, and cultural evolution, Mexico City equaled the cities of Spain. It was both an era of opulence, reflected by the glittering pageantry of the viceregal court, and of literary attainments as seen in the work of creole (native-born of Spanish ancestry) writers, philosophers, and mathematicians. Most outstanding of these men and women were Sor (sister) Juana Inés de la Cruz, Mexico's greatest poet, and her contemporary, mathematician, historian, and philosopher, Carlos de Sigüenza y Góngora.

The work of Sor Juana, whose full name was Juana Inés de Asbaje y Ramírez de Santillana, has no parallel in Spanish literature. A beautiful, graceful woman with a brilliant intellect, she was a great favorite at the viceregal court. Her entrance into a religious order at the age of sixteen was a shock to most of those who knew her, but it gave her the opportunity for the isolation and study which would not have been open to her otherwise. There was no other choice for the intelligent young woman of her time but marriage, which, she said, held no interest for her. She first entered the Carmelite order, as her spiritual ancestor Santa Teresa had done. But, unlike Santa Teresa, she found the austere discipline of the barefoot nuns too rigorous and left to enter the Jeronymite order.

She wrote voluminously, her work consisting of poems in various meters and encompassing many themes, religious morality plays, and some more worldly three-act comedies. Her love sonnets express a depth of passion sometimes reminiscent of San Juan de la Cruz, the great Spanish mystic poet.

Unlike poets on both sides of the Atlantic Ocean in the late sixteenth century, Sor Juana's verse is filled with ideas. Her hidden meanings come to light under intricate rhymes and popular displays of style. Sor Juana's most interesting poem, which consists of no less than 975 verses, falls into the realm of philosophy and metaphysics. In it she describes the

The magnificent yet intimate church architecture of New
Spain is shown in this painting of the Church of Betlemitas.

New Spain evolved a rigid caste system, with the Spanish born at the top. Their native-born children were creoles

subconscious mind and its activity during sleep. But she also points out that life itself is a dream and that to dream that life is a dream is a dream. The intellect moves freely, she writes, because it is not hampered by reality, for there is none. A dream can venture as a soul can venture to infinity because the mind can be equally free asleep or awake.

It is probable that she was influenced by Lope de Vega and Calderón de la Barca, the great Spanish dramatists. Yet she was in no way an imitator of anyone, but possessed the sensitivity and taste of a truly original artist. Her convent life, if we can believe the sentiments she expressed in her writing, was one of continuous conflict. Outwardly she found the restrictions on free thought onerous. Her inner conflict had given rise to much conjecture. Most critics ascribe it to her intense desire to find satisfaction purely through the intellect, but, because of the very brilliance of her mind, she failed. After years of introspection, she gave away all of her possessions, including her beloved books, and wrote a testament in her own blood which she signed, "I, Sor Juana Inés de la Cruz, the worst in the world." A few months later, at the age of forty-three, Sor Juana

died in the Jeronymite Convent that had been her only home.

The closest friend and confidante of Sor Juana was Carlos de Sigüenza y Góngora. In a time when scientific inquiry was strictly limited, he explored the real world in as many directions as his inquiring mind could take him. In the true baroque tradition he managed to separate worldly interests in science from religious orthodoxy. While still a young man he became a distinguished professor of mathematics and astrology at the University of Mexico.

As his reputation increased throughout New Spain, his interest turned more and more to the study of pre-Hispanic civilizations. He mastered the Nahuatl language and assembled ancient records and codices. In time, his collection of manuscripts became the most important in New Spain. Regrettably, some of his most important works, such as the history of the Chichimec Indians, his genealogy of Mexican kings, and other writings, have been lost. Only works by subsequent Mexican historians who acknowledged the importance of his works as contributions to their own have recorded his importance as a historian.

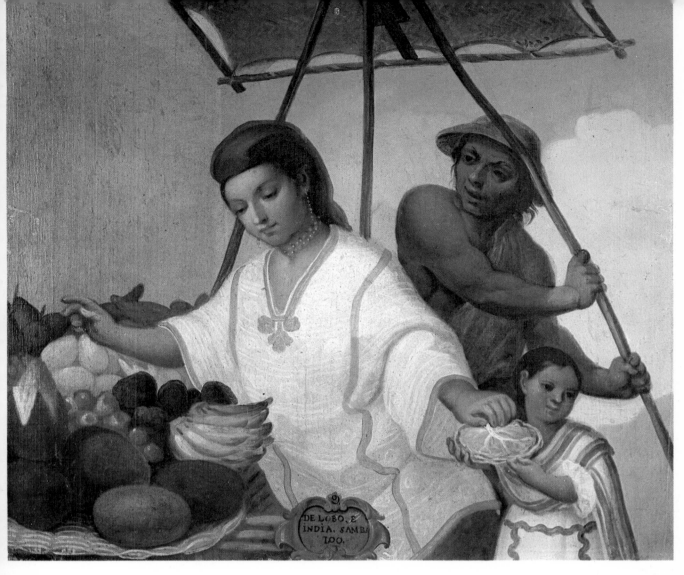

The little girl below, of mixed Spanish and Spanish-Indian parentage, would have become a member of a middle caste.

An example of a lower-caste child would be one born of an Indian father and a Spanish-Indian mother, as shown above.

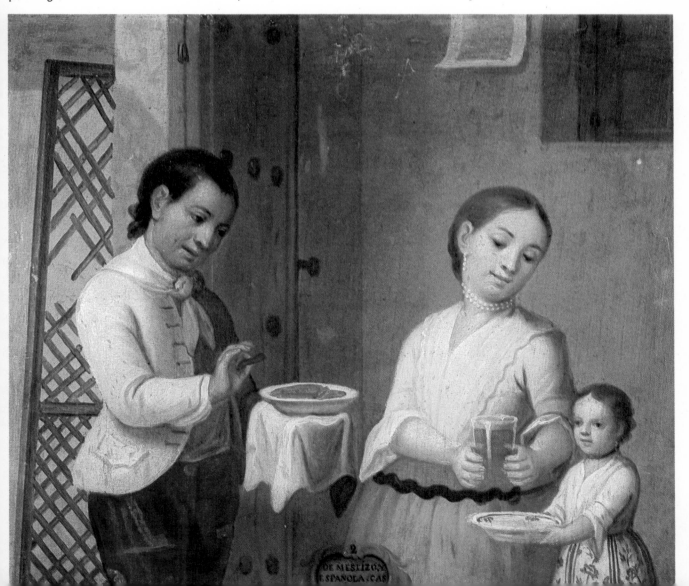

The Spanish-born Manuel Tolsá became famous for his equestrian statue of Carlos IV and his architectural works.

He has been considered by some critics as being the first to give form to the Mexican novel. *The Misfortunes of Alonso Ramirez* is a delightful account of the adventures of an imaginary young Puerto Rican sailor. Proud of his creole background, yet steeped in ancient traditions, Sigüenza was the first of the *Mexican* writers.

Yet the caste system, which had been inherited from Spain, showed no sign of weakening in the seventeenth and eighteenth centuries. At the top were the smallest, richest, and by far the most influential, the *peninsulares,* those born in Spain. They were also known by a more uncomplimentary name, *gachupines,* wearers of spurs.

The second most important group in terms of social and financial prestige were the creoles. The first conquistadors did not bring women along, but Spanish women immigrated soon after. Within two or three generations, their offspring outnumbered and deeply resented the *peninsulares.*

The third group, called mestizos, were born of Spanish and Indian parents. They had almost no opportunity to rise socially or politically. Some of them, however, entered commerce and made considerable fortunes. Below them were eight or more caste classifications, including the mulattoes, offspring of Spaniards and Negroes, and at the bottom were the zambos, the offspring of Negroes and Indians. It was the creoles and mestizos who were to lead the fight for independence from Spain.

INDEPENDENCE AND GROWTH OF FREEDOM

The priests Hidalgo and Morelos lead mass armed uprisings against Spain. They are executed, but Mexico's independence is won at last under Agustín de Iturbide, who declares himself emperor, but is forced to abdicate in favor of a republican constitution. General Santa Anna—mercurial, egotistical, and ruthless —dominates political life. Texas breaks away, and then the United States, in a war regarded as unjust by many of her own citizens, deprives Mexico of nearly half her territory.

HISTORICAL CHRONOLOGY	ART CHRONOLOGY
1810 *Parish priest, Miguel Hidalgo, leads masses against Spanish. Decrees abolition of slavery and head tax.*	*1810* *Insurgent newspaper,* El Despertador Americano.
1811 *Defeat at Guadalajara. Hidalgo and leaders captured and executed.*	*1813* *Portrait of rebel José María Morelos, painted by anonymous Mexican artist.*
1812 *Liberal constitution of Spain adopted, but colonial officials do not comply.*	*1816* *José Fernandez de Lizardi publishes satirical novel,* El Periquillo Sarniento.
1813 *José María Morelos organizes guerrilla campaign, liberating southern Mexico.*	*1822* *Mexican playwright, Manuel Eduardo Gorostiza, publishes* Teatro Original, *a collection of plays.*
1815 *Morelos defeated and executed.*	*Lancastrian method of teaching adopted by government to combat illiteracy.*
1821 *Plan of Iguala, drafted by Vicente Guerrero and Agustín de Iturbide, proclaims union, equality, and independence.*	*1826* *Claudio Linati opens first lithography workshop in Mexico City.*
1822 *Iturbide, leading figure in provisional government, establishes empire.*	*1831* *Posthumous portrait of Miguel Hidalgo by Antonio Serrano.*
1823 *Emperor Iturbide executed after liberal revolt.*	*1832* *Lorenzo de Zavala composes* Historical Essay on the Revolution of Mexico.
1824 *Republican constitution. Guadalupe Victoria elected president.*	*1833.* *Royal and Pontifical University of Mexico closed by liberal government. Department of Education established. Institutes of arts and sciences opened in state capitals.*
1828 *Spaniards expelled. Negro slavery abolished. Spanish fleet defeated.*	
1833 *Santa Anna elected president. Leaves government to Vice-President Gómez Farías.*	*1837* *Collected writings of José María Luis Mora. Academia de Letran founded by group called "generation of 37."*
1835 *Texas declares independence.*	*1841* *Pedro Gualdi prints* Monumentos de Mexico.
1838 *French invade Veracruz to collect debts. In defense, Santa Anna loses leg but recovers prestige.*	*1844* *Frederick Catherwood publishes drawings on Mayan art and architecture in London.*
1846 *Border incidents lead to war between United States and Mexico.*	*1846* *Spanish neoclassic painter, Pelegrín Clave, establishes residence in Mexico.*
1848 *Mexico relinquishes half of national territory in Treaty of Guadalupe Hidalgo.*	*1849* *First edition of Lucas Alamán's* History of Mexico.
1853 *Santa Anna heads conservative government.*	*1854* *Lorenzo de la Hidalga constructs church dome at Santa Teresa la Antigua.*
1854 *Revolt of Ayutla overthrows Santa Anna. Revolution acquires social character.*	

This portrait on tin is thought to be the earliest of Father Hidalgo, founder of Mexico's independence movement.

Struggle for Independence

In the opening decade of the nineteenth century, momentous events in Europe changed the course of Mexican history. Napoleon began a series of political maneuvers which influenced Carlos IV of Spain to abdicate. Then, after imprisoning Fernando VII, heir to the throne, and forcing his abdication, Napoleon invaded Spain and put his brother Joseph Bonaparte on the throne. All this brought chaos to New Spain, which became a country without a sovereign.

While these developments were unfolding, two liberal creoles began working secretly to move Mex-ico toward independence. One was a young military officer, Ignacio de Allende, who believed that Spain's problems in Europe offered a golden opportunity for the creoles to seize control through a semi-independent government loyal to Fernando VII. The other was a priest, Father Miguel Hidalgo y Costilla. It is he who is usually regarded today as the father of Mexican independence. At the time, he was fifty-five years old, a tall, balding man with strands of long gray hair combed back on either side of his expressive face. A voracious reader of banned books, he had been questioned and warned by the Inquisition, but not arrested. His parish was the poverty-stricken village of Dolores, some one hundred fifty miles northwest of Mexico City, where he labored to alleviate the economic distress of his mostly Indian parishioners. Defying the laws protecting imports, Hidalgo and his parishioners planted mulberry trees to begin a silk industry. Grapes were grown for winemaking, and a tile factory begun. To make the life of his village more joyful, he organized a band which enlivened the fiestas throughout the region. That he was popular with his Indian charges is an understatement; he was worshiped.

The priest and the military officer planned a revolt against the Spanish rulers for December 8, 1810. The corregidor of Querétaro learned of their plans and notified the military authorities, but his wife, Josefa Ortíz, who was sympathetic to the cause of independence, got word to the conspirators. Captain Juan Aldama rode through the night of September 16 to Dolores to inform Hidalgo of his imminent arrest. In response to the news, the priest is said to have remarked, "Gentlemen, we are ruined. Now there is no other way left but to go and catch *gachupines.*"

Before dawn that morning church bells sounded throughout the region, and Hidalgo mounted his pulpit in Dolores to attack the cruelty of the Spaniards. He did not advocate independence from Spain; but he explained that Spain was now in the hands of Napoleon, that her king, Fernando, was in a French prison, and that the Spanish-born elite of

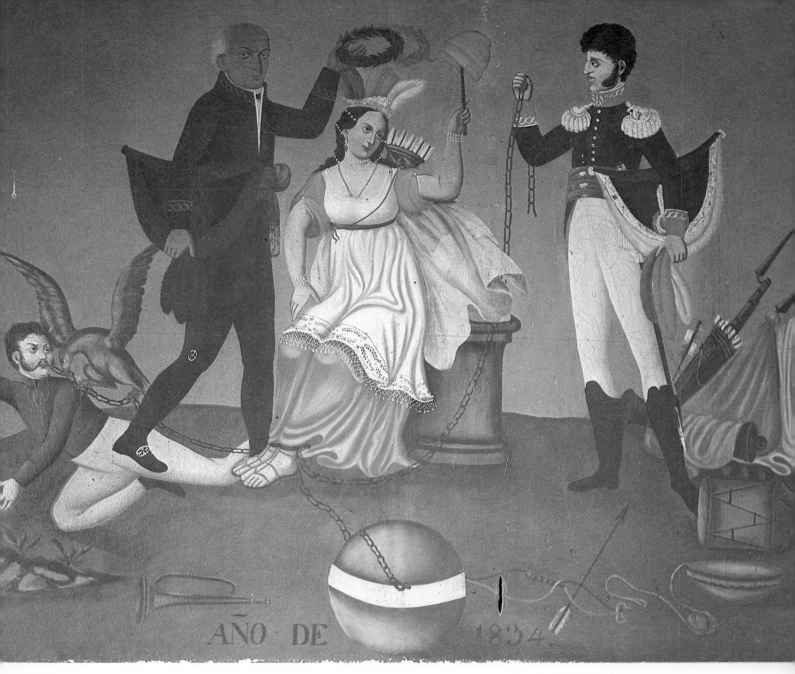

In this allegorical painting, Father Hidalgo crowns Mexico as he helps break the chains that tied her to Spain.

Mexico—the *gachupines*—were loyal to Napoleon and should therefore be exiled from Mexico. He is reported to have ended the sermon with the cry, "Long live Fernando! Long live Mexico!"

When Hidalgo left the church, nearly three hundred men and women followed him along the narrow road to San Miguel de Grande, now called San Miguel de Allende. Hidalgo carried the banner of Our Lady of Guadalupe. The slogan of freedom soon became "Long live Our Lady of Guadalupe! Long live Independence!"

At San Miguel the Spaniards were asked to surrender. Allende gave his word that no harm would be done to them or their property. Yet after the surrender, some elements of the mob began looting. Allende remonstrated with the mob leaders, but Hidalgo took the part of the people. From this time on Hidalgo took over as commander. As the masses followed him, they swelled to fifty thousand.

A heroine of independence was Josefa Ortiz, whose message to Hidalgo warning him of arrest triggered the uprising.

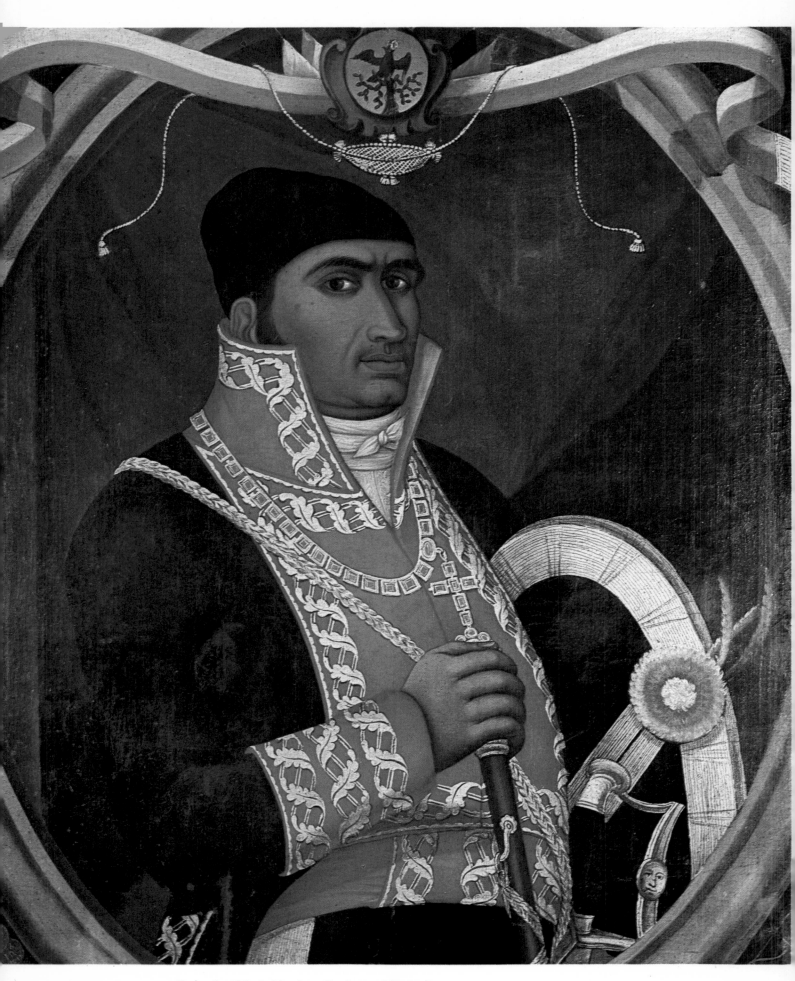

Father José María Morelos y Pavón was killed when
he continued the revolt after Father Hidalgo's execution.

The inscription on the plinth reads:

DON FELIX MARIA CALLE
DEL REY, BRUDER, LOSADA, FL
CAMPEÑO, MONTERO DE ESPINOS
TENIENTE GEN^L. DE LOS REALES E
VIREY, GOBERN^R. Y CAP^N. GEN^L. DE
N.E. PRESIDENTE DE SU R^L. AUDI
SUPERINTEND^E. GEN^L. SUBDELEGADO
REAL HACIENDA, MINAS, AZO
Y RAMO DEL TABACO, JUEZ
SERVADOR DE ESTE PR
DE SU R. JUNTA Y SU
G^L. DE CORREOS
MISMO REYN

A bitter and skillful fighter against Hidalgo and Morelos was Don Felix María Calleja del Rey, the Spanish viceroy.

205

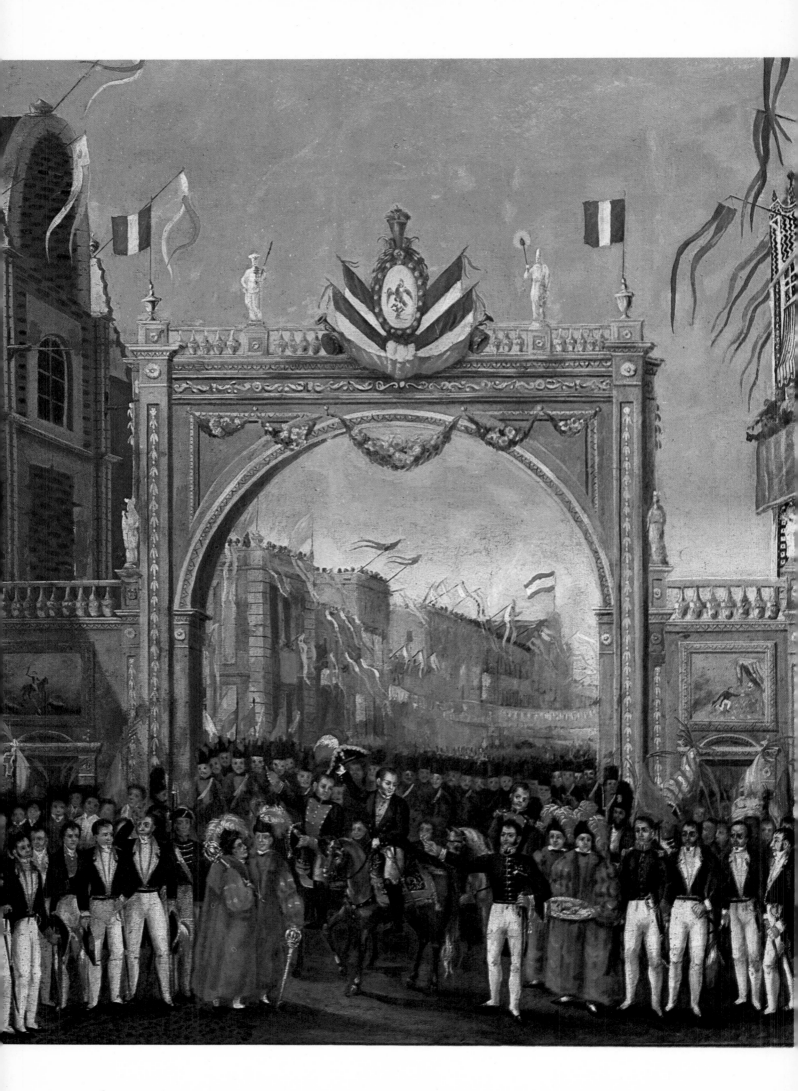

llende asked for time to mold them into an army, ut Hidalgo, preferring to lead a spontaneous move- ent, refused.

From San Miguel, Hidalgo took his still-growing ultitude to Guanajuato, one of the richest of the ining towns. There the Spanish commandant had oved the Spanish inhabitants and their valuables— me three million pesos in silver and cash—into a rtresslike granary (the Alhóndiga) near the center the city. When the Spaniards refused to surren- er, Hidalgo's Indians and mestizos attacked the ranary from all sides. For a time it looked as if the panish positions were impregnable. Many Indians ll from point-blank rifle fire. But a small squad,

advancing behind slabs of stone which deflected the bullets, reached the heavy wooden doorways and set them afire. With the entrance breached, the mob swarmed into the enclosure. The defenders, both soldiers and civilians, were attacked indiscriminately; most were killed. Then the mob fought among them- selves for the treasure.

The war that had started under the motto of "Long live Fernando VII!" had now become a class war. Self-rule became incidental to the immediate and total extermination of the Spanish-born. The struggle was led by a comparatively small group of liberal creoles and mestizos, but support came largely from peasants and miners, many of whom

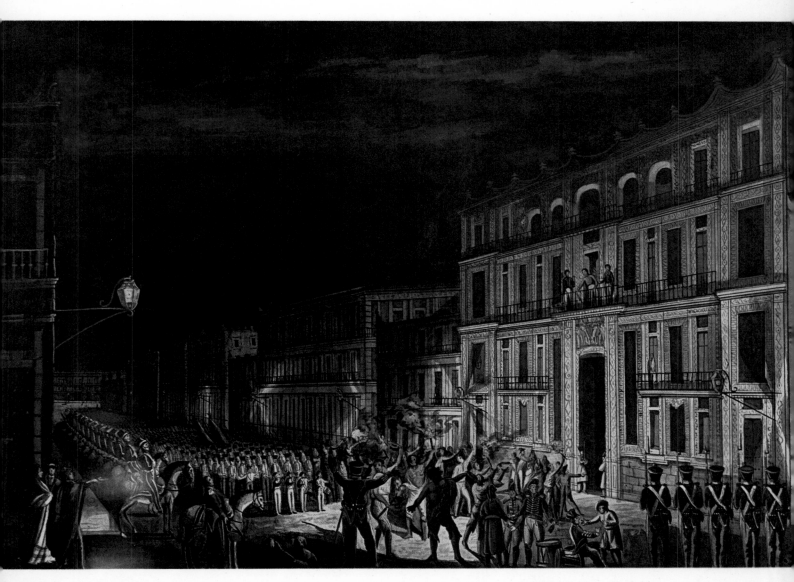

dependence from Spanish rule comes to Mexico as Presi- nt Agustín de Iturbide triumphantly enters the capital.

In a planned demonstration, Iturbide's followers ask him to become emperor. In a speech from a balcony, he accepts.

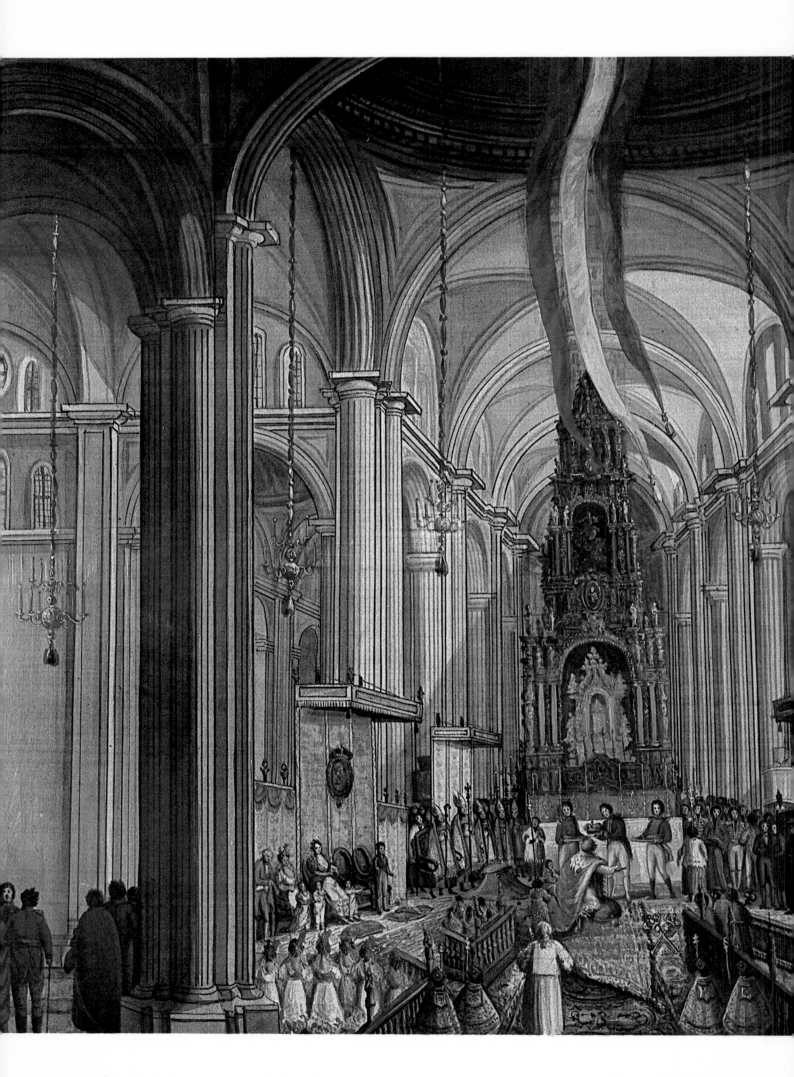

were trying to escape virtual slavery. Hidalgo had unleashed an emotional rebellion against injustices.

The Revolution continued to grow and the untrained army expanded. When the rebel forces numbered eighty thousand, Hidalgo led an assault on Mexico City. The frightened viceroy, who knew the city was almost defenseless militarily, tried to rally support psychologically by proclaiming the *Virgen de los Remedios* as the Virgin General of the Spanish Army. Her strength was to be tried against that of the Virgin of Guadalupe, whose standard Hidalgo carried. For some military or emotional reason which is not clear, Hidalgo ordered a retreat. His decision to turn back when the capture of Mexico City was imminent drained the Revolution of its momentum. Many of his followers lost enthusiasm for the cause and returned to their homes. When the Spanish General Félix María Calleja caught up with him at Aculco, Hidalgo met defeat for the first time.

But the Revolution was not yet over. José María Morelos had been successful in southern Mexico, while José Antonio Torres had encountered little trouble subduing the Spaniards of Guadalajara in the west, where Hidalgo was welcomed as a liberator. General Calleja, however, pursued Hidalgo to Guadalajara and challenged him to give battle. Allende advised Hidalgo against meeting the well-disciplined Spanish army outside the city. But Hidalgo insisted on marching out. The artillery and superior maneuvers of the Spaniards, as Allende had predicted, crushed the rebels. Calleja occupied Guadalajara and the revolutionary army melted away.

Now Allende took charge, but it was too late to

On July 21, 1822, in the cathedral of Mexico City, the president of the republic becomes Emperor Agustín I.

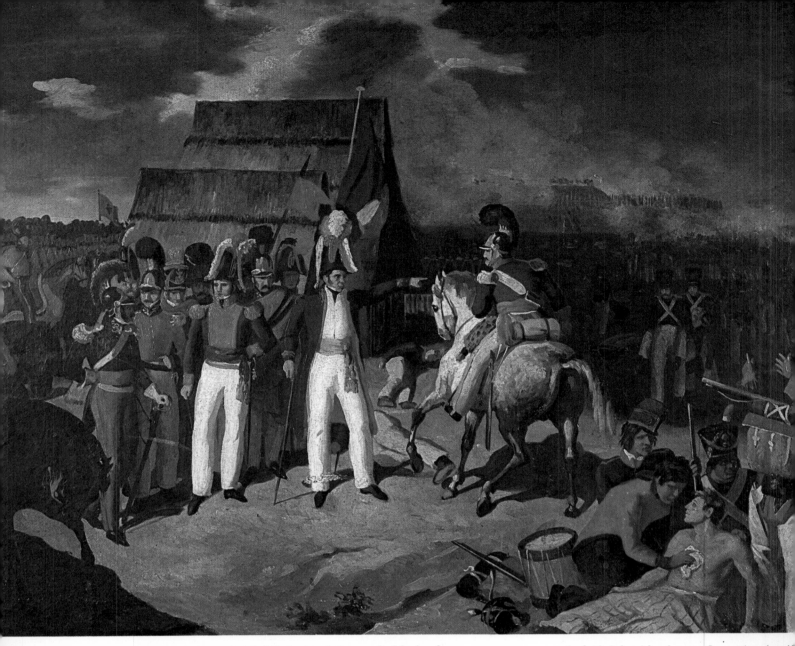

After Iturbide's fall, Spain tried to retake Mexico, but General Santa Anna defeated the Spanish army at Tampico.

At the height of her beauty, Santa Anna's wif Dolores was painted by the great Mexican artist Juan Corder

reorganize the revolutionists. Hidalgo and Allende went north toward San Antonio Bejar, now San Antonio, Texas, in the hope of joining with northern revolutionaries. In the mountains of Coahuila they were taken prisoner. Most of the revolutionists, including Allende, were shot. Hidalgo, because he was a priest, was turned over to the bishop of Durango. He was defrocked and excommunicated by the Holy Office, then "relaxed" to the Spanish authorities for execution. He was executed on July 30, 1811. His leadership of the revolution had been short-lived, but he had broken the ground for Mexico's future independence.

Leadership passed to José María Morelos, who, like Hidalgo, was a priest but, unlike Hidalgo, was also a talented military tactician. Instead of proceeding at the head of a large unorganized army, Morelos took time to train guerrilla bands. The suc-

cess of his hit-and-run tactics proved him right.

Morelos' plans for Mexico after independence in cluded a representative congress elected by the pec ple, an administrative system staffed by Mexican. equality under the law, and the abolition of slaver titles of nobility, government monopolies, sales taxe and all forms of tribute. He planned to replace thes onerous methods of collecting money by a per capit income tax of five per cent and an import duty o ten per cent.

Though most creoles, as well as the Spanish-bori found Morelos' 1814 constitution unpalatable, for time his guerrilla army held out against Genera Calleja. Then, at the end of the year, he began t lose territory to royalist forces. Part of the royalis success was due to the able leadership of a youn captain, Agustín de Iturbide, who had remaine loyal to Spain.

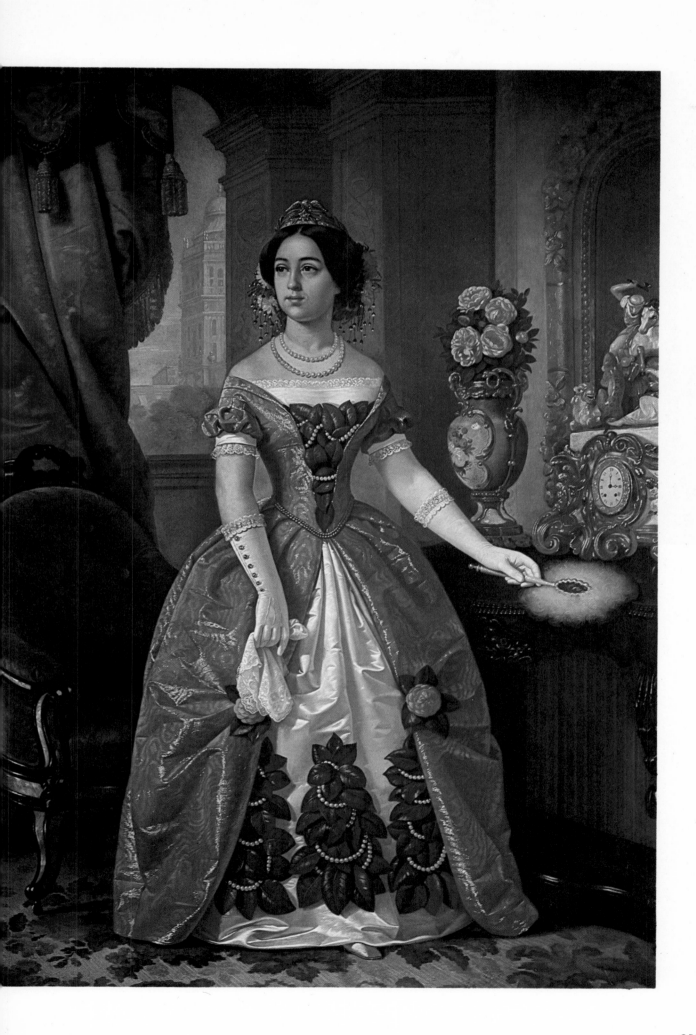

This gay scene of people strolling in the Alameda could be repeated any Sunday. Only the clothing has changed.

Morelos was ambushed and captured as he attempted to lead the rebel congress across the mountain country of Michoacán. He personally stood off the enemy until the members of his government got safely away; then he surrendered. Like Hidalgo, he was incarcerated by the Holy Office of the Inquisition. Charged with treason, heresy, and other crimes against the state, he was found guilty and turned over to the government authorities on December 22, 1815, for execution. Hidalgo had given the revolutionary movement inspiration. Morelos had given it purpose. After Morelos' death, other guerrilla chieftains, such as Vicente Guerrero, carried on the struggle for freedom.

While Hidalgo, Morelos, and Guerrero carried on the fight for independence in Mexico, events in Spain were shaping its course. The Spanish people,

with the help of the Duke of Wellington, had de feated the French. Fernando VII returned as king But he was not in control of events and Spanis policies changed from liberal to conservative, the back to liberal, and finally again to conservativ With no direction coming from the motherlan factions in New Spain began increasingly to loo toward leadership at home.

The leader who was to emerge was Agustín d Iturbide, the captain who had contributed to th defeat of Morelos. He was young, enthusiastic, and spellbinding orator. He was acceptable to the Spar iards and the creoles, and within a short time su ceeded in convincing the rebel General Vicent Guerrero that independence was more importan than the aims of any single group. Out of a meetin with Guerrero came the Plan of Iguala, publishe

Even more popular than the park, in the nineteen century as now, was the plaza de toros—*the bull rin*

February 24, 1821. It offered three guarantees: independence from Spain, equal rights for Spaniards and creoles, and the supremacy of the Catholic religion. The army which soon began to form in support of this plan became known as the *trigarante*—the army of the three guarantees. Within seven months Iturbide marched into Mexico City and formally proclaimed the independence of Mexico. The country was at last free from Spanish rule.

Although independence came to Mexico through Iturbide, he quickly besmirched his reputation by declaring himself Emperor Agustín I of Mexico. His rashness and brutality cost him support, and his empire lasted only eight months before he was deposed and exiled.

Iturbide's successor was Antonio López de Santa Anna, a young opportunist even more devious than Iturbide. Although Mexico adopted a constitutional government, General Santa Anna found extralegal ways to influence affairs of state. He preferred not to take the presidency himself, but to operate through others behind the scenes. At first he supported liberals. Guadalupe Victoria, a distinguished jurist, became Mexico's first president, followed by Vicente Guerrero. Later, Santa Anna tended to support conservative elements. During an incredible career, he betrayed the conservatives, the liberals, his own vice-president, the Texans, the Mexicans, and the United States government. He was in part responsible for the loss of Texas and the territories of California, Nevada, New Mexico, Arizona, and Colorado.

Continuously posing as patriot and savior of his country, he betrayed its best interests over and over again for his own gain.

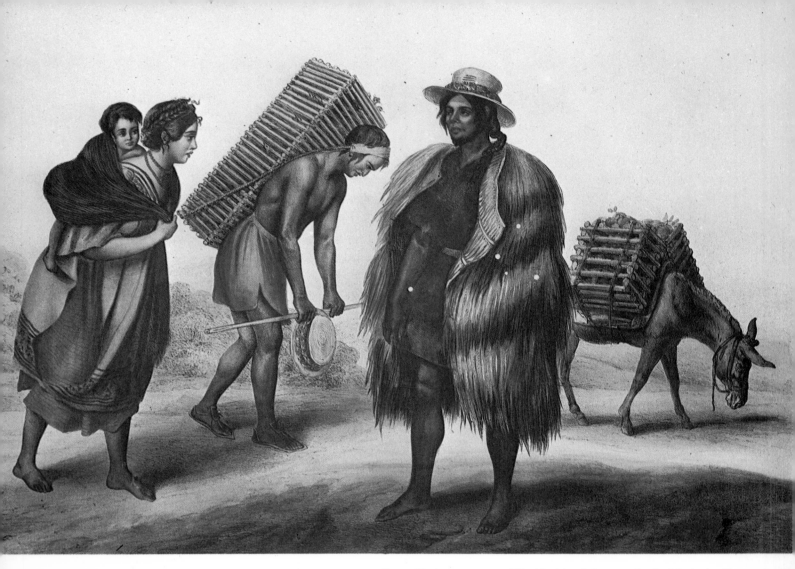

Don Carlos Nebel's paintings depicted ordinary life in the early 1830's. Above, Indian farmers and charcoal makers.

The ideal feminine type in the Mexican village was the poblana. The three below smoke and flirt with a vaquero.

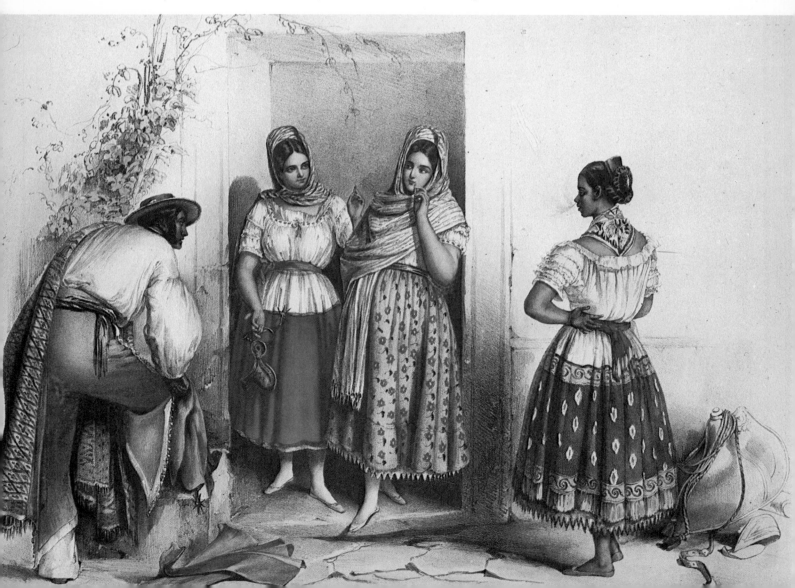

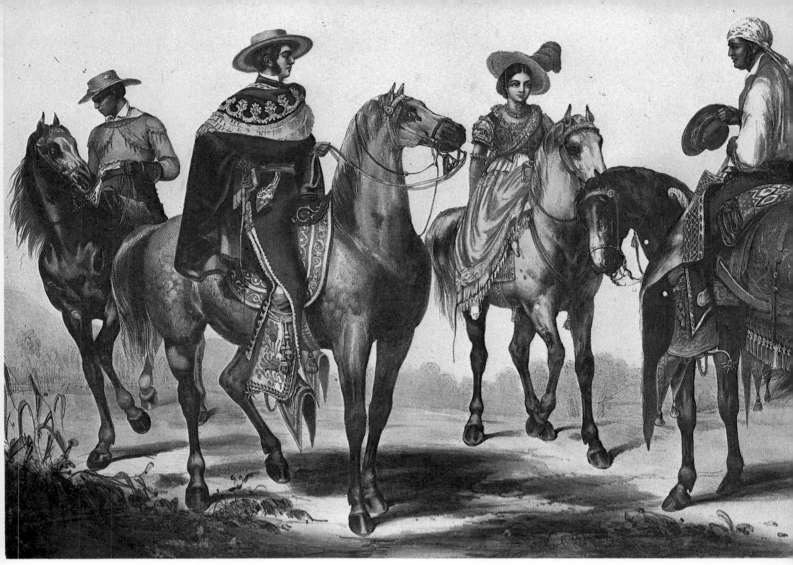

Above, a dashing hacienda owner and his wife, who rides sidesaddle, meet their overseer on a ride in the country.

Below, an Indian girl grinds corn on a metate *as her companion shapes* tortillas. *Many Indians still live this way.*

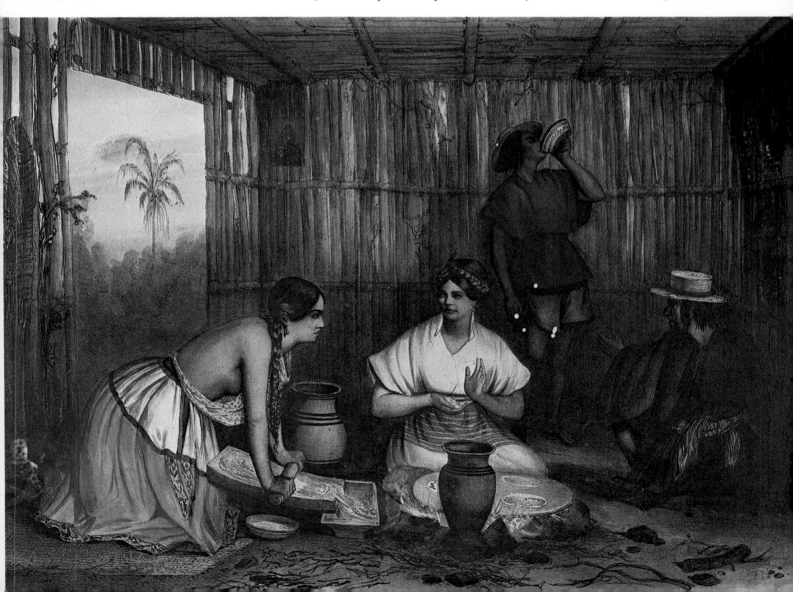

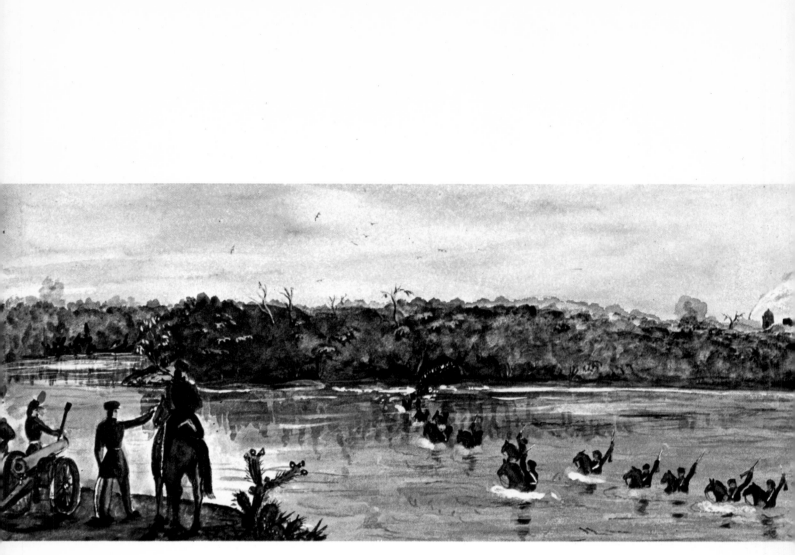

United States troops forded the Rio Grande River shortly after the first shots of the U.S.–Mexican War were fired.

The United States flag flies from a fortress above Monterrey. U.S. success was due to better training and arms.

War with Texas and the United States

As early as the 1820's, pioneer ranchers, farmers, and adventurers of all kinds had begun the movement westward from the Louisiana Territory into Mexican lands. They were led by Stephen Austin, who had obtained a grant of land and permission to colonize, and other large land grants followed. It was agreed that all the colonists would become Mexican citizens.

There was never any question about Mexico's valid claim to this northern territory. However, because the land had been only partially explored by the Spanish and because neither Spain nor Mexico had been able effectively to colonize or to protect it, the newcomers soon felt it was theirs by right of occupation.

Few colonists from the United States had any real intention of becoming Mexicans. Instead of adopting

Spanish customs, they evolved into a pioneer type of rough, rude, hard-working, hard-fighting men. They probably had more in common with the Indians they dispossessed and annihilated than with the Mexicans they despised. By the time General Santa Anna arrived in Texas in 1836 to protect Mexican rights, the takeover by the Texans had already occurred.

The Texas-Mexican War was fought for reasons which are difficult to determine. The Mexican commander, General Santa Anna, was more interested in himself than in preserving Mexico's territorial integrity, while Sam Houston, commander of the Texas army, used the war more to burnish his questionable reputation than to strike a blow for freedom and independence.

With such leadership on both sides, it is no wonder the war was a questionable affair from start to finish. The outcome might have gone either way. But the Texans, by a fortuitous combination of circumstances, won the battle of San Jacinto, captured Santa Anna, and persuaded him to agree to independence in exchange for his freedom.

Throughout the hostilities it had been clear that certain United States politicians were interested in adding Texas and other Mexican territory to the Union. They were to have their way when President James K. Polk decided that it was the "manifest destiny" of the United States to annex Texas, and to add Oregon, California, and the New Mexico territories. Polk's aggressive policy led to war with Mexico in 1845.

The United States–Mexican War was deeply unpopular in the United States, even among some of those who did the fighting. Ulysses S. Grant, who fought in the war as a young officer, said, for example: "We were sent to provoke a fight, but it was essential that Mexico should commence it. . . . I was bitterly opposed to the policy of annexation, and to this day regard the war which resulted as one of the most unjust ever waged by a stronger against a weaker nation."

Grant was not alone in serving in the United States–Mexican War against his principles. Young Robert E. Lee, then an artillery reconnaissance officer, played an important part in winning the war for the United States.

Another opponent was Abraham Lincoln, a young congressman from Illinois, who held that the war was unnecessary and unconstitutional. Lincoln's opposition to the war, bitterly expressed on the floor of the House, cost him his congressional seat and nearly ended his political career.

(Overleaf) The Mexicans fought bravely at Molina del Rey and Chapultepec but the United States won the war.

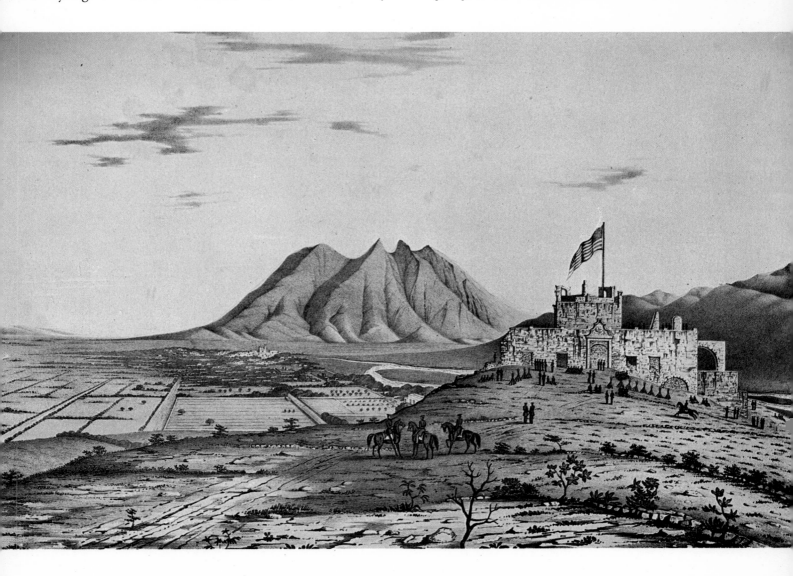

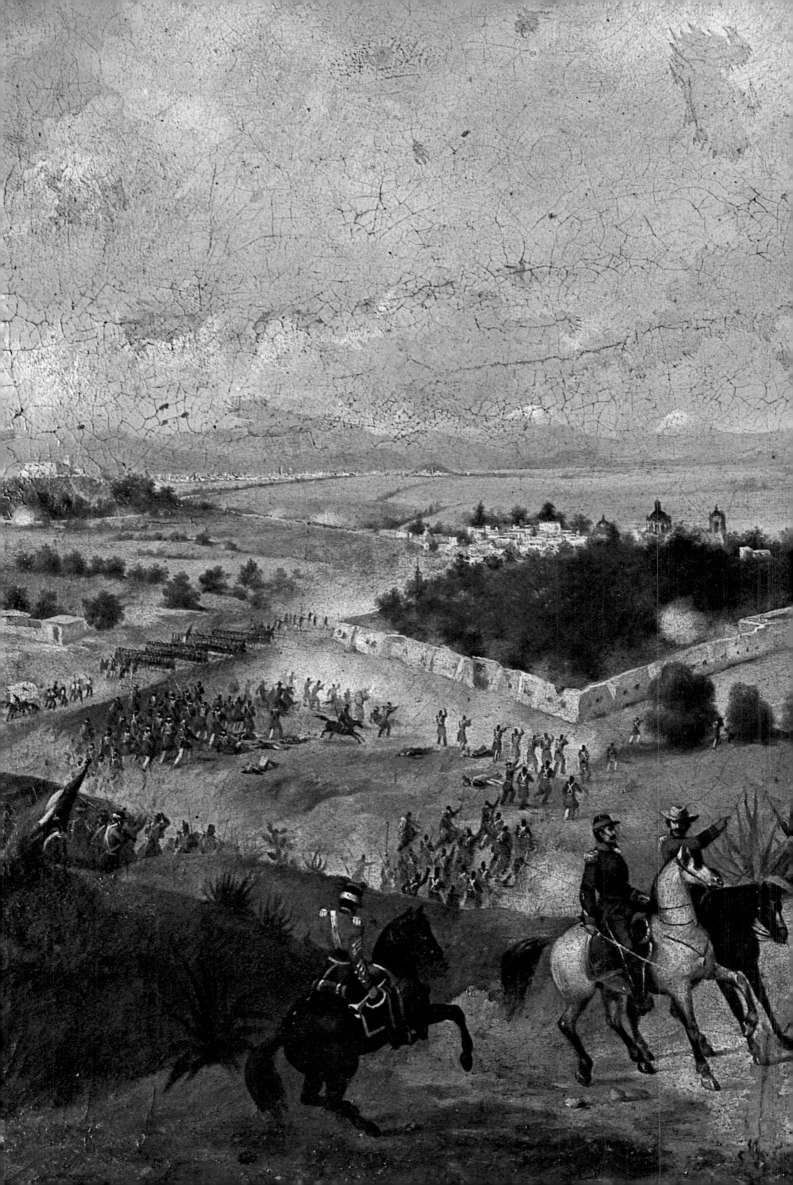

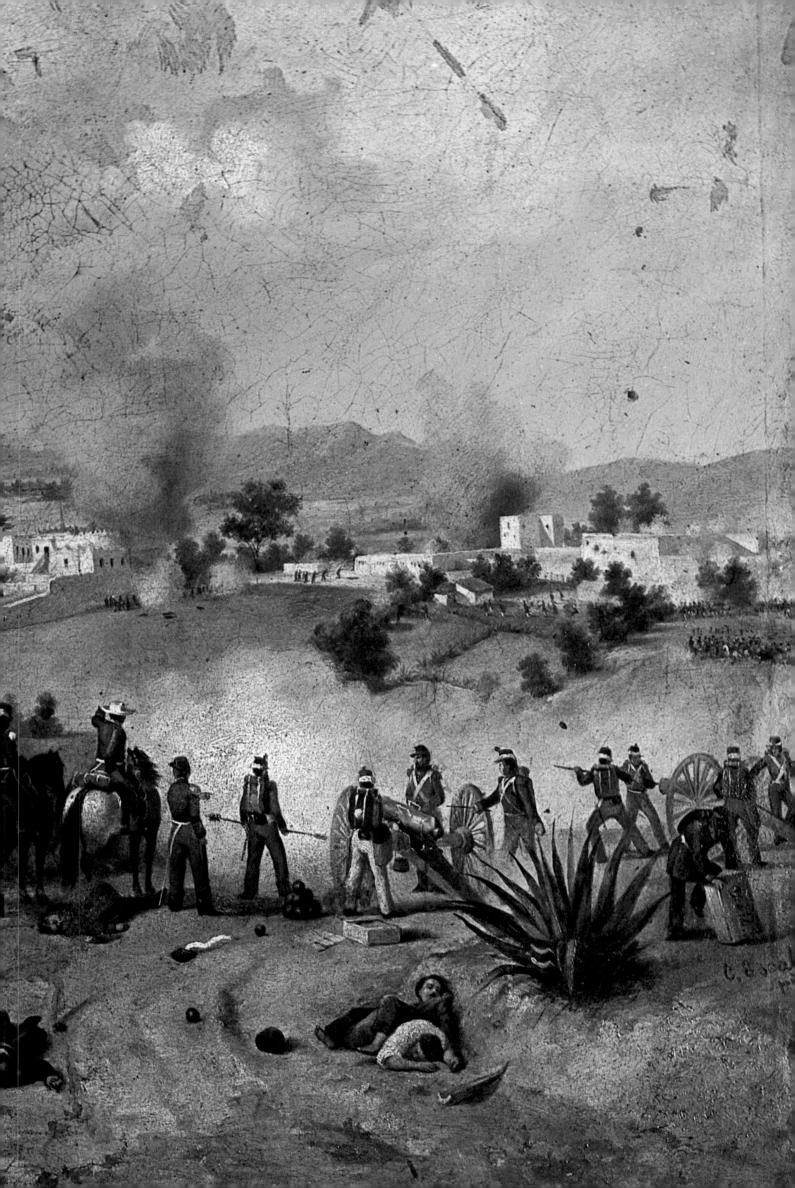

However, the decisions of President Polk and his cabinet prevailed, and preparations were made for a major war. The governor of Missouri was asked to put a thousand mounted men on the trail to New Mexico. Commodore John D. Sloat was told to occupy San Francisco Harbor, and Brevet Captain John C. Frémont headed an exploratory geographical and geodetic survey group that was alerted to take over California for the United States should the occasion arise. After General Zachary Taylor, called "Old Rough and Ready," had proved by his sluggish maneuvers that while he might be rough he was certainly not ready, General Winfield Scott, the

greatest general of his time, was put in charge of the American forces. Taylor was persuaded to move a little more rapidly from the north while Scott landed at Veracruz and fought his way across to Mexico City.

At Monterrey, Taylor's army sensed defeat after the Mexicans' repeated suicide charges had reduced the Americans by some 20 per cent. During the night, however, the Mexican army, unaware of how badly the Americans had been mauled and conscious only of their own losses, withdrew. Taylor claimed a great victory. At Cerro Gordo, Winfield Scott met Santa Anna in a critical battle. When the

A girl strains pineapple juice on the floor of a fruit-drinks shop. Other popular flavors were orange and almond.

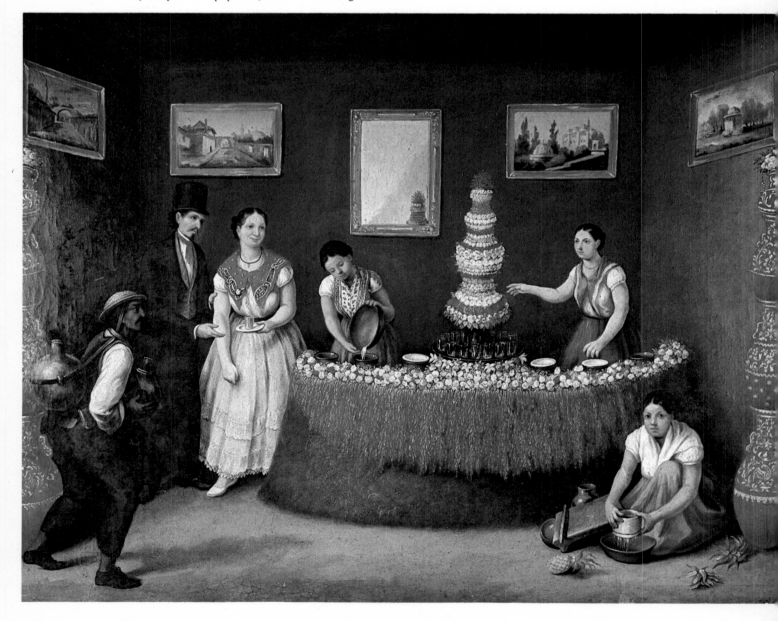

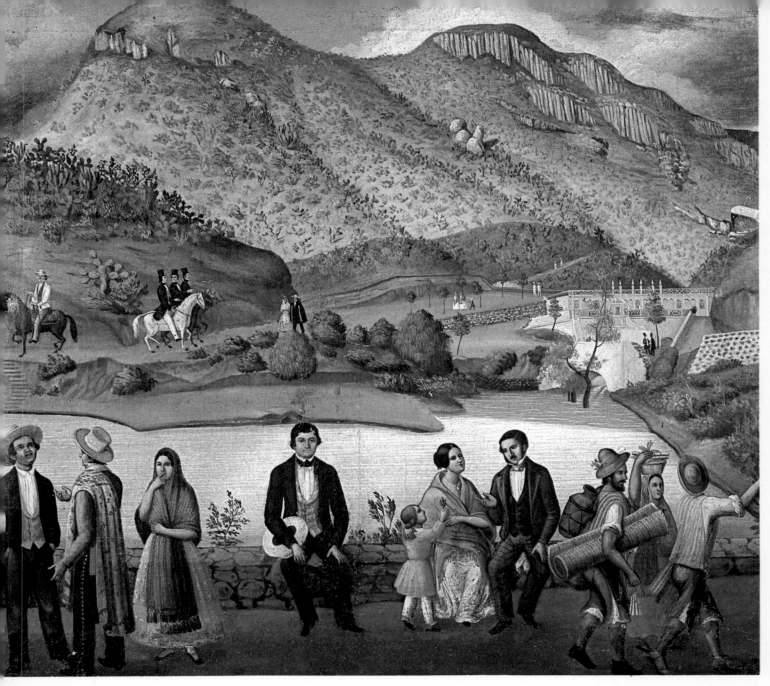

Mexicans of various social classes take the country air near Guanajuato. The Olla dam is in the background.

Mexican forces were on the brink of victory, Santa Anna, who wanted the glory of winning, ordered General Gabriel Valencia to retire. But the general refused. Piqued, Santa Anna rode away to his hacienda, leaving Valencia to face Scott. With Valencia's defeat, the road was open to Mexico City.

In the ensuing campaign Scott's well-trained, well-equipped, and well-led army pushed on to the last major fortification at Chapultepec, the high hill once defended by Cuauhtémoc against the conquistadors. Now its defenders included school-age cadets from the Mexican Military College, most of them in their teens and some little more than chil-

dren. Santa Anna, now back in the fight, offered to relieve them, but they refused, and along with some of the bravest contingents of the Mexican Army, including the Legion of San Patricio, they made the Americans pay in blood for every foot. But not only were they fighting a better-equipped and better-trained army; they were also opposing men who were to make military history in the Civil War: among the attackers were Robert E. Lee, Pierre G. T. Beauregard, and Ulysses S. Grant. When the cadets, who were among the last of the defenders, saw no hope of victory, a number of them earned a place in the pantheon of national heroes by leaping

*Toasts are proposed and men gather in small conversational
groups at a banquet honoring the general seated before*

the cake. Behind the group at center, a gentleman furtively squeezes a lady's hand as he helps her with her plate.

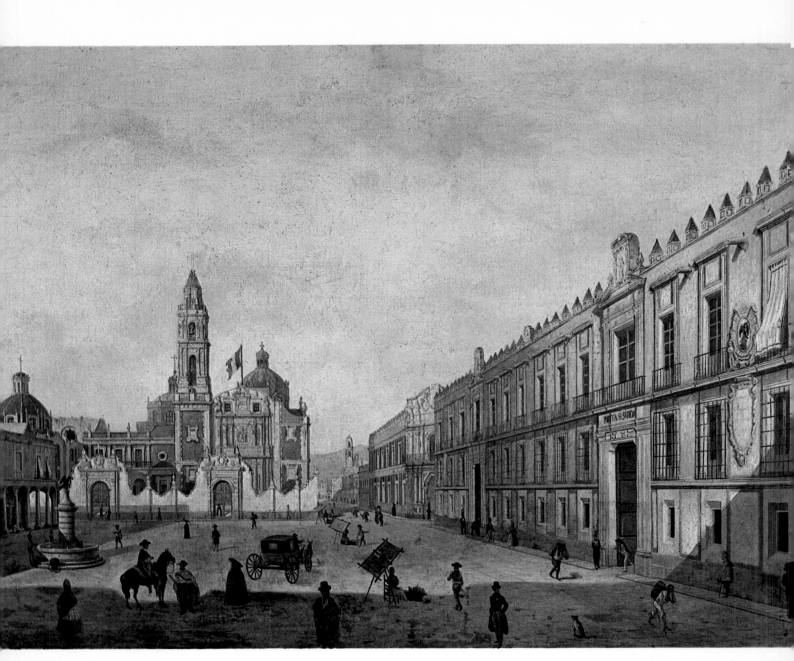

Mexico City around 1850. From left, the customhouse, Santo Domingo Church, and former Inquisition headquarters

from the jagged cliffs, as some of the Indians were said to have done 350 years earlier.

General Scott marched into Mexico City and received the surrender of the country. On February 2, 1848, the Treaty of Guadalupe Hidalgo was signed. It ceded California, Arizona, Colorado, Nevada, Utah, and a considerable portion of New Mexico to the United States. In return, the debts that Mexico owed to United States citizens (mostly for losses incurred during the revolutionary period preceding the war) were assumed by the United States government. In addition, the United States agreed to pay $15 million in cash. Never was so much land purchased for so little. The United States now stretched from ocean to ocean. Mexico had lost nearly half her territory at a stroke.

1854-1910
REFORM, DEMOCRACY, DICTATORSHIP

Benito Juárez, intelligent and honest, leads the liberal forces in the civil war that follows Santa Anna's overthrow. The liberals win, only to face the French, who install Maximilian as emperor. Deserted by Napoleon III, Maximilian is executed. At Juárez' death, Porfirio Díaz takes power and keeps it for thirty-four years. Díaz' dictatorship favors foreign interests and widens the gap between rich and poor.

HISTORICAL CHRONOLOGY	ART CHRONOLOGY
1857 *Separation of church and state. New federal constitution adopted.*	*1855* *Juan Cordero paints* Doña Dolores Tosta de Santa Anna.
1858 *Liberal government in Mexico City falls in conservative coup d'état. Civil war follows.*	*1856* *Lithographs of* Mexico and Its Surroundings *by Casimiro Castro and J. Campillo are printed.*
1859 *Benito Juárez issues decree nationalizing church property, proclaims freedom of religion.*	*1857* *Exhibition of the painting* Vista de la Arquería. de Matlala *by Eugenio Landesio.*
1861 *Liberals retake Mexico City. Juárez elected president.*	*1861* *Newspaper* La Orquesta *starts publication.*
1862 *England, Spain, and France demand payment of debts and occupy Veracruz. England and Spain withdraw. French invade interior and lose battle at Puebla on May 5.*	*1862* *Portrait of Emperor Maximilian by Santiago Rebull.*
1863 *Puebla and Mexico City fall.*	*1867* *Gabino Barreda opens the National Preparatory School in Guanajuato.*
1864 *French make Maximilian and Carlota emperor and empress of Mexico.*	*1875* *José María Velasco completes his paintings* The Valley of Mexico *and* Mexico.
1865 *United States weapons flow to Juárez' troops.*	*Felix Parra depicts on canvas Bartolomé de las Casas mission among the Indians.*
1867 *Liberals win decisive battle at Querétaro. Maximilian executed. Juárez re-elected president.*	*1884* Mexico a traves de los siglos *published.*
1872 *Juárez dies. Sebastian Lerdo de Tejada completes term.*	*1887* *José Guadalupe Posada, popular artist, cartoonist, social commentator, opens shop in Mexico City.*
1876 *Porfirio Díaz issues revolutionary plan of "effective suffrage and no re-election." Seizes government and becomes president.*	*1892* *Leandro Izaquirre reflects indigenous culture in painting,* El suplicio de Cuauhtémoc.
1880 *General Manuel Gonzáles, elected president.*	*1894* *Manuel Gutierrez Najera and Carlos Díaz Dufoo edit the* Revista Azul.
1884 *Díaz returns to presidency; governs as dictator until 1911.*	*1898* *Amado Nervo and Jesús Valenzuela found the* Revista Moderna.
1893 *The* científicos, *advisory group headed by José Limantour, favor foreign investors.*	*1907* *Porfirio Díaz inaugurates the Central Post Office Building designed by Adamo Boari.*
1906 *Flores Magón brothers, in Liberal party manifesto, protest Díaz tyranny.*	*1908* *José Vasconcelos and Antonio Caso found the Ateneo de la Juventud.*
1908 *Díaz announcement of free presidential election stimulates political activity. Francisco Madero's book,* Presidential Succession of 1910, *published.*	*1910* *National University of Mexico established. Inauguration of the Independence Column.*

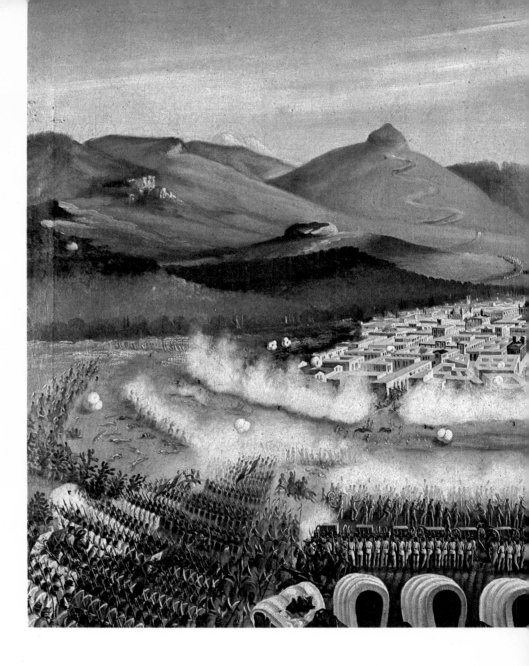

Juárez and His Times

The Zapotec Indians have occupied a wide strip of land in central Oaxaca for more than two thousand years. During this long period they have retained their ethnic identity, in spite of three hundred years of occupation by the Mixtec nation and an equally long occupation by the Spaniards. When change came, it came largely from within. As a result, the Zapotecs acquired a reputation for fierce independence, loyalty, and stability.

In the center of Zapotec country in 1806, in San Pablo de Guelatao, a child was born to two pure-blooded Zapotec Indians, Marcelino Juárez and Brigida García. Named Benito, the boy acquired the qualities of independence, loyalty, and stability characteristic of his people. Later he was to put them to use in the service of his country.

Growing up during the struggle for independence, Juárez was four when Miguel Hidalgo gave his patriotic sermon at Dolores, nine when Morelos was executed. He was fifteen and had just learned the Spanish language when Mexico became independent of Spain.

One of those who had an influence on Benito Juárez during his youth was Antonio Salanueva, churchman and bookbinder. He encouraged young Benito in his studies and the boy made rapid strides in his learning. Little encouragement was needed, for Juárez' capacity for study was immense. At eighteen he was the star pupil at the Catholic Seminary of Oaxaca, and his education was broadened when he transferred to the newly organized Institute of Arts and Sciences. When he graduated at the age of twenty-three, his standing was so high that he soon received a position as professor of experimental physics.

But it was the science of law and politics that fascinated him. Serving in one small government

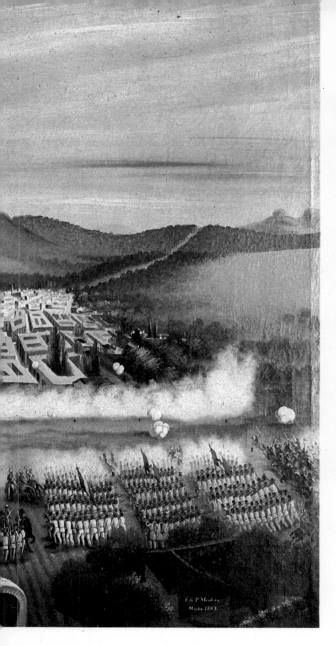

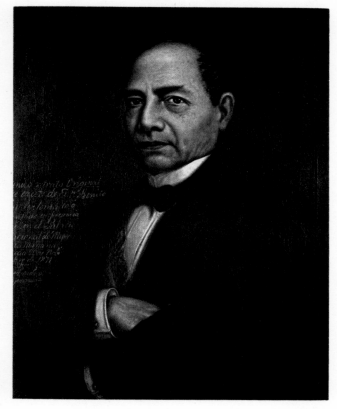

Benito Juárez, the Lincoln of Mexico, posed for this painting, the only original portrait of him ever painted.

At the battle of Silao in 1860, liberal forces defending the Constitution of 1857 defeated the conservatives.

ob after another, he diligently studied law in his spare time. At twenty-six, while legal secretary to the municipal council of Oaxaca, he received the degree of bachelor of law. Now he could put the letters Lic., or *licenciado* (lawyer), before his name. Only two years later he was admitted to the select group allowed to practice law before the supreme court of the republic.

The Zapotec traits that made Juárez a successful leader were almost exactly the opposite of those that had marked previous, more flamboyant leaders of Mexico. He spoke rarely, and when he did, quietly. He was reserved, hard-working, efficient, and above all a man of principle. His popularity depended entirely upon his accomplishments rather than his personality. Tireless at his duties, he moved from one post to another until, at the age of forty-two, he became governor of the important state of Oaxaca.

Juárez ran Oaxaca so well—building roads and public buildings and bolstering the Indians' agricultural income—that it became a model for other Mexican states. At the end of his term as governor, he left a surplus in the treasury.

This experience was to prepare him for the larger role he began to play after 1853. In that year Juárez became one of the principal leaders in opposition to the conservative government headed by Santa Anna. Santa Anna's immediate predecessors had been two honest and energetic patriots, José Joaquín de Herrera and Mariano Arista. But their moderate liberal governments had been acceptable to only a small percentage of the total population. Conservative economic interests were still very deeply entrenched and extremely influential in politics. The conservatives also had an able leader in the historian-politician Lucas Alamán, who was able to gain support for a revolt among rich landowners, clergy, and military officers. Alamán was convinced that only a benevolent dictator, leading a conservative government, could serve the best interests of the country and the people. But it was necessary to gain as much popular support as possible. Thus Alamán turned

to the mercurial but still popular Santa Anna to head the government.

It is conceivable that if Lucas Alamán had lived, he would have been able to control the excesses of his chosen leader, or at least, after the one-year period which had been agreed upon had been served, would have exchanged him for another. But unfortunately for Mexico, Alamán died before the end of Santa Anna's first year in office. Without Alamán to curb him, the dictator visualized himself as emperor. As the year ended, he arranged to have his followers propose that he be made permanent head of the government. He rejected the title of emperor, perhaps because the fate of Emperor Agustín I was still fresh in his mind, but assumed the title His Most Serene Highness. It is possible that no court has ever been better dressed or more deca-

dent. Santa Anna revived the etiquette of Iturbide' imperial court, and his generals, advisers, and friends became nobles.

But his continuous concern was to be sure there was always enough money in the treasury to keep the army loyal. This myopic preoccupation caused Mexico to lose another slice of her territory. For when Santa Anna learned that the United States would pay $10 million for the Mesilla Valley, the strip of land running from the present Yuma Arizona, to El Paso, Texas, he approved the sale This unpatriotic move contributed to his undoing and shortly thereafter he was toppled from power.

The revolt against Santa Anna's government began in the mountains of Guerrero, where Juan Alvarez, a mestizo involved in liberal activities, and Ignacio Comonfort, a creole and former custom

Drunkards, murderers, and prostitutes are pictured in this anonymous satire of the decadence of some parts of Mexico.

ollector, offered what they called the Plan of Ayutla. It called for re-establishment of the republic and an interim congress to serve until a new liberal constitution could be adopted. Benito Juárez was at this time in exile. He had been imprisoned briefly for his activities against the government, and when released he sailed to Havana and then to New Orleans. In that creole city, birthplace of many Latin American revolutions, Juárez, Melchor Ocampo, José María Mata, José Guadalupe Montenegro, and other liberals organized a revolutionary council to assist Alvarez and Comonfort.

In 1855, after Alvarez and Comonfort had successfully turned back the government forces, the liberal exiles in New Orleans made their way back to Mexico. Santa Anna quickly realized the seriousness of the revolt and fled the country.

During the next two years, Mexican society was made over. A primary aim of the new liberal government which now came to power was to curb the power of the clergy by reducing its excessive wealth. It was thought that this would stimulate the country's economy and create a system of small landholdings. Decrees were issued to this end. But attempts to implement them produced a strong reaction in the conservative camp and the country moved rapidly toward civil war. A constitution, adopted in 1857 and written largely by Benito Juárez, included reforms abolishing the special legal privileges of the clergy, guaranteeing freedom of religion, and providing for the expropriation and sale of church lands to the public. Public officials had to swear obedience to this constitution, and the church retaliated by excommunicating all who did.

Mid-nineteenth-century styles in children's clothing are charmingly depicted in this portrait of two little girls.

Despite laws limiting the activities of the church, such important fiestas as Holy Week were widely celebrated.

Further, it decreed that no one who accepted the constitution or who bought church property might come to confession or receive the sacraments and benefits of the church.

Under the constitution, Comonfort was inaugurated as the first president and Benito Juárez was named chief justice of the supreme court. Their government was soon faced with a widespread conservative rebellion. Its leaders, General Felix Zuloaga, seized Mexico City, and President Comonfort went into exile to the United States. The constitution provided for the chief justice to replace the president in such an emergency, and Benito Juárez assumed the presidency of Mexico. General Zuloaga, however, was in control of the capital; he too claimed the presidency, repealed the reform laws, and began a campaign against Juárez and the liberals.

Thus began the War of the Reform. In Querétaro, Juárez stopped long enough to appoint a cabinet. He went to Guadalajara, where he was almost killed when the soldiers mutinied. From Guadalajara he moved on to Manzanillo, a seaport on the west coast. There he appointed Santos Degollado head of the liberal army of the west, while he and his cabinet took the long way around to Veracruz via the Panama Canal.

For the next three years the liberal government was directed from the seaport of Veracruz. But most of the country was under the control of the conservatives, who held Mexico City and the other major cities.

The War of the Reform was more than a local revolution. In essence it pitted the church and the large landowners against the middle class, the

mestizos and the Indians. However, it is a mistake to think of it strictly as a conflict between the lower and the upper classes. In some provinces, Indians fought for the church; in others, upper-class creoles fought on the side of the liberals.

It was a time of great adversity for the Mexican liberals. They lost more battles than they won. But Juárez' honesty and quiet efficiency inspired the men that surrounded him. Among the members of his cabinet were his old friends Melchor Ocampo, Guillermo Prieto, Ignacio Ramírez, Miguel Lerdo de Tejada. Juárez made neither speeches nor compromises, and he left to Mexico a permanent moral heritage, the idea of an ever-evolving liberalism.

Against the liberals the clergy threw their best generals. The churches were stripped of their treasure to support the conservative army. Neither side

gave quarter. The shooting of prisoners became a routine practice.

From the point of view of the liberals, the war was one conducted by a constitutionally elected government and its representatives against a reactionary class. In July, 1859, Juárez' government issued new and far-reaching decrees against the church. Under the new laws, all clerical holdings except actual church buildings were confiscated. Nunneries were to be abolished upon the death of their present occupants. Perhaps the most far-reaching of the new laws applied to marriage, which officially became a civil rather than a religious contract. No longer would Mexicans be required to pay marriage fees to the priests.

Because so many of the liberal army were believers in the church and because the priests had so long

occupied the most important place in the educational system, the new laws sometimes placed the officers of the army in the position of killing their own priests for refusing to administer the sacraments. Churches were plundered of all that was salable. Sacred relics were sometimes tossed upon bonfires; sometimes they were carefully hidden away by the same men who were fighting to reform religion.

Both sides had difficulty financing the war and resorted to exceptional measures. Juárez' army confiscated a British silver train. The conservatives "released" 700,000 pesos from the British legation in Mexico and made a deal with a Swiss banker for 750,000 pesos in cash in exchange for Mexican government bonds worth 15 million.

Toward the close of the war, Juárez received help from the United States. When Spanish ships sailed from Cuba and attempted to blockade Veracruz, the United States alerted a warship, which proceeded to treat the Spanish vessels, which were flying Mexican flags, as pirates. Convinced that Juárez could bring stability to Mexico, the United States sent in shipments of munitions.

By 1860 the conservatives were beginning to suffer. No duties had been collected from Veracruz in three years. The churches had been stripped of most of their wealth. In the north a leading conservative general, Miramón, was defeated at Silao. There Juárez took over two thousand prisoners and, to the surprise of everyone, did not shoot them. In the south a young liberal lieutenant, Porfirio Díaz, distinguished himself in battle in Oaxaca and took over control of the region. He was to be decorated for his bravery by the Juárez government.

The final battle of the war took place at San

Family life meant devotion to parents and the home.
Estrada's painting of a dying mother is called The Agony.

Miguel de Calpulalpan on the road to Mexico City. After the defeat of their army under General Miramón, the conservative leaders went into hiding. By January 1, 1861, the War of the Reform was over. In ten days the taciturn president of Mexico arrived at a victory celebration arranged by Porfirio Díaz wearing a badly cut black suit and seated in a plain black carriage.

Three years of total civil war had wrecked Mexico's economy. Its customs receipts were pledged to England. France had extensive claims for compensation for the confiscation of the wealth of French citizens, the destruction of their property, and loss of life. The Spanish demanded payment for the killing of Spanish citizens. Juárez and his government agreed that compensation should be paid, but did not have the means to do so. With no other alternative available, the government suspended payments on all foreign debts for two years.

This was unacceptable to Mexico's three major European creditors, who decided to force payment by seizing control of the customs house in Veracruz. Troops representing France, England, and Spain were dispatched and occupied the city. After their arrival, there was no agreement as to how to proceed with the collections, but this soon became an issue of minor importance. France had another plan. It had been carefully worked out by Napoleon III, who wished to add Mexico to the French empire. It was an ideal time, the emperor conjectured, for such a move. The United States was completely preoccupied with its own civil war. It was expedient to involve Spain and England in the initial phase of the intervention, but those two countries, soon after learning of French intentions, decided to withdraw and leave the French in control.

233

France in Mexico

Napoleon III had been led to believe by influential Mexican conservatives in exile that Mexico would welcome a foreign monarch, and he expected an easy victory. Thus, when his well-equipped army of over six thousand men marched on Puebla, gateway to Mexico City, and was defeated by a Mexican force less than two-thirds its size, using weapons long antiquated, he was enraged. One-sixth of the French were killed in the first charge. The Mexican army began a counterattack that drove the French all the way to the coast. The date of this battle, the fifth of May, became a national holiday (Cinco de Mayo) equaled only by September 16, Independence Day (Diez y Seis).

Now the international prestige of France was at stake. No matter what the cost in men and material, Napoleon III had to have Mexico. An army of 28,000 men under three of his best generals—Bazaine, Forey, and Douay—was dispatched. This greatly enlarged force was successful in taking Puebla in its second assault.

After the fall of Puebla, Juárez, realizing that Mexico City was indefensible, took his government north to San Luis Potosí. For the next three years he fought a running battle against Maximilian and the French army.

The entire episode of the French intervention in Mexico seems like a romantic dream. Napoleon III and also Maximilian and Carlota, who had agreed to become emperor and empress of the French protectorate, were completely out of touch with Mexican reality. Maximilian sincerely wanted to under-

stand Mexico, its institutions, and its people, and he studiously applied himself. But his world and the New World were too far apart. The rising middle class, the intellectuals, and the patriots resented the French every moment they were on Mexican soil. Mexico represented a New World in ferment. Maximilian and Carlota represented the distilled traditions of the Old World.

Maximilian was too sensitive a man not to feel the resentment. At first he tried to adapt himself to the circumstances, but soon he isolated himself from all except the social aspects of Mexican life. The

French troops arrived early in 1862. Two zouaves are at lower right. Another, in red pants, is on the bridge.

archives at Chapultepec Castle show that a lavish ball was held at least every two weeks, a major banquet weekly, and at least three formal luncheons per week. These activities did not seem to tire the emperor, however, perhaps because he was practicing what he wrote: he had completely revised his six-hundred-page manuscript on the art of etiquette during his voyage to Mexico.

But Maximilian could not avoid involvement, for Juárez and the liberals refused to surrender. As the war dragged on, Maximilian's commanding officer asked him to authorize the shooting of Juárez' sol-diers when captured. Maximilian's signature on this measure made it virtually impossible for Juárez to pardon him when he fell into the hands of the Mexicans two years later.

By 1865, Napoleon III knew that he had been following a disastrous policy in Mexico. Without notifying Maximilian or Carlota, he ordered General Bazaine to begin evacuating the French troops from Mexico. The French general felt that it was his duty to inform Maximilian. True to his nature, Maximilian accepted the news calmly and indicated that he would abdicate and depart with the troops.

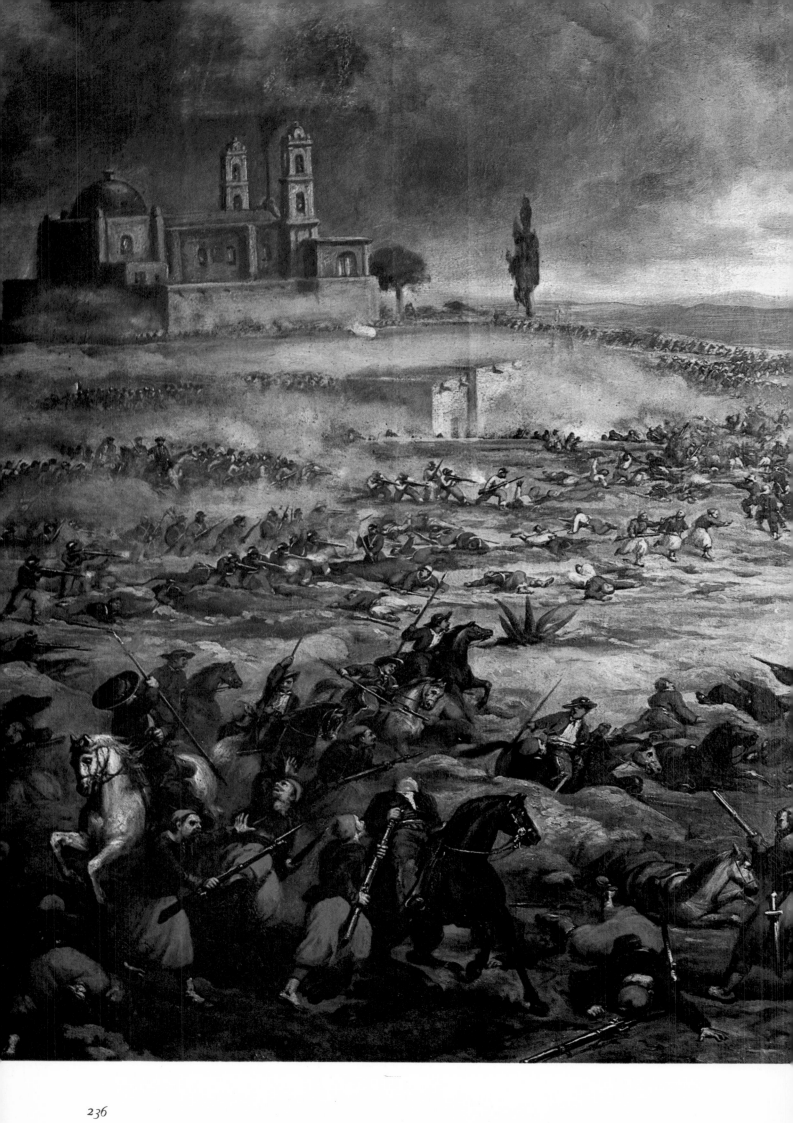

But Carlota liked her role as empress and, without reason, believed the Mexican people would stay loyal to her husband and herself. She left immediately for France, where she hoped to convince Napoleon III that he should continue to support the Mexican empire. After a stormy passage, Carlota went directly to the emperor and pleaded for his support. The discussion broke off when Napoleon, who was ill at the time, asked her to leave. Three days later, she saw him again, this time armed with his own letters promising support should Maximilian ever need it. The emperor promised to put the matter before his ministers. The ministers, who had never been in favor of this venture, decided unanimously that Maximilian should be abandoned.

From France, Carlota went to Rome, where she was granted a private audience with the pope. By this time, Napoleon's refusal to help Maximilian's desperate position and Carlota's own inability to find a solution had contributed to her complete mental collapse. She complained to the pope that people were trying to kill her; that agents of Napoleon had sprinkled poison on her food. Carlota was declared insane a few days later. There were many periods in the long years that followed when her mind was completely clear, but she never returned to Mexico. She lived to the age of eighty-seven on her family estate near Brussels.

When Maximilian learned by cable that his wife was under the care of a Dr. Reidel, director of a hospital for the insane, he realized the seriousness of her condition. His friends urged him to abandon the throne. He drafted the abdication proclamation, shipped his personal effects to Veracruz, and went to Orizaba, where he spent an agonizing six weeks deciding on an honorable course of conduct. In Orizaba there was a leading spokesman for the con-

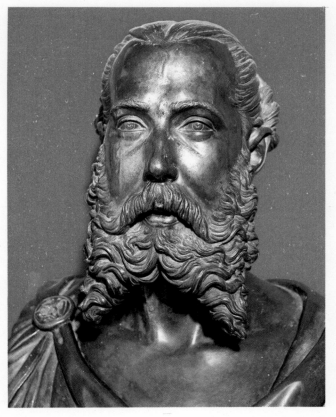

Maximilian of Austria was the puppet of Napoleon III, who attempted to extend the French empire to Mexico.

servative cause, Father Fisher, a German Jesuit and an extraordinarily persuasive man. It might even be said that Fisher, rather than the Mexican government, was responsible for the death of Maximilian. Fisher organized demonstrations of his supporters and seems to have convinced Maximilian that the honor of the Hapsburgs required that he stay on.

When General Bazaine embarked from Veracruz, Maximilian was left with only a small force. Yet he decided to go to Querétaro to meet the advancing liberal army. The battle of Querétaro became the sunset of the imperial dream. Almost the entire command of the emperor's army was captured.

Maximilian was placed on trial. Pleas for his pardon came to the government of Mexico from most of the kings of Europe. But Juárez felt that Mexico had suffered too often in the past from foreign adventurers. Maximilian had made himself responsible for the death of thousands of Mexican soldiers. On July 19, Maximilian, with his two generals, Miramón and Mejía, faced a firing squad on the crest of the Cerro de las Campanes de Querétaro (Hill of the Bells of Querétaro).

At Puebla on the road to Mexico City, the French army was decisively defeated by the Mexicans on May 5, 1862.

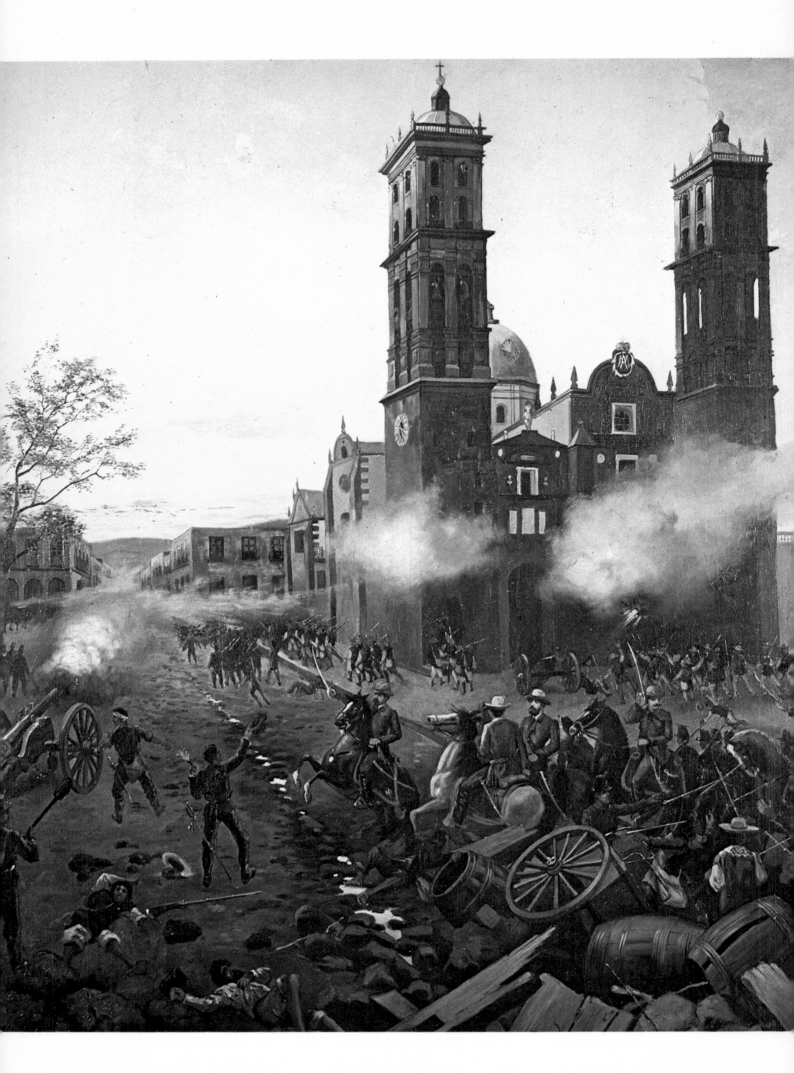

238

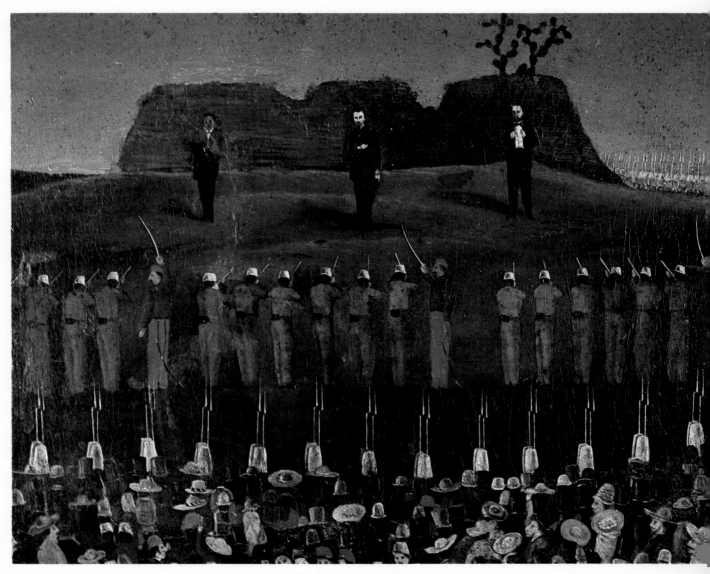

*Facing a Mexican firing squad with two of his generals,
Maximilian shouted "Long live Mexico!" and met his death.*

The succeeding months were not easy for Juárez. Believing that Mexico could not afford to maintain a large army, and that this portion of the public funds was needed to rebuild the country, he dismissed two-thirds of his soldiers without pensions. Many of the veterans formed their own armies and Juárez was forced to put down a series of minor revolts.

One of the dissidents was Porfirio Díaz. When Juárez agreed to run for another term as president, Díaz allowed his own name to be entered in the race. Although he was defeated overwhelmingly, he did not give up. His friends immediately began organizing the countryside for the next election.

When Juárez decided to run for a fourth term, more opposition to his re-election appeared. Not only Díaz opposed him but also some of his former

associates and friends, such as Sebastián Lerdo de Tejada. Lerdo felt that Juárez had served long enough. In the three-way election, none obtained a majority. The selection of a president was left to the congress. Juárez became president, Lerdo chief justice of the supreme court.

Now Juárez was faced with a rebellion engineered by Porfirio Díaz and his supporters. After a short but bloody series of battles, in which Porfirio's brother, Felix Díaz, was killed, the revolt was crushed. Juárez went back to his thankless task of the day-to-day running of the government. Díaz did not give up. He was actively engaged in revolutionary activity when, on July 18, 1872, President Juárez slumped over on his desk, the victim of a stroke which killed him a few hours later.

*On a rearing stallion, young General Porfirio Díaz
leads a Juárez army to victory over the French at Puebla.*

239

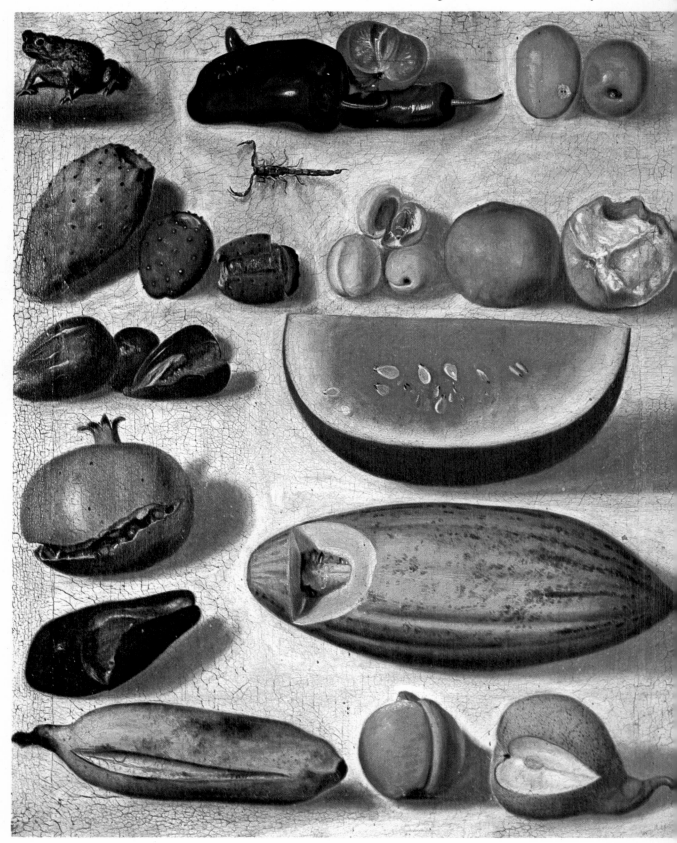

Atilana Garcia y Nemecio Rico dan gracia
a nuestra Señora de los Auxilios Enfermos
todos de una grave enfermedad. Octubre de 1877.
Y para perpetua memoria dedico este reta..
á 28 de Enero de 1...

*This unpretentious painting on tin, also by Hermenegildo
Bustos, portrays a family giving thanks to the Virgin.*

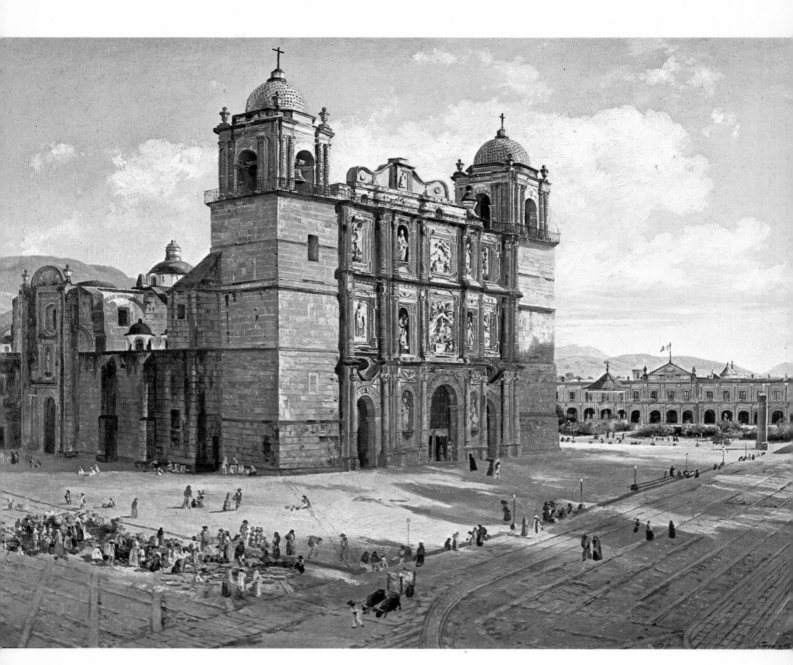

The cathedral at Oaxaca, a famous landmark, was painted by José María Velasco, Mexico's greatest landscape artist

Dictatorship of Díaz

The man who was to become president and dictator of Mexico for the succeeding thirty-eight years, was, like Juárez, of Indian descent. His ancestors were Mixtec, the same group that moved in and occupied, but never completely conquered, the Zapotec nation. Unlike Juárez, Porfirio Díaz was a man of limited education and unremarkable intellectual powers. He was an opportunist and, even in the early years of his regime, followed a policy of conservatism.

Ironically, the rise of Díaz to power was eased by some of the policies of his liberal predecessors. The philosophy of positivism, with its ideal of liberty, order, and progress, had been deeply instilled by Juárez' education minister, Dr. Gabino Barreda. Díaz took advantage of this positivist philosophy, but destroyed the liberty of the people in his pursuit of order and progress.

When Díaz became provisional president in 1876 he explained that he was a liberal conservative and identified himself with the idea that liberty was possible only when a certain level of order had been reached. But after he consolidated power, all the freedoms were forgotten. His was a philosophy of materialism, and that philosophy, ignoring human

alues, placed primary stress on building an orderly nd prosperous society.

The years of the Díaz dictatorship coincided in Jnited States history with the era of robber barons, he period when Jay Gould, John D. Rockefeller, Meyer Guggenheim, and many others were building inancial empires. In a sense, Porfirio Díaz was one f them, though wealth was only one of his passions. He craved power and prestige. He wanted Mexico to e known for her material progress, and he was villing to pay a price for rapid economic develop- ment. Americans and Europeans were given extraor- inary rights in Mexico in return for minimal nvestments of money and expertise. In a compara- ively short time, although it was not visible on the urface, Americans and Englishmen controlled most

of the utilities, the railroads, and the mining and mineral rights in Mexico.

In his quest for political power, Díaz was utterly ruthless. One example will suffice. When a con- spiracy broke out in Veracruz and suspects were taken into custody, Díaz did not investigate the details, but simply instructed the governor by tele- graph to shoot them. As a result, nine men who had no connection with the conspiracy were killed.

Justice in Mexico under Díaz was available, but only for a price and only for those who had proper connections. Even when legal decisions were in the public interest, it was Díaz' law rather than objective justice. Civil rights in such a system went un- defended, and those who protested were treated as bandits. But Díaz was particularly proud of his

In this peaceful landscape, Velasco captures the uality of the light and shadow of the Mexican countryside.

(Overleaf) In the shadow of the volcano El Citlaltepetl, a train dramatizes Mexico's progress in transportation.

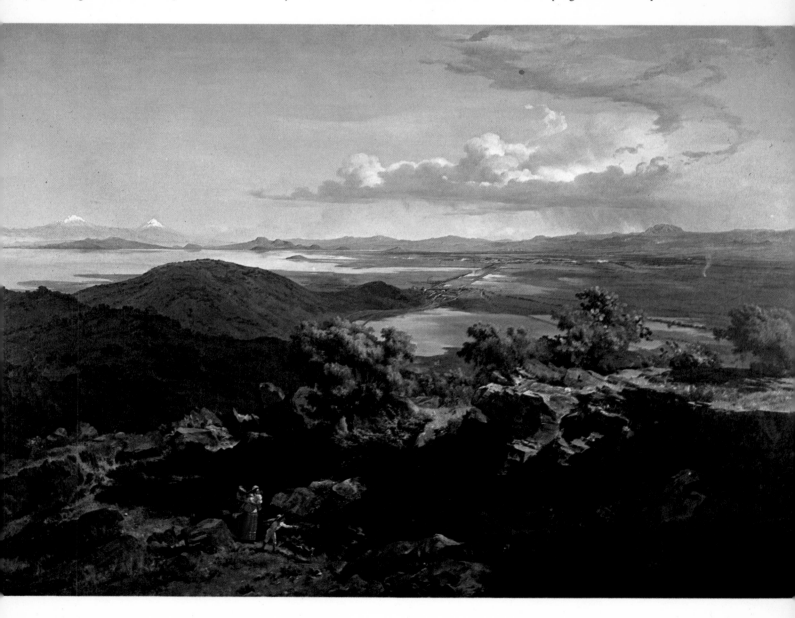

243

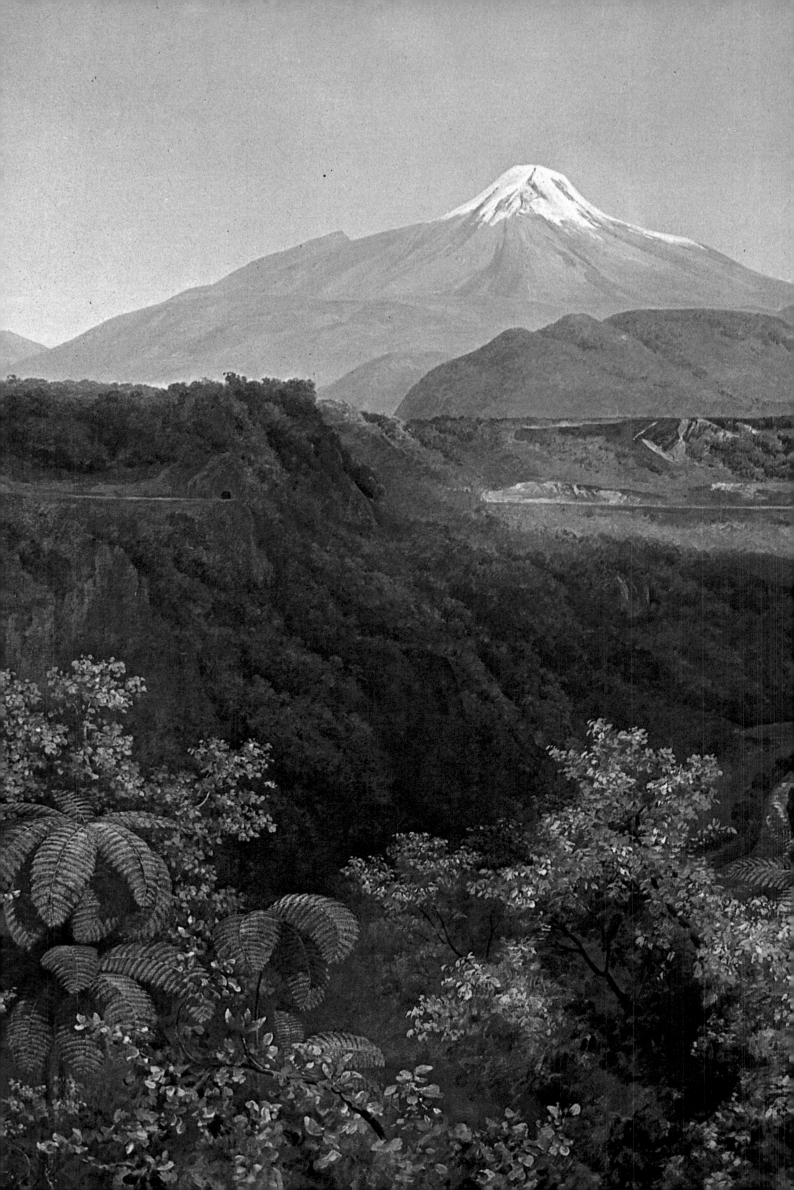

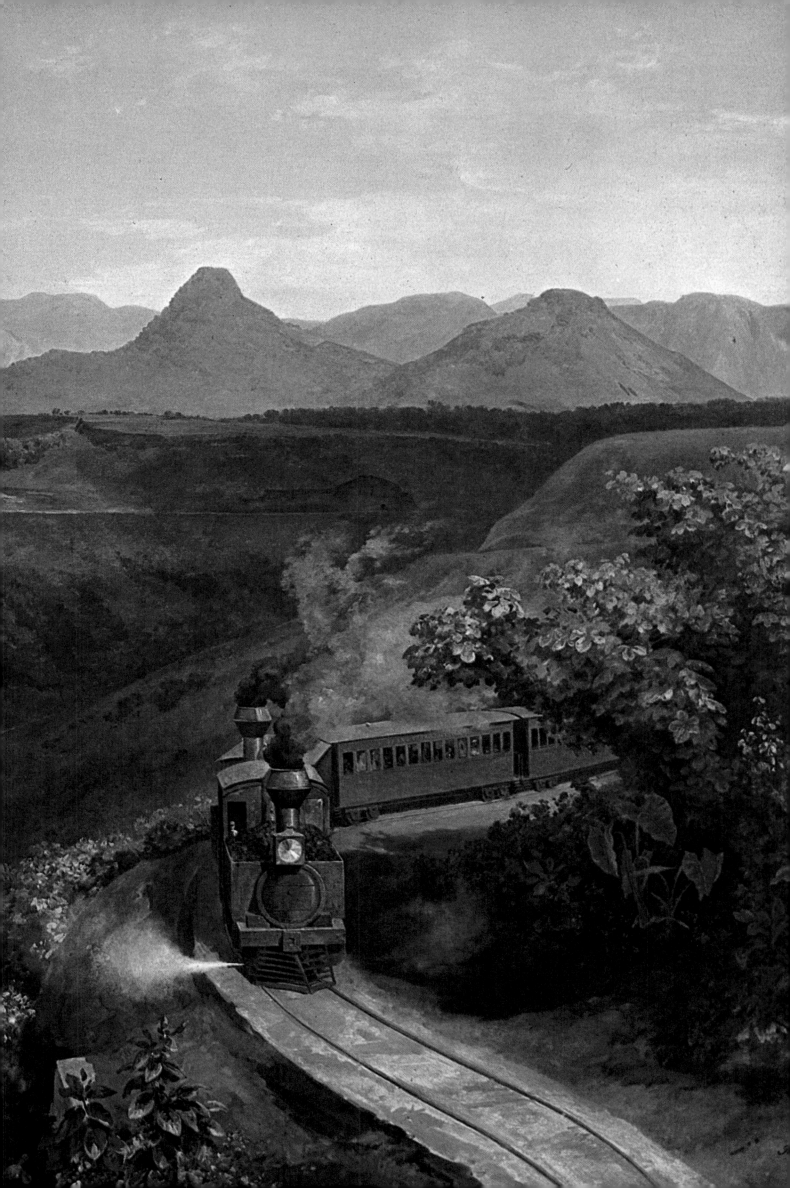

justice, for it was very efficient. To eliminate banditry throughout Mexico, Díaz organized the bandits into a police force to police banditry. It worked extraordinarily well. His picked police invited guerrilla groups who had been terrorizing certain areas to become part of a new national police force known as *rurales*. Their pay was small and they did prey on outlaws who did not join up. But most remained bandits, now under cover of law. They took what they pleased and there was no one to whom the peasantry could apply for redress. With them at his disposal, plus a well-trained army and a network of spies, Díaz created the first modern police state.

Although conditions for the upper class and part of the middle class improved, the state of the Indians and the vast majority of population declined under the economic policies of Díaz. The agricultural system became similar to that of the sharecroppers in the plantation country of the southern United States. In place of the plantation house with its broad, well-kept lawns was the hacienda. In both cases a small commissary sold the bare necessities of life to the workers at inflated prices. In Mexico, as in the southern United States, absentee landlords often controlled hundreds of thousands of acres. In neither locale was any interest shown in the welfare of those who worked the land.

By the beginning of the twentieth century, the Díaz dictatorship had been in power so long that most felt it would end only with the dictator's death. But toward the end of his seventh term of office, Díaz permitted an American correspondent, James Creelman, to prepare an exclusive story for *Pearson's Magazine.* When Creelman quoted Díaz as saying

In this cartoon, a kneeling governor prays to Díaz, "O Great Elector, do not forget me in the hour of election!"

While society folk go to the theater in their coaches, another performance, the Revolution, is about to begin.

Terrible Crimes of the Hacienda Owners, *a drawing by Posada, illustrates one of the causes of the Revolution.*

that under no circumstances would he stand for re-election, it started a chain reaction that sent the dictator into exile. When he gave out the interview, he thought he was speaking for United States consumption only. It did not occur to him that the interview would be picked up by the Mexican publication *El Imparcial* and widely read by both his enemies and his friends. Yet even after his closest associates, including his long-time treasurer, José Ives Limantour, suggested that it might be wise for him to keep his promise to retire, he disregarded everyone's advice and ran for the presidency once again. According to Díaz' count of the vote, he won. He allotted 196 votes to his major opponent, Francisco I. Madero.

1910-1940
REVOLUTION
AND PROGRESS

Madero forces Díaz' resignation and becomes president, but is betrayed and killed by Huerta. Zapata, Villa, and Carranza continue Revolution. They destroy Huerta, but cannot agree on leadership. Violent internal war begins. The military genius of Obregón makes Carranza president. He is followed by Obregón and Calles, whose antichurch laws bring on revolt of the *cristeros*. Lázaro Cárdenas implements the aims of the Revolution by land reform, and the return of mineral rights to the Mexican nation.

HISTORICAL CHRONOLOGY	ART CHRONOLOGY
1910 Madero campaigns until arrested. Díaz wins eighth term. Government sponsors centennial	*1911 Multicolor magazine illustrated by García Cabral and Santiago de la Vega.*
1911 Díaz resigns. Madero enters Mexico City.	*1913 Alfredo Ramos Martínez' open-air art school at Santa Anita.*
1912 Peasants demand land reform. Zapata attacks provisional government. Madero elected.	*1916 Mariano Azuela writes Los de Abajo.*
1913 Huerta seizes power. Madero assassinated.	*1917 Vision of Anahuac published by Alfonso Reyes.*
1914 Constitutionalist army organized by Carranza. Huerta exiled.	*1919 Mexican Academy of History founded.*
1915 Carranza reaches Mexico City. Zapata and Villa break with Carranza and capture Mexico City, forcing his withdrawal to Veracruz.	*1920 José Vasconcelos named minister of education.*
	1922 Roberto Montenegro paints early mural, Dance of the Hours, at School of San Pedro y San Pablo.
1916 Carranza retakes capital; receives United States recognition. Villa retaliates by attacking U.S. property, provoking armed intervention led by General Pershing.	*1926 Diego Rivera completes mural at National School of Agriculture. Adolfo Best-Maugard, theatrical designer, writes A Method for Creative Design.*
1917 New constitution provides for economic and social reforms. Carranza elected president.	*1927 Francisco Goitia, early revolutionary painter, acquires renown with his oil painting Tata Jesucristo.*
1919 Zapata continues revolt until killed.	
1920 Carranza unsuccessful in naming successor. Revolt of Agua Prieta. Obregón becomes president.	*1928 Publication of The Eagle and the Serpent by Martín Luís Guzmán.*
1921 National Agrarian Commission implements land reform.	*1929 Diego Rivera completes staircase mural, Tenochtitlán, at National Palace.*
1925 President Plutarco Calles brings organized labor into government.	*1931 Peasant Mother and Proletarian Mother of David Alfaro Siqueiros.*
1926 Government passes antichurch laws. Clerical dress outlawed. Revolt of cristeros.	*1933 Dr. Atl's The Clouds over the Valley.*
	Mural painted by Rufino Tamayo at Moneda 16, and Julio Castellano's mural at the Colegio Melchor Ocampo in Coyoacán.
1928 Obregón assassinated.	
1930 National Revolutionary party created.	*1934 Inauguration of the Palacio de Bellas Artes, designed by Adamo Boari.*
1934 Six-Year Plan adopted. Cárdenas wins election.	*1936 The National Institute of Anthropology founded, with Alfonso Caso as director.*
1937 Collective farms. Railroads nationalized.	
1938 Oil fields, mines, and natural resources declared property of nation.	*1938 Murals by José Clemente Orozco in Chapel of Hospicio Cabañas in Guadalajara.*
1940 Election brings Ávila Camacho to presidency. Mexico enters orderly course of development.	*1940 Castle of Chapultepec converted into National Museum of History.*

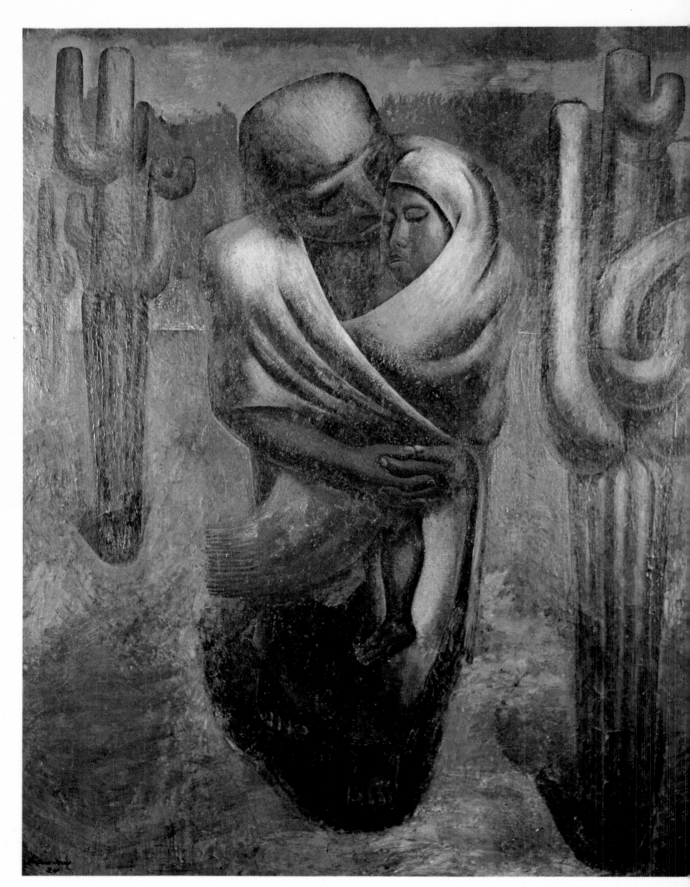

*David Alfaro Siqueiros, a revolutionist as well as an
artist, called this painting* Proletarian Mother and Child

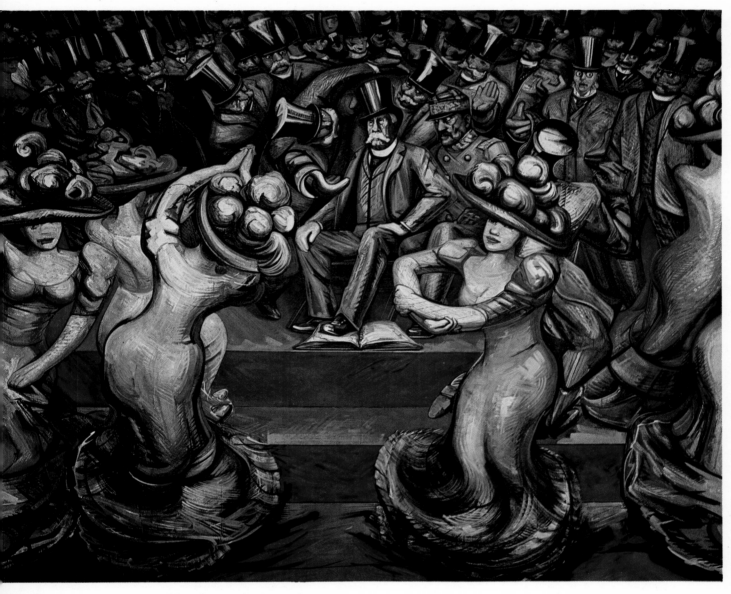

*Here Siqueiros shows Díaz crushing the constitution under-
foot and entertaining his supporters with dancing girls.*

Revolution and Progress

Beneath the surface prosperity and security of the
Mexico of Porfirio Díaz lay a smoldering restlessness
caused by the abject poverty and hopelessness of the
submerged peasant population. In 1910 this volcano
was still dormant, but growing political forces were
trying to chip away at the rigidly controlled Díaz
police state.

Hints of the eruption soon to come could be seen
every day in the works of a unique artist-caricaturist,
José Guadalupe Posada. Like Daumier in France
and Goya in Spain before him, Posada recorded the
subsurface of life in sharp, biting drawings that were
turned out and distributed each day with the regu-
larity of a newspaper. His *calaveras,* or skeleton

drawings, part of a tradition older than the Aztecs,
expressed the characteristically Mexican view of
death as a natural part of life while they commented
on every aspect of the political and social scene. It
was not necessary for the purchaser of Posada's daily
caricatures to be able to read; vividly and usually
wordlessly, he portrayed the events of the prerevolu-
tionary period. He made the square figure and bull-
doglike face of the white-mustached dictator and the
short form and dark eyes of his black-bearded ad-
versary, Francisco Madero, familiar to millions.

In September, 1910, millions of Mexicans—mostly
those of the middle and upper classes—came to-
gether in a great celebration. Its purpose was to com-
memorate the one-hundredth anniversary of the
independence of Mexico and, at the same time, to
mark the re-election and eightieth birthday of
Porfirio Díaz. No ancient Aztec rite, no viceregal

ceremony, no Catholic fiesta could compare with this triple celebration. Twenty carloads of champagne supplied the incredibly lavish banquets, and parades by the dictator's well-equipped army filled the streets. The public streamed to dedications of new buildings, art exhibitions, athletic events, and a performance of the opera *Aida*.

The hundredth-anniversary observance went beyond what the dictator had planned. It became an expression of Mexican nationalism rather than a mere personal tribute to an octogenarian tyrant. Although visibly poor Indians were kept well out of sight to strengthen the aura of affluence, such key events in Indian history as the meeting of Moctezuma and Cortés were re-enacted. Ancient American art, Indian dancing, and indigenous music were

recognized, perhaps for the first time, as part of Mexico's total cultural heritage.

Largely ignored amid the parades and banquets was a small but significant philosophical and intellectual renaissance. Symposia, lectures, and meetings of avant-garde political groups contributed to the growth of a body of thought which, years afterward, gave the Mexican Revolution a solid philosophical and spiritual foundation. A new cultural institute, El Ateneo de la Juventud (The Athenaeum of Youth), was organized by such outstanding intellectuals as Antonio Caso, an orator, scholar, and diplomat; Alfonso Reyes, a social philosopher, essayist, and poet; and José Vasconcelos, one of the great educators in any country at any time. These men and their followers were largely responsible for the

Revolutionists dance in this painting by Francisco Goitia, the first painter to take the Revolution as a theme.

A drunken, ragged guerrilla, gun in one hand, bottle in the other, is lighted by the burning buildings behind him

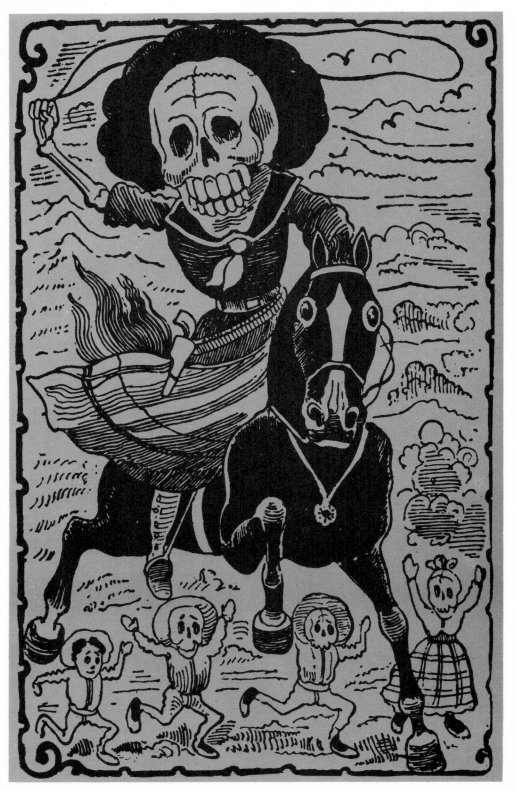

Posada vividly expresses the grim justice of the Revolution in one of his powerful calavera, or skeleton, drawings.

The execution of captured enemy officers by firing squa[...] became a common practice during the Revolution of 191[...]

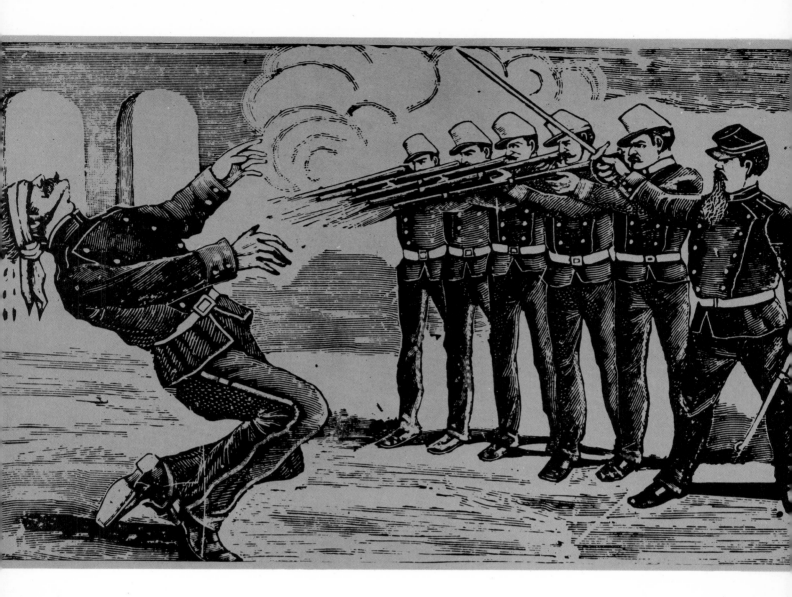

intellectual revolt against positivism. They directly opposed the *científicos* (scientists) of the Díaz regime. During the anniversary and birthday celebration, they released their own manifestos, which, while not revolutionary in the physical sense, were part of the assault on the *status quo*. Alfonso Caso perhaps best expressed the intellectual opposition to positivism and the so-called scientific method in government when he wrote, "The community which tyrannizes over man forgets that men are 'persons,' not biological units."

This was a philosophy that the young artists of Mexico understood instinctively. Some of them, like Gerardo Murillo, then thirty-five years old, were born revolutionists. Hating his academic-sounding name, this talented artist had changed it to Dr. Atl, a word meaning water in the Nahuatl Indian language. Realizing that the centennial offered a great opportunity for Mexican artists to produce works

that would be truly Mexican in inspiration and style, Dr. Atl organized El Centro Artistico, the first association of Mexican artists. The art revolution in Mexico began almost simultaneously with the political revolution. Art students of the National Academy of San Carlos called a strike to protest the domination of European influences. Like Dr. Atl, a number of young artists, including Francisco Goitia, José Clemente Orozco, and David Alfaro Siqueiros, joined the revolutionary army.

In the end, however, it was neither the artists nor the intellectuals who toppled the Díaz dictatorship, but a seemingly harmless amateur politician whom Díaz had allowed a few token votes in the 1910 election, Francisco I. Madero. The quiet, scholarly Madero was not alone. Two unlikely patriots flanked him. His first ally was a sometime bandit named Doroteo Arango, better known in history as Pancho Villa. Madero's other supporter, who never

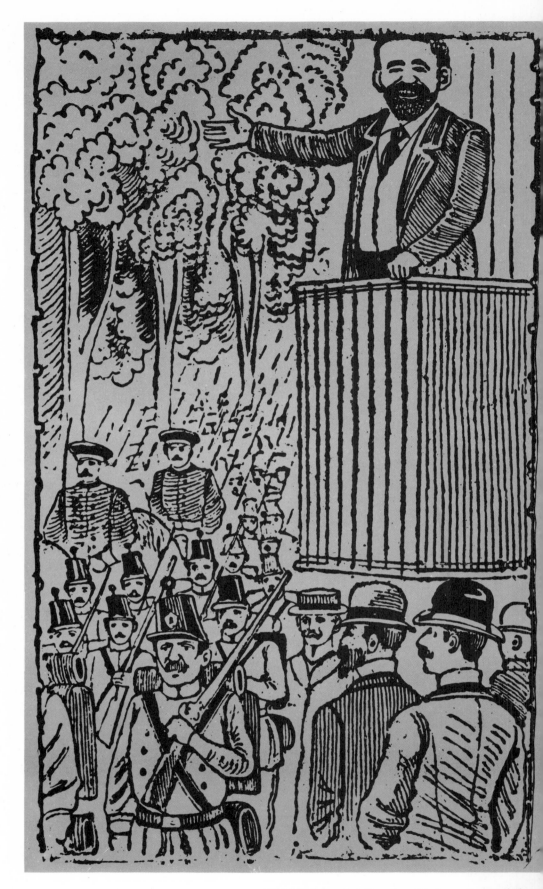

The black-bearded Francisco Madero was idealistic and
enormously popular, but he was an ineffectual president

completely accepted or trusted him, was the peasant leader Emiliano Zapata.

Only nine months after Díaz' great victory celebration, Madero, with Villa's army, took Ciudad Juárez on the American frontier and insisted that Díaz resign. The eighty-year-old dictator, weakened by defections and the corruption of his own government, had no choice but to accept. On May 26, 1911, he and wife Carmelita boarded a ship for France. Díaz died in Paris on July 2, 1915.

When Madero became president, Mexico expected not only peace but also many long-awaited political, economic, and social reforms. The new president had an unprecedented opportunity to implement such reforms. He was backed by the overwhelming majority of the Mexican people and could have prevailed against any small minority of well-entrenched politicians. But Francisco Madero could not bring himself to distrust even those who had proved conclusively that they could not be trusted. His almost

General Victoriano Huerta was devastatingly caricatured by Posada as a huge spider crushing the bones of his victims.

257

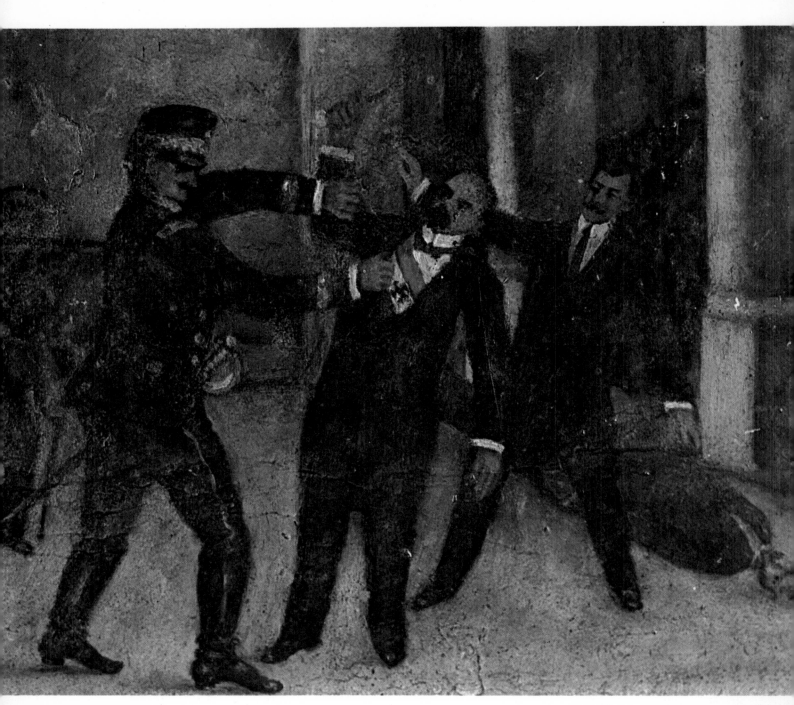

*President Madero and Vice-President Pino Suárez were
probably shot down in cold blood, as this artist believed*

Christlike ability to forgive even those who plotted his death and his faithfulness to his ideals made him a well-loved leader. Yet these very qualities prevented him from welding Mexico into the single nation it so desperately needed to be.

Instead of making sweeping changes in the government, Madero accepted the entrenched bureaucracy and kept some of the most conservative politicians as part of his cabinet. His failure to use the power of the government to redistribute the land and curb the power of organized religion began to cost him the support of both peasants and bourgeoisie. All around him were ambitious, unprinci-

pled men ready to take over at any sign of weakness. Three of them saw an opportunity and acted.

The nephew of the ousted dictator, Felix Díaz, along with General Bernardo Reyes, had been comfortably incarcerated for conspiring to overthrow the government. In jail they continued to promote an armed rebellion led by military men loyal to the old dictator. Once freed, they attacked the national palace with a small army. General Reyes was killed at the beginning of the engagement and the attack failed. Had Madero been more of a military man or had his generals been reliable, it would then have been a simple matter to surround and capture the

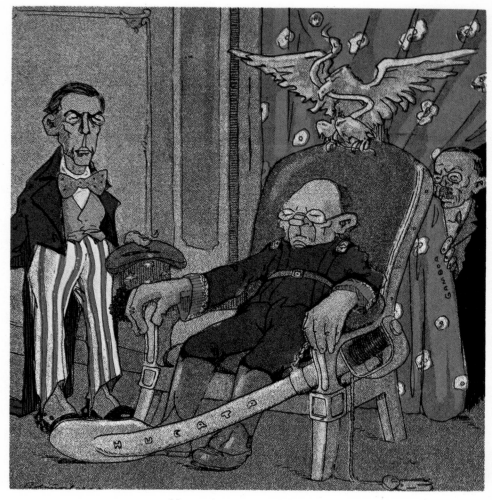

Huerta became president after Madero's death. His attempts at U.S. recognition were rebuffed by President Wilson.

rebels. But he put his faith in General Victoriano Huerta, the most sinister and untrustworthy man of the revolutionary period. One of Posada's best-known caricatures shows Huerta as a hairy man-eating tarantula, his many arms and legs crushing the bones and skulls of his victims. This was the man to whom Madero had entrusted his government and his life.

The next ten days were among the most tragic in all Mexican history. Huerta cared nothing for the lives of Mexican citizens who happened to be in his line of artillery. Buildings were crushed, whole streets razed by murderous cannon fire. One of Huerta's first moves was to redeploy his troops so that those loyal to Madero would lead the attack against the rebels and would thus be mostly killed off. Finally, when Huerta felt that he had shown Felix Díaz and his followers that he could overcome them, he made a deal: he, Huerta, would take over the government, and Madero would be disposed of.

On the day of the surrender, Huerta invited Madero's brother, the scrupulously honest treasurer of the government, to lunch with him. While the new dictator was plying Gustavo Madero with food and drink, he was having the president and vice-president arrested. Huerta left the restaurant first,

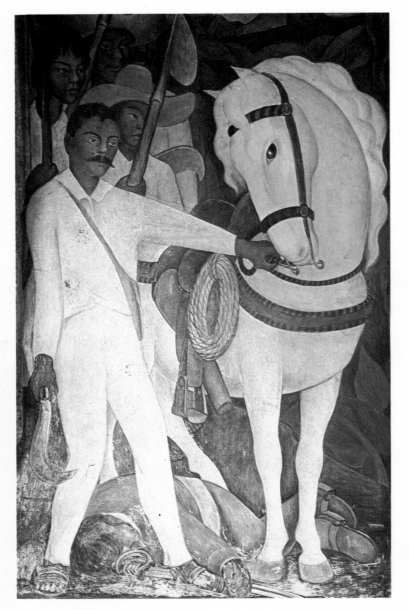

The peasant leader Emiliano Zapata is shown with a white horse in the famous mural by Diego Rivera at Cuernavaca.

and when Gustavo departed he was picked up by a military escort and shot.

When President Madero and his vice-president, José María Pino Suárez, were arrested by their own protectors, they were given the choice of death or exile. They chose the latter. Pedro Lascuráin, next in line to succeed to the presidency after Suárez, was sworn in. He had the honor of holding the post of president of Mexico for the shortest time in the history of the country. His tenure lasted forty-five minutes, just long enough for him to transfer the executive powers to Victoriano Huerta. It is said that when Lascuráin asked Huerta for a pledge that Madero's life would be spared, Huerta unbuttoned his shirt, took the medals of the Virgin of Guadalupe and the Sacred Heart of Jesus from around his neck and swore on them that Madero would be allowed to go into exile. But no such move was made. Each day, Madero and Suárez expected to join their wives and children, who had gone to Veracruz to await them.

Henry Lane Wilson, the United States ambassador, supported Huerta both before and after the coup, often without the knowledge or consent of his superiors, and he must share the responsibility for the betrayal of the Madero government. Madero's wife and sister had petitioned Ambassador Wilson to use his influence, as had most of the other foreign diplomats, on behalf of clemency. But when Huerta asked him his opinion regarding the disposition of Madero and Suárez, he made no move, no plea, to save their lives. Despite his record of continuous and blatant interference in the affairs of Mexico, he now piously protested that intervention in this case was out of the question.

Huerta had Madero and Suárez taken from the Palace to the penitentiary. There, outside the walls, they were shot. The official report issued afterward said that an armed group had attempted to rescue them, and that in the resulting fighting they had, regrettably, been killed. No evidence of such a rescue group has ever been found.

When Ambassador Wilson advised Washington to accept Huerta's explanation of the killing and recognize the new government, the newly elected president of the United States, Woodrow Wilson,

would have none of it. He not only refused to accept the explanation but called Huerta "the bitter, implacable foe of everything progressive and humane in Mexico." The only condition under which Woodrow Wilson would consider recognition of the Huerta government was a general election in which Huerta himself would not be a candidate.

The murder of Madero and Suárez electrified all of Mexico. It created a unanimity of opposition to the government even greater than during the Díaz regime. The country had had a taste of liberty. It would not accept a new dictatorship.

Yet this was not a new Revolution. It was the same Revolution that had begun one hundred years before when Hidalgo first raised the banner of the Virgin of Guadalupe for a free Mexico. It was the Revolution of Morelos, Guerrero, and Juárez. It was

the Revolution that Madero had won and had been able to consolidate.

Now the conscience of Mexico was aroused. It was as if, after the desperate growing pains of childhood, the whole country realized the absolute necessity of finding a mature identity. The revived Revolution was made up of many divergent elements, none of them seeming to know where they were headed. It was now a people's revolution rather than a political one. The striving for identity was not conscious; it took the form of a battle for freedom, for bread, for self-respect, and for recognition. It was the people of Mexico who fought and won the Revolution against tyranny. Their leaders varied in background, in temperament, and in the strength of their personal ambitions.

The most volatile of them was Pancho Villa, an

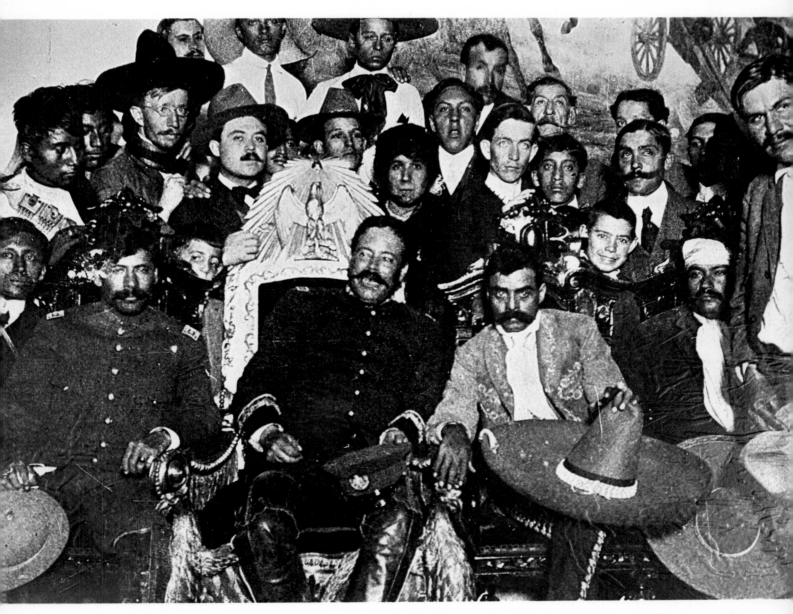

During the occupation of Mexico City, Villa sat for his photograph in the presidential chair with Zapata beside him.

idealistic, romantic, brutal, ruthless bandit. As a young man, he had worked on a hacienda and had killed the son of the owner, reputedly for molesting his sister. As a small-time guerrilla, he had fought against the *rurales* of Díaz. He was temperamental and irascible, but loyal to his friends and to the idea of liberty for Mexico. Until the Revolution was half over, he had never learned to read or write. The fantastic legend of Villa was vividly portrayed by the distinguished Mexican writer, Mariano Azuela, who traveled with Villa's army as a doctor. In his famous book, *Los de Abajo* (The Underdogs), Azuela has some soldiers describe Villa as follows: "Villa, indomitable lord of the Sierra, the eternal victim of all of the governments. . . . Villa, tracked, hunted down like a wild beast. . . . Villa, the reincarnation of the old legend; Villa as Providence, the bandit that passes through the world with the blazing torch of an ideal to rob the rich and give to the poor." And again, "If General Villa takes a fancy to you, he'll give you a ranch on the spot. But if he doesn't, he'll shoot you down like a dog! God! You ought to see Villa's troops! They were all northerners and dressed like lords! You ought to see their wide-brimmed Texas hats and their brand-new outfits and their four-dollar shoes, imported from the U.S.A." After quoting these extravagances, Azuela points out wryly that none of the men who have thus been describing Villa and his army have ever seen them.

Yet there was truth in the legend. The flamboyant Villa, a skilled horseman and marksman, was a man with a filed-trigger temper. He wore a soft felt hat pushed back on his broad, cheerful face. He neither drank nor smoked, and in the territory where he was *jefe* (chief) he did indeed take from the rich and feed the poor. He protected the peasants from the *rurales,* and they in turn protected and fed him. Villa knew that ammunition was far too precious to be wasted shooting prisoners, so he devised a method of stacking them up and executing three at a time with a single bullet. He started with a cavalry troop

of only 360 men, and at the height of his career commanded an army of 10,000.

The other great revolutionary leader who acquired legendary status in his own lifetime was Emiliano Zapata, leader of the peasant forces of the south. Like Juárez, Zapata was a taciturn Indian who spoke little but acted decisively. His people had been the underdogs for more than three hundred years. Their only hope for survival was to get enough land to work. While Madero's plan was concerned with politics, and Villa had no plan, Zapata was steadfast in his aim: land for the peasants.

He was a slim, dark man with a solemn, even saturnine countenance. With his high-crowned sombrero, white tunic and trousers, and cartridge belts draped across his chest, he became the most feared

Dr. Atl was an important revolutionary artist, write and organizer. He sat for portrait after the Revolutio

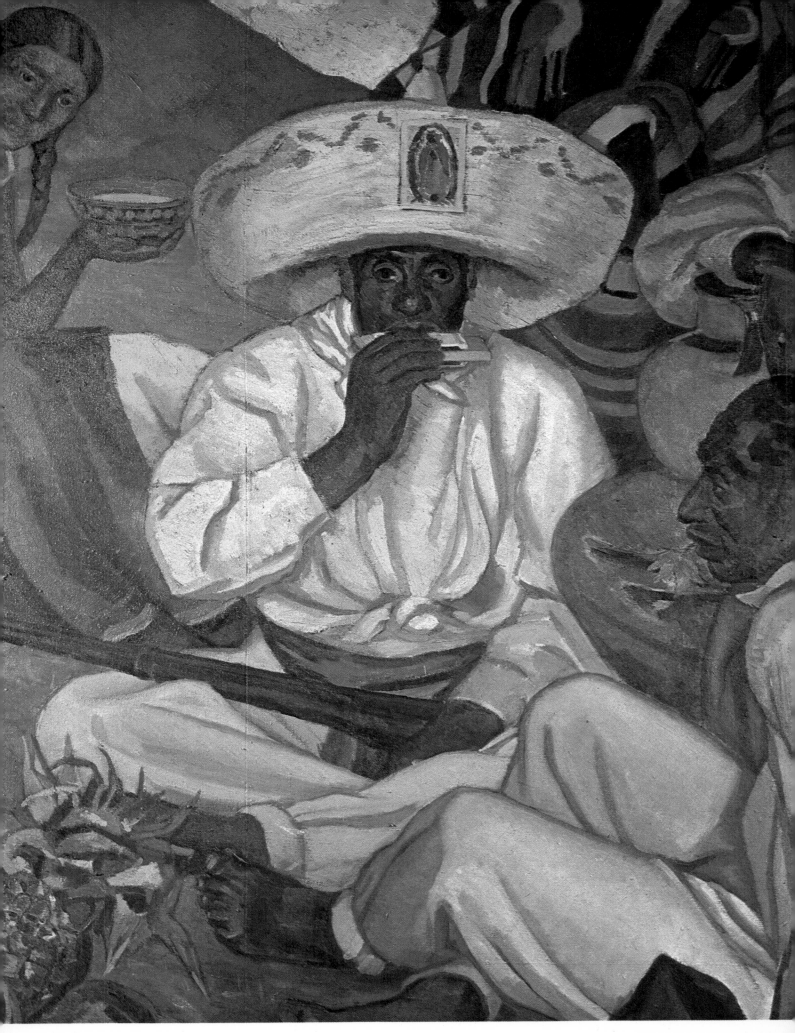

The likeness of the Virgin of Guadalupe, shown here on the sombrero of a campesino, *was a symbol of the* zapatistas.

and respected of the revolutionary leaders. No peasant in Mexico had any difficulty in understanding his program: it meant more corn for tortillas, more pigs, more chickens, and more chilis.

His fighting force was a ghost army of thousands of men, some armed with pitchforks and hoes, who could suddenly appear and just as suddenly vanish into the countryside without a trace, burying their guns and going back to their day-to-day work as farm laborers.

Zapata and Villa were united in their opposition to Huerta. The betrayal and death of Madero had particularly affected Villa. The president was perhaps the only man he had ever completely trusted. But he had no faith in Venustiano Carranza, who disputed Huerta's claim to the presidency and appointed himself Madero's successor. Tall, stout, and heavily bearded, Carranza looked like an Old Testament prophet. He had been appointed secretary of war by Madero even though he had taken little part in the fighting that preceded the fall of Díaz. Shortly after Madero's murder, Carranza declared himself First Chief of the Constitutionalist Army, with full executive power. He issued his *Plan de Guadalupe,* which demanded the resignation of Huerta and the formation of a new government. He made representations to Villa and Zapata, and, within a very short time, three armies were fighting against Huerta's federal troops. The central army was controlled by Carranza and led by a young ex-farmer turned soldier who in time would become the military genius of the Revolution, Alvaro Obregón. The army of the north was led by Pancho Villa, that of the south by Emiliano Zapata. President Wilson made it possible for the revolutionary army to be supplied with arms and ammunition from the United States.

At this point, if Carranza had been willing to accept Villa and Zapata for the patriots they obviously were—and if his ambition had been modest enough to let him live with the idea of someone else's becoming president of Mexico—perhaps the

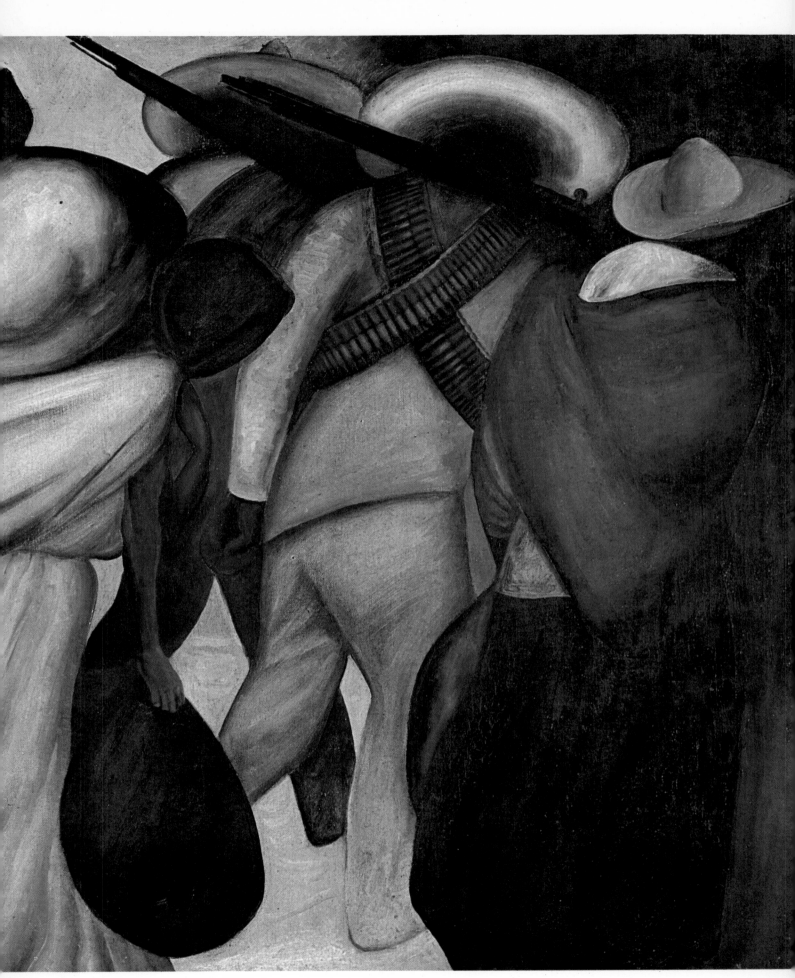

*Their backs as strong as the Revolution itself, faceless
soldiers and their women march in this painting by Orozco.*

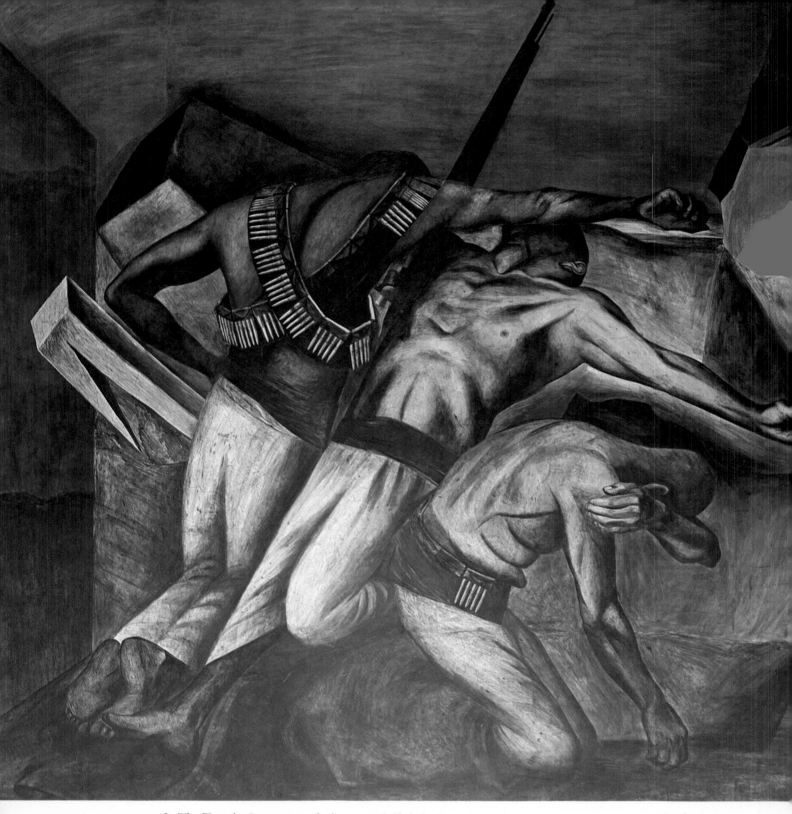

In The Trench, *Orozco uses the imagery of Christianity to express the enormous sacrifices of the revolutionaries.*

break between the three men would not have occurred. But it did. Now the three revolutionary armies were fighting each other as well as Huerta.

But before the actual battling among the three revolutionary generals began, Pancho Villa, disobeying the orders of Carranza, went ahead with his attack on the federal stronghold of Zacatecas. The city was a major prize and was well defended. But Villa's brilliant generalship won the battle, which was one of the bloodiest of the entire Revolution.

Between six and eight thousand federal troops wer killed and another three thousand captured. Vil lost some two thousand men.

Huerta's hopes collapsed with the fall of Zacat cas. He departed, like his old boss Porfirio Díaz, fc Paris. But it was not Villa but Alvaro Obregón, wit his Carranza army, who finally accepted the su render of the government at Mexico City. The di agreements between Villa and Carranza multipliec At the same time, Emiliano Zapata had notifie

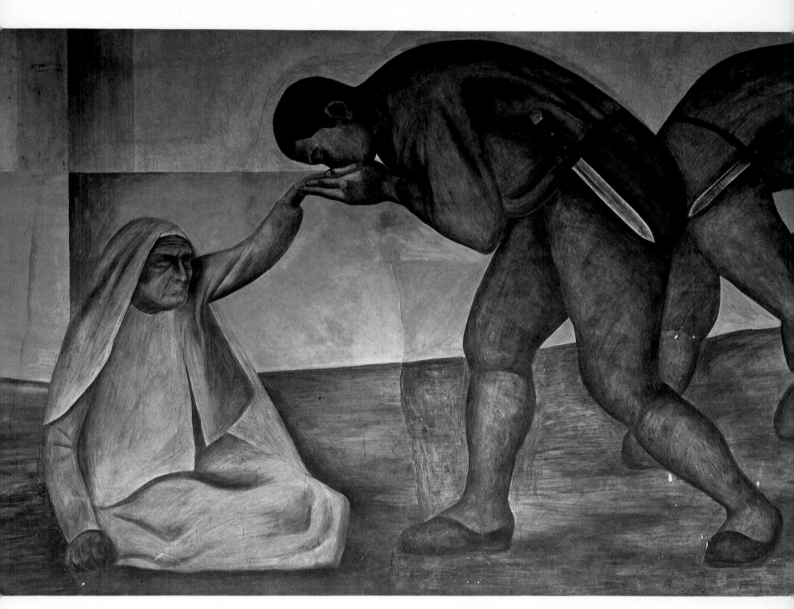

A young soldier, bayonet in his belt, takes leave of his aged mother in an early Orozco mural in Mexico City.

arranza that his *Plan de Guadalupe* was unacceptable because it did not contain the necessary land reforms. These internal quarrels led to the calling of a revolutionary convention, which was held in Aguascalientes in October and November of 1914. Neither Zapata nor Carranza attended the convention, but both sent representatives. General Alvaro Obregón represented Carranza. It was clear to the delegates that harmony was impossible as long as Carranza and Villa headed opposing military fac-

tions. Carranza surprised the convention with a letter stating that he was "disposed" to step down from his post and go into exile if Villa and Zapata would do the same. Villa, skeptical that Carranza would keep such a promise, half-seriously suggested two other alternatives which he thought might work better: that a convention firing squad shoot both Carranza and himself, or that they simultaneously commit suicide.

But the convention adopted Carranza's plan. Villa

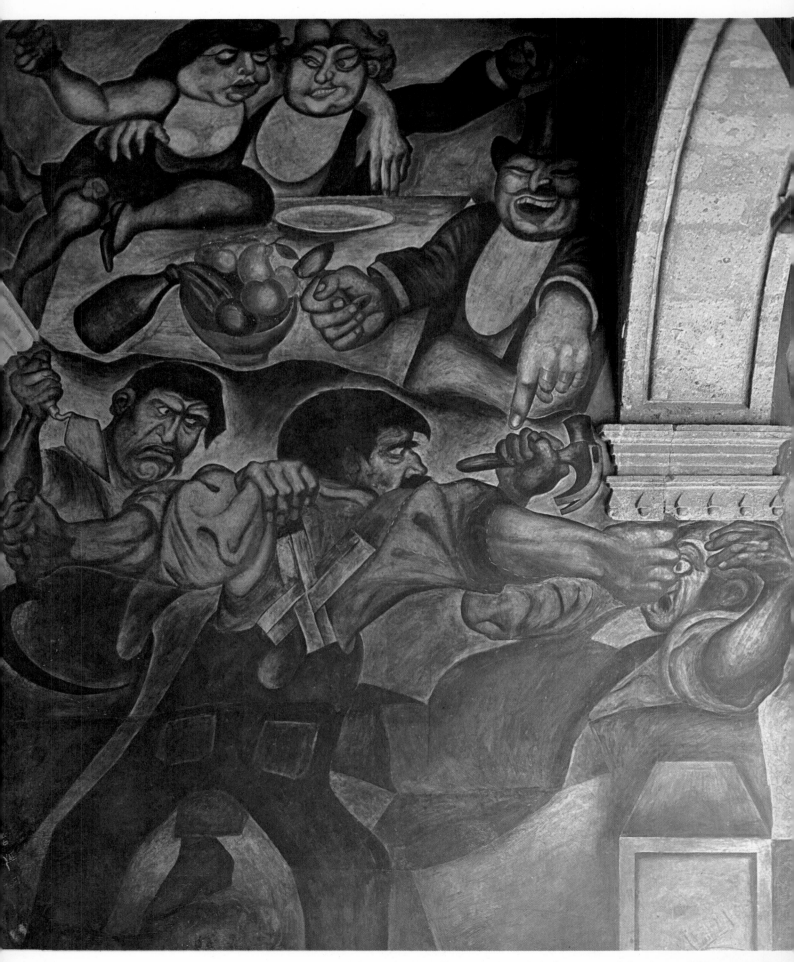

In one of Orozco's most searing murals, the well-fed rich amuse themselves by watching the workers brawl.

When a religious group defaced one of his murals, Orozco retaliated with this revealing study of hypocritical piety.

cepted it and resigned. Zapata's representative said
at if his agrarian reforms were adopted, he too
ould agree to resign. A compromise leader, Eulalio
utiérrez, was elected interim president of the re-
iblic until general elections could be arranged.
Obregón, satisfied with his work at the conven-
on, took the news of its decision to Carranza, but
und him no longer "disposed" to resign. His
cuse was that Gutiérrez was a figurehead for Villa
d that he did not want to see the country fall in
e hands of the ex-bandit. Obregón, convinced that
rranza would indeed be a better choice than Villa,
cted to stay with him.
Now Carranza was in trouble. Opposing him, and
pporting the new interim president, Gutiérrez,

were the forces of Pancho Villa in the north and
Emiliano Zapata in the south.

Zapata's opposition to Carranza, like most of the
actions of his career, was keyed to his passionate
dedication to land reform. With the help of a com-
rade, Otilio Monteaño, who was a former school-
teacher, Zapata had written and proclaimed the Plan
of Ayala. This broad program went beyond any
manifesto of Villa or Carranza in stating that end-
ing the peonage of the Indian population would
require breaking up the large landholdings and dis-
tributing the land among the peasants. The Conven-
tion of Aguascalientes had agreed to accept the Plan
of Ayala. But at no time did Carranza go on record
as accepting it. This united Zapata and Villa behind

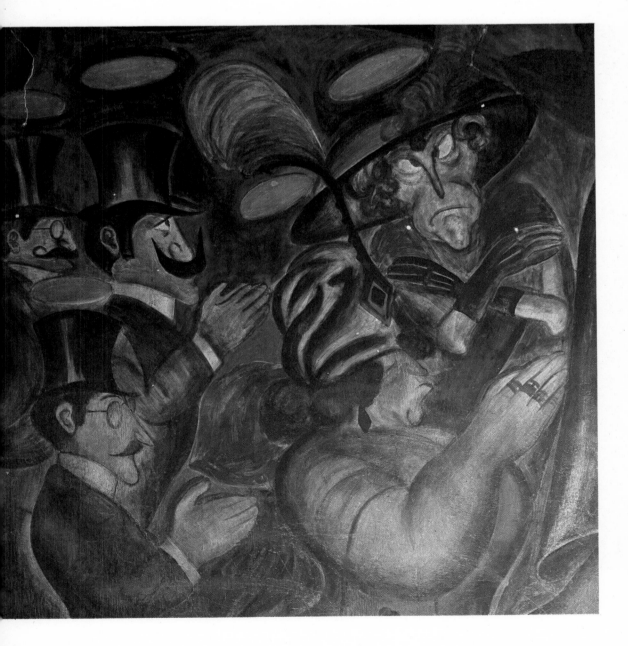

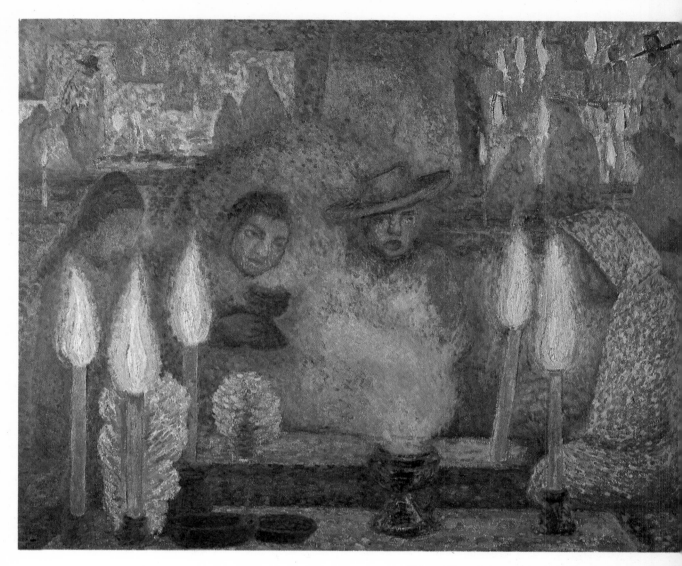

President Eulalio Gutiérrez, and their armies, converging from north and south, drove Carranza and his forces out of Mexico City.

The people of Mexico City had expected the Indian warriors, the *zapatistas,* to embark on an orgy of looting, rape, and murder. They were pleasantly surprised. While Villa's men caroused, the *zapatistas* quietly encamped around the suburbs and under the trees of the city and politely asked homeowners for a little food and water.

It was not long before the occupation forces of Zapata and Villa were forced out of the city and into a battle at Celaya by Obregón. The early fighting was dominated by Villa and his troops, but Obregón had planned a counterattack. It overwhelmed the Villa forces and won the battle for Carranza. A week later, Villa launched a second attack, but h lacked two essential ingredients for success. His ar tillery genius, one of the great heroes of the Revolu tion, General Felipe Angeles, had been injured an was in the north. Also, ammunition was desperatel scarce. It is said that Villa's soldiers had onl eighteen cartridges apiece. Obregón, on the othe hand, had unlimited ammunition. When the fight ing was over, Villa's army had been completely cu to pieces. Perhaps eight thousand men had been cap tured and at least four thousand were dead. Hun dreds of Villa's captured officers were herded into corral and mowed down by machine-gun fire. Vill continued to fight on, but he never again won major battle. When, on October 19, 1915, the Unite States recognized the *de facto* government o

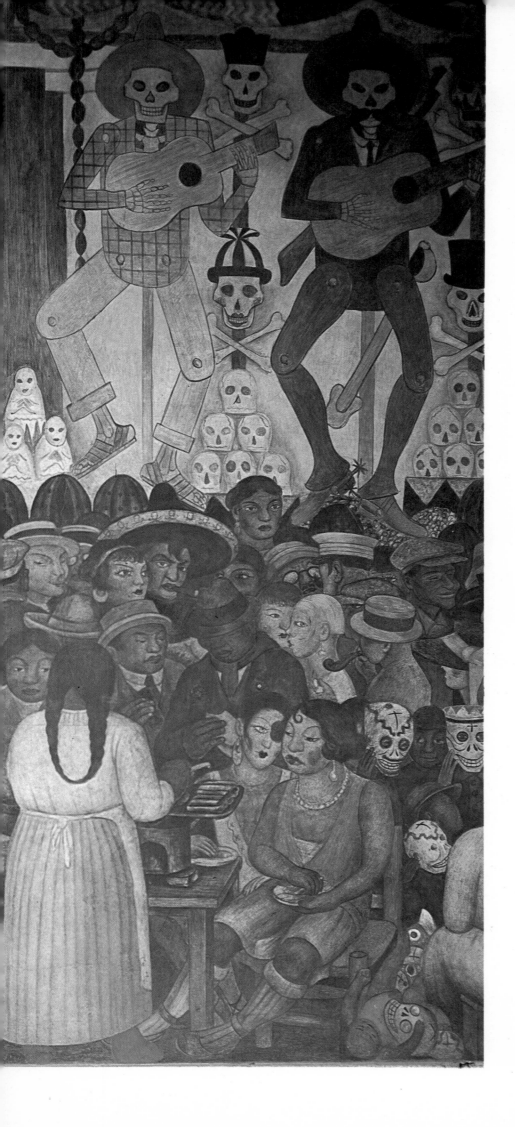

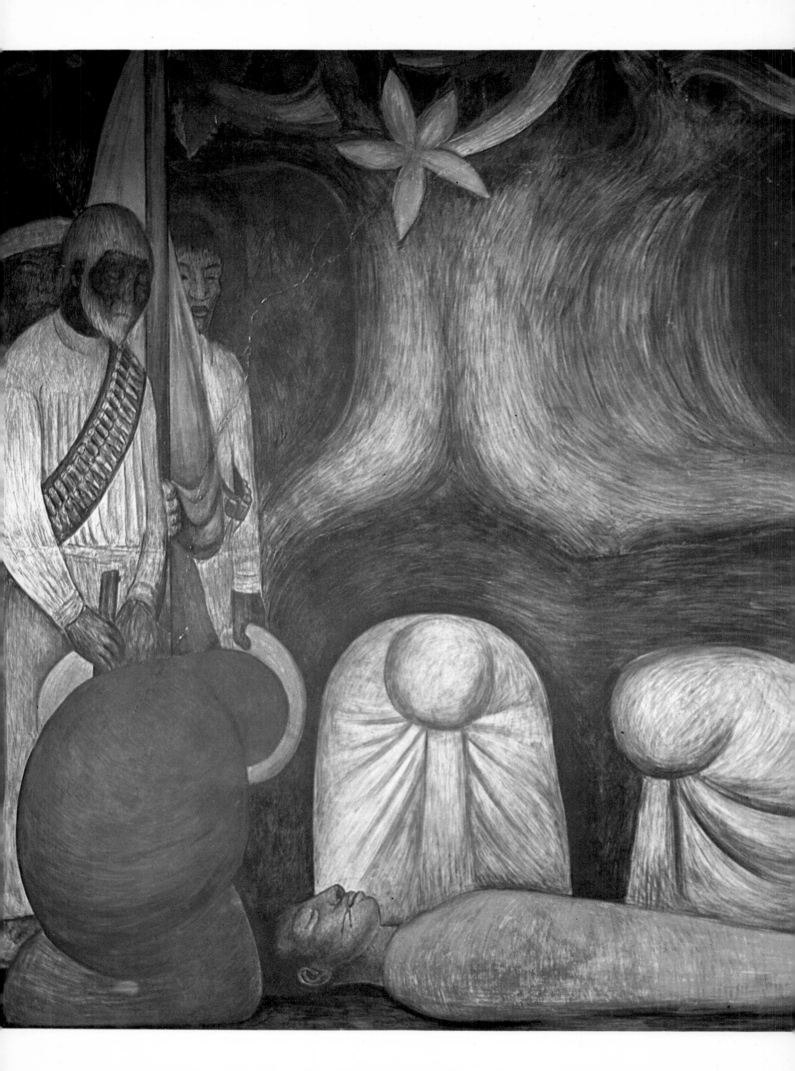

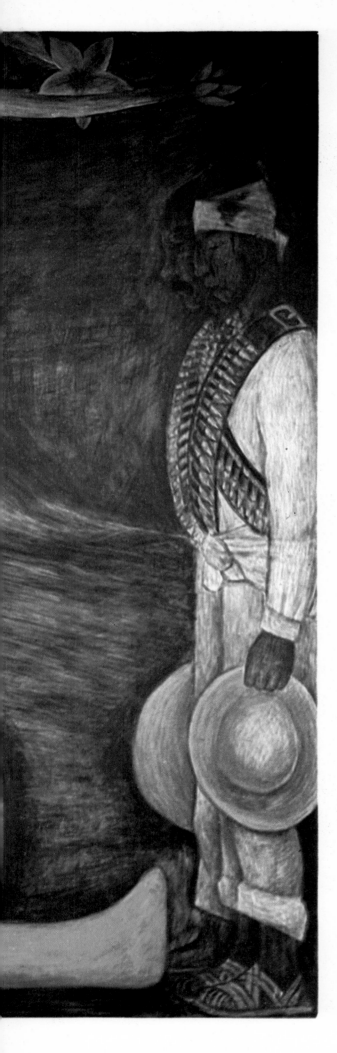

Venustiano Carranza, Villa went into hiding. He had always had good relations with the United States; now he became its enemy.

While Villa, Carranza, and Zapata had been fighting among themselves, their old enemy, Victoriano Huerta, had been in touch with the German government. The Germans, anticipating United States entry into the war in Europe, hoped to create a diversion by having Mexico attack from the south. Huerta was just the kind of man the Germans thought they needed. With almost unlimited funds, he arrived in New York and slowly began making contacts. Under surveillance by the United States Secret Service, he went to El Paso and made contact with Felix Díaz, the nephew of the ex-president, and other forces interested in starting a counterrevolution against Carranza. But the German conspiracy never came to fruition. Huerta died in El Paso, in bed, after a surgical operation.

While Huerta had been plotting, however, Villa had acted against the United States. His men had attacked a train traveling through the state of Chihuahua and killed the passengers. Sixteen of them were Americans. One more act of Villa's nearly provoked war between Mexico and the United States. With a party of guerrillas, Villa crossed the Rio Grande into Columbus, New Mexico, attacked the Thirteenth U.S. Cavalry, and made off with guns, ammunition, and horses.

These two incidents were more than the United States could ignore. President Wilson announced that General John J. Pershing would lead a regiment into Mexican territory strictly to capture and punish Villa and his men. Mexican sovereignty, he said, would be in every way respected. But the Mexicans did not see it that way. Carranza, who had at first agreed to Wilson's plan, changed his mind after a very short time. "Black Jack" Pershing and his men entered the country anyway and searched for Villa. They did not find him. He and his men melted into the hills of Chihuahua. But the excitement Pershing caused before he was forced to withdraw strained U.S.-Mexican relations almost to the breaking point. With the passage of time, relations with the United States improved for Villa. No

A fallen revolutionary is mourned by his comrades and family in a Rivera mural in the chapel at Chapingo.

273

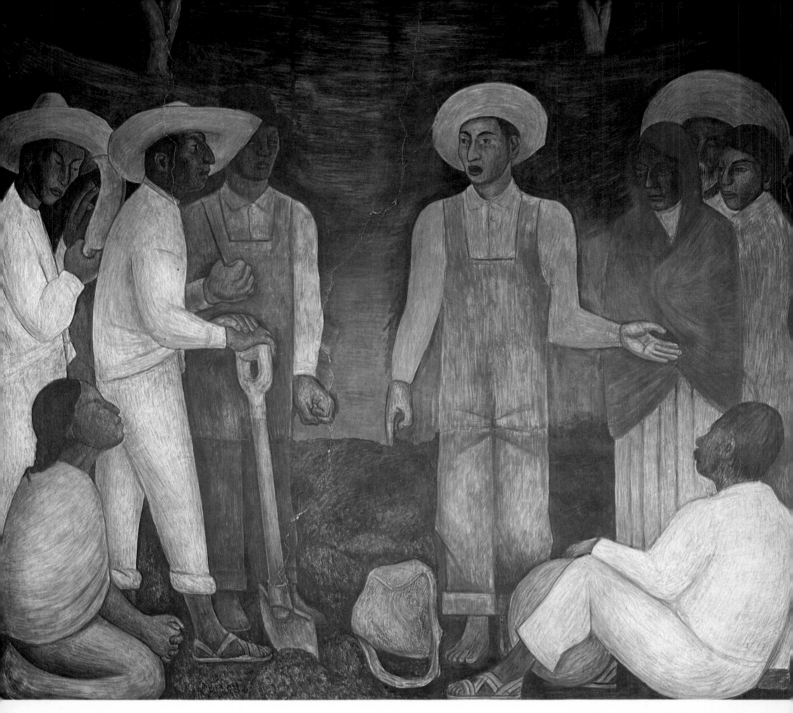

further efforts were made to punish him and he stayed out of the United States, but he continued to harass Carranza by raids in the northern region.

In Mexico City, more important issues were at stake. Zapata was still pressing for land reforms in the south and Villa occasionally marauding in the north, but essentially the Revolution was won. The new constitution was drafted in the early months of 1917, and in May of that year Carranza was officially elected president. The constitution, which he had pledged to defend, codified the most progressive legislation in the world at that time. For example, it gave the government the authority to expropriate and redistribute mineral resources. These resources could under no conditions be sold, although concessions could be granted for their operation. Also, it

detailed the rights of labor, including time off for working mothers of young children, maternity care, the right to strike, a maximum workweek, restrictions on child labor—all told, perhaps more sweeping reforms than those adopted by the Russians after their revolution in 1918. Organized religion was truly separated from the state. Religious schools were banned. Only native-born Mexicans could become priests. This historic document still serves as the basic constitution in Mexico.

Carranza accepted the constitution; but he failed to implement it, acted to suppress strikers, and made very few important steps in the direction of widespread land distribution. When he succeeded in having Emiliano Zapata murdered in a carefully planned ambush, he was totally discredited. Finally

Carranza was forced out of the capital by the Governor of Sonora, Adolfo de la Huerta (not to be confused with Victoriano Huerta), and General Plutarco Calles, Carranza's former minister of industry, commerce, and labor. They issued the Plan of Agua Prieta, which withdrew Sonora's recognition of Carranza as president and named de la Huerta as chief of the new liberal constitutional army. This was a signal for rebellions to break out across the country. Carranza suspected his long-time associate, General Alvaro Obregón, of plotting against him, and Obregón was forced into hiding. Generals, ministers, deputies, and finally the army began to change from Carranza's side to that of de la Huerta and Obregón. As Carranza and his entourage traveled cross-country toward Veracruz, they were attacked while they were encamped in an Indian town called Tlaxcalantongo. In the early hours of the morning, a troop of guerrillas led by Rodolfo Herrera (who had himself guided Carranza to the village) attacked. According to Herrera, Carranza, after being wounded in the thigh, committed suicide. Herrera was later questioned by Obregón and de la Huerta, but served no jail sentence. De la Huerta became provisional president. He was an excellent man for the job. He made conciliatory gestures toward Villa and granted land to him and to his men. He even managed to make peace with the *zapatistas*. De la Huerta remained in office for six months as provisional president until elections could be held. There was no doubt in Mexico as to who the next president would be. There was no more popular man in the country than General Alvaro Obregón.

Farm women bring hot lunch to three archetypical workers in this panel of Rivera's masterpiece at Chapingo.

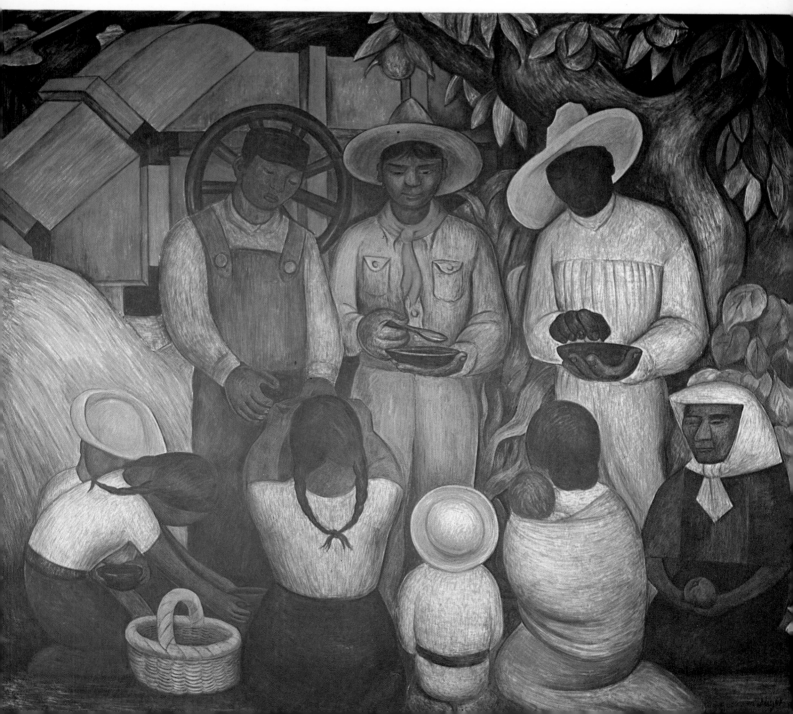

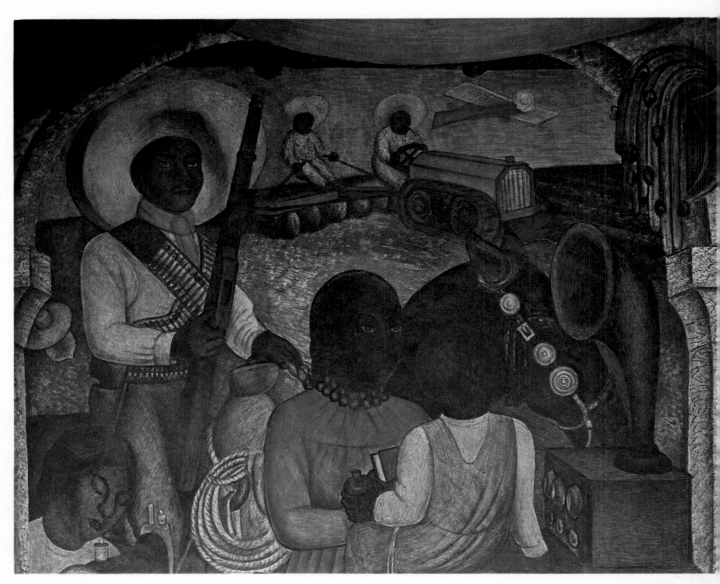

Schools begun by Vasconcelos taught reading, crafts, and agricultural skills. The radio became a useful adjunct.

The New Era, 1920-1940

Out of the destruction and death of ten years of revolution, a new Mexico was forming. With the election of Alvaro Obregón, long-delayed reforms began in earnest. The seeds of progress had been planted under Díaz and Madero by youthful thinkers, writers, and artists who were now mature men. They had lived through the harsh realities of war, but had not lost their dream. Now they could work in a peaceful atmosphere dedicated to a social revolution whose goals had been set forth so long ago.

Because of his intense interest in education, Alvaro Obregón made it possible for a start to be made in the diffusion of a genuine Mexican culture. To the new president, education was desirable but abstract.

To the man he selected as his minister of education, however, teaching was a reality and Mexican culture a lifelong vision. A scholar and intellectual leader in the latter days of the Díaz dictatorship, José Vasconcelos had chosen to fight for his vision of Mexico. He was forced into exile during the administration of President Carranza. In New York and Washington he had worked diligently if unsuccessfully for the recognition of the Gutiérrez provisional government. Obregón admired and respected him.

Vasconcelos brought to the Ministry of Education passionate energy and almost fanatical zeal. His vision of Mexico was as a synthesis of cultures and races that would make up a new world. Modern

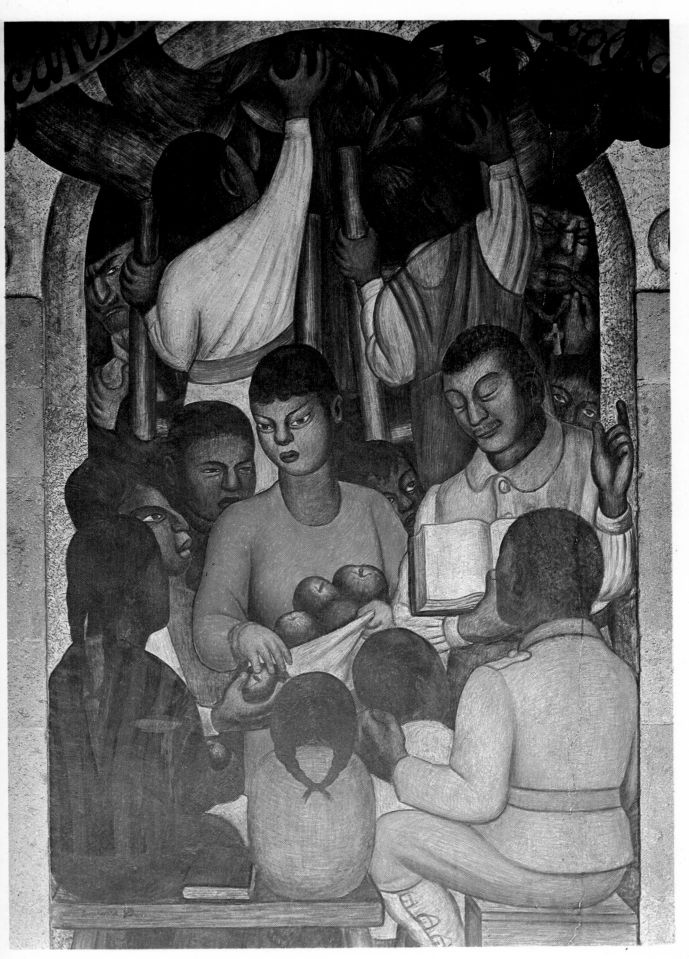

A plutocrat and a priest observe the scene with dis-
approval as a boy distributes apples in a crowded classroom.

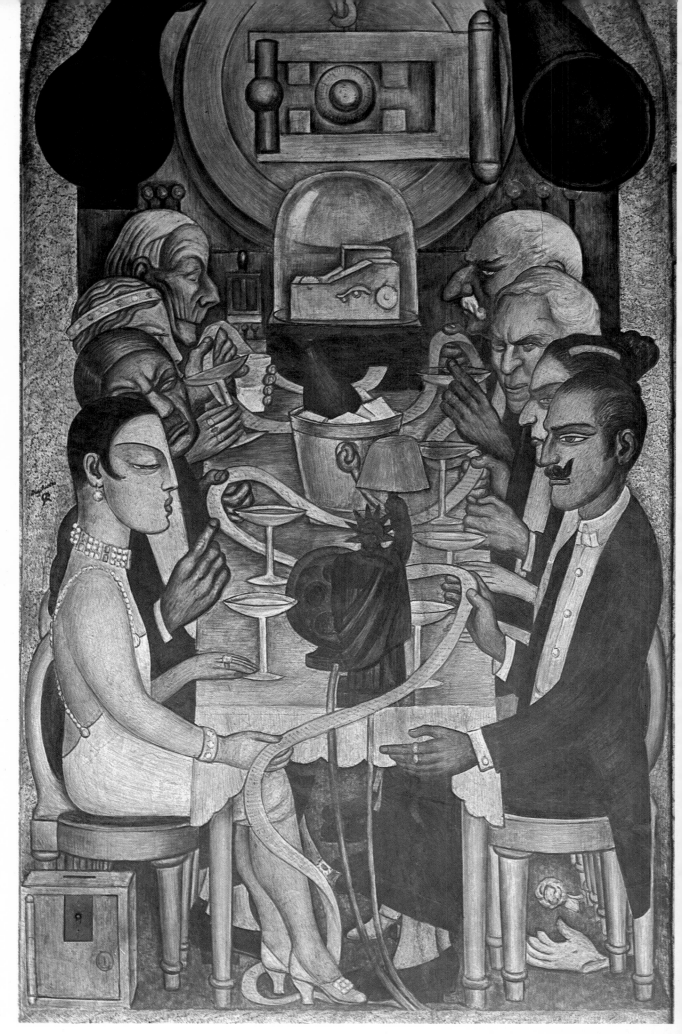

Among those reading ticker tape in this bitter Rivera of 1928 are John D. Rockefeller, Henry Ford, and J. P. Morgan.

Mexico would be built on the combined cultural traditions of the Indians and the Europeans. An integration of the peoples of Mexico—the Indians, the Spaniards, the Negroes, and the Asiatics—would one day produce what he called the "cosmic race." But for the present, there were millions of poor, illiterate Indians and mestizos, and it was to these people that his program was addressed.

The Ministry of Education sent its representatives out to the people, even in the remotest areas. Teams of practical, talented worker-teachers became the forerunners of the Quaker work camps and the Peace Corps. Vasconcelos adopted the missionary teaching technique used by the Spaniards, with teachers from the normal school replacing the missionaries. The first step in the educational plan was for a teacher to live with a group of Indians and to help them erect a school building, often four rough posts holding up a thatch roof. A team of teachers was then sent to the village while the original "missionary" went on to another area. Instruction teams included a craftsman who could teach the villagers how to improve the yield of the crops, forge iron, or dig a well. Other team members taught reading and mathematics and read aloud history, geography, and fiction in the village plaza. Often there was a musician who had two functions: he attracted the townspeople to the meetings, and he conducted classes for the musically inclined.

From the Obregón government Vasconcelos managed to get three times as much money for education as had been spent by the Díaz regime. Yet, as he repeatedly said, it was so little that he could only begin the process that would continue in future generations. The library program encountered many difficulties. Mexico had one great library, the Biblioteca Nacional, but there were no books for use in the rural schools.

Though opposed by many legislators, Vasconcelos, as always with Obregón's firm support, set up a printing plant at the university. He hoped to

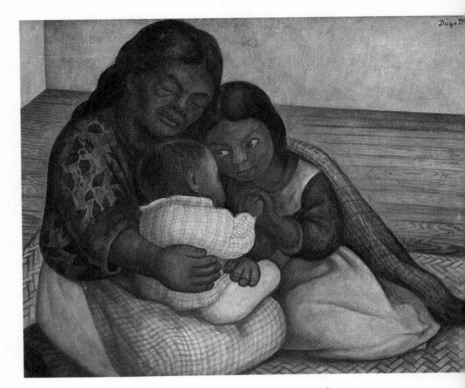

Rivera was perfectly capable of painting tender scenes, as this small canvas of a mother and daughters shows.

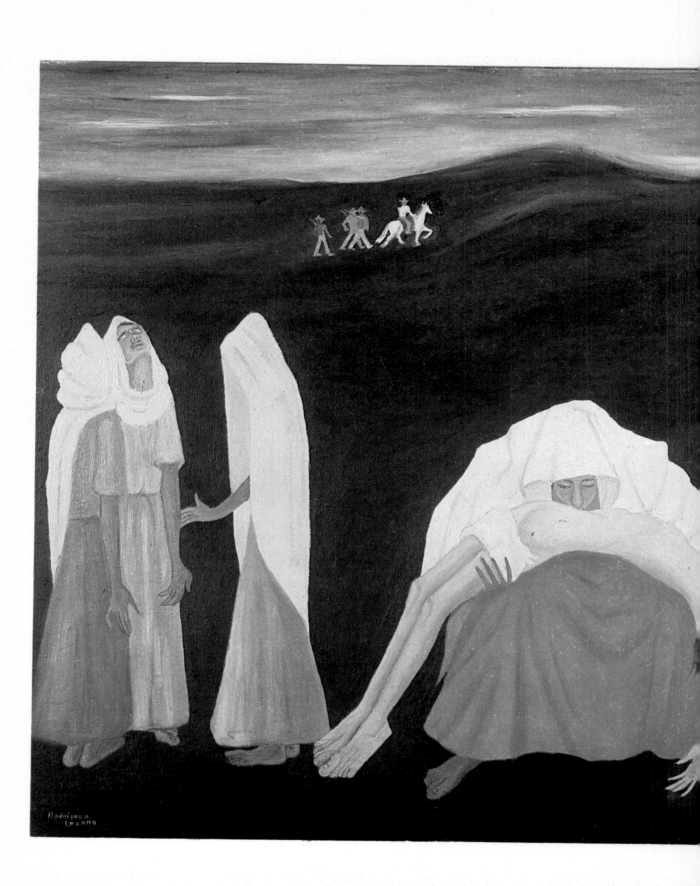

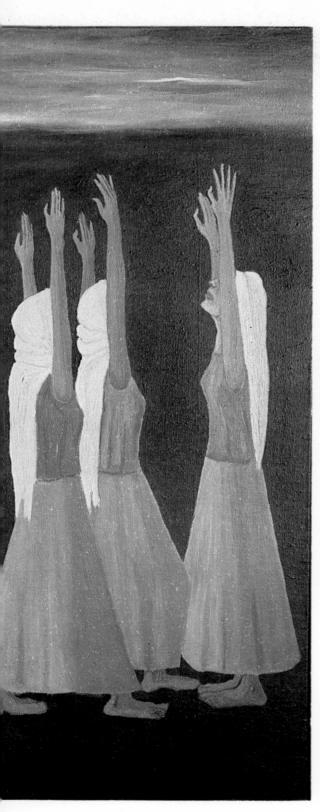

The women of Mexico weep for their dead in stark, evocative painting by Manuel Rodriguez Lozano.

print fifty thousand copies each of a hundred titles. The money ran out long before the ambitious scheme was completed, but editions in Spanish of Plato, Homer, Dante, Goethe, and thirteen other titles were completed.

Distribution of the classics to the Indian and mestizo population brought more criticism, but Vasconcelos believed the Indians should be treated exactly as other citizens. He showed great respect for the traditional arts, encouraging the ancient folkways in pottery, weaving, music, poetry, and dance among the Indians. But he did not let this become the extent of their education. His policy—that every Indian should be educated to enter the public schools of the country—remains the policy of contemporary Mexico.

A feeling for color and design seems instinctive to the people of Mexico. This sense of beauty may spring from their natural environment, with its awesome vistas of mountains, deserts, and seascapes. There is a clarity of light in the Mexican atmosphere. It adds a special brilliance to the already remarkable landscape patterns. Throughout the day, colors shift from deep violets to cardinal reds or from dull to shining greens. The contrast in the light is exceptional. Distant mountains become so sharply visible they seem close enough to touch, but then in a moment they are misty and remote. Gleaming white dwellings with brilliantly painted doorways and windows stand out against the ever-present fields of color and the hills with their marching rows of green maguey cactus plants.

It is no wonder that art played such an important role in the Mexican Revolution. And it is doubtful that any revolution in any country ever had such a talented, perceptive group of artists to record its struggle for freedom. But the artists of Mexico were not a group standing apart from the mainstream of life. They had seen the destruction and terror of the military phase of the Revolution firsthand. Now they would actively participate in carrying out the social revolution.

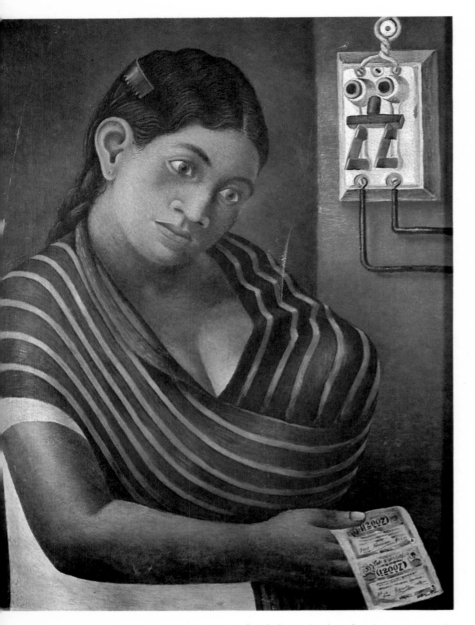

Nursing her baby under her shawl, a woman sells lottery tickets in this 1932 painting by Antonio Ruiz.

A system of rural art schools was set up by the Ministry of Education. The men who taught in them had been, almost to a man, fighters for freedom. To the schools came farmers, miners, and industrial workers, and the artists did more than teach. They were active in labor organizations, the theater, and especially in translating their own sensitive images of the Revolution into terms understandable to the people of Mexico.

The men and women who taught in the outdoor schools became real heroes, for though they were accepted by the overwhelming majority, they had to face the hostility of some superstitious Indian groups who resented outsiders coming into their communities. The church also attacked the new education system just as the system itself attacked the church. Teachers were sometimes robbed, attacked, beaten and even killed. Yet the schools thrived and the pattern of rural education set up at this time still holds throughout the most remote regions of the republic.

Certain painters, including Orozco, Rivera, Siqueiros, and Tamayo, not only focused on the Revolution of 1910 but took as their theme the total revolution in Mexico.

Orozco painted destruction as rebirth. Man, he said, must continuously destroy himself and be reborn over and over. Life to Orozco was a continuous battle, but in destruction itself he found new life. Two examples from the hundreds of works left by Orozco illustrate this theme. One, the *Man of Flames* shown at the beginning of this chapter, shows man in space being consumed and simultaneously reborn in flames. Orozco's vision is close to the ancient Mexican Indian theme whereby man sacrifices himself that the sun may continue to shine upon mankind. In another mural in the same building, Orozco shows the surface of the earth and below it the bones, skeletons, and relics of all past civilizations. On the surface a huge wheel, representing progress, is crushing into powder the evidence of past struggles. Behind the wheel is the hopeful life of a dawning day.

In 1921, a painter of enormous energy and complete technical mastery over the medium that he selected, the mural, returned to Mexico from Europe, where he had dabbled in surrealism and cubism—Diego Rivera was a giant, even among the painters of his time. According to Lola Olmedo, his long-time intimate friend, Rivera loved painting more than anything else in the world—even more than women and food. "He liked to be seen with women and he loved women very much. Only one

ng pleased him more than being out to dinner or
a gala celebration with two beautiful women: that
s free time to paint. He carried scraps of paper in
 pocket, and between drinks or between courses at
ner was continuously sketching. Painting was his
e love."

He painted the history of Mexico always realisti-
ly, sometimes with a savage sense of caricature and
other times with great compassion for a people
ight up in the tragedy of life. Yet, unlike Orozco,
vera was neither cynical nor fatalistic. He satu-
ed his paintings with trenchant wit and exuberant
suality.

One of Rivera's patrons was the American am-
sador, Dwight W. Morrow. Morrow had come to
exico at a time when the United States govern-
nt and United States bankers were deeply con-
ned over what they considered the radicalism of
 Obregón administration. The government-
anized labor movement worried them, and they
re alarmed by talk of Mexico's being taken over
 the Communists. The talk was without founda-
n. Both Obregón and Calles deported Commu-
ts by the hundreds. Neither had any intention of
wing a Communist-type government in Mexico.
At the Conference of Bucareli (so called because
sessions were held at 45 Bucareli Street), the then
esident Calles had agreed not to change any oil
icessions made prior to 1917, when the Mexican
stitution was adopted. This was a victory for the
merican capitalists. It had also been agreed that no
propriation of foreign industry would be made
chout cash payment. The bankers were confident
t Mexico would never be able to afford the large
yments that would be required.

Dwight Morrow arrived in the wake of these
eements. He loved Mexico and was rich enough
have no interest in personal financial advantage.
 built a magnificent home at Cuernavaca and
nt much of his time learning the customs and
kways of the Mexican people. One outstanding
1 generous gesture was to commission Diego
vera to paint the magnificent mural which may
1 be seen in Cortés' palace, the municipal building

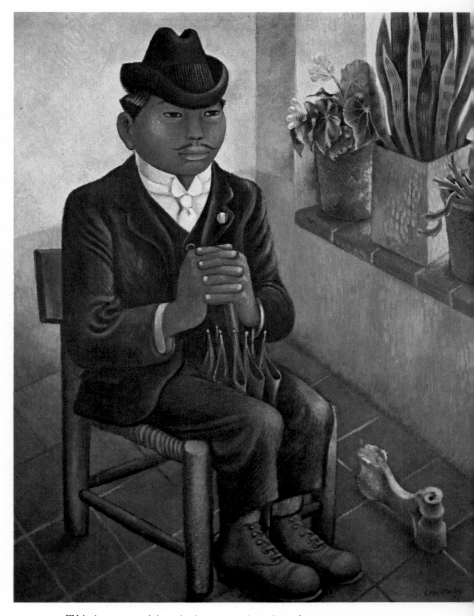

*This famous satiric painting of a minor functionary
to whom a bone has been tossed is by Miguel Covarrubias.*

in Cuernavaca. Morrow paid for the mural out of
his own personal fortune.

In addition, Morrow brought two outstanding
men to Mexico who helped to cement Mexican-
American relations. The first was Colonel Charles
A. Lindbergh. Morrow convinced him to make a
good-will flight to Mexico, and he was joyfully re-
ceived and feted by the Mexicans. He also became

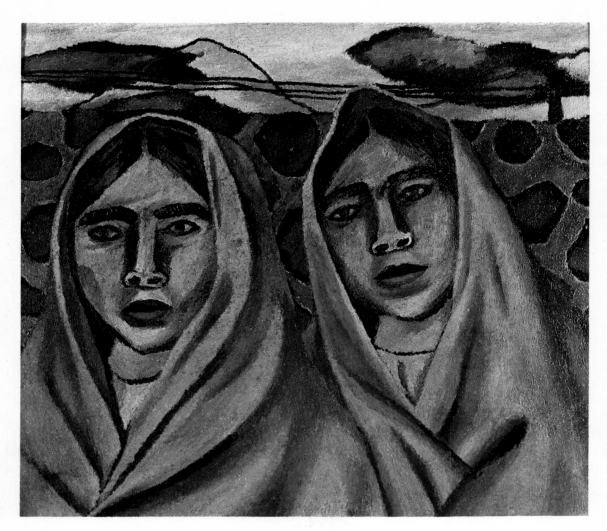

Two women in an early work by Rufino Tamayo, widely regarded as the greatest contemporary painter of Mexico.

very well acquainted with Morrow's daughter, Anne, and made her his wife.

The other foreigner Morrow brought to Mexico had an even more important mission. Obregón had been anticlerical, but his successor, Plutarco Calles, was even less tolerant of the church. Under Calles' regime, a series of laws was passed (and, like Luther's theses, posted on church doors) which amounted to religious persecution. Clerical garb was outlawed, and monasteries and convents were ordered closed. Church buildings became the property of the state, scores of Spanish priests were de-

ported, and religious instruction was forbidden. T severest measure of all forbade the administration the sacraments. In retaliation, the pope in Ron ordered all Mexican churches closed and all chur personnel out of the country.

With the rural areas reacting first, the Catholi rose en masse and the revolt of the *cristeros* bega In a series of bloody battles, the rebellion was p down, but the peace that followed was an uneasy or At this crucial time, Dwight Morrow arranged f Calles to meet and confer with Father John Burl an emissary of the Catholic Church. In time, Cal

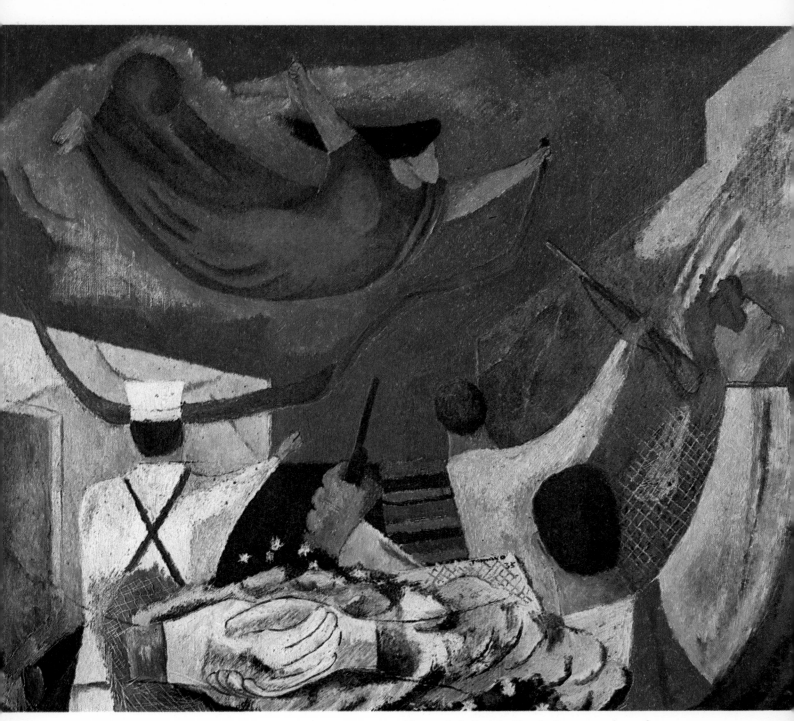

dopted a more reasonable attitude and, with Morrow acting as go-between, priests and nuns greed to re-enter Mexico and the churches were pened once again.

Calles was a strong man in the Latin tradition who dominated three of the presidents who followed him. He himself had been the hand-picked successor to Obregón, but Obregón had not wished to relinquish power as soon as he had. After Calles' term, Obregón pushed through an amendment repealing the constitutional ban on re-election. But only a few days after winning the election that followed, Obregón was assassinated. The last of the great revolutionists had met violent death. All of them had been assassinated—Madero, Zapata, Carranza, and Obregón. Villa outlived them all, but he too was shot down in an ambush in 1926.

In 1934, a protégé of Plutarco Calles, Lázaro Cárdenas, became president of Mexico. When the former president tried to reassert his former role, Cárdenas had him exiled to the United States. Cárdenas turned out to be nobody's man but his own. His loyalty was strictly to the constitution of 1917, and he implemented it in every way he could.

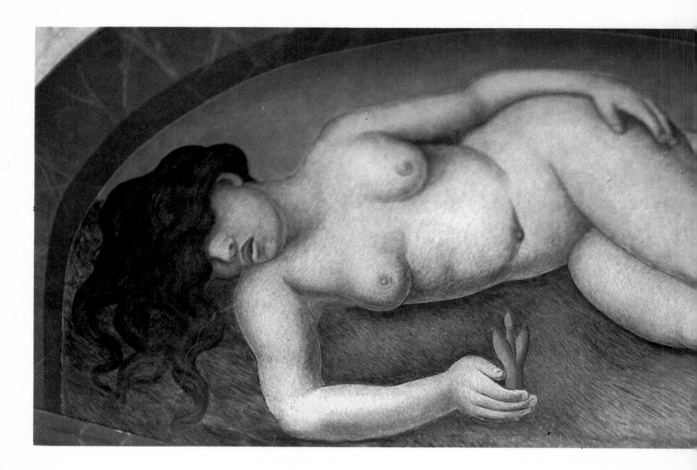

Such outstanding artists as Orozco, Siqueiros, Rivera, and Rufino Tamayo had been forced, for economic reasons, to leave Mexico. All of them had gone to the United States, where they had produced important murals in California, Michigan, and New York. Rivera's mural at Rockefeller Center, with its sympathetic portrait of Lenin, caused an international uproar when it was destroyed. Later, from the original sketch, Rivera repainted the mural at the Palacio Nacional de Bellas Artes in Mexico City.

But with the election of Lázaro Cárdenas in 1934, a new era opened in Mexico for artists and writers. Mural painting thrived as it had in the early days of Obregón. Freedom to paint and write were only a small part of the reforms the Cárdenas regime accomplished for Mexico. The new president had three important aims. Most important was the restoration of land to the peasants. His second great goal, like Obregón's, was more schools. His third goal was the organization of students, workers, and farmers into their own unions. Along with this, Cárdenas promoted a system of worker co-operatives.

In large measure, he succeeded in all three aims. His administration distributed twice as much land to the farmers as all those before him. There were more strikes than ever before, but, under Vicente Lombardo Toledano, labor became a more responsible body than ever before.

Because Cárdenas had no personal ambition beyond serving Mexico, his administration was relatively peaceful. A simple man of simple tastes, he refused to live in the presidential palace. During his tenure in office, the economy of Mexico made great advances. He led the way by insisting upon cutting his salary in half. The president even contributed his own landholdings to the land reform program.

Cárdenas became known throughout the country as a listener. He would push aside diplomats and bankers to hear the pleas of his beloved *campesinos*. His most unusual listening device was to give free service on the telegraph lines for an hour a day to anyone in Mexico who wished to transmit his complaint directly to the president.

But Cárdenas is best known as the man who gave back to Mexico the rights to its own mineral resources. When the oil workers struck the foreign-owned oil companies, the oil companies and the workers agreed to submit to arbitration. The arbitrators found for the workers, but the companies refused to abide by the supporting decision of the supreme court. At this point, Cárdenas acted. Despite the risk of reprisals by the United States, he

announced, on March 18, 1938, the expropriation of the foreign-owned oil companies. The United States, under President Franklin D. Roosevelt, reacted calmly. The crisis was grave, but the Cárdenas administration surmounted it.

The Revolution has been over for many years, but it still exists in its revealing paintings and in its legends. The shade of Hidalgo, his white locks flying, still leads his Indians toward freedom; Díaz still entertains the stout, top-hatted capitalists with dancing girls; the sinister shadow of Huerta falls over the Madero administration; Zapata and Villa still ride the misty plains and humid forests.

Somewhere between the dream and the reality a new Mexico found its way. Yet there is always a skeleton at the feast or at the famine as a grim reminder to all Mexicans of the joy of living.

Rivera's painting of Virgin Earth *sheltering a plant as she sleeps is considered one of his most important works.*

A Promethean figure leans from the mouth of a volcano and gives man fire as electricity in this Rivera mural.

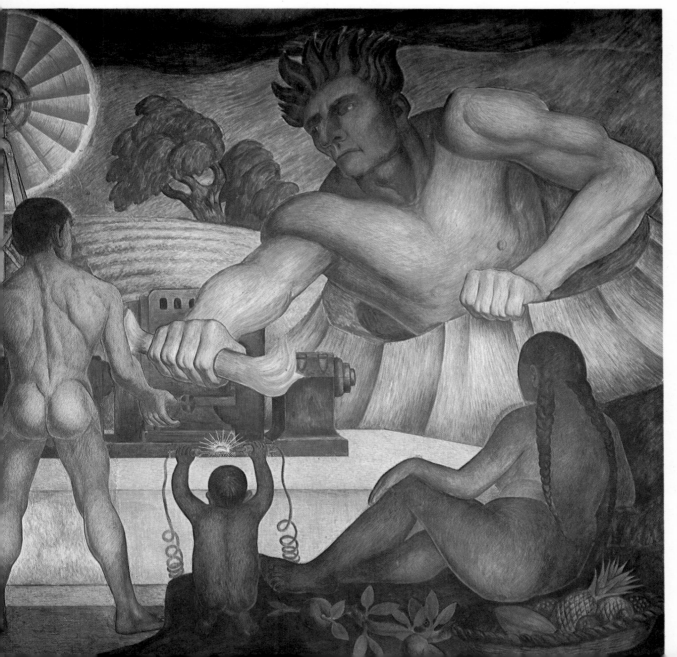

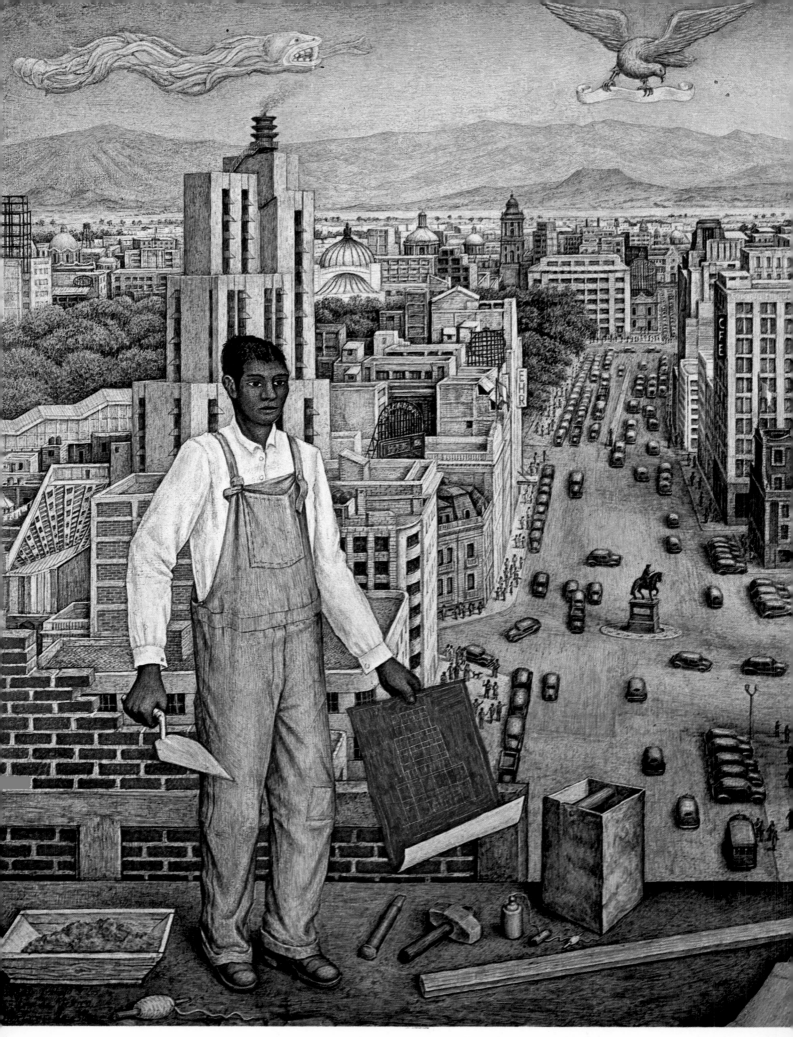

A Mexican workman builds toward the world of the future in this detail from an easel painting by Juan O'Gorman. The symbols of ancient Mexico, the eagle and the serpent, are seen in the sky high above the growing city.

The binding of the book is a facsimile of the *amate* paper made from wood bark used by the people of ancient Mexico for drawings and manuscripts. The end papers show figures from each period in pre-Conquest Mexico.

Typography is set in Granjon by American Book–Stratford Press, Brattleboro, Vermont.

Printed and bound by Toppan Printing Company, Tokyo, Japan.

WORKS OF ART

ht.: 52.7 cm.; Museum of Primitive Art, New York

61 *Young man looking into mirror;* ceramic; Jalisco; ca. 200 B.C.; ht.: 36 cm.; Museo Regional de Antropología e Historia, Villahermosa, Tabasco

62–63 *Parents and children;* ceramic; (l. to r.) Jalisco, Colima, Colima, Michoacán, and Colima; 200 B.C.– A.D. 200; M.N.A.H.

64 *Men's temple or house;* ceramic; from Ixtlán, Nayarit; 1st century A.D.; M.N.A.H.

THE CLASSIC ERA

65 *Mayan goddess;* from Jaina, Campeche; A.D. 200–900; M.N.A.H.

66 *Priest or warrior;* ceramic; from La Ventilla, Teotihuacán; ht.: 8.5 cm.; M.N.A.H.

67 *Three figures of Teotihuacán;* ceramic; from La Ventilla, Teotihuacán; A.D. 350–650; av. ht.: 7.5 cm.; M.N.A.H.

68a *The Earthly Paradise of Tlaloc* (detail); mural, fresco painting; A.D. 360–650; Palace of Tepantitla, Teotihuacán

68b *The Earthly Paradise of Tlaloc* (detail); happy, singing dancers (see page 68a)

69 *The Earthly Paradise of Tlaloc* (detail); man kicking ball (see page 68a)

70–71 *Two seated men;* ceramic; from La Ventilla, Teotihuacán; A.D. 250– 375; ht.: 5 cm.; M.N.A.H.

72 *Articulated figure;* ceramic; from Tetitla, Teotihuacán; A.D. 400–800; ht.: 38.5 cm.; M.N.A.H.

73 *Dancing figure;* ceramic; Teotihuacán; A.D. 350–650; ht.: 9 cm., M.N.A.H.

74 *Reclining man with shaved head;* ceramic; Teotihuacán; A.D. 400– 900; ht.: 12.2 cm.; M.N.A.H.

75 *Water carrier;* ceramic; from San Mateo Tepetilla; Teotihuacán; A.D. 400–900; ht.: 18.4 cm.; M.N.A.H.

76 *Yacatecuhtli, god of commerce* (detail); from Zacuala, Teotihuacán: 1 B.C.–A.D. 900; M.N.A.H.

77 *Clay mask;* ceramic; Teotihuacán: 1 B.C.– A.D. 900; ht.: 19 cm.; M.N.A.H.

78 *The Scribe* (detail); stone; from Palenque ruins; Mayan: A.D. 300– 650; state of Chiapas

79 *Great chief on pedestal;* bone; from region of the Usumacinta River; Mayan: A.D. 200–400; ht.: 6.5 cm.; M.N.A.H.

80 *Homage to the god of corn;* stone

slab; from Palenque; Mayan: A.D. 644–720; Museo de Palenque, Chiapas

81 *Panel of the Slaves;* stone; from Palenque ruins; Mayan: A.D. 600– 700; Museo de Palenque, Chiapas

82 *Royal burial chamber of Palenque* (detail); stone; from Temple of the Inscriptions; Mayan: A.D. 633; length: 381 cm.; Palenque ruins, Chiapas

83 *Palace panel* (detail); stone; from Palenque, Mayan: A.D. 400–600; Palenque ruins, Chiapas

84 *Mayan vase* (detail); from the Heights of Usumacinta; Mayan: A.D. 700; ht.: 22 cm.; Museo Regional de Antropología e Historia, Villahermosa, Tabasco; coll. of Carlos Pellicer

85 *Vase with warriors;* ceramic; polychrome decoration over orange "slip"; from Jaina, Campeche; Mayan: A.D. 700–900; ht.: 16.5 cm.; M.N.A.H.

86 *Seminude solar deity;* ceramic; from Teapa, Tabasco; Mayan: A.D. 700; ht.: 60 cm.; Museo Regional de Antropología e Historia, Villahermosa, Tabasco

87 *Anthropomorphous rattle;* ceramic; from Jaina, Campeche; Mayan: A.D. 200–900; ht.: 18.5 cm.; M.N.A.H.

88 *Richly dressed woman facing man;* ceramic; from Jaina, Campeche; Mayan: A.D. 700–900; ht.: (l. to r.) 21.2 cm., 19 cm.; M.N.A.H.

89 *Figure representing jaguar;* ceramic; from Jaina, Campeche; Mayan: A.D. 700–900; ht.: 12.5 cm.; M.N.A.H.

90 *Maya wearing maxtlatl;* ceramic; from Jaina, Campeche; Mayan: A.D. 400–700; ht.: 17.5 cm.; M.N.A.H.

91 *Standing nobleman;* ceramic; from Jaina, Campeche; Mayan: A.D. 700–900; ht.: 18.8 cm.; M.N.A.H.

92 *Woman with high hat;* ceramic; from Jaina, Campeche; Mayan: A.D. 700–900; ht.: 18.5 cm.; M.N.A.H.

93 *Woman weaver;* ceramic; from Jaina, Campeche; Mayan: A.D. 700–900; ht.: 16.5 cm.; M.N.A.H.

94 *Ballplayer;* ceramic; from Jaina, Campeche; Mayan: A.D. 700–900; ht.: 12.8 cm.; M.N.A.H.

95 *Woman of high caste;* ceramic; from Campeche; Mayan: A.D. 400– 700; ht.: 19 cm.; M.N.A.H.

96 *Human mask;* gold; from Cenote Sagrado de Chichén Itzá, Yucatán; Mayan: A.D. 900–1250; ht.: 2.4 cm.; M.N.A.H.

97a *Bell-shaped gold ornament;* from

Cenote Sagrado de Chichén Itzá, Yucatán; Mayan: A.D. 900– 1250; ht.: 4.3 cm.; M.N.A.H.

97b *Gold ornament;* from Cenote Sagrado de Chichén Itzá, Yucatán; Mayan: A.D. 900–1250; ht.: 3.8 cm.; M.N.A.H.

98 *Bird man or god;* ceramic; from Ocotlán, Oaxaca; Monte Albán III: A.D. 300; ht.: 24 cm.; coll. Howard Leigh, Mitla, Oaxaca

99 *Jaguar funerary urn;* polychrome ceramic; Oaxaca; Monte Albán III; Zapotec: 200 B.C.–A.D. 800; ht.: 88 cm.; M.N.A.H.

100a *Xipe-Totec;* Oaxaca; Monte Albán IV: A.D. 800–1200; ht.: 44 cm.; Museo Regional de Antropología e Historia, Oaxaca

100b *Standing Tlacuache;* ceramic; Oaxaca; Monte Albán IV: A.D. 800– 1200; ht.: 42 cm.; Museo Regional de Antropología e Historia, Oaxaca

101 *Bat vampire goddess;* ceramic; Monte Albán III: A.D. 100; coll. of Howard Leigh, Mitla, Oaxaca

102 *Gold pendant;* from Coixtlahuaca, Oaxaca; Mixtec: ca. A.D. 1000; ht.: 10 cm.; M.N.A.H.

103 *Gold pendant solar disk;* from Oaxaca; Mixtec: ca. A.D. 1000; ht.: 11.8 cm.; M.N.A.H.

104 *Musician playing turtle shell;* ceramic; from southern Valley of Oaxaca; Monte Albán IV: A.D. 800–1200; ht.: 44 cm.; coll. of Howard Leigh, Mitla, Oaxaca

THE NEW CIVILIZATIONS

105 *Totonac head;* ceramic; from El Faisán, Veracruz; A.D. 600–899; coll. of Dr. Kurt Stavenhagen, San Angel, Mexico City

106 *Woman's torso* (detail); ceramic; from Remojadas, Veracruz; Totonac: A.D. 200–500; ht.: 49 cm.; Museo de Antropología de la Universidad Veracruzana, Jalapa, Veracruz

107 *Goddess Cihuateteo;* ceramic; from semiarid zone of Veracruz; Totonac: A.D. 200–500; ht.: 30 cm.; Museo de Antropología de la Universidad Veracruzana, Jalapa, Veracruz

108 *Mictlantecuhtli, lord of the dead;* ceramic; from Tierra Blanca, Veracruz; Totonac: A.D. 600–900; ht.: 37 cm.; Museo de Antropología de la Universidad Veracruzana, Jalapa, Veracruz

109 *Warrior on throne;* ceramic; from El Faisán, Veracruz; Totonac: A.D. 200–500; Museo de la Universidad Veracruzana, Jalapa, Veracruz

110 *Smiling man;* ceramic; from Apachital, Tierra Blanca, Veracruz;

231 *Holy Week in Cuautitlán;* oil on canvas; Juan de Miranda; 1858; Museo Nacional de Historia, Chapultepec Castle, Mexico City

232–233 *The Agony;* oil on wood; José María Estrada; 1852; Instituto Nacional de Bellas Artes; coll. of Museo Nacional de Arte Moderno, Mexico City

234–235 *Grand Bridge;* oil on canvas; anonymous; ca. 1862; Museo Regional de Guadalajara, Jalisco

236 *Battle of the 5th Day of May, 1862;* oil on canvas; ca. 1862; Museo Nacional de Historia, Chapultepec Castle, Mexico City

237 *Bronze portrait of Maximilian;* sculpture; Felipe Sojo; 1864; Museo Nacional de Historia, Chapultepec Castle, Mexico City

238 *Taking of Puebla;* oil on canvas; Prieto; 1902; Museo Nacional de Historia, Chapultepec Castle, Mexico City

239 *The Execution of Maximilian, Miranón, and Mejía;* oil; anonymous; ca. 1867; Museo Regional de Guadalajara, Jalisco

240 *Still life with watermelon;* oil on wood; Hermenegildo Bustos; 1874; Instituto Nacional de Bellas Artes; coll. of Museo Nacional de Arte Moderno, Mexico City

241 *Offering of Atilana García and Nemensio Rico;* oil on tin; Hermenegildo Bustos; 1879; Instituto Nacional de Bellas Artes; coll. of Museo Nacional de Arte Moderno, Mexico City

242 *Oaxaca Cathedral;* oil on canvas; José María Velasco; 1887; Museo Nacional de Bellas Artes, Mexico City

243 *Valley of Mexico;* oil on canvas; José María Velasco; ca. 1900; Museo Nacional de Arte Moderno, Mexico City

244–245 *The Train;* oil on canvas; José María Velasco; 1897; Museo Nacional de Arte Moderno, Mexico City

246 *Peregrinations of the Governors;* magazine: *El Hijo del Ahuizote,* 1902; Hemeroteca Nacional de México

247 *A theater scene;* watercolor; Alcalde; from magazine: *Comico;* 1898; Hemeroteca Nacional de México

248 *Terrible Crimes of the Hacienda Owners;* zinc engraving; ca. 1910; José Guadalupe Posada; coll. of Jaled Muyaes; Talleres "Policromia," Mexico

REVOLUTION AND PROGRESS

249 *Man of Flames;* fresco; José Clemente Orozco; 1939; cupola of the auditorium of the Instituto Cabañas

250 *Proletarian Mother and Child;* oil on canvas; David Alfaro Siqueiros; ca. 1924; Museo Nacional de Arte Moderno, Mexico City

251 *The Revolution Against the Porfirio Díaz Dictatorship;* mural in acrylic resin paints; David Alfaro Siqueiros; 1957–1967; Museo Nacional de Historia, Chapultepec Castle, Mexico City

252 *The Dance of the Revolution;* oil on canvas; Francisco Goitia; ca. 1916; coll. of Adolfo López Mateos

253 *El Revolucionario Maderista;* oil on canvas; Francisco Goitia; ca. 1916; Museo Nacional de Arte Moderno, Mexico City

254 *Calavera Soldadera;* wood engraving; José Guadalupe Posada; ca. 1910; Instituto Nacional de Bellas Artes, Mexico City

255 *Shooting of Capitán Clodomiro Cota;* zinc engraving; José Guadalupe Posada; ca. 1910; Instituto Nacional de Bellas Artes, Mexico City

256 *Francisco Madero;* wood engraving; José Guadalupe Posada; ca. 1910; Instituto Nacional de Bellas Artes, Mexico City

257 *Calavera Huertista;* zinc engraving; José Guadalupe Posada; ca. 1910; Instituto Nacional de Bellas Artes, Mexico City

258 *Shooting of Madero and Pino Suárez;* oil on cardboard; anonymous; ca. 1913; Museo Nacional de Historia, Chapultepec Castle, Mexico City

259 *Now or Never;* magazine: *El Hijo del Ahuizote;* Sept. 6, 1913; Hemeroteca Nacional de México

260 *Emiliano Zapata;* mural (detail); Diego Rivera; 1929; Cortés' Palace, Cuernavaca

261 *Villa in the Presidential Chair;* photograph; Dec. 6, 1914; Museo Nacional de Historia, Chapultepec Castle, Mexico City

262 *Dr. Atl;* pastel; 1900; Museo Nacional de Arte Moderno, Mexico City; coll. of Carlos Contreras

263 *Campamento Zapatista* (detail); oil on canvas; Fernando Leal; 1922; Museo Nacional de Arte Moderno, Mexico City; coll. of Sra. Francina Audirac Vda. de Leal

264–265 *Revolutionists;* oil on canvas; José Clemente Orozco; ca. 1930; Museo Nacional de Arte Moderno, Mexico City

266 *The Trench;* mural; José Clemente Orozco; 1926; Preparatoria Nacional de México

267 *The Mother's Farewell;* mural; José Clemente Orozco; 1926; Preparatoria Nacional de México

268 *The Rich Banquet While the Workers Quarrel;* mural; José Clemente Orozco; 1923; Preparatoria Nacional de México

269 *Churchgoers;* mural; José Clemente Orozco; 1926; Preparatoria Nacional de México

270 *The Wake;* oil on masonite; Diego Rivera; 1926; Museo Nacional de Arte Moderno, Mexico City

271 *Day of the Dead in the City* (detail); mural; Diego Rivera; 1923; Ministry of Education, Mexico City

272–273 *Revolution, Germination;* mural; Diego Rivera; 1926–1927; auditorium, National School of Agriculture, Chapingo

274 *Revolution: Florescense* (see pages 272–273)

275 *Revolution, Frutification* (see pages 272–273)

276 *Completion of the Agrarian Revolution;* mural; Diego Rivera; 1926; Ministry of Education, Mexico City

277 *Blessed Fruit of Knowledge;* mural; Diego Rivera; 1926; Ministry of Education, Mexico City

278 *Night of the Rich;* mural; Diego Rivera; 1928; Ministry of Education, Mexico City

279 *Mother and Children;* oil on canvas; Diego Rivera; 1934; coll. of Sra. Lola Olmedo

280–281 *The Revolution;* oil on canvas; Manuel Rodríguez Lozano; 1946; Museo Nacional de Arte Moderno, Mexico City

282 *Lottery Ticket Seller;* oil on canvas; Antonio Ruiz; 1932; Museo Nacional de Arte Moderno; coll. of Sra. Mercedes P. de Ruiz

283 *The Bone;* oil on canvas; Miguel Covarrubias; ca. 1930; Museo Nacional de Arte Moderno, Mexico City

284 *Two Women;* oil on canvas; Rufino Tamayo; 1930; Instituto Nacional de Bellas Artes; coll. of Lic. Licio Lagos

285 *Call of the Revolution;* oil on canvas; Rufino Tamayo; 1935; coll. of Pascual Gutierrez Roldan

286 *The Virgin Earth;* mural; Diego Rivera; 1929; auditorium, National School of Agriculture, Chapingo

287 *Fruition: The Fecund Earth* (detail); mural; Diego Rivera; 1927; auditorium, National School of Agriculture, Chapingo

288 *The City of Mexico* (detail); tempera on masonite; Juan O'Gorman; 1949; Museo Nacional de Arte Moderno, Mexico City

BIBLIOGRAPHY

ALAMÁN, LUCAS, *Historia de Méjico* (5 vols.), Mexico City, 1849–1852

American Heritage, *Book of Indians*, New York, 1961

Artes de Mexico (periodical), various issues, Mexico

AZUELA, MARIANO, *Two Novels of Mexico* (tr. by L. B. Simpson), Berkeley, 1956; *The Underdogs (Los de Abajo)* (tr. by E. Munguía, Jr.), New York, 1963

BANDÉLIER, FANNY, *The Journey of Álvar Núñez Cabeza de Vaca and His Companions*, New York, 1904

BERNAL, IGNACIO, *Mexico Before Cortez* (tr. by W. Barnstone), New York, 1963

BOURNE, EDWARD GAYLORD, *Spain in America 1450–1580*, New York, 1962

BRANDENBURG, FRANK, *The Making of Modern Mexico*, Englewood Cliffs, N.J., 1964

CASO, ANTONIO, *México, Apuntamientos de Cultura Patria*, Mexico, 1943

CHAMBERLAIN, SAMUEL E., *My Confession*, New York, 1956

CLINE, HOWARD F., *Mexico—Revolution to Evolution 1940–1960*, London, 1962; *The United States and Mexico*, New York, 1963

COE, MICHAEL D., *Mexico—Ancient Peoples and Places*, New York, 1966

CORTÉS, HERNÁN, *Cartas de Relación de la Conquista de Méjico*, Mexico, 1908

COVARRUBIAS, MIGUEL, *Indian Art of Mexico and Central America*, New York, 1966; *Mexico South*, New York, 1946

CUEVA, MARIO DE LA, *et al.*, *Major Trends in Mexican Philosophy* (tr. by A. Robert Caponigri), Notre Dame, Ind., 1966

DE VOTO, BERNARD, *The Year of Decision 1846*, Boston, 1943

DÍAZ DEL CASTILLO, BERNAL, *The Bernal Díaz Chronicles* (tr. and ed. by Albert Idell), New York, 1956; *Discovery and Conquest of Mexico*, New York, 1958

DOBIE, J. FRANK, *The Mustangs*, Boston, 1952

DURÁN, FRAY DIEGO, *The Aztecs* (tr., ed., annotated by Doris Heyden and Fernando Horcasitas), New York, 1964

EMMERICH, ANDRÉ, *Art Before Columbus*, New York, 1963

ENCISO, JORGE, *Design Motifs of Ancient Mexico*, New York, 1953

ENRIQUEZ, RAFAEL DE ZAYAS, *Juárez*, Mexico, 1906

FERNANDEZ, JUSTINO, *Mexican Art*, London, 1965

GANN, THOMAS, and THOMPSON, J. E., *History of the Maya*, New York, 1935

GLASS, JOHN B., *Catalogo de la Colección de Codices*, Mexico, 1964

GRUENING, ERNEST, *Mexico and Its Heritage*, New York, 1928

GUZMÁN, MARTÍN LUIS, *The Eagle and the Serpent* (tr. by Harriet de Onis), New York, 1965

HANKE, LEWIS, *Bartolomé de Las Casas—Historian*, Gainesville, Fla., 1952

HARING, C. H., *The Spanish Empire in America*, New York, 1947

HORGAN, PAUL, *Conquistadors in North American History*, New York, 1963

HUMBOLDT, ALEXANDER VON, *New Spain* (Vols. 1–4, tr. from French by John Black), New York, 1966

Katunob, newsletter bulletin on Mesoamerican anthropology (ed. by George E. Fay, various issues), Colorado State College, Greeley, Colo.

LALLY, FRANK EDWARD, *French Opposition to the Mexican Policy of the Second Empire*, Baltimore, 1931

LANSFORD, WILLIAM DOUGLAS, *Pancho Villa*, Los Angeles, 1965

LEON-PORTILLA, MIGUEL, *Aztec Thought and Culture* (tr. from Spanish by Jack Emory Davis), Norman, Okla., 1963

LEONARD, IRVING A., *Baroque Times in Old Mexico*, Ann Arbor, Mich., 1959

LEWIS, OSCAR, *Five Families*, New York, 1959; *Tepoztlán—Village in Mexico*, New York, 1966

Los Angeles County Museum of Art, *Master Works of Mexican Art*, Los Angeles, 1963

LOWIE, ROBERT H., *Indians of the Plains*, New York, 1963

MADARIAGA, SALVADOR DE, *The Rise of the Spanish American Empire*, New York, 1965

MANNING, W. R., *Early Diplomatic Relations between the United States and Mexico*, Baltimore, 1916

MATA, EFREN NÚÑEZ, *México en la Historia*, Mexico, 1951

McHENRY, J. PATRICK, *A Short History of Mexico*, New York, 1962

MEAD, MARGARET, and CALAS, NICOLAS (eds.), *Primitive Heritage*, New York, 1953

MERRIMAN, R. B., *The Rise of the Spanish Empire*, New York, 1918–34

MOSK, SANFORD A., *Industrial Revolution in Mexico*, Berkeley, 1954

MOTOLINÍA, TORIBIO DE, *Historia de los Indios de Nueva España*, Mexico, 1914; *History of the Indians of New Spain* (tr. and ed. by Elizabeth Andros Foster), Berkeley, 1950

MOYSSEN, XAVIER, *México—Angustia de Sus Cristos*, Mexico, 1967

MYERS, BERNARD S., *Mexican Painting in Our Time*, New York, 1956

PADDOCK, JOHN, *Ancient Oaxaca*, Stanford, Calif., 1966

PARKES, HENRY BAMFORD, *A History of Mexico*, Boston, 1960

PAZ, OCTAVIO, *Anthology of Mexican Poetry* (tr. by Samuel Beckett), Bloomington, Ind., 1958; *The Labyrinth of Solitude* (tr. by Lysander Kemp), New York, 1961

PIÑA CHAN, ROMÁN, *Una Visión del México Prehispanico*, Mexico, 1967

PLENN, VIRGINIA and JAIME, *A Guide to Modern Mexican Murals*, Mexico, 1963

POINSETT, J. R., *Notes on Mexico*, New York, 1824

POSADA, JOSÉ GUADALUPE, *La Revolución Mexicana*, Mexico, 1960

PURCELL, WILLIAM L., *Frontier Mexico 1875–1894* (ed. by Anita Purcell), San Antonio, Tex., 1963

RAMOS, SAMUEL, *Profile of Man and Culture in Mexico* (tr. by Peter G. Earle), Austin, Tex., 1962

ROBERTSON, WILLIAM SPENCE, *Iturbide of Mexico*, Chapel Hill, 1952; *Rise of the Spanish-American Republics*, New York, 1921

ROEDER, RALPH, *Juárez and His Mexico*, New York, 1947

SAHAGÚN, FRAY BERNARDINO DE, *General History of the Things of New Spain*, Florentine Codex (12 vols., fr. from Aztec by Charles E. Dibble and Arthur J. O. Anderson), Santa Fe, N.M., 1957

SANTA ANNA, ANTONIO LÓPEZ DE, *The Mexican Side of the Texas Revolution* (tr. by Carlos E. Castañeda), Dallas, 1928

SIERRA, JUSTO, *Juárez, Su Obra y Su Tiempo*, Mexico, 1905–1906

SIERRA, JUSTO (ed.), *Mexico, Su Evolución Social* (3 vols.), Mexico, 1900–1902

SIMPSON, LESLEY BYRD, *Many Mexicos*, Berkeley, 1966

SOUSTELLE, JACQUES, *The Daily Life of the Aztecs* (tr. from French by Patrick O'Brian), London, 1961

TAYLOE, EDWARD THORNTON, *Mexico 1825–1828* (ed. by C. Harvey Gardiner), Chapel Hill, N.C., 1959

THOMPSON, J. E., *Mexico before Cortez*, New York, 1933

THOMPSON, J. E., *Maya Archaeologist,* Norman, Okla., 1963

TOLEDANO, VICENTE L., *La Libertad Sindical en México,* Mexico, 1926

TOOR, FRANCES, *A Treasury of Mexican Folkways,* New York, 1947

VAILLANT, GEORGE C., *The Aztecs of Mexico,* New York, 1941

VASCONCELOS, JOSÉ, *A Mexican Ulysses* (tr. and ab. by W. Rex Crawford), Bloomington, Ind., 1963

WESTHEIM, PAUL, *The Art of Ancient Mexico* (tr. from Spanish by Ursula Bernard), New York, 1965

WINSHIP, G. P., *The Coronado Expedition,* Washington, D.C., 1896

WOLFE, BERTRAM D., *Portrait of Mexico,* New York, 1937

WOOLLEY, SIR LEONARD, *The Beginnings of Civilization,* New York, 1963

ZIMMER, HEINRICH, *Myths and Symbols in Indian Art and Civilization* (ed. by J. Campbell), Washington, D.C., 1946; *The Art of Indian Asia* (2 vols., ed. by J. Campbell), New York, 1955

INDEX

Numbers in *italic* refer to illustrations

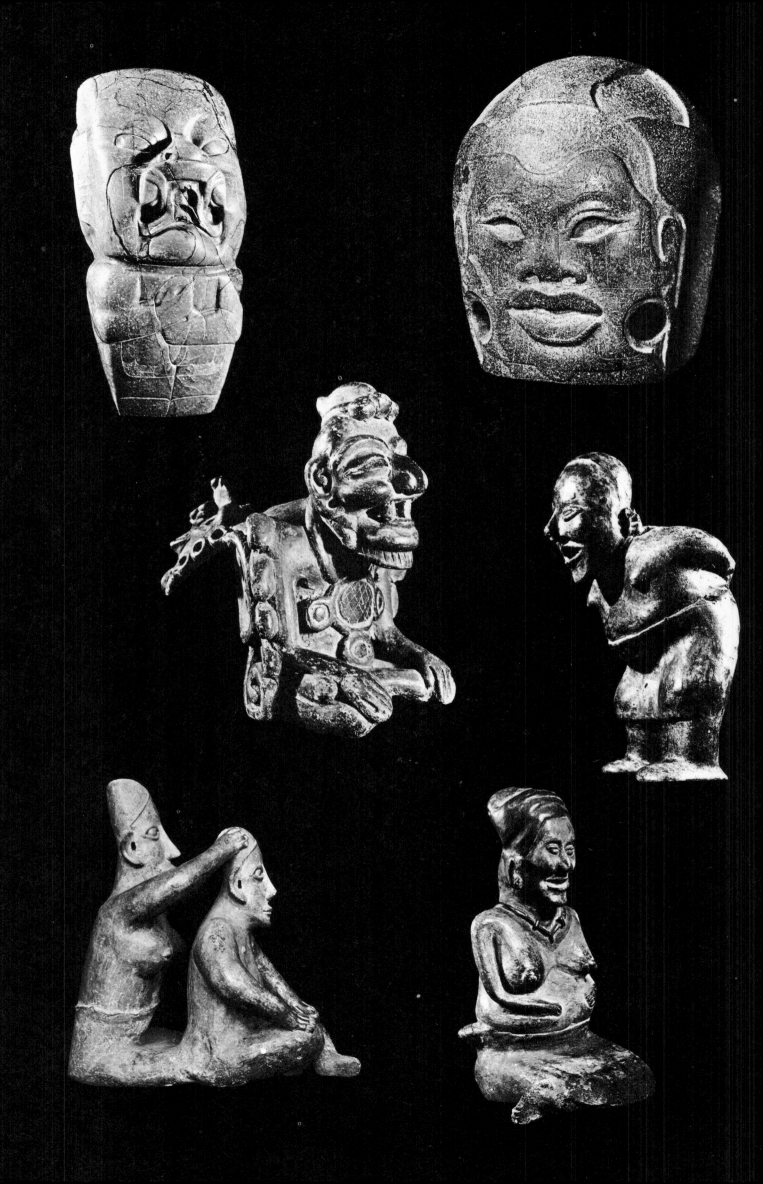